Janina Struk is a freelance documentary photographer, writer and lecturer. She is also the author of the acclaimed book, *Photographing the Holocaust: Interpretations of the Evidence* (I.B. Tauris, 2004) which presents a history and critique of images taken during the Holocaust, 1939–1945.

For Tim

Private
Pictures

SOLDIERS' INSIDE VIEW OF WAR

JANINA STRUK

I.B. TAURIS

LONDON · NEW YORK

Published in 2011 by I.B.Tauris & Co Ltd
6 Salem Road, London W2 4BU
175 Fifth Avenue, New York NY 10010
www.ibtauris.com

Distributed in the United States and Canada
Exclusively by Palgrave Macmillan
175 Fifth Avenue, New York NY 10010

ISBN: 978 1 84885 442 0 (HB)
 978 1 84885 443 7 (PB)

A full CIP record for this book is available from the British Library
A full CIP record is available from the Library of Congress

Library of Congress Catalog Card Number: available

Printed and bound in Great Britain by TJ International Ltd, Padstow, Cornwall

MIX
Paper from
responsible sources
FSC® C013056

Contents

Illustrations

Acknowledgements

I thank all those who have generously contributed their time and knowledge to this work. In the UK thanks to the staff at the Polish Institute and Sikorski Museum, especially Krzysztof Barbarski, Andrzej Suchcitz and Stanisław Żurakowski; to Richard Davis and staff at the Special Collections Department at the University of Leeds; to the Special Collections Department at the University of Birmingham; to the Second World War Experience Centre in Leeds; the Gulf Veterans' Association; to the Office of the Judge Advocate General with special thanks to Policy Advisor Peter J. Fisher for reading and commenting on Chapter Six. Thanks also go to Captain Alexander Allan, Malcolm Andrews, Dave Corrigan, Joanna De Regibus, Mireille Gealageas, Andy McNab and Alan Slingsby.

I would also like to acknowledge the receipt of a grant from the Authors' Foundation, UK, which helped to get this book under way.

In Toronto thanks to Maja Sutnik, Sophie Hackett and staff at the Art Gallery of Ontario (AGO) and to Jeanette Neeson and Douglas Day, whose warm and generous hospitality made my research visit possible and an absolute pleasure.

In Poland thanks to Zara Huddleston and Józef Łysek for their hospitality during all my research trips; to Christine Rickards Rostworowska and Bogusław Rostworowski for their friendship and hospitality in Kraków; to Anna, Andrzej and Paweł Stefaniuk; to Antoni and Elżbieta Bożek for translating texts; to Jerzy Tomaszewski for sharing with me his archive and wartime memories. I also am grateful to Anna Bohdziewicz for sharing with me memories of her father, Antoni Bohdziewicz, and for our pleasurable meetings in Warsaw. Thanks also to Andrzej Rybicki at the Muzeum Historii Fotografii in Kraków.

In Hamburg my thanks go to Hannes Heer for an enjoyable meeting as well as for reading Chapter Five of this book and giving valuable advice on such a complex story; to Petra Bopp for sharing with me her archive and her thoughts on soldiers' pictures; to Ute Wrocklage; thanks also to Jet Baruch at the Rijksmuseum in Amsterdam. In Israel thanks to Yehuda Shaul, Noam Chyrut and Avichay Sharon and all courageous members of Breaking the Silence. In the USA thanks to Kim Newton, C. J. Grisham, Devin Friedman, Edouard Gluck, Dave Herbert and Chris Wilson.

Special thanks must go to Robert Fisk for sharing with me memories of his father, William Fisk, and for kindly giving permission for his photographs to be reproduced in this book. Special thanks and appreciation must also go to my remarkable late uncle, Second World War veteran, Cecil Ripley who so generously shared with me his wartime memories, inspirational stories and photographs and some are reproduced in this book.

There are two people whom I am especially indebted to and without whose support this book would not have been written, my editor at I.B.Tauris Philippa Brewster, whose skill, patience and commitment to this book kept it on track, and Tim Gopsill, whose encouragement, comments and advice at each stage of this work were invaluable and deeply appreciated.

Every effort has been made to trace all the copyright holders, but if any have been inadvertently overlooked we will be pleased to make the necessary arrangements at the first opportunity.

Preface

The idea that war is hell is not new, but the idea that
war is an atrocity is new. *Philip Gourevitch.*[1]

In 2005 I was interviewed on RTE, Irish national radio, about my previous book, *Photographing the Holocaust: Interpretations of the Evidence* (I.B.Tauris, 2004). I spoke about the large number of photographs taken during the Second World War by German soldiers that showed crimes they themselves committed. I told the story of Max Täubner, an officer in the SS, the elite Nazi force headed by Hitler's right-hand man, Heinrich Himmler. Second Lieutenant Täubner took photographs of an execution of Jews in Nazi-occupied Ukraine. Under the Nazi regime the murder of Jews was sanctioned, but taking images of the killing was forbidden. Täubner's pictures were apparently so graphic that in 1943 he was court-martialled, dismissed from the SS and sentenced to ten years' imprisonment, though he was pardoned by Nazi authorities in January 1945. The judge presiding over the court martial said the pictures were 'deplorable ... shameless, utterly revolting', as though the problem was with the photographs and not what they depicted.[2] It has not been uncommon during the last century for the soldiers who have taken pictures of brutality to be condemned more severely than the perpetrators of that brutality.

I also mentioned during that interview that at that time four British soldiers were facing a court martial for taking pictures of the abuse they had meted out to Iraqi prisoners in Basra in 2003. I could sense the journalist's incredulity at the implied parallel: was I saying that British soldiers were on the same moral plane as the Nazis? I was not, but there were similarities between the cases.

Max Täubner had taken his films to two photo shops in southern Germany while on leave, and when the prints were made he showed them to friends and colleagues. Likewise, the snapshots taken by former British soldier Gary Bartlam came to the attention of the authorities because he had taken his film to a photo shop in Tamworth, Staffordshire, while on leave. A shop worker, horrified by what she saw on the prints, had called the police. The soldiers in both cases had apparently assumed that their private pictures were unlikely to trouble the casual viewer.

The outrage caused by the pictures taken by British soldiers in Basra had come just months after the publication of the photographs taken by American soldiers at Abu Ghraib prison near Baghdad. Meanwhile, there had been controversy over images that purported to show the mistreatment of Iraqis by British troops published by the *Daily Mirror* on 1 May 2004 – only days after the Abu Ghraib pictures surfaced. These, it was discovered, had been faked, but it transpired that scenes

similar to those depicted in the pictures had indeed taken place. Subsequently, in Germany there was fury when the German press published pictures taken by German soldiers in Afghanistan that showed them fooling around with a human skull thought to have been taken from a mass grave.[3] Other examples continue to seep into the press. There seems to be no end to soldiers' macabre war pictures.

I remember my own response when the Abu Ghraib pictures were splashed across the front pages of the world's press. I was in Poland at the time, trawling the archives looking at photographs taken during the Second World War. Many were the private pictures of German soldiers that showed populations in the occupied territories in Eastern Europe being cruelly humiliated or worse. I was still shocked by the pictures taken in Iraq and the other soldiers' images that began to emerge from these recent wars. They raised many questions. Perhaps soldiers had always taken pictures at war, but why did they photograph their own brutality? What did they want to show and why? Furthermore, if soldiers chose to take cruel pictures that could incriminate them or their colleagues, why did they keep them?

These questions apply equally to the pictures taken during the years 1939–45 by German soldiers that I was familiar with and that line the walls of Holocaust museums and exhibitions worldwide, but few people drew parallels between these and the Abu Ghraib pictures. Was that because those taken by German soldiers are contextualised by the perceived uniqueness of the Holocaust, in which questions of provenance and authorship tend to be put aside? Context is all. When in Germany in 1995 the authorship of snapshots taken by German soldiers became the focus, to 'prove' the involvement of the Wehrmacht (the German Armed Forces) in Nazi crimes, the public outcry threatened the foundation on which post-war Germany was built.

When in 2007 the Rijksmuseum in Amsterdam held a small exhibition of German soldiers' pictures, taken during the Nazi occupation of the Netherlands, visitors were perplexed and uncertain about how to 'read' these 'ordinary snapshots taken in extraordinary times', as they were described, in the context of a world famous art museum. One visitor commented: 'Does this recent acquisition bear a purely historical note or is it a "homage" or a "tribute" to the Nazis? What is the message being passed across?' But these pictures, made extraordinary only by the context, seemed innocent enough – a photo of a soldier on a donkey on the beach in the north of Holland, a soldier chatting with Dutch citizens, a woman casually leaning on a windowsill holding a cup and saucer standing next to a smiling German soldier. Other visitors made associations with the pictures that often had little to do with what they showed, including the Holocaust, the war in Iraq and American propaganda. Some said they portrayed the humanity of war while others said they portrayed its cruelty. One elderly Dutch visitor looked at the photographs and began to weep and rushed outside. No one knew what he had seen in those seemingly innocuous pictures.

I asked one young man at the exhibition if he was surprised that soldiers had taken pictures at all. He said: 'I am not surprised as I have been in the military myself. All boys dream about being a soldier sometime in life. You have all these boyish pranks so taking pictures makes them eternal … I was drafted to the Swedish

Army and spent a while in Israel ... you see it partially as a vacation because you are with your friends ... so you take pictures from day to day. I took pictures with the locals or my first ride on a camel or other tourist pictures but you are in uniform.'[4] The tourist in uniform is a recurrent theme among soldiers' pictures.

The Rijksmuseum was one of the many places that my questions about soldiers' pictures had led me. I visited national and local archives, war museums, private collections and art galleries, including the Art Gallery of Ontario (AGO) in Toronto where I discovered a large collection of photo albums made by soldiers of participating armies in the First World War, some of which are included in this book. I spoke to war veterans and soldiers who had served in Iraq and Afghanistan as well as former members of the Israeli Defence Force (IDF) who had made their private pictures public as way of drawing attention to the treatment by the IDF of Palestinians in the Occupied Territories. An exhibition of their photographs curated by Breaking the Silence (BTS) that shows the abuse and humiliation of Palestinian civilians was displayed in Tel Aviv in June 2004, a month after the Abu Ghraib pictures shocked the world. Although the exhibition caused some controversy in Israel, in Europe and the United States it was largely ignored. There was no political context in which the pictures could be understood. As Susan Sontag has written: 'What determines the possibility of being affected morally by photographs is the existence of a relevant political consciousness.'[5] However, six years later, in 2010, increasing interest saw global reaction to former IDF soldier Eden Abergil's snapshots that showed her posed smiling in front of a detained blindfolded and handcuffed Palestinian man on her Facebook page.[6]

In 2006, I attended a British Court Martial and listened to young working-class soldiers, dwarfed by the pomp and circumstance of the British legal system and the military hierarchy, testify to their service as soldiers in Iraq. These were witnesses at Britain's first ever war crimes trial, following the death of twenty-six-year-old Iraqi hotel worker Baha Mousa while in British military custody in Basra in 2003. I had been drawn to the case to hear the evidence of Stuart Mackenzie, who was alleged to have had a hand in the production of the faked pictures published in the *Daily Mirror*, although it has never been proven.

Besides searching for pictures in traditional museums and archives, I discovered that, in this first war of the Internet age, a glut of soldiers' pictures was freely available online on personal and commercial websites and even a pornographic website. Some of them were innocuous images similar to those exhibited at the Rijksmuseum, but others that reflected the barbarity of war were truly shocking. I had never seen images like these. Had war always looked like this from the inside? Over the next two years I trawled what seemed like an endless number of sites and tracked down some of the soldiers who had posted pictures and webmasters who hosted them to try to find out why.

Of the thousands of pictures and hundreds of photo albums that I looked at, I discovered that, as long as it has been technically possible for soldiers to take pictures at war, the same subjects reoccur time and time again – touristy pictures, pictures of colleagues and social occasions, a fascination for indigenous peoples, military brutality and the dead.

Even in the photo albums made during the Boer War (1899–1902) elements of the incongruous juxtapositions of jaunty social pictures alongside cruel and brutal images were already apparent. That this unnerving combination is found in a format generally reserved for the niceties of family life is all the more disconcerting. Soldiers' war time albums like family albums, are not intended for public scrutiny.

When I set out to search for soldiers' pictures I was not sure what I would find. But the more I looked the more it seemed that a soldiers' view of war had little to do with the view generally portrayed by professional war photographers. Their images do portray the tragedy and suffering of war but in a contrived manner, composed to conform to professional aesthetic standards and the demands of the picture editors of commercial media, who themselves are bound by considerations of taste, politics and sales.

These findings led me to ask questions about the way in which the genre of war photography has developed and why. As the wars in Iraq and Afghanistan drag on, one question continues to preoccupy me: why are soldiers' pictures not considered as reliable evidence of the realities of war, when carefully composed and selective professional pictures are?

The genre of war photography does not include pictures taken by those who fight the wars. Anthologies and histories of photography rarely contain soldiers' pictures. The majority of museums and archives, even those specialising in warfare or military affairs, rarely consider soldiers' pictures to be of informational or historical value. When soldiers' photo albums are donated to the Imperial War Museum in London, for example, they are examined for pictures considered to be significant for the museum's remit – military hardware, camps, regiments, uniforms and so on. The photographs are then copied and catalogued under appropriate headings, thus removing them from their original context. The albums themselves are stored away and rarely looked at again. The stories they try to tell are ignored. My own requests to gain access and study the large collection of albums deposited at the archive were greeted with incredulity. I was upbraided by officials for asking to see too many of them. My competence as a researcher was questioned. What could I hope to accomplish by studying so many photographs? I wondered how often readers at the British Library are admonished for requesting too many books.

Historians and researchers do ponder over photographs but invariably in search of specific subjects: a female pilot in uniform, perhaps; a captain at the helm of the ship, a First World War trench, refugees fleeing conflict – generic photographs to illustrate certain stories. Photographs are used to illustrate texts but rarely studied as texts in themselves. Even when in the 1960s radical historians began to consider seriously the experiences of 'ordinary' people, and when historic photographs of working-class communities and personal photo albums were given status and became items for collectors for the first time, soldiers' pictures and photo albums of their wartime experiences were overlooked.[7]

At that time in the 1960s war was raging in Vietnam. Many American soldiers took personal pictures, but newspapers and magazines in the USA and Europe

were filled with the professional images of war photographers. These photographs taken in Vietnam, some of which achieved iconic status, determined the way that war would be portrayed for four decades.

When the wars in Afghanistan and Iraq began early in the twenty-first century, expectations were raised and questions asked by those in the business of representing war. What kind of images would this impressive tradition of war photography produce? But it was a new century, not just on the calendar but in terms of communications and popular taste. This was the age of the Internet, of 'reality' culture and 'citizen journalism', and the professional 'objective' view that for half a century had influenced the way the public regarded war looked inadequate and seemed to lose its authority. Some editors turned to soldiers' pictures for an alternative, 'inside' view of war, but they encountered surprising results, as examined in this book.

The search for the inside view of war is not just a phenomenon of the 'reality' culture of the twenty-first century. Since the mid-nineteenth century photography has continually been called upon to provide 'real' depictions of war more dramatic than the last. In spite of this, the raw brutality of war so frequently depicted in soldiers' pictures has rarely crossed the threshold into general public consciousness. When it does it causes controversy, outrage and confusion and is often dismissed as the work of 'a few bad apples'. This book shows this is far from the case. Buried beneath the tradition of war photography, which can glamorise war and inadvertently endorse the ideology that justifies and perpetuates it, is a glut of disregarded soldiers' pictures that, if widely seen, might just challenge the authority of the generally accepted view of war.

ONE
Outrage at Abu Ghraib

A photograph is a secret about a secret.
The more it tells the less you know. *Diane Arbus.*[1]

Pictures that shook the world

In April 2004 pictures of a young woman called Lynndie England were broadcast on the CBS News programme *60 Minutes* and transmitted around the world. There was shock, outrage and condemnation. These were the first of a series of pictures that showed her and fellow soldiers from the 372nd Military Police (MP) Company, an army reserve unit based in Cresaptown, Maryland, humiliating and torturing Iraqi detainees in Abu Ghraib prison near Baghdad. There was much handwringing that Lynndie England was just a 'girl next door' and that the blame should have been directed higher up the military and even political hierarchy. There was less comment on the nature of the incriminating images themselves – who had taken them and why. For these were not documentary photographs taken by war photographers to expose a mighty wrong. They were private pictures taken by soldiers – regular army reservists, ordinary kids from small-town America, seemingly with no sense of shame.

In one picture (Figure 1.1) Lynndie England is holding what looks like a dog leash, which is attached to the neck of a naked Iraqi man. She is glancing towards the man, who has a grimacing expression and is lying on the floor outside a prison cell. In another, England is standing arm in arm with soldier Charles Graner, who at the time was her lover. They are posed grinning for the camera behind a number of naked Iraqi prisoners who are piled on top of each other in a kind of pyramid. England later said that this scene was photographed because 'it looked funny.'[2] In another picture Lynndie England is shown with a cigarette dangling from her mouth as she points at the genitals of a naked Iraqi man with a hood over his head as he masturbates. Three other hooded naked Iraqi men stand side by side, with their hands covering their genitals.

Another picture shows a hooded Iraqi prisoner balanced on a cardboard box. He is wearing a makeshift blanket poncho with his arms outstretched and his hands seemingly attached to electrical wires (Figure 1.2).

But it was the image of Lynndie England holding the man on the leash that, according to an editorial in the *Independent* in May 2004, was 'certain to become one of the defining images' of the US occupation of Iraq.[3] Here was a young

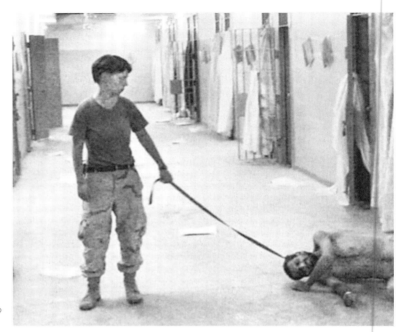

Figure 1.1 Lynndie England with an Iraqi prisoner taken at Abu Ghraib prison, Baghdad, Iraq, 2004.

woman, slight in build with short cropped hair, dressed in a loose-fitting T-shirt, army fatigues and lace-up boots – an androgynous figure – domineering over and humiliating a naked Iraqi man by treating him like a dog. England became the focus of newspaper headlines that described her as cruel, savage and lacking in morality: 'America's Shame', 'The Destruction of Morality', and 'Shocking Image that Spells Disaster for the U.S. in Iraq' were but a few.[4] She was depicted as a 'global hate figure' with a 'taste for cruelty'. In an article that asked: 'What turns a woman into a savage?' she was described as displaying a sadism that 'denies the virtues of womanhood'. In the *Sun* newspaper she was depicted as a 'witch' while in the *Daily Mail* Lawrence James said she was 'the latest in a long sequence of ruthless women … who were prepared to use the extremes of cruelty to get what they wanted' including, he said, Traudi Schneider, a Nazi guard at Ravensbrück, a concentration camp for women in northern Germany where 117,000 women and children died. But was Lynndie England any of these things? In one report England was quoted as saying: 'I was instructed by persons in higher rank to "stand there, hold this leash, look at the camera" and they took pictures for PsyOps (psychological operations) … I didn't really … want to be in any pictures.' In a sworn statement she said the leash had been placed on the 'detainee' to get him to confess to raping an Iraqi boy.[5] Although England said she realised how perverse the image looked in the media, she said that she saw it differently. 'I don't see the infamous picture from the Iraq war, I just see me. It's just a picture.'[6]

When I first saw the images taken by American soldiers at Abu Ghraib I was reminded of the private pictures taken by German soldiers during the Second

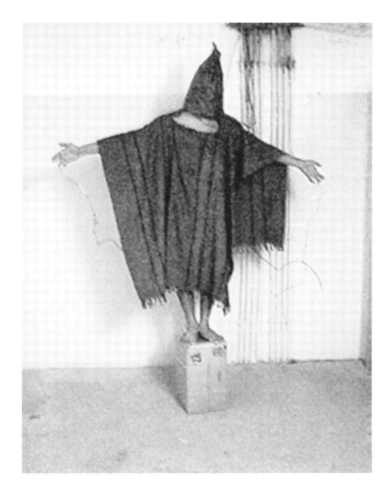

Figure 1.2 An image of an Iraqi prisoner taken at Abu Ghraib prison, Baghdad, Iraq, 2004.

World War. Hundreds of thousands of photographs were taken in Poland and the former Soviet Union that showed crimes committed against civilian populations – Slavs, Russians and particularly Jews. A large number show their humiliation: Jews being made to perform cruel and demeaning acts or having their sidelocks cut, alongside soldiers jeering, laughing, poking, mocking, tormenting, sometimes killing. There were no digital cameras then, but even so these snapshots were widely distributed among soldiers as souvenirs. Some fell into the hands of Polish and Jewish resistance groups and were used as evidence of the crimes committed in these occupied territories, a subject discussed in Chapter Four. But for decades many of these pictures were of little interest, until in the late twentieth century the proliferation of memorials to the 6 million murdered Jews and the commercialisation of the Holocaust gave these ordinary German soldiers' pictures a currency they otherwise would not have had. In 1995 hundreds of German soldiers' pictures were exhibited as evidence of the complicity of the Wehrmacht (German Armed Forces) in crimes committed by the Nazi regime. This exhibition and its repercussions will be discussed in Chapter Five.

Many who saw the images taken at Abu Ghraib said they found them disturbing, but it was sometimes difficult to pinpoint exactly why. The subject matter was deeply troubling, but there was something else. Their ambiguity aroused a strange kind of prurient curiosity and troubling voyeurism. By looking at them we seemed to become involuntary witnesses to bizarre and mysterious rituals, with sexual themes – scenes that seemed contrived and set up. It was as if they concealed more than they revealed. 'In every act of looking', John Berger has written, 'there is an expectation of meaning.'[7] What then did the pictures mean? Some likened them to pornography and said that they reflected 'a kind of degenerate decadence'.[8] As if to support this idea, all media published the pictures of naked prisoners with their genitalia pixilated, as though their nakedness was the worst aspect of the images. In an article in the *Guardian* Katherine Viner had little doubt that 'pornographic culture' had influenced the soldiers. She wrote: 'It is hard not to see links between the culturally unacceptable behaviour of the soldiers in Abu Ghraib and the culturally accepted actions of what happens in porn.' Although Viner added there were differences and that 'it is insulting to suggest that all porn actors are in the same situation as Iraqis, confined and brutalised in terrifying conditions', she wrote that the images in both are the same.[9] Historian John Keegan also wrote that the picture-taking had been influenced by 'video pornography. ... It's what the soldiers watch in the bar and barracks room that I think gave them the idea,' he said.[10]

To add to these pornographic associations, the picture of the hooded man standing on a box with his arms outstretched was described by author Philip Gourevitch as an image of 'carnivalesque weirdness' that appeared to belong to 'some dark ritual, a primal scene of martyrdom', but Mark Danner, author of *Torture and Truth*, said there was nothing carnivalesque about the picture. It shows, he said, a pose well known to interrogators: 'It is called the Vietnam ... It was developed in Brazil. It combines stress positions with electrocution or in this case the threat of electrocution and sensory deprivation – the hood.'[11]

If Danner was correct, and the acts being perpetrated were torture, then were the images intended as part of the torture, to humiliate and degrade? Or were they trophy pictures – that is personal snapshots of a humiliated or defeated or dead enemy? Or both? In 2004 the celebrated veteran journalist Seymour Hersh said: 'Nothing would be as threatening to an Arab men [transcript error] than the idea that you had photographs of him in this horrible position that you could show to friends, neighbors and family ... The cameras seem to be much more important, much more systematic.'[12] Susan Sontag expressed the idea that taking pictures was complicit in the abuse. She wrote: 'The grin is a grin for the camera. ... There would be something missing if, after stacking the naked men, you couldn't take a picture of them.'[13]

The idea of taking photographs intended to humiliate or degrade the enemy was not new. In 1933, after the National Socialists came to power in Germany and ordered a boycott of Jewish shops, officials took photographs to intimidate and publicly shame those who did not comply. In Iraq under Saddam Hussein videos were made of the brutal treatment of prisoners by security police to humiliate and dishonour them. In 2003, British soldiers in Iraq were given authorisation to take pictures of captured Iraqis who were alleged to have stolen supplies from an army

camp near Basra. The threat was that the photographs could be passed on to the Iraqi police. These pictures will be discussed in Chapter Six.

But only one aspect of the pictures taken at Abu Ghraib seemed certain, that they were private pictures intended as souvenirs to be shared only among friends and fellow soldiers, not to be seen by the public and transmitted worldwide. It was this aspect, perhaps more than any other, that appeared to give them the power to disturb. Karen Davies, a deputy picture editor of the *Sunday Telegraph*, said that although as an editor she had seen many shocking war images, the Abu Ghraib pictures were not only the worst she had ever seen but 'a vision of hell'. Davies was uncertain whether to define them as trophy pictures or atrocity pictures, but the fact that they were private pictures made them far more shocking than war images taken by professional photographers. 'A war photographer witnesses the situation as seen', Davies said. 'The difference is that the soldiers are involved in the abuse at Abu Ghraib … they are participating in the pictures … they had created the scene and then taken the picture.'[14]

Photojournalists are also known to have set up scenes to add impact to their pictures, and on other occasions it has been claimed that the presence of a photographer has influenced events. The image taken by Joe Rosenthal during the Second World War that shows US marines raising the American flag at Iwo Jima was staged after the battle. The same accusation has been levelled – though never really proved – against the Hungarian-born photographer Robert Capa over a celebrated image of a fighter being shot dead in the Spanish Civil War. When Eddie Adams photographed the public shooting of a Viet Cong fighter in Vietnam, it was said that the presence of the camera had encouraged the event to happen. But the Abu Ghraib images were something else again. Here were the protagonists setting up the scene and then taking the pictures themselves.

Journalists and commentators were compelled to draw attention to the differences between the pictures taken at Abu Ghraib and professional war pictures. Photojournalist Jon Swain argued that, unlike professional pictures, those taken at Abu Ghraib are 'a glorification of war and killing'. The soldiers' subject, he wrote, is 'shocking and graphic – more horrifying than the "shock and awe" footage of the attack on Baghdad taken by real war photographers.'[15]

That Swain had used the term 'real war photographers' adequately conveyed the indignation and apprehension expressed by many commentators at the idea that these amateur snapshots might take their place alongside memorable photographs from previous wars. As a consequence there was a great deal of retrospection on the tradition of war photography, particularly photographs taken during the war in Vietnam – a period seen to represent the golden days of photojournalism when war photographers were regarded as defenders of the truth and their photographs had the power to move opinion. The Abu Ghraib pictures, wrote journalist Eric Deggans, were certainly 'not the kind of war images Americans who grew up during the world wars or Vietnam are accustomed to seeing.'[16]

Besides the indignation, there was a sense that the Abu Ghraib pictures had impinged on the genre of war photography in a way that no amateur war pictures had previously done. Whether that was due to the distinct lack of powerful professional pictures from Iraq was the subject of debate. But as shocked as editors and

commentators were by the Abu Ghraib pictures, they were also curious about what other secrets a soldier's camera might reveal about war. These themes are taken up in Chapter Eight. The question of how to locate the images taken at Abu Ghraib within photography's rigidly defined genres continues to preoccupy those in the business of representing war.

When in the autumn of 2004 seventeen pictures taken at Abu Ghraib were displayed at the International Center of Photography (ICP) in New York, curator Brian Wallis wrote that the exhibition, entitled 'Inconvenient Evidence: Iraq Prison Photographs from Abu Ghraib', 'fundamentally calls into question the relationship between photography and war'. In a display designed to further question that relationship, the soldiers' pictures were downloaded from the Internet, photocopied and pinned 'as casually as possible' to the wall with drawing pins.[17] To display the work of a well-known war photographer in this way, without the conventional window-mounts and frames, would have been regarded as a mark of disrespect. Clearly these were not intended to be seen as war photographs.

The ambiguous status accorded the Abu Ghraib pictures meant they were loosely aligned with other 'atrocity' images that had been taken for a variety of purposes in other conflicts. In a review of the exhibition in the *New York Times*, Michael Kimmelman compared them with mug shots of prisoners taken by an official photographer at Tuol Sleng, the Khmer Rouge prison in Cambodia where thousands of people were executed in the late 1970s, and which had been exhibited at the Museum of Modern Art (MoMA) in New York in 2003. He also likened them to official pictures taken by Nazis and snapshots taken by German soldiers as well as images taken by amateur and professional photographers at the lynchings of African Americans in the southern states of the USA. Regardless of the intent and purpose of their authors, Kimmelman saw the evidential value of all photographs. He wrote: 'Even the most repulsive photographs bear witness. They are evidence. And therefore a kind of gift to memory.'[18]

Kimmelman also mused on the ethical problems of exhibiting pictures that, he said, 'occupy a morally ambiguous state' on the walls of a gallery: 'Placing these atrocious pictures in a sleek white room and inviting us to cogitate on their visual properties raises some interesting ethical questions.' He justifiably wondered why the Abu Ghraib pictures were on display, when videos made by insurgents of the beheadings of American citizens widely available on the web were not. 'Would it be considered an invasion of the dead man's privacy? Too disgusting? Politically incorrect?' he asked. Furthermore, if these pictures had achieved such notoriety in just a few months, he wondered, where might they be in another six months time?[19]

By then there had been a massive cultural appropriation of the pictures which ranged from their incorporation into works of art to their use in a board game marketed in the USA called 'Battle to Baghdad: The Fight for Freedom' as well as to promote the fashion industry. In the summer of 2006, *Italian Vogue* carried a series of photographs with an unambiguous reference to the Abu Ghraib images. Under the headline 'State of Emergency' one colour photograph shows a woman wearing an orange dress lying on the ground. The boot of a police officer is on her neck. Another shows the same woman wearing a black dress kneeling on the ground in a white tiled corridor with her hands behind her head. On either side of

her is a gloved policeman. One holds a truncheon, the other a dog on a leash that is baring its teeth at her. Historian Joanna Burke writes that these images 'take the pornography of terror to another extreme. ... In these fashion photographs, we see how those images of torture have been translated into consumer products. ... In our current moral state of emergency, torture has become fashionable.'[20]

The pictures in *Italian Vogue* reminded me of a photograph published on the front page of the *Independent on Sunday* in January 1995, the same month as the fortieth anniversary of the liberation of Auschwitz-Birkenau. It showed a gaunt-looking catwalk model at a Paris fashion show dressed in a striped pyjama outfit, with short, roughly cropped hair. When the designer Rei Kawakubo was asked about the outfit, with its clear reference to that worn by prisoners at the concentration camp, he replied: 'The meaning, there is no meaning.'[21]

In 2008 the Abu Ghraib pictures were on the walls of another art gallery, this time in Brighton, England. In a major exhibition of war photography entitled 'Memory of Fire: The War of Images and Images of War' they were flat mounted on a large freestanding display board presumably for the same reasons that they were pinned to the wall at ICP in New York, to distinguish them from the work of professional photographers. From now on, in spite of their ambiguous status, no exhibition of war photography would be complete without them.

Souvenirs from Iraq

The incriminating pictures had been taken at Abu Ghraib between 18 October and 30 December 2003, a period when the prisoner population had dramatically increased from around 1,000 to 6,000. In August General Geoffrey Miller, who had developed interrogation techniques at the US prison in Guantanamo Bay, arrived to oversee operations at Abu Ghraib. On 15 October the 372nd Company, trained to support combat operations, was transferred from Al-Hillah to the prison to act as guards. Only two of them, including Charles Graner, had any experience as prison officers. The company commander, Captain Donald Reese, who voiced his concern to Major David DiNenna, commander of the 320th MP Company (the 372nd was attached to the 320th MP Company) about his soldiers' lack of experience, was a window-blind salesman in civilian life.[22]

When soldiers of the 372nd Company described their initial impressions of the dire overcrowded conditions at Abu Ghraib, and the constant mortar attacks they were subjected to, they referred to other images from horror or science fiction films, or of Nazi concentration camps. Images, it seemed, were more fitting to their experience than words. Jeremy Sivits said: 'It was hell. ... It was like out of a horror movie',[23] while Javal Davis described his first impression of Iraq – the burning tanks and destroyed vehicles – as being like 'a Mad Max Movie'. The prisoners' 'encampments', he said, 'looked like one of those Hitler things, like a concentration camp, almost.'[24] Sam Provance likened the prisoners to 'movie props ... You see these Iraqi people,' he said, 'It is hard to imagine they're human. They're just the stock detainee. ... I always tell people Abu Ghraib was *Apocalypse Now* meets *The Shining*.'[25] Sabrina Harman said of the events at Abu Ghraib: 'It seemed like stuff that only happened on TV, not something you really thought was going on. It's just

something you watch and that is not real.'[26] As Susan Sontag has written: 'Reality has come to seem more and more like what we are shown by cameras.'[27]

At Abu Ghraib, the 372nd Company assigned to the hard site, where the so-called dangerous inmates were held, were frequently ordered by Military Intelligence (MI) officers to loosen up the prisoners for interrogation. This included depriving them of sleep by any means possible, including stress positions, humiliation, shouting and playing loud music. The identity of the MI officers was apparently not known to the regular soldiers – they wore neither identifiable uniforms nor name tags – so the soldiers gave them nicknames in the same way they gave them to prisoners. One, who had served in Guantanamo, was known as Gitmo Guy and another as Big Steve because of his size.[28]

According to Philip Gourevitch and Errol Morris, in their book *Standard Operating Procedure*, an in-depth study of the Abu Ghraib pictures based on extensive and detailed interviews with soldiers of the 372nd Company, the prisoner whom Lynndie England was holding on a leash had been nicknamed 'Gus'. Shortly before the pictures of him had been taken, Graner had gone to his cell with fellow soldiers Megan Ambuhl and Lynndie England, armed with a 'cargo tie down strap' and camera. The use of the strap had been personally authorised by Major David Auch, a physician who commanded the Abu Ghraib medical unit.[29] Graner put the strap around the prisoner, handed it to England and asked her to pose for a 'souvenir' picture. Three pictures were taken in the space of a minute. In two of them Megan Ambuhl can be seen standing on the edge of the frame, although in the majority of the published versions she has been cropped out, presumably because she is considered inconsequential to a scene that appeared to be about England's abuse and humiliation of an Iraqi. But England said that, as far as she was concerned, the pictures were nothing to do with her and the Iraqi, but were everything to do with the relationship between her and Graner. The picture, she said, '[is] showing that he has power over me, and he wanted to demonstrate that power. Anything he asked, he knew that I would do it.'[30]

England said Graner had his own reasons for taking pictures. After serving as a marine in Kuwait in Operation Desert Storm (1991) he returned to the USA with symptoms of Post Traumatic Stress Disorder (PTSD), including nightmares and headaches. When he sought help he discovered no one believed what he had been through, and he could not prove it. Consequently, when Graner was deployed to Iraq, he decided to take photographs as evidence of whatever happened to him. 'He wanted to take pictures of everything, because then there would be evidence that it happened', said England. 'And whenever he wanted me to grab his camera to take a picture when he couldn't, I did it.'[31]

Soldier Ivan 'Chip' Fredrick described Graner as 'a picture person … normally proud of the pictures he took'. He had shown the pictures of naked male Iraqi detainees with their heads covered with women's knickers to his superior officers – seemingly without repercussions. He also had a picture of the human pyramid of naked Iraqis as a screensaver on his laptop on which he and other soldiers watched war movies and episodes of *M*A*S*H*, the popular American television series about US soldiers in the Korean War.[32]

Other 372nd Company reservists were also keen amateur photographers. Sabrina Harman took pictures of a prisoner nicknamed Taxi Driver – named as such because he had been arrested while driving a taxi. In the picture he is naked, except for women's knickers covering his head. His hands are cuffed behind his back and attached to cell bars higher than his shoulders, forcing him to bend forwards bearing his weight on his wrists – a position known as a Palestinian hanging, because of its use in Israeli prisons.[33]

On 20 October 2003, Harman described the scene in a letter to Kelly, whom she called 'my wife'. She writes: 'At first I had to laugh so I went on and grabbed the camera and took a picture. One of the guys took my asp and started "poking" at his dick. Again I thought, okay that's funny then it hit me, that's a form of molestation. You can't do that. I took more pictures now to "record" what is going on.' Her motivation for taking the pictures might have changed, but the images themselves could not reflect that. She described the cruel treatment of other prisoners and continued: 'The only reason I want to be there is to get the pictures and prove that the USA is not what they think. But I don't know if I can take it mentally.'[34] Harman and Ivan 'Chip' Frederick also had taken pictures of the hooded Iraqi wearing a makeshift poncho standing on a box. Frederick had instructed the Iraqi – nicknamed Gilligan – to hold out his arms while they took pictures.[35] Gilligan was so named apparently because the soldiers likened him to his 'television namesake' – presumably the clownish fictional character and icon of American comedy, in the American television sitcom *Gilligan's Island*. In the full frame of Harman's picture Frederick can be seen on the far right-hand side looking at the display screen on his digital camera, though in the majority of published versions he too has been cropped out, perhaps because he was considered a distraction from the weirdness of the hooded man.

According to Sabrina Harman, Gilligan was neither electrocuted nor physically harmed. The mock electrocution scene lasted around fifteen minutes – long enough for the pictures to be taken. Gilligan was one of the soldiers' favourite prisoners and, according to Megan Ambuhl, 'pretty decent'. She said she had a picture of him sharing a meal and a smoke with Charles Graner. Harman said that 'he was laughing at us towards the end of the night, maybe because he knew we couldn't break him.' She called him 'just a funny, funny guy' and said she was 'baffled' that the image of Gilligan had become an icon of Abu Ghraib. 'There's so many worse photos out there. I mean, nothing negative happened to him, really. … I think they thought that he was being tortured, which he wasn't.' Some time after leaving Iraq Harman had the image of Gilligan tattooed on her arm, but she considered that a private matter.[36]

Like many other young American soldiers, Sabrina Harman had joined the military to fund college. Pictures fascinated her, and she intended to train as a forensic photographer. 'Even if somebody is hurt,' she said, 'the first thing I think about is taking photos of that injury.' In July 2003 Harman had written in a letter from Iraq to her father: 'On June 23 I saw my first dead body. I took pictures!' Harman also took pictures of a mummified kitten's head which she photographed in incongruous situations – with a cigarette or wearing sunglasses – and with fellow soldiers. She had taken pictures at a morgue in Al-Hillah, where she was photographed alongside the corpses smiling in a thumbs-up pose – a pose she said she had picked up from kids in Al-Hillah.

'Whenever I get into a photo, I never know what to do with my hands, so I probably have a thumbs-up because it's just something that automatically happens.'[37]

Sabrina Harman had her thumbs up and a broad smile when she was photographed kneeling next to the dead body of Manadel al-Jamadi, an Iraqi prisoner who had been tortured to death during interrogation by MI officers. A fellow prisoner said that he heard al-Jamadi being tortured and crying out: 'I listened to his soul crack,' he said. Al-Jamadi's dead body was packed in ice and left under lock and key in a shower room until arrangements could be made to remove it. That evening Harman and Graner went to the shower room, where al-Jamadi became the subject of a detailed photo shoot. 'We just checked him out and took photos of him', said Harman. Graner took the picture of her smiling with a thumbs-up alongside his bruised and broken face. When later asked about the photograph, she said: 'I always smile for a camera, it's just the natural thing we do. ... It wasn't anything negative towards this guy. I didn't know he was just murdered.'[38] In fact Harman said that she wasn't really thinking when they took the pictures: 'It was just – hey, it's a dead guy, it'd be cool to get a photo next to a dead person. I know it looks bad. ... But when we were in that situation, it wasn't as bad as it looks coming out on the media, I guess, because people have photos of all kinds of things. Like, if a soldier sees somebody dead, normally they'll take photos of it,' she said.[39] It was as though every happening at war, even the corpse of a murdered man, was regarded as a photo opportunity.

The following day the body of al-Jamadi was removed from the prison on a stretcher with a fake intravenous drip inserted into his arm so that other prisoners did not suspect he was dead. Ironically, the cruel snapshots taken by Harman and the other soldiers were the only evidence that al-Jamadi had died at Abu Ghraib. Did that make Harman a witness or a perpetrator? Or both? In an article in the *Guardian*, Geoffrey Macnab suggested that, in a different context, Sabrina Harman 'could just as easily have won a Pulitzer prize for being among the team who actually took these shots and, in turn, let the world know what was going on.'[40] But none of the photographs of al-Jamadi was used as evidence. When Harman was eventually court-martialled for her involvement in the Abu Ghraib picture affair, including taking pictures of al-Jamadi, all charges against her were dropped. 'In order to make the charges stick, they were going to have to bring in the photos [of al-Jamadi] which they didn't want, because obviously they covered up a murder', said Harman. The implication was that without the pictures, there was no murder. No one has yet been charged for the death of al-Jamadi.[41]

In December 2003 while home on leave, Harman left a set of her Abu Ghraib pictures with Kelly and then wiped them from her personal computer. When she returned to Iraq she did not take her camera. 'I did not want to see anymore,' she said, as if taking pictures was the only way of authenticating that which she had witnessed.[42] Not all Sabrina Harman's pictures had been taken of the dead and injured, or at Abu Ghraib. In May 2004, as the Abu Ghraib story broke, journalists at the *Sunday Telegraph* were busy preparing to print one of the prison pictures on the newspaper's front page, when another photograph caught the attention of Karen Davies. It showed a pretty young American soldier with a big smile and her arm around a young Iraqi boy; the kind of picture a tourist might take. She

recognised the smile. It belonged to the woman who featured in the picture along-side the dead al-Jamadi. Davies found this picture of Harman profoundly disturb-ing. How could the woman who had posed for a picture alongside a corpse show such kindness towards a child? On 7 May, instead of an Abu Ghraib prison pic-ture, the *Sunday Telegraph* published the image of Harman with the Iraqi boy.[43]

There were many touristy pictures like this one of 372nd Company sightsee-ing around Iraq. When journalist Christian Davenport wrote in an article in the *Washington Post* about the set of soldiers' pictures that had included those from Abu Ghraib he said: 'The collection of photographs begins like a travelogue from Iraq. Here are US soldiers posing in front of a mosque. Here is a soldier riding a camel in the desert. And then: a soldier holding a leash tied around a man's neck in an Iraqi prison. ...'[44] But mundane tourist pictures alongside cruel images of war would be a common attribute in the photo albums of soldiers throughout the twen-tieth century and will be discussed in Chapter Three.

Uncovering the evidence

That the pictures taken at Abu Ghraib came to public notice at all was due to the actions of Joseph Darby, also with the 372nd Company, who on 13 January 2004 decided to hand over CDs containing around 279 images to the US Army Criminal Investigation Division (CID). There are conflicting accounts of why he did this. In one interview Darby said that he came across the incriminating pictures by acci-dent when he asked Charles Graner for snapshots of tourist sites they had visited. 'I wanted to take home some pictures', said Darby. 'We had seen some astounding places, the tower of Babylon [*sic*] and city of Babylon and been through a lot of history stuff that you read in the bible and history books so I wanted pictures.'[45] Graner handed him two CDs that also contained the pictures taken in the prison, including those of the naked Iraqi men piled in a pyramid. Darby said that initially they had made him laugh, but the others – the humiliation and what he called the 'sexually explicit-type stuff to humiliate the prisoners' – bothered him. These pic-tures, he said, 'crossed the line to me. I had a choice between what I knew was mor-ally right and my loyalty to other soldiers. I couldn't have it both ways.'[46]

But according to Gourevitch and Morris, Darby had been given the CDs by Graner when he had asked for pictures of a bloody shoot-out between a prisoner and soldiers that had taken place at Abu Ghraib in late 2003. Darby had been on leave at the time of the incident but knew that there would be images since almost everyone had a camera. Darby, who had been in the army for eight years, did not have a reputation as a moral-ist. Rather, he was known by colleagues as 'an aficionado of smut' due to his large col-lection of pornography. While serving in the Balkans he had been known as 'the porn king of Bosnia'. According to fellow soldiers, his motive for handing over the pictures may have been revenge. He had been subjected to taunts about being overweight and was nicknamed Fat Bastard by Frederick and Graner among others.[47]

In return for the CDs, Darby had been promised anonymity by the authori-ties, but within a few weeks the then US Secretary of Defense, Donald Rumsfeld, gave his name away on American television. To some Darby became a hero, but to others he was a traitor. In 2005 he received a Profile in Courage Award from the

John F. Kennedy Library Foundation in Boston – but he was also driven from his home in Jenners, western Maryland. 'I am not welcome there,' he said, 'they (the community) look at the fact that I put an Iraqi before an American.'[48]

When Darby had handed over the CDs at Abu Ghraib an immediate investigation was launched, although apparently reluctantly. An Army Public Affairs Officer, Lieutenant Colonel Vic Harris, one of the first to see the pictures, said that he was shocked by them, but more so by the army's response: 'I heard the discussions of the staff and our commanders, and there was no intention of doing anything other than trying to contain them ... and try to prevent the images from getting out to the media, to make it go away and not let the public know about it,' he said. Harris called a friend, Dana Roberson, at CBS and tipped her off about the abuse and the pictures.[49] The television station began its own investigation and contacted, among others, Joe Darby. When on 14 April CBS informed the Pentagon that it intended to broadcast the images, General Myers asked for two weeks' delay on the premise that their release would inflame anti-US tensions in Iraq – even though he had apparently not seen them.[50]

By 16 January 2004, only three days after Darby had handed over the pictures, the CID had issued a three-page memorandum to all military personnel at Abu Ghraib listing 'prohibited activities', including the 'creation or display of any pornographic or sexually explicit photographs'. It also stated that 'personnel will neither create nor possess photographs, videotapes, digital videos, CD/DVDs, computer files/folders, movies or any other medium containing images of a criminal or security detainee currently or formerly interned at Baghdad Central Correctional Facility, located at FOB Abu Ghraib, Iraq.'[51]

In addition, an amnesty was declared on all soldiers' personal pictures. A notice was issued that requested that all photographs be placed in a provided amnesty box 'without penalty or legal consequence' and that no questions would be asked.[52] But Sabrina Harman said that she never saw anyone go near the box. Megan Ambuhl thought the box was a deliberate scare tactic. The real message, she said, was: get rid of your contraband, but do it some other way. According to Javal Davis, this ploy worked. Everyone started destroying their pictures. 'Everyone in theater had a digital camera,' he said. 'Everyone was taking pictures of everything, from detainees to death. Like in Vietnam, where guys were taking pictures of the dead guy with a cigarette in his mouth. ... The mind-set over there, I'd say, would be numb. I mean, when you're surrounded by death and carnage and violence twenty-four hours a day, seven days a week, it absorbs you.'[53] The soldiers at Abu Ghraib were not the only ones destroying pictures. A report by the American Civil Liberties Union (ACLU) stated that as a result of the controversy caused by the Abu Ghraib pictures, there was evidence that American soldiers in Afghanistan had also destroyed pictures that showed 'abuse and maltreatment' of prisoners.[54]

During the investigation that followed, leading forensic expert Special Agent Brent Pack, whose job it was to produce a time line of events depicted in the Abu Ghraib pictures, determined that they had been taken on five soldiers' digital cameras – the majority on the cameras of Charles Graner, Sabrina Harman and Ivan 'Chip' Frederick. 'The pictures spoke a thousand words', said Pack, 'but unless you know what day and time they're talking, you wouldn't know what the story was.

It isn't until you look at the individual acts that are documented that you can say with any certainty what they actually depict. That doesn't serve a political purpose, but it does serve a criminal justice purpose.'[55]

Brent Pack, who had served in Operation Desert Storm and at Guantanamo Bay, said that he had no emotional response to the pictures and was not concerned with motives. His job was to establish whether the acts depicted in the pictures were criminal acts. The nudity, the hooded Iraqi standing on the box, the men with knickers on their heads, the Palestinian hangings were, he said, 'standard operating procedure'. He added that he did not expect people who had not experienced what he had, to understand the pictures in the same way. 'All a picture is,' he said, 'is frozen moments of time and of reality. You can interpret them differently, based on your background or your knowledge. But when it comes time where you're presenting them in court, what the photograph depicts is what it is.'[56] In 2005, when a British Court Martial was asked to determine the meaning of a set of pictures taken by British soldiers that showed abuse being meted out to Iraqi detainees in Basra in 2003, the jury was asked by the defence to disregard the images themselves and consider what was happening at the instant the pictures were taken. The interpretation of pictures at that court martial will be discussed in Chapter Six.

A glut of pictures

A few days after the first Abu Ghraib pictures were broadcast by CBS, the *New Yorker* published more with an exclusive story by Seymour Hersh. Hersh had obtained a report written by General Antonio M. Taguba, who had been assigned by the Pentagon in January 2004 to investigate and produce a report on the alleged prison abuse. The report stated that the prison was rife with abuses, and there were numerous 'detailed witness statements' and 'the discovery of extremely graphic photographic evidence' to support the allegations that the abuse was perpetrated by members of the 320th Company and also by members of the American intelligence community. For reasons that are not clear, Taguba did not include photographic evidence in his report.[57]

That American soldiers were abusing and torturing prisoners held in US detention facilities in Iraq, Afghanistan and Guantanamo Bay had been known about since 2003. Seymour Hersh had received reports that the abuse was so bad in Abu Ghraib that women prisoners were smuggling out messages to family members asking to be killed because they had been defiled by American soldiers.[58] Taguba's report confirmed this. At that time there were a number of women and children as young as ten years old in Abu Ghraib – mostly held for the purpose of gaining access to or taunting their husbands or fathers. In December 2003 an Iraqi woman known as 'Noor' smuggled a note out of Abu Ghraib claiming that US guards had been forcing Iraqi women prisoners to strip naked. Human rights and civil liberties groups, including ACLU, Amnesty International, Human Rights Watch and the International Committee of the Red Cross (ICRC) had published reports about 'gross and systematic violations of the Geneva Conventions'. The ACLU cited a number of examples, including one report that a US Army captain had taken an Iraqi welder into the desert, told him to dig his own grave and pretended to shoot

him.[59] The practice of forcing prisoners to dig their own graves before their execution was carried out during the Second World War by Nazi execution squads in Eastern Europe and the Soviet Union. Photographs taken at these executions have survived as evidence of these horrific scenes.[60]

In February 2004, two months before Taguba's report became public, a twenty-four page ICRC report on the abuses in Abu Ghraib had been leaked to the public. It contained references to the fact that pictures were being taken, though the authors of the report had not seen them. It stated: 'Several Military Intelligence officers confirmed to the ICRC that it was part of the military intelligence process to … use inhumane and degrading treatment including physical and psychological coercion. …' Acts of humiliation included 'being made to stand naked against the wall of a cell with arms raised or with women's underwear over the head for prolonged periods – while being laughed at by guards, including female guards, and sometimes photographed in this position.'[61] In spite of the ICRC report, it was not until the images were published that these words had any impact. Donald Rumsfeld, who claimed not to have known about or have seen the pictures until they were broadcast on American television, said: 'It is the photographs that give one the vivid realisation of what actually took place. Words don't do it. The words that there were abuses, that it was cruel, that it was inhumane … you read that and it's one thing. You see the photographs and you get a sense of it, and you cannot help but be outraged.'[62] Furthermore, in an interview Javal Davis expressed a similar viewpoint when he said: 'If there were no photographs there would have been no Abu Ghraib.'[63] Similarly, in 1945, when Nazi crimes were discovered in the concentration camps, many said it was only when they saw the pictures that they believed the reports. This is no doubt why, at Guantanamo Bay, private cameras and mobile phones were strictly forbidden, and soldiers were rigorously searched from the outset.[64] However, official video footage was taken. According to Stephen Kenny, the lawyer who represented former Guantanamo prisoner David Hicks, 500 hours of videotape 'as explosive as anything from Abu Ghraib' does exist.[65]

The indignation expressed towards the pictures taken at Abu Ghraib meant that it was not always clear whether the outrage was directed at the abuse being perpetrated or at the fact that it had been photographed, or both. When the former US President George W. Bush said that he was shocked and disgusted by the pictures, Susan Sontag wrote that his comment suggested that 'it was as if the fault or horror lay in the images, not in what they depict.'[66] When eleven soldiers were court-martialled and found guilty for their role in the Abu Ghraib picture scandal, Ken Davis, another soldier who served at Abu Ghraib, said with incredulity that it seemed that they had been found guilty, not for torturing prisoners, but for taking pictures.[67] The same could be said about the conviction of SS man Max Täubner in 1943 and of other instances when disconcerting soldiers' pictures have come into the public domain – including during the court martial of British soldiers who had taken pictures of the humiliation of Iraqis in Basra in 2003, discussed in Chapter Six. The point was made by former Israeli Defence Force (IDF) soldiers whose public exhibition of pictures taken by members of the IDF in the Occupied Palestinian Territories in the 2000s is discussed in Chapter Seven.

Within weeks of the publication of the first pictures from Abu Ghraib, Seymour Hersh disclosed that there were more: 'I can tell you it was much worse…there are worse photos, worse videotapes, worse events.'[68] Donald Rumsfeld acknowledged that 'there are a lot more photographs and videos that exist', while Senator Lindsey Graham said: 'We're talking about rape and murder and some very serious charges.'[69] The CID apparently had more than ninety videos and around 2,000 pictures showing alleged prisoner abuse, pornography, dead Iraqi prisoners, Iraqi women being made to bare their breasts at gunpoint, Iraqi women being raped and an Iraqi boy being sodomised. There were also images of American soldiers in 'simulated sexual acts'.[70]

On 12 May, just days after the Abu Ghraib pictures had made headline news, the *Boston Globe* published pictures that were said to show uniformed American male soldiers raping at gunpoint two Iraqi women wearing traditional black robes. The pictures had been distributed at a press conference held by Boston City Councillor Chuck Turner and community activist Sadiki Kambon. Turner said that he had been given them by a Nation of Islam representative, Akbar Muhammed, and added: 'The American people have a right to see them.'[71] But a week before the *Globe* published them the news website WorldNetDaily (WND) had declared them to be fakes. WND journalist Sherrie Gossett reported that in fact the images had been taken from two pornographic websites known as Iraqi Babes and Sex in War, featuring male and female actors. According to Iraqi novelist Buthaina al-Nasiri they were being widely circulated on Arabic websites 'causing confusion between genuine abuse and fantasy'. When Linda MacNew, owner of Iraqi Babes, was asked about the pictures she said that she had no knowledge that they were being used as anti-coalition propaganda and was unaware of the controversy over the abuse of Iraqis in Abu Ghraib prison. 'I was all against the war to begin with', MacNew said, and with regard to the pictures of rape: 'That stuff happens over there all the time anyway.'[72]

Whether Turner had known that the pictures were faked was not clear, but after it was confirmed they were bogus, he reportedly said that he had hoped that their publication might have prompted the Pentagon to release what he called 'the real ones'. That did not happen, however. The Bush administration argued that their release would 'endanger' the lives of troops serving in Iraq and jeopardise any trials in which they may be used as evidence. It further stated that the release of photographic evidence would 'violate the government's obligations under the Geneva Conventions, by infringing the rights of the prisoners who appeared in the photographs.' The ACLU noted in response that '[p]hotography exposing inhumane conditions at German and Japanese concentration camps played a powerful role in the historical developments of the Geneva Conventions themselves.'[73] Images taken by the American, British and Soviet armies, on liberation of the Nazi concentration camps, as well as those taken by Nazis and German soldiers were presented as evidence in the trials of Nazis war criminals, notably at the Nuremberg International Military Tribunals (1945–9).

Despite pressure from ACLU, which sought the release of all the images being held by the CID through the Freedom of Information Act, the Pentagon continued to prevent their release. When Barack Obama was elected President in 2008 there were assurances that his administration would release the pictures. In May 2009, much to the anger of ACLU, President Obama changed his mind and blocked their publication.

He declared that their release would 'further inflame anti-American opinion and put troops' lives in danger' – an echo of the Bush administration's justification for not releasing them in 2004. President Obama gave a similar explanation in 2011 when he took a decision not to release pictures of the body of Osama bin Laden who was assassinated at his compound by US Navy Seals in the garrison town of Abbottabad in Pakistan in May that year. A day after the killing, an official photograph was released that showed the President and his White House team apparently watching the live video footage of the action as it unfolded transmitted direct from 'helmet cams' mounted on the Seals' helmets – technology sometimes used by ordinary American soldiers to record their wartime experiences (discussed in Chapter Eight). Despite pressure put on the President to release images of Bin Laden he said during an interview on the CBS programme *60 Minutes*: 'I think it is very important for us to make sure that very graphic photos of somebody who was shot in the head are not floating around as an incitement to additional violence – as a propaganda tool Osama bin Laden is not a trophy.' The term 'trophy picture' had come into general political discourse in the twenty-first century as a consequence of the public discussion about pictures taken by troops in Iraq and Afghanistan – notably the Abu Ghraib pictures.

But unlike the pictures of bin Laden, the President said he regarded the images taken at Abu Ghraib as 'not particularly sensational' a view contrary to that held by some US legislators who had seen nearly 2,000 of them five years earlier.[74] On 12 May 2004, legislators had been given an opportunity to view the unseen images – the same day the *Boston Globe* had published the faked rape pictures. Some described the experience of looking at the pictures as a descent into the 'wings of hell', or 'gut wrenching'. Senator Richard Durbin said, 'And when you think of the sadism, the violence, the sexual humiliation, after a while you just turn away, you just can't take it anymore.' Senator Bill Nelson told CBS: 'Some of the videos are more disturbing than the still photos that you've seen', while Senator James Jeffords said that the pictures were 'horrible. But they go by so fast. Terrible scenes. ... It was click, click, click.'[75]

In 2009 it emerged that there were more unreleased pictures. According to the *Daily Mail*, Lynndie England claimed to have 800 unseen pictures from her time in Iraq which the newspaper reported would be 'highly damaging to the US Army and the White House'. Gary Winkler, her biographer, apparently believes that at some point she will try to sell them to the highest bidder.[76]

What did they mean?

The published images taken at Abu Ghraib provoked diverse reactions, varying according to the social and political contexts in which they were seen. At each transition – from a personal digital camera to a computer screensaver, from a timeline by a forensic scientist to evidence in a military courtroom or in the media – the images acquired a different meaning. Journalist Eric Deggans wrote that while the 'American media talked to the relatives or attorneys for the soldiers that did the tormenting, the Arab media talked to the people connected to those who were tortured. So the images each media presents are the same, but the way they are humanised and put into context is different. ... The context of how the image is placed may be more important than the image itself.'[77]

When Roman Krol, who had served with the 372nd Company, saw the pictures broadcast on television in the USA he said that they conveyed a completely different message from the situation he had witnessed in Abu Ghraib. He said: 'What I feel when I look at the pictures here, and what I felt when I actually saw that incident is just a completely different perspective. When you sit in your living room, on your comfortable couch, and watch this on TV, even after seeing this in real life, it looks so much worse. On the photos it seems like it's actual real torture.'[78]

For the millions of people throughout the world who opposed the invasion of Iraq the pictures reaffirmed and represented everything that was wrong with the war. For those who supported the war they represented the only thing wrong with it, 'a few bad apples' – the phrase used by the former Bush administration in an attempt to place the blame on a few low-ranking soldiers. In some countries the images were brandished as a weapon to incite opposition to the invasion. A Kuwaiti newspaper, *Al-Watan*, warned that the pictures were 'a gift to Islamic fundamentalists'.[79] Throughout the Middle East, demonstrators in opposition to the occupation of Iraq carried placards displaying the pictures. One large banner included the image of Lynndie England with the Iraqi man on the dog leash, with the slogan 'Pictures talk'. In Iran this image and that of the hooded Iraqi standing on a box were exhibited as wall murals. At Cairo University there were angry scenes as students brandished the photographs in front of a visiting Kuwaiti academic who defended the USA. A male student was reported as saying: 'Why were these photographs taken at all? This implies the soldiers were enjoying themselves. This is what gives us most pain and sorrow.'[80] Dr Akbar Ahmed of the American University in Cairo said that the photographs 'will become the recruiting poster of radicals trying to attack the West. If Osama bin Laden had come to Madison Avenue and asked for an advertising image to help him recruit, this would be it.'[81] In Gaza City, posters of the Abu Ghraib pictures covered in swastikas were attached to British and Indian graves at the Commonwealth military cemetery and thirty-two graves of soldiers killed in the First World War were reportedly defaced and vandalised.[82]

In the USA, in spite of the revulsion expressed towards the Abu Ghraib pictures, some questioned whether they should have been made public at all. A visitor to the CBS website comments page wrote: 'Was I supposed to be horrified by the reports of Iraqi prisoners being positioned in "pornographic" positions and humiliated by American soldiers? I was not. During your report, all I could think of was the murder, torture, maiming, burning and beheading of innocent civilians ... carried out by terrorists and supporters of Saddam Hussein' Another person wrote that the fact they were broadcast at all 'verges on treason in a time of war' while someone else asked: 'Is this going to help our soldiers who are there. I doubt it.'[83]

In the US military newspaper *Stars and Stripes* readers also voiced their discontent with the public release of the photographs. One wrote: 'Under any other circumstances, those in possession of and publishing such photos likely would have been charged with pornographic offenses. ... But the publication of the photos was tantamount to inciting a riot. Those who demand the release of additional photos are simply sensationalizing for political purposes and personal gain. They serve no public interest.' Another online reader commented: 'I am astounded at the

commotion caused by the incidence at Abu Ghraib prison in Iraq. It's as though the politically correct among us have lost all touch with reality.'[84]

But there were those who agreed with the fact the images were shown. Some made associations, as Javal Davis had done, with pictures that showed crimes committed by the Nazis during the Second World War. One person commenting online wrote: 'I can only compare the images that you showed of the Abu Ghraib prison with images I have seen from concentration camps', while another said: 'Why are we treating our prisoners as if they lived with Hitler during the Holocaust?'[85]

In an essay about the pictures taken at Abu Ghraib, Susan Sontag asked why soldiers, or those in any army, inflict pain and suffering on others. 'They do so,' she writes, 'when they are told or made to feel that those over whom they have absolute power deserve to be mistreated, humiliated, tormented. They do them when they are led to believe that the people they are torturing belong to an inferior, despicable race or religion. For the meaning of these pictures is not just that these acts were performed, but that their perpetrators apparently had no sense that there was anything wrong in what the pictures show.'[86] In Afghanistan in June 2004 a platoon of US military police videotaped a beating they meted out to an Afghan detainee and posed for a photograph with their weapons pointed at the heads of a group of detained Afghans. When the army began an investigation into the abuse, the military police claimed that they did not realise they had done anything wrong until they saw the outrage over the images of abuse at Abu Ghraib.[87]

Author and former SAS man Andy McNab, who was imprisoned in Abu Ghraib during Operation Desert Storm, says that trophy pictures are common among all soldiers. He was shocked by the Abu Ghraib pictures but not surprised by them. 'The uncomfortable reality is that many soldiers could do what those men and women did,' he said, 'the process of preparing young soldiers for war is about training men to have an instinct to kill. It is also about keeping that instinct under control when it is not needed. That is not always possible. It is when the control breaks down that soldiers take trophy pictures. They [trophy pictures] are great to have if you are the guy who has the trophy but from the command point of view they are a nightmare because they can be used by the enemy as propaganda and put soldiers' lives at risk.'[88]

Forbidden photography

When the wars in Afghanistan and Iraq began, the US authorities had initially encouraged soldiers to take their cameras to war in Iraq and Afghanistan as a way of keeping in touch with family and friends. However, following the release of the Abu Ghraib pictures an order was issued banning digital cameras, camcorders and cell phones from all military compounds in Iraq. There is no evidence that it had any effect. An American soldier calling himself Zaku posted a response to the ban on an Internet site from Baghdad. He wrote: 'A ban on digital media? ... What kind of farce is this? We get packages from amazon.com ... I own a laptop, have two digital cameras and a camcorder ... The army will not raid my supply and steal my digital cameras ... We're human beings, we're men trained to do what most people wouldn't think of doing. Believe me we'll find a way round it.'[89]

Another American soldier and 'milblogger' (military blogger – these are soldiers inspired by citizen journalism, who choose to report on their own war) calling himself CJ, who had served in Iraq, told me that no one took the ban seriously. He had taken hundreds of pictures himself, mostly with disposable cameras, popular among soldiers. In an email he wrote: 'It'll be a cold day in hell before I allow the military to dictate what pictures I can and cannot show, provided they don't violate OPSEC [Operations Security] or break the law. ... We do not live in a fascist state and I think it is wrong to censor troops.' CJ had been inspired to take pictures by his grandfather's Second World War journal which he had seen as a child. 'He had some pictures of his time in WWII', said CJ, although he did not say what the pictures showed. 'I wanted to ensure that my kids had a record of what I did in Iraq', he added.[90]

Military commanders and government officials have often attempted to suppress or destroy soldiers' pictures. During the Second World War American officials prevented from release pictures taken by American soldiers that showed GIs with Japanese body parts as trophies.[91] German soldiers were frequently issued with notices that prohibited them from taking private pictures at concentration camps, mass executions or public hangings. In 1941 a commander of the Wehrmacht issued an order aimed at soldiers serving on the Eastern Front that stated: 'It is prohibited for all members of the Wehrmacht to take photos of executions, shooting as well as hanging, as well as to take photos of the bodies of dead Russian soldiers. It is further prohibited to send such prints already in existence to the homeland because it is highly undesirable that photos of such unaesthetic subject matter be distributed among the civilian population.'[92] Pictures taken by members of the Wehrmacht will be discussed in Chapter Five.

Andy McNab recalls that in Northern Ireland in the 1970s there were fines of up to £500 for soldiers caught with cameras. Even so, photographs were taken. On Bloody Sunday in 1972, one picture was taken of a dead body on top of an armoured truck outside the Divis flats. 'It was displayed in the corporals' mess for years until the early 1980s; it was just always there', McNab told me. Other pictures he called to mind showed the gruesome remains of members of the Irish Republican Army (IRA) who had blown themselves up in Derry while making explosives. They were pinned up on the wall of a British Army barracks with comments posted next to them, 'One down a million to go ... that sort of thing', said McNab.[93]

During the Falklands War (1982) many British soldiers were known to have cameras. On one occasion some of them were ordered to hand in their films on the premise that their pictures would be printed and an exhibition organised. Instead the films were dumped into the sea. In Kuwait during Operation Desert Storm similar tactics were adopted. Pictures taken by British soldiers were routinely collected by commanding officers and dumped at sea.[94]

But some soldiers' pictures of that war did survive. One former British soldier, who now suffers from Gulf War Syndrome, shared with me his personal snapshots that show colleagues grouped together smiling for the camera in the desert around Kuwait. He told me that there were strict rules about taking pictures, but that, as commanders had told them before the fighting that a large percentage of them would probably not survive the ensuing battle or chemical

attacks, no one really cared about rules and regulations.[95] In the USA an exhibition of the personal photographs of American Gulf War veterans entitled 'Sight Range: Photographs and Stories by Veterans of Desert Storm' was on display in New York at the time the Abu Ghraib pictures were on display at ICP, although it received little press coverage. Curator John Movius said that the exhibition 'emphasises the power of amateur photography in times of war … while raising awareness of veterans issues, including Gulf War Syndrome'.[96] But there is no evidence that either could be the case.

One contributor to 'Sight Range' was former soldier Tracie Stevens. Alongside her pictures she wrote: 'I was flying MedEvac escort. … One time we came under heavy fire from another chopper. It was shooting rounds all over, just really shooting. And I took out my camera. I kept it hidden in my First Aid kit. The other MPs were like, "What are you doing?" And I said, "I want to take a picture. I'm taking pictures!" And they're screaming, "Shouldn't you shoot back?" I just wanted to take a picture.' On one occasion Stevens lent her camera to some marines, but when she saw their images she burned the negatives. 'When I got the film back,' she said, 'I was shocked … there was some twisted stuff on there. They were dressing up the Iraqi corpses, posing with them, putting cigarettes in their mouth, things not worth going into. … No way I am letting my kids see that,' she added, 'I would never want them to think that I was indecent over there. But you know, some people really lost it. They would take pictures of mutilated Iraqi corpses and then sell them to the Saudis, who would make copies to sell in their markets.'[97]

Soldiers' pictures nearly always remain private, but from time to time, as with the Abu Ghraib pictures, they break out of obscurity and are published in the press. There have been some notable instances. In February 1942 pictures taken by a German soldier that showed civilians being publicly hanged were published in the *Daily Sketch* and *Soviet War News Weekly* (see Chapter Five, Figure 5.3); ten years later, in 1952 a picture in the British Communist Party newspaper, the *Daily Worker*, showed a British Royal Marine commando proudly holding up the severed heads of two Malayans. The British government said that the photograph was a fake and a 'communist trick' but it eventually admitted the picture was genuine and that the heads had been severed 'for identification purposes'. In 1993 Canadian airborne soldiers participating in the United Nations peacekeeping mission to Somalia Operation Restore Hope were prosecuted for the torture and subsequent murder of sixteen-year-old Shidane Arone. One of the soldiers had taken trophy pictures of the torture. During the same peacekeeping mission Belgian soldiers had 'roasted' a Somali child over a bonfire and taken photographs. The child was badly burned. The Belgians were acquitted by a military court on the basis that there was insufficient evidence.[98]

But none of these pictures, even when they emerged into the public domain, shook the world in the way that those taken at Abu Ghraib did. None had stimulated the same kind of interest, even though soldiers had been taking pictures at war for more than a hundred years. By the First World War, with the rise of popular photography and the production of the small pocket camera, contrary to military orders, thousands of soldiers went to war with a camera.

TWO
Learning to Photograph War

In itself the photograph cannot lie, but,
by the same token, it cannot tell the truth;
or rather, the truth it does tell, the truth
it can by itself defend, is a limited one. *John Berger.*[1]

Wild imagining

In 1998 the celebrated British war reporter Robert Fisk came across an old tin box decorated with a painting of a young woman with roses in her hair in the attic of his mother's home in Kent. It contained more than a dozen small black and white photographs taken by his father during the First World War. It was his first appreciation that Second Lieutenant William Fisk, who had served with the 12th Battalion King's Liverpool Regiment on the Western Front from August 1918, had taken pictures at war. Their format indicated that they had been taken with a pocket-sized camera.

Among the pictures are three of William Fisk: one shows him posed among a number of the regiment's fellow officers, another is a uniformed portrait (Figures 2.1 and 2.2) and a third shows him riding his horse behind the front lines. The handwritten caption on the reverse of this picture reads: 'Self on Whitesocks near Hazelbruck'. Another, out-of-focus, photograph shows an eerie trench landscape north of Arras, with shell holes and the blackened stumps of dead trees (Figure 2.3).

When Lieutenant William Fisk went to the Western Front with his camera, he was just nineteen years old. Cameras were not allowed under military law. Possession of them was punishable by court martial with a possible death sentence, but for many it seems to have been a risk worth taking. Robert Fisk does not know why his father – usually compliant with authority – had taken illicit pictures, but he was not alone. Thousands of soldiers from all sides took their cameras to the First World War. The question was, why?

Since its invention in the mid-nineteenth century photography has been doggedly attached to war. The idea of being able to capture dramatic battle scenes seemed a thrilling prospect to academics, scientists and writers and became the subject of speculation and wild imagining. But whether a photograph could adequately portray such scenes would be the subject of ongoing supposition and debate.

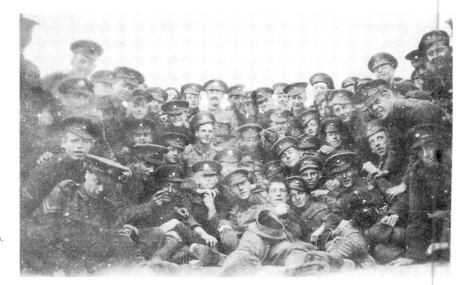

Figure 2.1 Lieutenant William Fisk (hatless front row) with the 12th Battalion, King's Liverpool Regiment, 1918. (Courtesy of William Fisk)

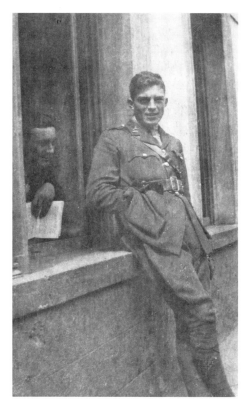

Figure 2.2 Lieutenant William Fisk. (Courtesy of William Fisk)

As early as 1839 the French chemist and physicist Joseph Louis Gay-Lussac wrote: 'A battlefield with its successive phases can be represented photographically with a completeness that is quite unattainable by any other means.'[2] In 1843 the author of an article in the *Edinburgh Review* mused on the idea that 'the fields of ancient and modern warfare will unfold themselves to the soldiers' eye in faithful perspective and unerring outline.'[3]

Photography enthusiasts quickly adopted the terminology of war. Cameras, like weapons, are 'loaded', 'aimed' and the subject 'shot'. In the 1850s cameras were even designed to look like weapons. Thomas Skaife of London produced a camera called a Pistolgraph, so named, he said, because the 'little instrument' was not unlike a pistol, 'one being constructed to take life, the other likeness'.[4] Skaife's idea was not unique: there was a flurry of weapon-like cameras, but they were expensive and sometimes quirky and there is no evidence that they were produced in

large numbers. But the alliance between weaponry and photography continued.

In 1911, a novel entitled *The Camera Fiend* by American author E. W. Horning told the story of a scientist/photographer who invents a stereoscopic camera designed to hide a revolver which shoots the victim at the same time as taking a picture. Perhaps this book was the inspiration for the psychological thriller *Peeping Tom* made in 1960 by British film-maker Michael Powell, in which the protagonist murders women while using a movie camera to record their dying expressions of terror. But Horning's fantasy was not as far-fetched as it might appear. By 1938, in the USA, a camera that fired bullets had been produced, and in the twenty-first century specialist camera mounts made for rifles made it possible to fire the weapon and 'shoot' stills or video simultaneously. These weapons were used by snipers during the war in Iraq in 2004 (see Chapter Eight).

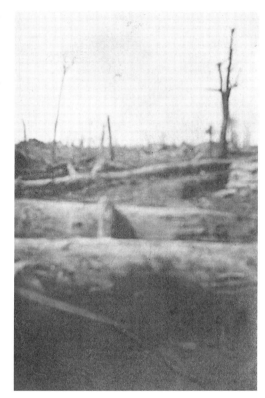

Figure 2.3 A photograph taken by William Fisk from a trench north of Arras in 1918, in the last days of the Great War. (Courtesy of William Fisk)

That Horning's novel had featured a stereoscopic camera reflected the popularity of stereoscopic pictures at that time. The image consisted of two almost identical photographs which, when looked at through a viewer known as a stereoscope, gave an illusion of being three dimensional – enhancing the sense of reality for those looking through the stereoscope. In middle-class drawing rooms stereoscopes proved a popular way of viewing the images of the day – exotic foreign locations, battle scenes and pin-ups. In 1865 the London Stereoscopic Company, whose slogan was 'No home without a stereoscope', sold half a million pictures.[5]

By 1859 the American essayist and critic Oliver Wendell Holmes excitedly predicted that battles from what he called 'the next European war' would be seen in stereoscopic pictures. But his enthusiasm quickly wavered when he saw photographs taken during the American Civil War (1861–5) by Matthew Brady. Following the search for his wounded son on the battlefields, Wendell Holmes found the pictures too much to bear. He wrote: 'It was so nearly like visiting the battlefield to look over these views, that all the emotions exited by the actual sight of the stained and sordid scene, strewed with rags and wrecks, came back to us, and we buried them in the recesses of our cabinet as we would have buried the mutilated

remains of the dead they too vividly represented.'[6] The need to hide the gruesome pictures as expressed by Wendell Holmes is a practice often referred to by soldiers with regard to their own pictures of war and instances are referred to later in this book.

The business of photographing war

In the mid-nineteenth century as there were no professional photographers, so there were no amateurs either.[7] At a time when empires were expanding, colonial wars were being fought and adventurism, travel and tourism were on the increase, the business of photographing war was primarily the domain of entrepreneurial travellers, wealthy 'enthusiasts' or military officers.

One of the earliest known soldier-photographers was Charles J. Betts, who during the Mexican–American War (1846–7) visited the homes of American soldiers on request 'to take miniatures of the dead and wounded'.[8] In 1848 John McCosh, a military surgeon, took pictures in Punjab during the Second Sikh War (1848–9) and later in Burma (Myanmar) during the Second Anglo-Burmese War (1852–3), although the only indication of a military operation in his pictures is the posed portraits of the uniformed officers. His surviving album of calotypes also include scenic views, portraits of administrators, their wives and daughters, and 'natives' photographed either looking directly at the camera or from a side position, styles that from the late nineteenth century would be commonly associated with identity photographs. McCosh saw his role as a witness to pivotal moments in history, and in this sense he was ahead of his time. Before he retired he published a handbook *Advice to Officers in India*, in which he recommended that every assistant surgeon 'make himself a master of photography in all its branches' and create pictures that would be 'a welcome contribution to any museum'.[9]

The entrepreneurial traveller was also keen to capture war scenes although motivations varied. In 1859 a gentleman traveller known as J. L. wrote to the *Photographic News* about how he had intended to make a tour of Switzerland with his camera but had decided instead to record the Second Italian War of Independence, which had broken out in April that year. J. L. explained: 'The exciting prospect of being able to get plates of battlefields, sieges, and other incidental scenes, made me change my course.' But there was another incentive. He wrote: 'I should not like to miss an opportunity of getting a photograph of a field of battle, so that when the excitement of the conflict is past…they might not then perhaps talk so flippantly of war.' But in the nineteenth century photography was a hazardous and arduous business. Camera equipment was cumbersome and expensive, and transporting glass plates and chemicals for processing was precarious. None of J. L.'s photographs survived. His photographic chemicals were spoiled during the journey and some of the negatives turned out 'badly'.[10]

The Crimean War (1854–6) was the first war in which journalists and photographers had attempted to capture events in ways that had not been possible before and which set a new pattern for reporting war.[11] In 1854 an article in *Practical Mechanics Journal* suggested that photographers should be attached to military expeditions

to 'obtain undeniably accurate representations of the realities of war and its contingent scenery, its struggles, its failures and its triumphs'. The article went on to state that unlike a painting, 'a photographic picture brings the thing itself before us.'[12] That same year a young woman wrote in a letter to her fiancé in the Crimea: 'I send you, dear Alfred, a complete photographic apparatus which will amuse you doubtless in your moments of leisure, and if you could send me home, dear, a good view of a nice battle, I should feel extremely obliged. PS. If you could take the view, dear, just in the moment of victory, I should like it all the better.'[13] Souvenir photographs from the front with dedications to family and friends seemed popular. During the Boer War (1899–1902), Sergeant Thomas H. Harrisson, who served with the Royal Ambulance Medical Corps (RAMC), inscribed his small pocket Kodak photo album with the words: 'My dear wife in memento of my visit to South Africa 1901 and 1902.'[14]

By the time of the Boer War there had been innovative developments in camera technology, and photography had became a popular middle-class pastime. Consequently, it was the first war in which military personnel took pictures in any significant numbers, although the cost of cameras restricted the practice mainly to officers. The small hand-held camera with faster shutter speeds (around 1/25 second) had made it possible to catch people in motion in spontaneous, animated or even clandestine poses. These new types of pictures taken by amateurs were called 'snapshots' – a term derived from hunting with a gun. Some of the earliest 'snapshot' cameras were called 'detective' cameras, creating a further association between photography and surreptitious picture-taking. These specialist cameras were designed to look like books, parcels, handbags, walking sticks or sometimes guns, and those who used them to 'snap' unsuspecting members of the public sometimes gained a reputation as voyeurs or as public nuisances.[15]

In 1888 the American firm Kodak had marketed the first popular mass-produced roll-film folding pocket camera, with a unique developing and printing service, with the slogan 'You Press the Button, We Do the Rest'[16] – a nineteenth-century equivalent to the digital point-and-shoot camera carried by soldiers in Iraq in the twenty-first century.

By 1900 specialist amateur photography magazines were published and exhibitions organised. In May 1895 *Kodak News* was launched, and two years later, in 1897, Kodak curated an international exhibition of amateur photography with prize money of £600. During 1904 and 1905 a second Kodak exhibition toured Britain, to national acclaim. It included photographs taken by Queen Alexandra, who was said to be a keen amateur photographer. At the time a large proportion of amateur photographers were women, and the Kodak Brownie was marketed at a female clientele. By 1910 'the Kodak Girl', in her distinctive long striped dress, holding her folding camera, had become a popular advertising icon and would remain so for four decades.[17]

In 1905 the press reflected the public's enthusiasm for the Kodak travelling exhibition. The *Bournemouth Daily Echo* reported that 'at Croydon…the doors had to be locked, so great was the crush, while at St Leonard's the great hall, capable

of seating 1,500 people, was found too small, and people had to be turned away from the doors.' *The Amateur Photographer & Photographic News* (*AP*), a serious magazine for the amateur that had been founded in October 1884, reported: 'The Kodak travelling Exhibition seems to be stirring up the country like a revolutionary banner as it passes from town to town ... creating a yearning for camera and lens in others in who heretofore the wish was dormant.'[18]

But the advent of amateur snapshot photography was not welcomed by all. Serious 'enthusiasts' generally frowned upon this popular movement and saw it as discrediting the art of photography. As a consequence, distinctions were made between a photograph and a snapshot. The novelist and editor Carlo Rim wrote: 'There is the posed photo and the snapshot, just as there is sculpture and a footrace.' The posed photograph, he said, held its own, because its benevolent collaboration with time was asked for, whereas a snapshot 'is something complete in itself ... it flies in the face of time, violates it'. The snapshot, he further commented, 'has invaded that ultimate refuge of the pose: the family album', which he said would be peopled by 'silly grimaces and human hams'.[19] During the Boer War an officer chose to differentiate between snapshots and photographs by way of an inscription on the cover of his photo album which read: 'Photographs and Snapshots during the South African War 1901–1902.'[20]

Cameras for war

When the First World War began in August 1914, photography was at a peak of popularity as an amateur pursuit, but in theatres of war it was against military regulations. That soldiers might take pictures of the dead or injured or images that in any way reflected the barbaric nature of trench warfare was outlawed from the outset. A General Routine Army Order stated: 'The taking of photographs is not permitted and the sending of films through the post is prohibited. Any officers or soldiers (or other persons subject to military law) found in possession of a camera will be placed in arrest, and the case reported to the General Headquarters as to disposal.'[21]

In spite of this stringent policy, camera manufactures were remarkably cavalier about targeting soldiers in advertising campaigns. One Kodak advertisement stated: 'Make the parting gift a Kodak. Wherever he goes the world over, he will find Kodak film to fit his Kodak.' The compact Kodak Vest Pocket Camera (VPC), marketed as 'The Soldier's Kodak Camera', proved to be one of the most popular. It measured only 6.5 cm x 4 cm and was supplied with a 'military' case that could be attached to a belt. Within three years sales of VPCs had increased fivefold, and when the USA joined the war in 1917 American soldiers bought them too. By 1918 almost 2 million had been sold.[22] The Autographic Camera, launched by Kodak in 1914, was also popular. It provided a facility to write captions on the photograph by applying pressure with a stylus on the sensitive paper between the film and backing paper after the exposure had been made. When the film was developed the caption appeared on the picture. There are many surviving examples of soldiers' autographic camera pictures and some are referred to in Chapter Three.[23]

From reveille to taps, each hour will bring something new into the life of every young soldier. New surroundings, new habits, new faces, and new friendships will make for him a new world—a world full of interest to him *to-day* and and a world upon which he will often dwell in memory when peace has come again.

And this new world of his offers Kodak opportunities that will relieve the tedium of camp routine at the time and will afterward provide what will be to him and his friends the most interesting of all books—his Kodak album.

Figure 2.4 A Kodak camera advertisement, entitled 'Kodak in Camp'.

As thousands of men left their families to go to war, photographs became a popular means of sharing cherished memories. Camera advertisements exploited this poignant connection between photographs and memory. An Ansco Vest Pocket Camera advertisement read: 'Keep the Door of Memory Open with an Ansco: Pictures always tell a story better and quicker than words.'[24] Furthermore, a Kodak advertisement encouraged soldiers to make photo albums as a way of safe-guarding their memories.

The advertisement entitled 'Kodak in Camp' shows an American soldier sitting at a table in a large tent (Figure 2.4). He is turning the pages of his album as another soldier looks on. On the table next to the album is his Kodak camera. The suggested atmosphere is one of calmness and tranquillity. Curiously Kodak chose to use a drawing rather than a photograph.

Besides making a connection with photography and personal memory, an advertisement for an Ensignette camera recognised the historical contribution soldiers' snapshots could make to a public memory of war. It stated:

> Judging from the number of cameras known to have been taken to the front by officers – and, no doubt, by many privates – a vast number of unique records, and some most valuable material must rapidly be accumulating. Much will be of great historical interest and scientific value, while the incidental interest of a good deal of the rest will be remarkable. Perhaps you have a soldier friend going to France. New drafts are going continually, and an 'Ensignette', which can be stowed away in a tunic pocket or strapped to a belt is the one and only camera that is really strong, easy to load, and useful under all circumstances.[25]

The advertisement went on to mention pictures of the extraordinary unofficial Christmas Truce in December 1914 when, between Christmas Eve and Boxing Day, not a shot was fired. British and German soldiers left their trenches to exchange cigarettes and Christmas wishes, an event, the advertisement stated that had been recorded 'in something more reliable than printers' ink'. One poor quality black and white picture widely published in the British press in January 1915 showed a group of twenty-six British and German soldiers standing side by side. The *Daily Sketch* said it was 'one of the most remarkable photographs ever taken of this war'.[26]

Another picture of the truce thought to have been taken by Private Turner at Ploegsteert, near Armentières, shows a group of German and British soldiers fraternising (see back cover). Private J. Selby Grigg of the London Rifle Brigade, who featured in the photograph, explained in a letter home the circumstances in which the picture was taken:

> Turner and I and some of our pals strolled up to the reserve trenches after dinner, we found a crowd of some 1,000 tommies [*sic*] of each nationality holding a regular mothers' meeting between the trenches. We found our enemies to be Saxon. ... I raked up some of my rusty German and chatted with them. None of them seemed to have any personal animosity against England and all said they would be jolly glad when the war was over. Turner took some snaps with his pocket camera.[27]

In January 1915 the *Daily Mail* published a number of letters written by British soldiers who had participated in the truce. In one letter a soldier explained that the truce had started on Christmas Eve at around 7.30 pm when German soldiers in a nearby trench began singing and lighting candles. One of them challenged the British soldiers to go across and share a bottle of wine. After initial apprehension, one soldier went with a 'big cake' in exchange. The rest followed. They even helped the German soldiers bury their dead.[28]

Although the truce received press coverage in 1915, and is well known among historians, these snapshots are not considered significant war pictures, perhaps

because they defy what war is supposed to be about. They do not show proud marching soldiers or supposed heroic acts, but rather a different kind of heroism that challenges and problematises the premise on which war is built and battles are fought. These affecting images of young German and British soldiers eager to communicate and share cigarettes and good will poignantly convey the futility of war. On 26 December soldiers on both sides were ordered back to their trenches to resume the killing.

For photographic manufacturers war had become a profitable business. The press began to publish stories about the keen interest soldiers and sailors had in photography. *AP* reported that it had become a 'favourite pursuit' among naval officers, who were transforming their cabins into darkrooms: 'The electric lights have been painted over with lurid red and every air hole has been pasted up with newspapers.'[29] On occasions trenches became sites of makeshift darkrooms where soldiers reportedly processed their film. One British soldier was said to have made a dug-out darkroom in the trenches on an island just off the coast of Gallipoli. A French soldier who wanted a photograph of himself to send to his family made an improvised camera 'by means of cigar boxes, the bellows consisting of a section of a jacket sleeve'.[30] A great deal of trouble was taken to preserve photographs taken at the front. An Italian officer, Lieutenant Giuseppe Dellorto, included pictures in letters home for safe keeping. In one letter he wrote, 'I have some photographs which have been given to me – I'll send you one in each letter and you will keep them for me. I want to make a little collection as a memento. ... Please do see that they are kept so that they are not lost or spoiled.' He also asked for film which he said he could not get at Udine: 'Tell Gino to send me 10 rolls of Kodak film 4 1/2 x 6 which ... contain 8 pictures.' Although he did not say in his letter what the pictures he sent home showed, he did acknowledge the risks involved: 'I am sending you some more photographs,' he wrote, 'I could send you a lot of other very good ones but they are dangerous.'[31]

An army of snapshooters

At the onset of war in 1914 the British press had been enthusiastic for the dramatic photo opportunities that they hoped war would bring. Some newspapers, including the *Daily Mirror*, the world's first illustrated daily newspaper when it was launched in 1904, relied heavily on the relatively new and fashionable concept of photographs-as-news as a selling point.[32] But rigorous British government censorship created a severe shortage of images, a situation that would change little throughout the war.

In August 1914, the Official Press Bureau had been established by First Lord of the Admiralty, Winston Churchill. All pictures intended for publication had to pass its rigorous vetting procedures. Throughout the war, the Press Bureau issued a number of 'D' Notices – instructions sent to newspaper and magazine editors with regard to the suitability of stories and pictures for publication. One notice, dated February 1915, stated that all pictures must be published with the supplied captions and an official logo which would make clear to the public that only those pictures passed by the censor could be published. A Press Bureau memorandum

made clear that photographs 'of an unnecessarily gruesome nature ... showing German dead or grievously wounded English soldiers, should not be published in the press'.[33] The same rules had applied to artists. As war artist Paul Nash famously said: 'I am not allowed to put dead men in my pictures because apparently they don't exist.'[34]

With increasingly stringent regulations and a lack of good official photographs, during January and February 1915 the press began to publish amateur pictures taken by military personnel, although the captions often proved more revealing than the pictures themselves. On 20 January the *Daily Sketch* published a front-page picture of the battle cruiser *Inflexible* silhouetted on a distant horizon with the headline 'The most wonderful battle picture of all'. The grey blobs in the ocean waves are, according to the caption, 'German sailors struggling in the water ... waiting to be saved' – survivors of the *Scharnhert* which had refused to surrender and was sunk off the Falkland Islands. The picture was taken by a sailor from the crow's nest of HMS *Invincible*: 'No photographer up till now has accomplished so wonderful a feat and no such wonderful battle picture has been published before', claimed the caption.

Stories about how pictures had been taken were commonly published and were light, quirky and entertaining. *AP* reported a story about a French infantry unit under fire in the forest of Argonne. The officer in charge had, the report said, 'turned his back on the enemy ... and with the little camera he carried took a photograph of his men. That was all. Then the detachment resumed operations astonished somewhat, but at the same time comforted. There was a sound psychology to it. ... The snap of the shutter became in a way symbolic.'[35] The *Daily Mirror* published a photograph that showed four barely visible Saxon soldiers emerging from trenches among a mass of fallen tree trunks and branches in dense woodland with the headline 'Photographing the enemy: French officer "snaps" the Germans'. According to the report they had been drawn out of their trenches by the French Lieutenant whistling a German tune. The name of the tune was not revealed. But when they came into view, the Lieutenant reportedly asked them if they minded having their portraits taken. They agreed and apparently were 'quite pleased'.[36]

These stories and pictures were a distraction and did nothing to depict the fact that during the first few months of the war hundreds of thousands of soldiers were being systematically slaughtered on the battlefields of northern France. According to a British government document, although 'very secret' weekly information and statistics with regard to the numbers killed and injured was being sent out to a list of 140 selected newspaper editors, all had 'given written undertakings to safeguard the information'.[37] So skilfully avoided were the gruesome facts of war – in either words or pictures – that after the war had ended, in 1920 a former director of the Press Bureau wrote: 'A most remarkable feature of our newspapers during that time was that they bore no palpable trace of having been censored at all. An outside observer, if he chanced to miss the occasional tirades against the Press Bureau might reasonably conclude that there was no censorship in force.'[38]

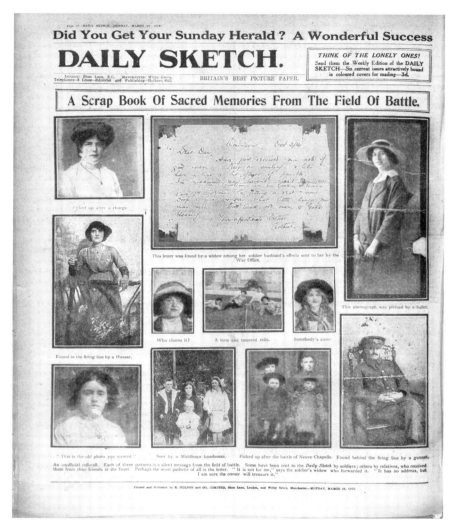

Figure 2.5 A page from the *Daily Sketch*, 29 March 1915: 'A Scrap Book of Sacred Memories from the Field of Battle.'

In fact in 1915 the only clue in the press that men were dying in the trenches of northern France was the family snapshots published in the *Daily Sketch*. The pictures had been found among the personal belongings of the dead and sent to the newspaper by fellow soldiers in the hope that those who featured in them might recognise themselves. These ordinary family mementoes, whose only value was as personal pictures, had acquired a value as evidence of the death of those who carried them to war.[39]

In March 1915, the *Sketch* published a full page of these family snapshots with the headline 'A Scrap Book of Sacred Memories from the Field of Battle' (Figure 2.5). The captions printed alongside gave them a poignancy they otherwise would not have had: 'Picked up after a charge', 'This photo was pierced by a bullet', 'Picked up after a battle at Neuve Chapelle', 'Found in a firing line by a Hussar' and 'Somebody's sister'. In June the newspaper published another page of

soldiers' snapshots, this time with the headline: 'The dying soldier's farewell message'. A handwritten note printed alongside a portrait of 'an Irish soldier's sweetheart', read: 'You can tell her he died Happy. He took this poto [*sic*] out of his pocket when dying & said first Poor Mother then Poor girl Goodbye.'[40]

But poignant family snapshots and quirky stories about soldier-photographers were clearly not enough to satisfy the needs of the press. In May 1915, an editor of the Newspaper Illustration Agency made a plea to the War Office for what he called 'a very pressing requirement of the press'. In a letter he asked the Army Council to permit a photographer to go to France to take pictures for 'Recruiting purposes and Press illustration'. He suggested the photographer 'could be placed under orders not to make any camera exposure that would be detrimental to the interests of the British, French or Belgian armies' and that the pictures would be 'submitted to the Army Council and the Director at the Press Bureau for sanction before issue to the Press'. In effect he was arguing for a rigorous censorship policy. As beneficial as the request seemed to be for the authorities and press alike, he seems to have had no response, but after conscription was introduced in January 1916, elements of the idea were put into practice.[41]

In March 1916 Lieutenants Brooks and Brooke were appointed, according to a government official, to take 'official pictures for the press and propaganda purposes'. The *Daily Mail*, which paid £5,000 for the exclusive rights to make and sell picture postcards of their photographs, described them as 'plucky cameramen' at the front, whose pictures had all the atmosphere of the 'real thing'. Two other officers, Captain Wilbraham and Major Campbell, were also appointed as official photographers, but this was not made public and their pictures were said to be for 'intelligence purposes' only, not for public release until after the war had ended.[42]

Although the appointment of official photographers went some way to solving the problem, it was by no means adequate. To the *Daily Mirror* the solution to the lack of good front-line pictures was to make a direct appeal to 'officers with cameras' for their snapshots from the front. In February 1915 the newspaper began a series of advertisements that pledged to pay soldiers 'large sums of money' in exchange for their snapshots of war, an idea that it claimed would 'stimulate photography'. On 25 February the *Mirror* ran a headline: 'War snapshots that will win £1,000: amateurs' chance.' The sum was, the advertisement stated, 'the largest ever offered for a news picture in the history of illustrated journalism for the most interesting snapshot of a war happening'. The competition would last until the end of July, film would be developed free and participants' names would not be disclosed.[43]

To some commentators offering such extraordinary sums to soldiers' for their pictures (the current equivalent of an estimated £250,000) was irresponsible. It could lead, said one, to soldiers putting down their rifles and picking up their cameras.[44] But the *Daily Mirror* was not new to controversy. In 1911 it became the first British national newspaper ever to publish 'atrocity' images when it featured pictures taken during the Italian–Libyan War. One front-page picture showed dead bodies of civilians strewn around a rural landscape with

the headline 'Photographic proof of Italian barbarity in Tripoli: Native family slaughtered in an Arab village'. Whether this picture was evidence of the slaughter was not substantiated. But soon afterwards the photographer, Thomas Grant, was deported from Libya.[45] The *Mirror* was in trouble again when in October 1914 it published an unauthorised picture of a battle cruiser escorting the first contingent of Canadian soldiers to England. In the first of what would be a series of condemnatory letters from the Press Bureau to the *Mirror*, the newspaper was criticised for publishing the picture in 'direct disobedience of the instructions issued to the Press'.

By the end of 1915, the *Mirror* had allegedly breached Press Bureau regulation with such regularity that the Bureau referred the cases to the courts, though the Attorney General did not take them up as he insisted that a prosecution would fail. On another occasion the Bureau threatened to refuse to supply the *Mirror* with official photographs, though there is no evidence that this threat was carried out. These actions did not deter the *Mirror*; in fact the newspaper became more brazen in its use of pictures. In 1917 it published a photograph that showed a group of soldiers at the National Institute for the Blind who, according to the caption, were receiving 'a lesson in anatomy'. The caption (apparently the *Mirror*'s own) stated that the skeleton being examined had been 'a living German' only one year before, causing outrage in Germany and a great deal of anger among staff in the Press Bureau.[46]

The *Mirror* was not the only newspaper to disregard Press Bureau instructions. Within two days of the newspaper's appeal to soldiers for their pictures, the *Daily Sketch* and the *Daily Mail* had followed suit and pledged even bigger cash prizes to soldier-photographers in exchange for their snapshots. The *Sketch* opened its competition to professionals as well as to amateurs and raised the stakes in the battle for pictures by offering a prize fund of £10,000.[47] There was a flurry of excitement in the amateur press. Kodak gave substantial publicity to the competitions and issued special posters, pamphlets and leaflets. *AP* declared: 'Picture making by "live" Photographers is the modern trend'. The magazine began to offer advice to soldiers. In an article headlined 'Photography at the front: Some practical notes from one who has been there', a correspondent under the pseudonym 'Medico' described the subjects soldiers should not photograph. He wrote: 'Don't flourish your camera about in the face of generals ... don't take pictures that could possibly be of the smallest assistance to the enemy; you might be captured Don't ever photograph the horrible, such as the execution of a spy; you will find war quite horrible enough, without perpetuating the seamy side of it.'[48]

The Secretary of the Royal Photographic Society, John McIntosh, praised the *Daily Mirror* for 'displaying an enterprise and generous spirit that are most praiseworthy'. Its offer, he said would 'undoubtedly stimulate all camera users to make the best use of their opportunities to take war pictures ... and result in raising a new army of amateur photographers who would not otherwise have been attracted to the art'. McIntosh said that he had no doubt that they would want to emulate what he called 'the adventurous spirit of a former secretary of the society,

Mr Roger Fenton', who had taken photographs during the Crimean War and who, he said, had published 'a very handsome volume of pictures actually taken at the war – a wonderful event in those days'.[49]

In fact Roger Fenton's photographs were very different from what Fleet Street had in mind. Fenton, an entrepreneur and a prestigious figure known for his travel pictures of Russia and landscapes of Britain, travelled to Crimea under the patronage of Queen Victoria and Prince Albert, financed by publisher Thomas Agnew & Sons. Although Fenton is said to be the first war photographer, he was essentially a travel photographer. Photographic historian Ian Jeffrey writes: 'To a certain extent the Crimean photographs are nothing more than incidentals to an absorbing adventure story which began with Fenton's arrival at Balaclava on 8 March 1855.'[50]

At the time of Fenton's commission to the Crimea, public opinion was beginning to turn against the war. Reports in *The Times* dispatched by celebrated newspaper journalist William Howard Russell had been an influential factor. His accounts had vividly described the appalling conditions that soldiers were encountering at the front. In one report Russell wrote, 'The dead, laid out as they die, are lying side by side with the living, and the latter present a spectacle beyond all imagination. The commonest accessories of a hospital are wanting; there is not the least attention paid to decency or cleanliness – the stench is appalling.'[51]

The authorities needed to counter Russell's graphic dispatches and hoped that Roger Fenton's photographs would do the job. That pictures should be given the task of countering the horrors of war described in words indicated that at this time words were seen to be more powerful than pictures – a position that would be reversed in 1945, when images of the Nazi concentration camps were used to describe scenes that it was thought words could not. But the images taken by Fenton presented viewers with none of the atrocities of war. The majority are portraits of stiffly posed generals and officers and their associates. Although he wrote in his diary about how he was witness to the piles of unburied bodies and that he 'saw them lying in heaps', he felt no urge to take photographs of them. Instead, he described the delights of the menu when he dined with Captains Holder and Manson. And when Fenton gave a lecture at the Royal Photographic Society after his return he did mention the 'sordid conditions of the troops' but he had no photographs as evidence.[52]

So, in 1915 when the press were requesting pictures from soldiers, the kind taken by Roger Fenton was not what it wanted at all. The *Daily Sketch* stated that it had no interest in promoting art photography, a category in which the newspaper implicitly placed Fenton's photographs. In a column about the competition, set in bold italic type, the *Sketch* stated: 'Our scheme is simple and direct. We want topical photographs, and we want them every day. We want the best pictures, war and general news pictures. We are not concerned with the encouragement of the photographic art. ... Photographic art is often suspiciously akin to faked pictures.'[53]

That the *Sketch* had associated photographs with fakery reflected the complex role that photographs were already understood to inhabit. They were indisputable

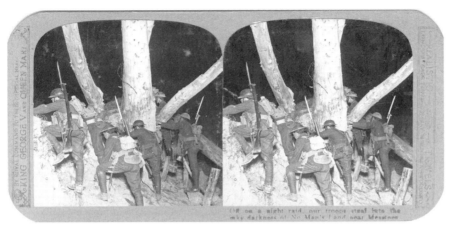

Figure 2.6 A stereoscopic image from a First World War series entitled 'Realistic Travels'. The caption reads: 'Off on a night raid our troops steal into the inky darkness of No Man's Land near Messines'. (Private Collection)

records of truth, but paradoxically they could also be made to deceive. By 1915, there were notable examples of so-called war photographs that had been tampered with either for use as propaganda or for dramatic effect, including by Fenton himself. In the aftermath of the notorious Charge of the Light Brigade, where 600 British soldiers had lost their lives during the Crimean War, Fenton had scattered cannonballs around the scene of the battle, presumably to add drama to an otherwise unremarkable landscape.[54] Whether this was known about at the time is unclear. In 1871, during the Paris Commune, faked photographs (made by a collage technique) of dead communards were produced as propaganda to 'prove' they had been defeated.[55] Three decades later, during the Boer War a sequence of photographs that were supposed to show the Battle of Colenso was reportedly taken in Muswell Hill in north London. The Boer War was the first war to be recorded on film but it transpired that some of this film footage was also faked. Some scenes, thought to have been authentic at the time, had in fact been 'enacted' in South Africa, or reconstructed and shot in Britain by commercial film companies deterred from filming on location by the long distance involved. But the London-based film producer R. W. Paul had the innovative idea of supplying two officers with cameras to shoot film on his behalf, although neither secured images of 'actual fighting'. Colonel Beevor of the Scots Guards reportedly took around 'a dozen good films'.[56]

The First World War also had its share of faked photographs. A collection of stereoscopic pictures, entitled 'Realistic Travels', was distributed throughout the British Empire; it included an image that showed a group of six soldiers with bayonets emerging from a trench at night (Figure 2.6). The picture is sharp and brightly lit, as though with a powerful flashgun or perhaps studio lights, an unlikely scenario on the Western Front. The soldiers' uniforms are clean, their boots are shiny and their poses look static, as though choreographed. The caption reads: 'Off on a night raid our troops steal into the inky darkness of No Man's Land near Messines.' The caption also states that the pictures in the 'Realistic Travels' collection were 'finished and printed entirely

by ex-servicemen', as though this would give the images an authenticity they patently lacked.

In 1915 the British press did not want posed, reconstructed or faked official photographs but 'snapshots' – taken by amateurs. Amateur snapshots were regarded as giving a personal interpretation and, without an official agenda, were regarded as more reliable when it came to telling the truth. The *Sketch*, which told its readers not to waste their time on 'elegant effects', perceptively defined the snapshot as having 'defects... movement, surprise, expression, incident... the very effects which give a picture its actual news value'.[57] These attributes were similar to those claimed for professional documentary photography in the 1920s, when for the first time the small hand-held roll film cameras would become popular with professionals as well as amateurs. It could be said that the 'snapshooters' of the First World War were forerunners to the photojournalists of the Second World War and other subsequent wars.

The soldiers' snapshot competitions run by the *Mirror*, *Sketch* and *Mail* proved immensely popular and thousands of pictures poured into editorial offices from Europe, Russia and the Middle East. Those published showed war as if it were a series of light-hearted comradely encounters, amid occasional scenes of human tragedy – French infantrymen enjoying a glass of wine in a village, women delivering bread to a British base, a group of happy civilians smiling for the camera, a horse drinking from a 'picturesque stream'. There were plenty of hospital scenes, although devoid of gruesome or bloody detail. Occasionally images of dead bodies were published, but only those that showed the enemy or colonial dead, not apparently the British. One photograph published in the *Daily Mail* showed three men hanged from a tree in West Africa. A British soldier looks on. They were 'natives' who according to the caption had 'fallen into the hands of the Huns'.[58]

By the spring of 1915 all three newspapers were regularly publishing the prize-winning snapshots. They were accompanied by predictable headlines and jaunty stories and readers were frequently reminded of the great personal risk that war photography involved. Even though few showed any arresting elements, each was described as more 'remarkable' or 'wonderful' than the last.[59] The *Mirror*'s 'Great £1,000 Picture' was described as 'perhaps the most remarkable picture the present war had produced on either land or sea'. It showed around a dozen survivors of *Falaba*, the first British passenger liner to be sunk by a German U-boat, clinging to an upturned lifeboat. Their heads and faces had been crudely retouched with pencil that made the photograph look like a drawing. The story of how the picture was taken, reported the *Mirror* 'was a romance in itself'. The photographer, an officer described as 'a cool plucky Englishman', had taken the picture from on board the ship before being in the water himself for more than an hour. How the film had been saved was not mentioned but a picture of the ruined camera was also published.[60] Another picture in the *Mirror*, headlined, 'Photograph which a Dead Man Took', showed little more than a stark wooded landscape of bare trees. The accompanying story reveals that the soldier had been about to take a picture of

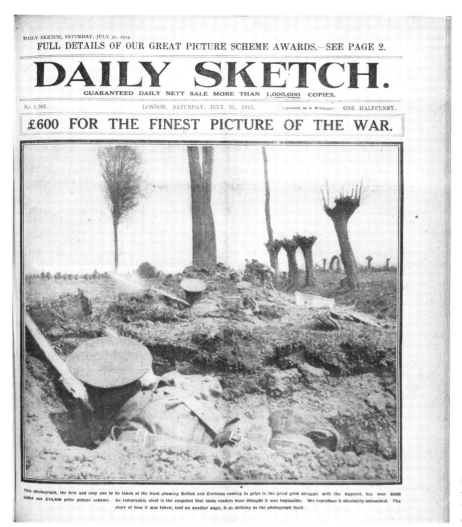

Figure 2.7 Front page of the *Daily Sketch*, 31 July 1915: '£600 For the Finest Picture of the War'.

an anticipated explosion ahead of him when, as he pressed the shutter, a piece of shrapnel killed him.[61]

It appeared that the *Mirror* was also using pictures taken by a former staff photographer. A photograph taken at Neuve Chapelle on 10 March 1915 by a wounded soldier with a camera he kept concealed in his bandolier was published with the headline 'Wounded man props himself up to take a photograph'. It showed a bleak landscape with plumes of smoke rising from the ground. A group of barely visible soldiers are crawling forward towards sandbags and a wounded soldier is lying in the foreground. The picture was taken by Private F. A. Fyfe of the Royal Highland Fusiliers; a former *Mirror* photographer, a fact undisclosed by the newspaper.[62]

On 31 July 1915 the *Daily Sketch* published a front-page photograph with the headline '£600 for the finest picture of the war' (Figure 2.7). Taken on the Western Front during the Second Battle of Ypres, the photograph shows three officers in a trench in a landscape of mud and dead trees – though only their hats are visible. They are pointing their bayonets in the direction of a line of advancing German soldiers who appear as a dark fuzzy mass on the horizon. It was taken by a young officer from the King's Liverpool Regiment – the regiment to which William Fisk belonged – and was reportedly reproduced 'absolutely untouched'. The caption read: 'No photograph yet published has so strikingly visualised the moment for which every British soldier longs, as this wonderfully vivid picture.' The newspaper reported that a Mrs St Quentin received the picture from a 'friend from the front' and that the story of how it was taken was 'as striking as the photograph itself'. The officer had watched the German line advancing, then photographed them; as the order to 'charge' was shouted, he dropped his camera and ran forward with his men.[63]

By 1916 there was official pressure to prevent soldiers' pictures reaching the press. In July, the Press Bureau issued a 'D' notice that reiterated the General Routine Order that prohibited soldiers taking pictures or sending films through the post. The 'D' notice also stated: 'In view of this order the press are requested to refrain from publishing advertisements calling for snapshots and photographs from the front. Such advertisements may tempt officers and men to disobey the Routine Order and therefore likely to prejudice the discipline of His Majesty's Forces.'[64] In December 1917, the order was restated in a memorandum from the War Office to the Press Bureau which stated: 'No photographs are allowed to be taken by any officer or man except the official photographer ... so it is requested that you will stop all photographs as suggested.'[65]

The disappointment of photography

The dramatic claims made for the amateur pictures published by the press were debatable, to say the least. When photography was invented, it had been assumed that the objective eye of the camera would more than adequately replace the subjective eye of the artist. But this was not necessarily the case. Although no one denied that a photograph accurately recorded the literal truth of a scene, the problem was that this truth did not always seem to convey the sense of the drama of war that had been expected.

As a result of this disappointment, some editors preferred the graphical interpretation of a scene and continued to publish the more traditional drawings or illustrations that were often based on photographs. In 1859, during the Second Italian War of Independence, a French photographer had written: 'I shall bring back in my portfolio photographs of all kinds, which would be useful to a painter of battle scenes', implying that his images would require embellishment by the artist's imagination to have the desired impact.[66]

In December 1914, in an article in *The British Journal of Photography* (*BJP*), A. F. Tilney had attempted to outline what he thought to be the core of the problem: that the 'literal accuracy' or 'literal truth' in a photograph did not necessarily

equate with realism. He recalled the inadequacy of images taken during the Boer War and compared them to those published in the first months of the First World War. He wrote:

> During the Boer War photography was used to illustrate the military epi-
> sodes. It was the first appearance of the camera on the actual battlefield.
> People thought at last they had the real thing, and scoffed at the memory of
> the 'special artist's' imaginations in the past. But when the mind had become
> accustomed to this actuality it began to tire of it and to wish for the spirit
> rather than the letter of these thrilling episodes. In the present war we find
> that the best weeklies are giving drawings that bring home to the spectator
> the important truths of war – the horror and the stress of it. What the accom-
> panying photographs give are either tame, bare landscapes with no sign of
> war in them or wayside incidents that are sometimes obviously faked and
> rarely have any dramatic force.[67]

Tilney's point was correct. During the Boer War pictures that commonly showed barely visible columns of troops on horseback pulling 'pom-poms' – artil- lery pieces – across distant rivers in vast flat plain landscapes relied heavily on captions for dramatic effect. A photo album compiled by Major J. N. Townsend illustrates the problem well. One photograph in the album that shows a long line of men, some on horseback, who appear as specks on the distant horizon is captioned 'Going into action – Klip Drift'. Another picture, captioned 'Women's concentra- tion camp – Potchefstroom', taken from outside the camp perimeters, shows little more than a barbed wire fence. In the far distance there are a few white dots on the horizon, perhaps tents. Another photograph, captioned 'Burning farm where a laager was', suggests a fire, but the tiny plume of smoke occupies less than a quar- ter of the frame of the picture.[68] The drama of the scenes was left to the viewer's imagination.

This was a point that Ernst Jünger, a former First World War German offi- cer, right-wing thinker, author and photography enthusiast, recognised. He compared war photographs to fossils in that they only offer, he said, 'the raw material for contemplation'. To convey the drama of war, he said, required 'imagination'.[69] How to apply such imagination to photographic images was the question that exercised the minds of those concerned with the representation of the war, including Ivor Nicholson, an official at the British Press Bureau. In 1917 Nicholson's concern with regard to the lack of dramatic war pictures prompted him to circulate a paper among Army General Headquarters staff and official photographers that offered a solution. The paper demonstrated a precise understanding that photographs needed to be a means of communica- tion as well as information, and that a photographer was an interpreter of the events being photographed as well as a technician. It advised photographers that in order to successfully combine these elements they should work at 'close range' to their subjects so as to get 'intimate' pictures with as much detail as possible. It suggested that the men in the pictures should be recognisable but

not posed. The images should capture 'the everyday commonplace details of life at the front, which may seem trivial to the man who sees them day after day, [*sic*] help the outsider in forming a clearer perception of the meaning of war to those who are waging it.' The suggestion was that rather than 'vague stretches of country with no arresting feature to stir the imagination of the ordinary newspaper-reader' the pictures could show 'what men are like – how a trench is constructed – how men eat and sleep – the friendship which exists ...'. Photographs, the paper stated, should tell a story and 'sets' of pictures could be taken of the same men or unit, 'a sort of cinema record of an action – or a week's work'. The paper stressed: 'The closer the camera can bring the war to the neutral or the civilian, the more successful will be its work.' With a remark-able degree of insight, the paper suggested that the viewer should be made to think 'What should I feel like if I were there?'[70]

This was a question that photographers were being asked to consider during the war in Iraq in the first decade of the twenty-first century. Then the search for an intimate view of war would cause some editors to turn to soldiers' pictures to fulfil the task it appeared that photographs taken by war photographers were unable to achieve: bear witness from the inside.

Ivor Nicholson received little response to the paper. But its ideas were way ahead of their time. Not only did it explain the task that would be required of pro-fessional photographers, it also more than adequately described the key elements of photojournalism and the documentary tradition which developed in the 1920s and 1930s. Then the seemingly contradictory features of photography – objectiv-ity and personal interpretation, professional and amateur, the photograph and the snapshot – elements that had been regarded as separate during the First World War – would combine to create the basis of modern photojournalism, when the role of the war photographer became that of witness.

Photography on the home front

While the British press encouraged soldiers to take snapshots at the front, it also had suggestions for the ways in which practising professionals and amateurs at home could join the war effort. 'Never before in the history of war has photography played so prominent a part,' proclaimed an article in *AP*.[71] The *Westminster Gazette* recommended that photographers give lantern displays in camps or military hospi-tals, while in south London members of a camera club came up with the initiative 'to develop the plates made by the radiographs of wounded soldiers'. There were also suggestions that wounded soldiers themselves should be photographed in their hospital beds. An article in *AP* stated: 'Just take your camera along, and picture him with his scars of honour ... the majority of men appreciate a personal photo-graph more than any of the countless gifts a grateful public have showered and are showering upon them.'[72] Though wounded soldiers became a common subject for the camera, the photographs did not show their bloodied wounds or twisted bro-ken limbs or disfigured faces. The gruesome and terrifying consequences of war seemed to demand a respectful distance. When British nurses Elsie Knocker and Mairi Chisholm, who ran a first aid post near the Belgian lines, took photographs

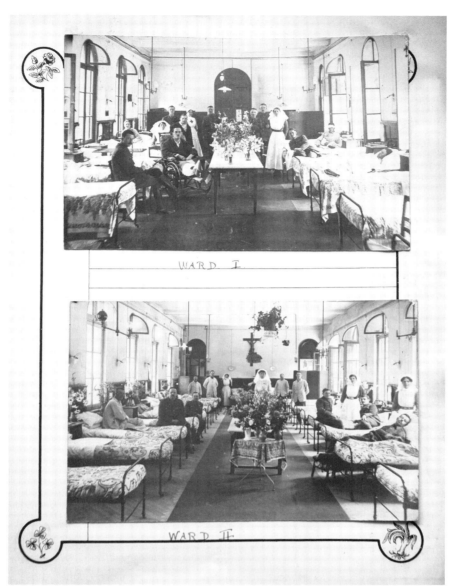

WARD I.

WARD II.

Figure 2.8 A page from the personal photo album of Mrs Ysenda Maxtone Smythe, Voluntary Aid Detachment (VAD) worker. (Courtesy Liddle Collection, Leeds University Library)

of their work they did not show the horrors they themselves described in their diaries.[73]

Similarly, when Mrs Ysenda Maxtone Smythe, one of thousands of middle and upper-class women Voluntary Aid Detachment (VAD) workers who helped out as auxiliaries in hospitals and first aid posts, made a photo album during her service in a hospital near Rouen, in northern France, her pictures of hospital wards were devoid of any unpleasant scenes. On one page are two photographs of tidy wards decorated with plants and flowers (Figure 2.8). The people in them – nurses dressed in clean starched uniforms and patients either wearing military or hospital

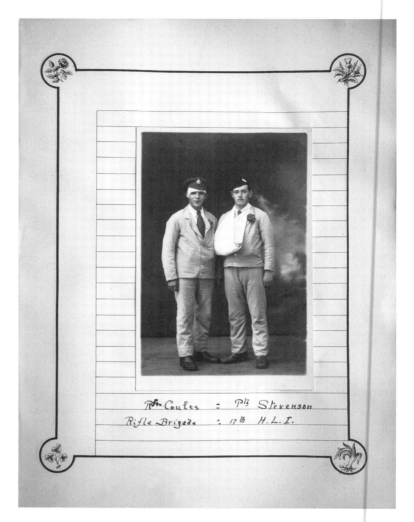

The handwritten caption on the photograph reads:

Pt. Coules : Pt⁵ Stevenson
Rifle Brigade : 17ᵗʰ H.L.I.

Figure 2.9 A page of the personal photo album of Mrs Ysenda Maxtone Smythe, Voluntary Aid Detachment (VAD) worker. The picture shows Private Coules and Private Stevenson. (Courtesy Liddle Collection, Leeds University Library)

uniforms, some lying in neatly, made-up hospital beds – are stiffly posed looking towards the camera and appear to have been carefully choreographed to create a pleasing composition.

Among the other photographs in her album are studio portraits of soldiers, some wearing clean, neatly applied bandages. In these pictures they are standing in pairs in front of a scenic backdrop of clouds, dressed in hospital uniforms, with shirts and ties and regimental hats, looking directly at the camera. One page shows Private Coules with a bandaged head and Private Stevenson with his arm in a sling (Figure 2.9).

The value of these and other pictures is expressed in the letters of thanks that Mrs Maxtone Smythe received from soldiers grateful for her nursing care. Some asked her for photographs. One soldier wrote: 'I would be very pleased if you could let me have one photograph of me in my uniform, the one you took the

day I came away.' Other soldiers offered to send her their uniformed portraits: 'I have not had my photograph taken but will not forget to send you one when I do', wrote one.[74]

During the First World War the uniformed photograph – the 'khaki portrait' – became an essential requirement among soldiers and immensely popular, as it still is today. Until then uniformed portraits had been largely the domain of the officer class, who were commonly photographed in decorative uniforms in grandiose poses that resembled paintings of the aristocracy.[75] When ordinary soldiers had been photographed they were pictured not as individuals but in groups standing alongside military hardware, or in battlefields, as though they were a natural part of the landscape of war – though the demand for a more personalised portrait was evident during the Crimean War. Roger Fenton had written in his diary about the 'crowds of all ranks' who flocked to his 'photographic van' to have their pictures taken. He complained, 'Everybody is bothering me for their portrait to send home', although it seems he turned them away.[76] During the American Civil War, ten years later, enthusiastic photographers journeyed to the front and set up their cameras to take portraits of soldiers as a lucrative business opportunity. In 1896 Carlo Brogi, an Italian photographer, wrote generally about the popularity of uniformed portraits: 'The conscript who joins his regiment has no sooner put on his uniform than he hastens to send a photograph to his family and to the inconsolable girl he has left behind.'[77]

But in order to convey the appropriate message and instil in the soldier a sense of pride and identity, the 'khaki portrait' had to comply with certain photographic conventions. In 1915 *AP* issued technical and aesthetic advice to photographers on suitable poses and lighting. It recommended not placing the soldier square on to the camera and not using harsh lighting – attributes commonly associated with identity photographs or police mug shots of criminals. Rather, the magazine advised the use of a diffuser or reflector to give a soft natural effect, 'the kind that is incidental to an ordinary living room'.[78]

So great was the demand for uniformed portraits that in April 1915 the *Daily Mirror* reported: 'Nobody was busier in London yesterday than the suburban photographer. The combination of war and holidays brought such a rush of Khaki-clad customers that many photographers were unable to cope with the demands upon their activity.' One high street photographer reported: 'We have cut our price quite considerably for men in uniform. ... But the idea is becoming more popular each week, and this Easter tide has brought such a rush of work as I never before remember.'[79]

This 'khaki portrait' of Corporal Louis Henry Matthews of the Royal Corps of Signals, who served for more than three years in the trenches – at the Somme, Ypres and Passchendaele – was taken in a Cheshire studio (Figure 2.10). It shows him wearing a heavy army regulation shirt and buttoned-up overcoat. His dark hair is neatly parted and he stares into the camera lens. On the back of the photograph is written: 'Taken after the 3rd Battle of Ypres, the Big Push which ended World War One. Hell on earth' Many years later his daughter, Gladys Matthews, had added her own note to the back of the photograph. It read: 'After the Battle of Ypres. Portrait of a man who has looked into hell. ... The expression

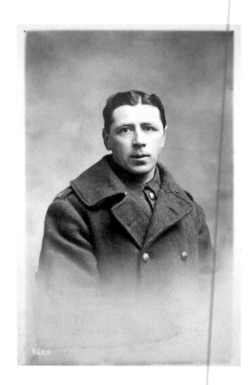

Figure 2.10 A uniformed studio portrait photograph of First World War soldier Corporal Louis Henry Matthews. (Courtesy Liddle Collection, Leeds University Library)

in his eyes is one of extreme pity and compassion.'[80] It is perhaps also an expression of exhaustion, of a man who has seen too much of war. In the three years that Corporal Matthews had spent in the trenches, more than one million men had been slaughtered. On the first day of the Somme alone, 20,000 British soldiers were massacred.

Snapshots from Home

Besides soldiers being supplied with pictures of themselves, in July 1915 a national charitable scheme was launched called Snapshots from Home. It was administered by the YMCA, to supply soldiers at war with photographs of their families and loved ones with the desired effect of boosting morale at the front. All soldiers, including British POWs and soldiers from the colonies were eligible for the scheme, free of charge. An advertisement declared: 'No soldier or sailor who has asked for some snapshots in his wallet shall have asked in vain, no matter how remotely in the country his home may be.' Throughout Britain Snapshots from Home League Committees were established, made up of ministers, social workers and 'society ladies'. By December the committees had recruited around 7,000 representatives who had dispatched a remarkable 60,000 snapshots, with a turnover of 500 a day. Within six months there were more than 10,000 enrolled volunteer photographers and 65,000 applications had been received from men at the front, 400 of them from POWs in Germany. In Liverpool an exhibition was organised and a snapshot club established to instruct photographers new to the scheme.[81]

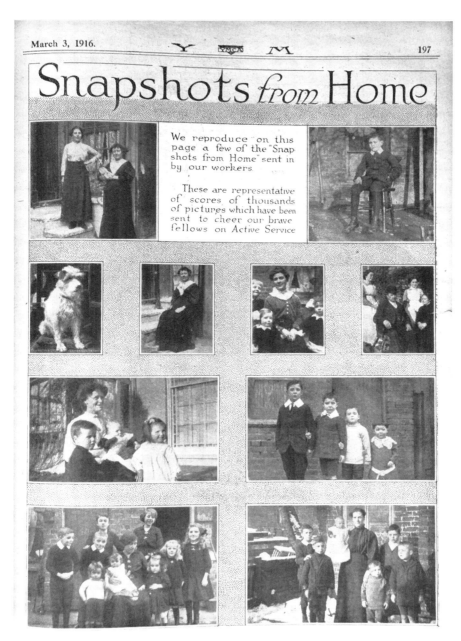

March 3, 1916. Y M 197

Snapshots *from* Home

We reproduce on this page a few of the "Snapshots from Home" sent in by our workers.

These are representative of scores of thousands of pictures which have been sent to cheer our brave fellows on Active Service

Figure 2.11 Snapshots from Home in *The British Empire YMCA Weekly*, 3 March 1916. (Courtesy of University of Birmingham Special Collections Department)

Throughout 1915 and 1916 the YMCA journal, *The British Empire YMCA Weekly* (*YM*), regularly published snapshots issued through the scheme. On 3 March 1916 *YM* printed a full page of pictures that showed women and children in homely environments, dressed in their Sunday best and posed in front of the camera. There is even a picture of a family dog (Figure 2.11). These poignant snapshots were intended to stir in the soldier a sense of longing for the family life

he had left behind, in contrast to the 'khaki portraits' that were intended to inspire in the family a sense of pride for their loved one at war. The combination created a bond between soldier, family and nation that helped to maintain morale among the troops in the front line in the most brutal war in history at the time.

Whereas the 'khaki portraits' were generally taken in the neutrality of a portrait studio, soldiers' families were photographed in the style that had been commonly applied to the industrial working classes since the late nineteenth century – in the poor urban environments to which they were seen to belong. Soldiers' homes with their cramped backyards or their small dimly lit sitting rooms presented an unwelcome challenge to some photographers, who were used to taking pictures of the middle classes in the comfort and exclusivity of portrait parlours and drawing rooms. Consequently, their photographic excursions were often embarked upon with a sense of adventure, trepidation or even disdain. Some photographers noted the aesthetic and technical problems that arose when taking pictures in what were regarded by them as unpleasant surroundings. One advised 'not to be afraid of taking the lady with a plant pot apparently growing out of her head or with a horribly spotty background of mottoes and cheap prints'. Although such backgrounds would, he wrote, 'enrage the canons of pictorial photography, it will give a homely touch which your soldier friend will be most grateful for'.[82] Other photographers refused to work in such conditions. In Doncaster there was a reported shortage of willing photographers because they were not prepared to visit the homes of coal miners.[83]

When Alvin Langdon Coburn, the American celebrity portrait photographer then living in Britain, signed up as a photographer and worked in some of the poorest areas of south London he was asked why he had enrolled in the scheme. He said: 'I felt so helpless. ... Then came "Snapshots from Home" with the slogan "Cheer Them Up!" Can we look Tommy Atkins in the face if we do not put our hearts into this work?' One of Coburn's colleagues regarded his involvement in the project as, he said, 'rather like giving a classical concert in Whitechapel' – Whitechapel at the time was a poor area of London.[84]

Soldiers were grateful for their snapshots and letters of thanks were regularly published in *YM* and *AP*. One soldier wrote: 'Just a line to thank you for the snapshots of my wife and family which I received today. I can assure you that I very much appreciate them, and I have no doubt that the YMCA "Snapshots from Home" League will be the means of bringing happiness to many a soldier besides myself.'[85] Private W. Paffett wrote: 'I now have the greatest of pleasure in writing these few lines to you in acknowledgement of the snapshots. ... I must tell you it makes a soldier feel at home when he can see the old people whom he left so long ago. I am sure I can go into battle with a stout heart for looking at the photos.'[86] Doris Davidson, a London photographer, made an album of people she photographed. It included letters sent to her from soldiers and their families by way of thanks. One soldier wrote: 'As you may guess a photo is one of the best tonics a man can have when miles from his beloved wife and family.'[87]

The poignancy of family snapshots and their importance to soldiers was tenderly expressed by a worker in a photographic shop in the Orkney Islands. The

diarist wrote about the hundreds of officers and sailors who came ashore from the Royal Naval anchorage of Scapa Flow to have their photographs framed. 'No sooner was the door opened,' she wrote, 'than they crowded in and both shops were full up all day. ... We have framed hundreds of pictures for the Fleet officers to decorate their cabins and help cheer them up during the lonely and monotonous times of the war when they are far from homes and friends.' In 1918, when the diarist heard that a British ship had been sunk, she wrote that she was unable to work for the thought of 'all our men who had pictures in to be framed and who might never come back'.[88]

That a link be sustained between soldiers at war and families at home was a significant psychological ploy promoted by the authorities, and which was fundamental to the sustainability of war. It set an important precedent for other armies in future wars, and reinforced the idea that a soldier was not only fighting for the nation but for family values as well. During the twenty-first-century wars in Iraq and Afghanistan, digital technology might have made it possible for soldiers to exchange snapshots with their families within minutes, but the basic principle remained the same. In June 2009, barely one month before nineteen-year-old British soldier Cyrus Thatcher was killed in the war in Afghanistan, he wrote in a letter to his mother about the pleasure of having received pictures of his family: 'I stared at them for about an hour I cant [sic] explain how good it is to get pictures and stuff you get grown men close to tears at the sight of there kid [sic] ... its really strange how this place fucks with your head and emotions.' He also thanked all those who had sent him 'fags and sweets' but added: 'URGE people to send photos they keep the moral SKY HIGH.'[89]

Towards the end of the First World War enthusiasm for Snapshots from Home seemed to have waned. Historian Bernd Hüppauf has written that the barbarity of life and death at the front left very little for soldiers to identify with, or relate to, in terms of family values. He writes: 'Soldiers felt cut off from real life. Often no connection seemed possible between their lives in the trenches and the life they remembered back home. At first, looking at photographs of their families, wives, children, and girlfriends helped maintain connections and establish a sense of spatial and temporal orientation for their emotional landscape. After a while, they stared at these photos, and the photos remained silent. The soldiers' imagination was no longer able to create the context necessary for these photos to become suggestive parts in personal memories and stories.'[90] Instead soldiers took their own images of war. Maybe it was the trauma caused by their terrifying experiences that impelled them, when they got home, to keep their pictures and their experiences to themselves, hidden from the family life they were trying to reintegrate with.

A soldier's reluctance to share wartime memories or their pictures is a familiar story of veterans of what became known as the War to End All Wars and other wars since. Second Lieutenant William Fisk kept his visual memories, but like the majority of his fellow soldiers he kept them hidden away, perhaps for the same reasons as Oliver Wendell Holmes had 'buried' those pictures taken of the American Civil War: because on looking at them the 'horror and revulsion' returned. Only in

1998, six years after William Fisk's death, did Robert Fisk discover the old tin box in the attic of his mother's house, where his father had kept his wartime picture collection. He had not only kept his pictures private but his memories too. Robert Fisk recounted that although the former Second Lieutenant had been an avid reader on the First World War throughout his life, he rarely wanted to talk about his participation. When on one occasion Robert Fisk asked his then elderly father to recall his own memories of the trenches he simply said: 'All it was, fellah, was a great, terrible waste.'[91]

THREE
Telling Tales

How will you understand your past when all
you have is photographs? *Ilan Ziv.*[1]

A sailor's wartime album

The first private military photo album I ever saw was compiled by my uncle, Petty Officer Cecil Ripley, a sailor in the British Navy during the Second World War. Uncle Cec had what he described as a 'good war'. Despite the constant danger, he had neither been witness to any atrocities nor suffered personal injury. Instead, the youthful factory worker from a small industrial town in the north of England found himself fulfilling a dream: to travel and see the world. His war took him to Jamaica, Australia and the USA. He bought himself a Kodak box camera and took pictures as souvenirs to show family and friends back home. Uncle Cec was a sailor, but, like all military men, he was also a tourist.

When my elderly uncle decided to show me his two albums I had the sense that I was being invited to look at something intensely private. He had shared photo albums of holidays, but not his wartime albums. Uncle Cec had bought the albums, specially designed for members of the armed forces, while stationed in the USA (Figure 3.1). Not all the photographs had been taken by him; some had been collected from or swapped with colleagues and friends, a common attribute in soldiers' photo albums. But all the pictures were accompanied by handwritten captions in white ink, a way of giving a personal meaning to sometimes impersonal photographs.

At first the albums appeared straightforward, but their stories were idiosyncratic, and meandering and fragmented rather than linear. The narrative seemed just out of reach. One album included pictures of happy moments: a group of young sailors in uniform smiling and fooling around for the camera, a portrait of the ship's captain and its crew, colour picture postcards of Jamaican sunsets and tropical views. One page showed pictures of Jamaican people – these had been bought locally, although Cec could not remember where: a group of men he had captioned 'ready for church' and a group of semi-clad women captioned as 'their wives'.

This album also included images of a different kind. On a double page, captioned 'The invasion of Crete', are two pictures of aeroplanes reduced to a formation of tiny dots in the sky – one is nosediving towards the sea with a plume of black smoke coming from its rear; dozens of parachutes hover above. On the

The cover of Cecil Ripley's Second World War photo album. (© Mr C. Ripley)

opposite page are two barely distinguishable grainy out-of-focus black and white pictures of dead soldiers. One shows a twisted corpse still attached to a parachute, the other a skeleton shrouded in the ragged remains of a uniform. 'This dead body would have been of a German', Uncle Cec told me. That the tonal range of the prints was lost and their quality was poor indicated that they had probably been copied many times. I wondered how many other sailors or soldiers had included these pictures in their albums.

On another page, entitled 'Jamaica', are three incompatible black and white pictures (Figure 3.2). One, which shows a grisly close-up of the bloodied face of a dead airman, is captioned 'A German air ace 1918'. In the second a person is standing in front of a lopsided collapsed building. It is captioned: 'Result of earthquake 1926'. The third shows a man standing with a hoe in his hand. Underneath my uncle had written: 'A "Lepper" taken at Spanish Town. Note the hands'. I wondered if this incongruous combination of pictures – the dead airman, the collapsed building and the man with deformed hands – scenes recorded decades and thousands of kilometres apart, was perhaps a metaphor for the wanton destruction of war. Is there really such a thing as a good war?

I was disturbed that my uncle had included such macabre and bizarre pictures in his personal albums. The disconcerting juxtaposition of a scenic tropical paradise, my uncle as a young, handsome sailor and unidentified corpses distorted what I thought a personal photo album was supposed to show. Family albums are meant to reassure and comfort, not to disturb. I felt awkward, as if I had entered a personal space that I did not fully understand – a feeling similar to that evoked when I looked at pictures taken by the American soldiers at Abu Ghraib, even though they were not similar at all. I asked my uncle why he had included these pictures. Before he replied there was an uncomfortable silence: 'Because,' he said, 'they show the reality of war'. But they did not reflect the reality of *his* war. He had not been present

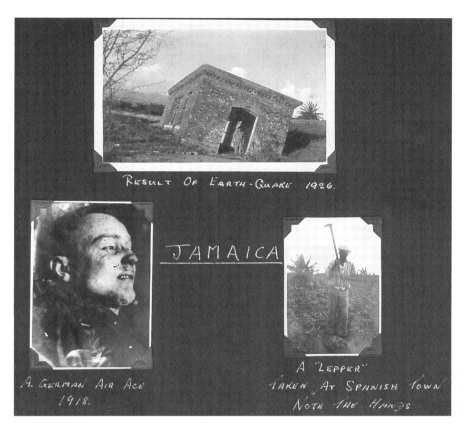

RESULT OF EARTH-QUAKE 1926.

JAMAICA

A. GERMAN AIR ACE
1918.

A "LEPPER"
TAKEN AT SPANISH TOWN
NOTE THE HANDS

Figure 3.2 A page from
the private photo album
of Cecil Ripley. (© Mr C.
Ripley)

at the invasion of Crete, or been witness to the gruesome scenes depicted, or did he
know who the dead men were. But the trophies of war somehow implicated him.
He had exchanged the pictures for a few pennies from the ship's official photogra-
pher, who regularly copied pictures he thought of interest to young sailors.

Uncle Cec chose not to say more about this page; instead, as it lay in front of
us, his memories turned to other stories about his Jamaican experience. As he con-
tinued to carefully turn the pages of his album it became apparent that the stories
he told often had little to do with what the images showed. Rather, the moment
photographed acted as a trigger to other memories – the bigger picture – that might
otherwise have been forgotten. It was as though the images in the album acted
merely as a way of accessing the past. With time memories fade, become unreli-
able and fragmentary or can distort events, whereas pictures can act as proof that a
particular moment did happen.

Looking at a photo album is different from rifling through a pile of old photo-
graphs. Individual pictures can seem arbitrary and lacking in cohesion, whereas in
an album they have been selected, ordered and connected by the passage of time and
the desire to tell a story. These stories bring order and meaning to selected mem-
ory and random moments captured by the camera, although stories in an album
are never complete. A photo album can be a way of assembling and articulating

thoughts and feelings, a private testament of participation, a way of remembering an experience. It can also be a way of forgetting. Veterans of all wars talk of concealing their photo albums, as if the memories needed to be assembled, and then put away.

As I looked at my uncle's photo albums I wondered how they would be 'read' when he was no longer able to embellish the pictures with his stories? Perhaps his treasured memories would be disregarded as the inconsequential snapshots of an amateur? Or maybe, like others, his albums would lie abandoned on a dusty shelf of a second-hand shop waiting to catch the eye of a collector. Or would his private albums become public documents deposited in an archive or museum for researchers or historians to pore over in search of meaning? An archive would impose its own meaning. No archive or museum is ever neutral. But only one thing was certain; that placed in a different context, the pictures would no longer have the meaning bestowed on them by my uncle's memories, further removing them from what John Berger called the 'residue of a continuous experience'.[2] When Roland Barthes wrote about his complex emotional associations towards a photograph of his mother, in *Camera Lucida*, he chose not to reproduce the picture for the reason that, he said, to the reader it would be an 'ordinary' and 'an indifferent picture'.[3] Similarly, in the public domain my uncle's wartime pictures would undoubtedly become part of a generalised memory of war.

Tourists in uniform

In December 2006 I sat in an archive in Toronto looking through a collection of more than a hundred original photo albums made by soldiers from participating armies in the First World War – British, American, French, German, Czech, Austrian, Russian, Swiss, Polish and Canadian. The unique collection at the Art Gallery of Ontario (AGO) reflects the diverse theatres of that war, including the Western and Eastern Fronts, Russia and the countries of the Middle East and Mesopotamia (present-day Iraq). In the majority of them were common themes: personal and official photographs, including crashed aeroplanes and weaponry, picture postcard views of German or French towns and cities, mostly destroyed, and memorabilia – war medals, postage stamps, travel tickets or souvenir banknotes. The images were sometimes accompanied by handwritten or typed captions that helped anchor their meaning. At other times there were no captions at all, leaving the photographs open to interpretation.

The compilers of these albums mostly remained anonymous, though there were some clues. Some had costly leather-bound covers personalised with embossed lettering displaying a regiment, a rank or sometimes a name. Others were covered in decorative fabric, while a few had simple covers of worn brown packing paper tied together with rough string. Some had been purchased with pages already decorated with faint drawings of marching soldiers or military hardware to act as backdrop to a soldier's memories. Others had ready-made slogans printed on the covers – 'Snapshots', 'Sunny memories' or 'The Ideal Scrapbook' – phrases that at times seemed incongruous with the subject matter.

There was something troubling about looking at the pictures in these personal albums. I had looked at thousands of war pictures made by professional

photographers and although the subject matter might have been affecting, they were not disturbing in the same way. These soldiers' albums seemed at odds with the professional published viewpoint. The success of professional pictures and photo stories depends largely on their lack of ambiguity, so with the help of a caption, their message can be 'read' with a minimum of effort required from the viewer. But the stories that the soldiers' albums tried to tell were unclear, fragmentary and often confusing. Their personalised design and layout, use of pictures and handwritten captioning reflected the intimate nature of these albums to the effect that searching their pages trying to make sense of their stories seemed voyeuristic – like going through the personal belongings of a stranger looking for clues to their owner's past – and futile, because it is impossible to know the intentions or feelings of the soldiers who compiled them.

In spite of their individuality, some of the albums compiled by soldiers from the same nations display common characteristics – even to the extent of apparent ethnic stereotypes. Albums made by Polish legionnaires, prior to Poland's Independence, reflect a national pride and artistic flair, while those made by German soldiers, the majority of the collection, show a knowledge and appreciation for design and a technical and aesthetic proficiency in photography. Some of those made by American soldiers are casual and untidy and include particularly gruesome pictures, while the jaunty albums made by British soldiers who had served in the Middle East commonly include images of biblical sites and indigenous populations.

The pictures in these British soldiers' albums reminded me of the images, influenced by anthropological attitudes, made by the late nineteenth-century traveller-photographers who visited the ancient sites of the Middle East. At the time empires were expanding, tourism was increasing and travel photographs were popular and widely available. Photography did more than supply images of the picturesque of these so-called exotic locations; it became a way of colonising them. Their indigenous peoples were commonly placed square on in front of the camera and represented as strange, uncultured or bizarre, sometimes characterised as 'coolies' or 'natives' or allocated biblical roles – as shepherds or water carriers – that embalmed them in some imagined picturesque past. This prevailing and essentially colonialist viewpoint was regarded as neutral. Not surprisingly, when soldiers took pictures they adopted and imitated this way of seeing and by doing so assumed the authority integral to the success of imperialism.

But there had been objections to this viewpoint. At the turn of the nineteenth century Ottoman officials had protested at the way in which their culture and people were being portrayed for the Western tourist. In 1900 there was an imperial decree that forbade the sale of images related to the Holy City of Mecca, Muslim buildings and ceremonies and portraits of Muslim women.[4] There is no evidence that this had any effect. Picture postcards of scenic views and 'exotic' looking indigenous peoples, including pin-up pictures of semi-clad women, were widely available. When the imperial armies arrived in 1917 the production of these images increased. That same year the English-language *Basra Times* advertised the Mesopotamia Studio as a stockist for Kodak film, and in major towns and cities, including Baghdad, Basra and Mosul, commercial photography studios catered for soldiers with cameras.[5]

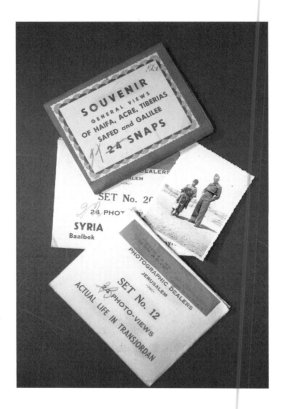

Figure 3.3 Packets of souvenir snapshots from Syria, Transjordan, Haifa, Acre, Tiberius, Safed and Galilee in the collection of a Polish Second World War soldier. (Courtesy of the Polish Institute and Sikorski Museum)

There are many extant albums compiled during the First World War by British soldiers in the Middle East. There were fewer restrictions on taking pictures than on the Western Front and other theatres of war. The vast distances between London and the front lines meant that photographs were perceived as less of a threat by the authorities.[6] The photo opportunities that the ancient sites of the Middle East presented to soldiers were greeted with enthusiasm. Lieutenant E. F. Bolton, who served in Mesopotamia in 1917–18 with the 1/5th Battalion Queen's Regiment, began his personal photo album with a note in which he expresses his good fortune to find himself travelling among the world's most ancient sites. In 'Jottings from Mesopots (up the Tigris to Baghdad)' he writes:

> Those who are unfortunate enough, or rather fortunate enough, not to have visited and seen for themselves the country between the rivers Tigris and Euphrates, can have but a poor idea of Mesopotamia. At school we connected these two rivers with the story of the garden of Eden and the lands between with the idea of a fair country only inhabited in the biblical days, but now only fit for daring explorers such as Stanley or Cook. Little did those of us, who, in our school days, learnt of the garden of Eden, imagine for one moment that we should in a few years time be sleeping and journeying in a train ... in that very same garden – We blush to think what Eve would say![7]

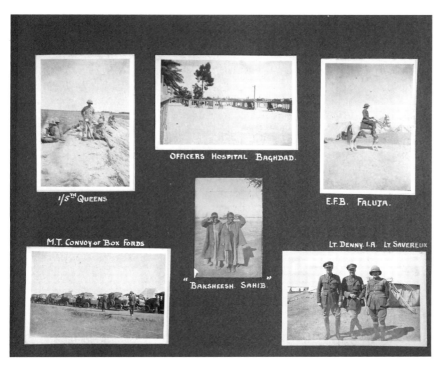

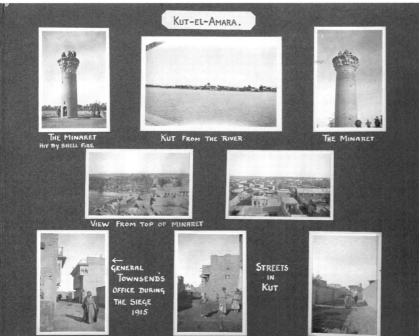

Figure 3.4 Two pages from the private photo album of Lieutenant E. F. Bolton, 1/5th Battalion The Queen's, Mesopotamia 1917–1918. Top page, from left to right: 1/5th Queens, Officers Hospital Baghdad; EFB Faluja; MT Convoy of Box Fords; Baksheesh Sahib; Lt Denny I. A.; Lt Savereux. Lower page: Kut-el-Amara; The minaret hit by shell fire; Kut from the river; The minaret; view from top of minaret; General Townsend's office during the Siege 1915; Streets in Kut. (Courtesy Liddle Collection, Leeds University Library)

Lieutenant Bolton's album includes a page of pictures that show his regiment, the officers' hospital in Baghdad and two raggedly dressed children saluting for the camera with the caption: 'Baksheesh Sahib' ('A gift please, sir') (Figure 3.4, top page). It also includes a picture of the dignified upright posture of Lieutenant Bolton on horseback in Faluja. Officers were commonly photographed with their horses (as was William Fisk); it was a symbol of status.

Another page is captioned Kut-el-Amara and has two pictures of 'The minaret hit by shell fire' and a view of 'Kut from the river' (Figure 3.4, bottom page). A picture of a building is labelled 'General Townsend's office during the siege 1915'. The siege of Kut, lasting 147 days, marked one of the biggest defeats in British military history, in which thousands died.[8]

During the Second World War Polish soldiers also compiled photo albums of their journeys through the Soviet Union and the Middle East. In 1941, following Stalin's amnesty for thousands of Poles who had been deported to Soviet labour camps following the Soviet occupation of eastern Poland on 17 September 1939, they began their journey to freedom. Their route took them through to Iran, Iraq and Palestine, where many regrouped in order to return to Nazi-occupied Europe to rejoin the fight. Many albums made by these Polish soldiers include innovative graphic design, drawings and illustrations.

An album compiled by soldiers of the 22nd Infantry Regiment, 8th Rifle Battalion, tells a story of the Poles' journey from the Soviet labour camps through the Soviet Union, to Iraq, Persia and Palestine. The decorative blue and gold cover features an outlined map of Poland, with the words: 'A story' (Figure 3.5, top page). On one page, handwritten in white ink, is the text: 'The evacuation from the USSR'. It shows civilians and Polish pilots preparing for their journey (Figure 3.5, bottom page).

Polish soldiers of the 1st Carpathian Division assembled an album of their service in the Middle East. One page captioned 'Egypt 1940–1941' (Figure 3.6, top page) includes snapshots of soldiers in the desert, alongside ancient sites, riding on camels and on leave in Cairo. On another page are three photographs: two, dated 1943, show soldiers on training exercises, the other shows a group of soldiers on a day trip. Also on the page is an almost biblical drawing of a soldier walking with a heavily laden donkey (Figure 3.6, bottom page).

Although photo albums compiled by Poles display the same fascination as British soldiers' albums for the ancient tourist sites, they lack the imperialistic attitudes often depicted in them. Jack Munnock, who served in Iraq in the Royal Air Force (RAF) during the 1920s and 1930s at Basra and Shaibah, began his album with a hand-drawn map of Arabia that featured Iraq, Egypt, Syria and Persia. The pictures that follow show the Blue Mosque in Baghdad and street scenes in Basra and other towns and cities in Iraq. Pictures of local people are defined by their perceived occupation: 'Amara worker', 'Arab water carrier', 'Arab barber'. On one page (Figure 3.7, top page) are three photographs: a man on a camel, captioned 'Arab desert policeman' and a 'Kurd witch-doctor'. There is also a public hanging. In this picture four uniformed Iraqi policemen are standing to attention in front of the dangling hooded corpse. One of them is saluting. It is captioned 'Charlie

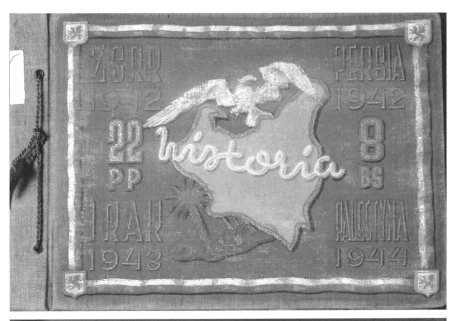

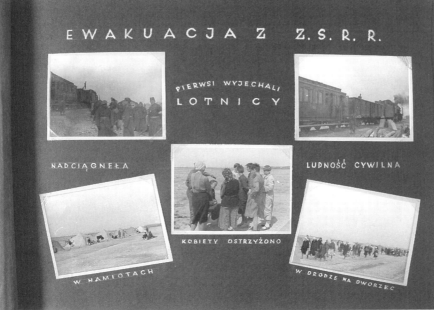

Figure 3.5 Two pages from a photo album compiled by soldiers of 22nd Infantry Regiment, 8th Rifle Battalion. Top page: The cover of a photo album made by soldiers of 22 Infantry Regiment, 8th Rifle Battalion. Lower page, left to right: Evacuation from the USSR; Arrived; The pilots were the first to leave; Civilian transport; In tents; The women's hair has been cut; On the way to the station. (Courtesy of the Polish Institute and Sikorski Museum)

Peace' – a seeming reference to a nineteenth-century British criminal, a notorious burglar who was sentenced to death in Britain for murder.

Another page of Munnock's album is entitled 'Types of Arab women' (Figure 3.7, bottom page). It features three photographs of women posed for the camera and in a type of traditional dress. In two studio portraits – unlikely to have been taken by Munnock – the women are given familiar names: 'Hortense' and 'Nima'. A third

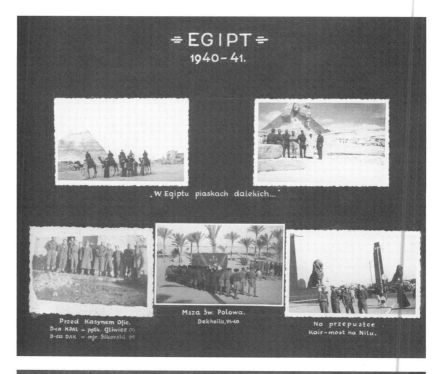

Figure 3.6 Two pages from a photo album made by soldiers of the 1st Carpathian Light Artillery Regiment. Top page, left to right: Egypt 1940–1; Far away sands in Egypt; In front of the casino; Holy Mass; On leave in Cairo – a bridge over the Nile. Lower page, Top to bottom: A day trip in Cedry (?); Training VIII–1943; Training VIII–1943. (Courtesy of the Polish Institute and Sikorski Museum)

Figure 3.7 Two pages from the private album of Jack Munnock, who served with the RAF overseas including in Basra with 203 Fighter Bomber Squadron in 1930–1 and 84 Squadron in Shaibah. Top page, left to right: Arab Desert Policeman; Kurd witch-doctor; Charlie Peace. Lower page, left to right: Types of Arab women; left to right: Hortence, Arab Bint with Chico, Nima. (Imperial War Museum, 2004-11-20)

picture of a woman holding a child is captioned: 'Arab Bint with "Chico" '. On another page a large picture of a young woman baring her left breast is unaccountably captioned 'Janet: Maida Vale'.[9] Maida Vale is a district of north London.

These images are reminiscent of the digital pictures found on the CDs of the American soldiers responsible for the pictures taken at Abu Ghraib. They too

Figure 3.8 A page from
the private album of H.
C. Bertram, 4th Regiment
Imperial Yeomanry, Boer
War 1900–1, 'Taken from
nature'. (National Army
Museum, 6610–57)

included snapshots of tourist sites in Iraq and Iraqi women being made to bare their breasts for the cameras. But even earlier, during the Boer War (1899–1902), images that reflected imperialistic attitudes and showed violence towards, and humiliation of, indigenous peoples were included in military photo albums.

An album (Figure 3.8) of pictures taken during the Boer War and assembled by H. C. Bertram of the Imperial Yeomanry, a cavalry regiment made up of mostly upper-class volunteers, includes two studio images of partially clothed young black women. They are awkwardly posed for the camera, wearing strings of beads and baring their breasts. In one image the women seem visibly perplexed: one is absurdly perched on a bicycle as she stares outside the frame of the photograph. In the other picture the women assume unconvincing seductive poses. The scribbled handwritten caption reads: 'Taken from nature'.

B. H. Hodgson, also of the Imperial Yeomanry, compiled an album that includes one page with four pictures. Three are captioned 'Native policeman', 'Boer children' and 'Boer women' (Figure 3.9). Those photographed are standing squarely in front of the camera. A fourth image captioned 'Black and White' shows a uniformed soldier standing with his arms around the shoulders of two black women on either side of him. He is smiling for the camera, while the eyes of the women appear downcast, as though to avoid its gaze.

On another page of Hodgson's album is a group of five women and children posed in front of the camera with the caption 'Group of Christian Niggers' (Figure 3.10). Underneath are two other pictures; one shows a black soldier marching alongside a long line of men with the caption 'Native convicts under escort'; the other shows three white civilian men, two holding sjamboks (whips). One has his whip raised over the exposed back of a black man who appears to be lashed to the frame of a cart. The text reads: 'Sjamboking a nigger'.

Colonial attitudes and a fascination with indigenous types were not only upheld by British soldiers. The albums of German soldiers who had served during the

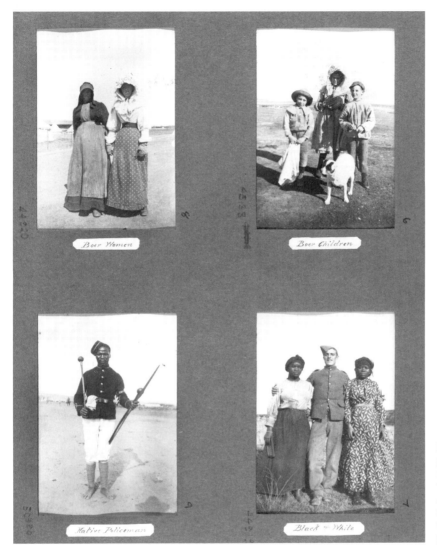

Figure 3.9 A page from the private photo album of B. H. Hodgson, of 21st Battalion Imperial Yeomanry, Boer War 1900–2. Text reads, left to right: Boer women; Boer children; Native policeman; Black & White. (National Army Museum, 7202-23-1)

First World War on the Eastern Front sometimes included pictures of peasants or Jewish 'types' – the kind of pictures commonly associated with those taken by German soldiers during the Second World War, although these earlier pictures lacked the cruelty and the barbarism frequently portrayed in images taken by Nazis and members of the Wehrmacht from 1939 to 1945.

In the First World War album of German soldier Kurt Nicolai, one page includes four neatly arranged pictures framed by black borders and accompanied by typed captions (Figure 3.11). A 'Russian farming family' is lined up outside their home in Dombrowa, in East Prussia (now in Poland) in a similar way that British soldiers had lined up Boers in South Africa or Arabs in the Middle East.

In contrast, the surviving albums compiled by Russian soldiers during this period lack images of alien 'types'. The majority of pictures included in these

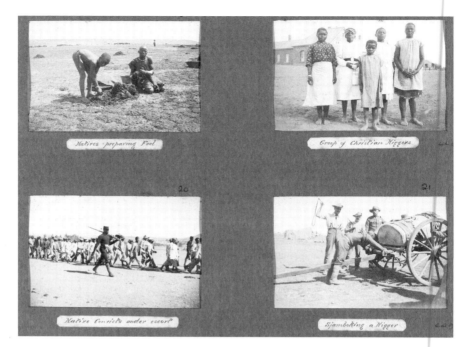

Figure 3.10 A page from the private photo album of B. H. Hodgson, of 21st Battalion Imperial Yeomanry, Boer War 1900–1902. The text reads, left to right: Natives preparing Fuel; Group of Christian Niggers; Native Convicts under escort; Sjamboking a Nigger. (National Army Museum, 7202-23-1)

albums are epic in style and look choreographed. They were probably taken officially. They show military encampments in vast, forested landscapes.

This style of picture-taking was also a feature of albums compiled by Polish officers, conveying their sense of nationalist pride. Captain Stanisław Schuster-Kruk of the 2nd Polish Legion Infantry Regiment made an album that included a page of photographs of his colleagues, carefully choreographed on rocks by the sea at Odessa in Ukraine. The handwritten captions in white ink record the names of those in the pictures (Figure 3.12).

Major Jan Sas-Tatomir of the 4th Polish Legion Infantry Regiment compiled an album that on one page shows uniformed portraits of officers and groups of soldiers in military encampments in the Biała Podlaska region, in the Russian Empire (now in eastern Poland) (Figure 3.13, top page). On another page, two large photographs of regimental groups are placed alongside six smaller portraits of family members (Figure 3.13, bottom page). This combination – common to soldiers' albums of all nationalities – suggests a bond between family and nation (discussed in Chapter Two) and a conviction that a soldier takes pride in defending family values as well as those of the nation. These elements gave war an ethical dimension crucial for the compliance of soldiers in the First World War and in later wars.

The stories they try to tell

Some of the most disturbing photo albums I came across in the AGO collection were those compiled by American soldiers who had served on the Western Front. In one of these albums the soldier seems to have struggled to make sense of the fragments

Stall in POPOW.

Kurts Quartier in DOMBROWA
vom 24.12.14.-3.1.15.

Russische Bauernfamilie im Hin-
tergrunde Rittmeister BÜRKLIN.

Figure 3.11 First World War album, vol. 186, pt. 1 (69733), Nicolai, Kurt (German, d. unknown), 'Personal album, German soldier at Eastern Front'. Top row, from left to right: Stable in Popow; Kurt's accommodation in Dombrowa. Bottom row: (both photos) Russian farming family: Captain Bürklin in background. (© 2009 Art Gallery of Ontario)

of war. Its thirty-nine worn, fragile pages are tied together with a string. On the faded cover is a simple pastel drawing of a butterfly and a flower and, scrawled in large handwritten letters: 'Photografs Album'. The delicate drawing, coupled with the handwriting and misspelling, adds to its poignancy. Inside, disconcerting war images are placed alongside photographs of civilian life. Unlike the album made by the Polish officer, whose juxtaposition of uniformed soldiers and family pictures conveyed a sense of unity and pride, in this album the juxtaposition suggests rather a sense of fragmentation, alienation and confusion.

The story the album tries to tell is chronological. It spans a twenty-year period, beginning in 1917, the year that the USA joined the war, and ends in 1938, the year before the outbreak of the Second World War. On the first page is a large picture of two civilian men posed on a horse and trap. A large American flag is attached to the horse's bridle and a smaller one to the seat (Figure 3.14). The caption reads: 'North Beach, 1915'. On the opposite page is a large 'khaki portrait' of one of the men in the previous picture. This photograph is dated 1917 and signed 'Frank'. We assume Frank to be the creator of the album as he features on almost all of its pages. In this portrait he is casually posed: his arm is rested on a plinth and his legs are crossed. An American flag can just be seen in the left-hand side of the frame. Frank's 'khaki portrait' serves as a way of introducing the album and presiding over and authorising the stories that follow, a feature common to many soldiers' albums. The other nine pictures on this double page show Frank as a soldier and as a civilian. They are fitted side by side as if every space needed to be filled – a style consistent throughout the album. In one small, tightly cropped wartime portrait picture Frank has downcast eyes, as

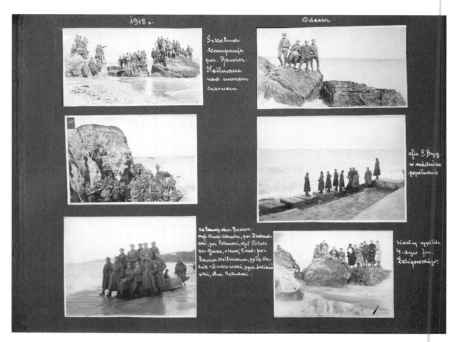

Figure 3.12 A page from the private album of Polish officer Captain Stanisław Schuster-Kruk, 2nd Polish Legion Infantry Regiment 1914–1917 of the 'Szkolna' Company in Odessa 1918. (Courtesy of the Polish Institute and Sikorski Museum)

though he is staring at something outside the frame. Whatever he is looking at, his gaze looks troubled.

In the majority of photographs, Frank is often alone and rarely smiling. But in one extraordinary (and unexplained) photograph he seems to be standing proudly alongside four German officers. The album also includes a large number of images of German soldiers, alive and dead, and captioned either as 'Huns' or 'German Cooties', 'Boches' or 'Fritz'. There is even a picture of German children: two young girls stand side by side – a reminder of Snapshots from Home described in Chapter Two. They were probably taken from the possessions of prisoners or the bodies of the dead. Alongside the German children are images of weaponry, 'a German dug out' and a spectacular night-time explosion captioned 'no man's land'. This image features in the albums of other American soldiers. Among the images of children, explosions and weapons is a selection of memorabilia untidily stuck on to the pages – foreign banknotes, transportation tickets and a 'German propaganda notice'. It is as though he is trying to set down every last detail, perhaps in an attempt to make sense of his wartime experience. The sheer number of untidy irregular shaped pictures, the disparate themes and the memorabilia crammed together give the album a frenzied feel, as though the story is running out of control.

In the midst of this visual chaos, one picture, filling an entire page, shows a corpse clothed in rags with a skull lying next to a dilapidated gun carriage as though it has been arranged for the camera (Figure 3.15). In large capital handwritten letters is the word 'WAR!!!!! (Frenchmen)'. The image of the corpse is remarkably similar to the photograph in Uncle Cec's album.

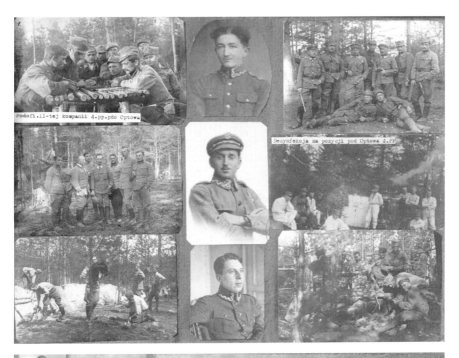

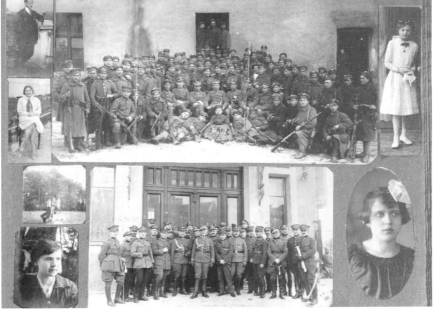

Figure 3.13 Two pages from a private photo album compiled by Polish officer, Major Jan Sas-Tatomir, 4th Polish Legion Infantry Regiment, who served on the Eastern Front 1914–1917. (Courtesy of the Polish Institute and Sikorski Museum)

The album's narrative becomes less frenetic and more ordered when in 1919 Frank is discharged and returns to civilian life. From now on the pictures are larger in size and fewer to each page. The majority are taken in rural America. We assume the former soldier to be a gardener as he is photographed in garden nurseries and

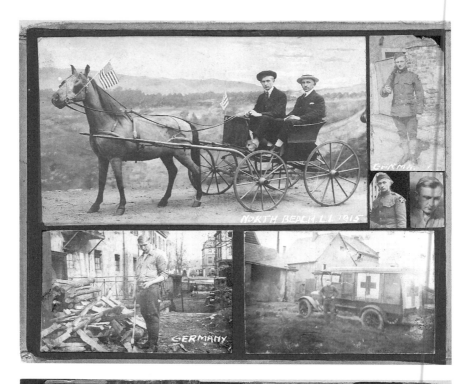

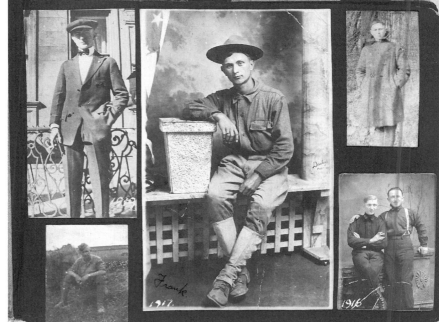

Figure 3.14 Double page of a First World War album, vol. 32 (69477), unknown, twentieth-century (American), 'Personal album, American Soldier in France, 1916–1941'. First page, top row, left to right: North beach L.I. 1915. Upper right: Germany. Lower right: two smaller photos; unidentified man. Bottom row, left: Germany. Right: Red Cross Ambulance. Second page, top row, left: Unidentified man. Centre (large photo): Frank 1917. Right: unidentified man. Bottom row: left: unidentified man, right: 1916. (© 2009 Art Gallery of Ontario)

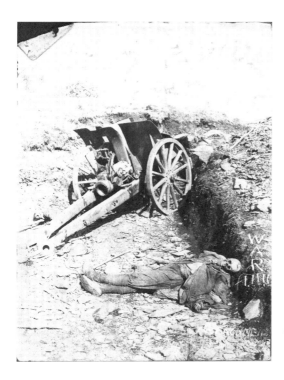

Figure 3.15 First World War album, vol. 32 (69477), unknown, twentieth-century (American), 'Personal album, American Soldier in France, 1916–1941': 'War!!!!! (Frenchmen)' (© 2009 Art Gallery of Ontario)

greenhouses. But the war is never very far away. Sporadically placed alongside pictures that show him on a farm, smiling with a group of friends, or pulling a hay cart, are small pictures of the young soldier that feature earlier in the album, including the photograph of the author with the transfixed gaze and downcast eyes. These pictures are more faded than the rest, giving them a ghost-like quality. It is as though throughout his life the war haunts him. The disturbing memories will not leave him alone. Friedrich Nietzsche has written about memory: 'Perhaps there is nothing more terrible and mysterious in the whole prehistory of mankind than our mnemonic technique. We burn something into the mind so that it will remain in the memory; only what still hurts will be retained.'[10]

Another American soldier's First World War album has an image on the first of its forty-eight pages of a soldier in a trench holding a camera. It is captioned 'Belleau Woods, Chateau-Thierry a marine snapshooter'. The majority of pictures are of ships and submarines, with gruesome trench scenes taken after major battles that were fought before the US Army arrived at the Western Front.

On one page (Figure 3.16) are nine black and white photographs roughly arranged around a central image that shows a trench littered with human skulls and bones, captioned 'After the Marne fighting (1914–1916)'. The other pictures – which, according to the captions, were taken at Verdun, Chateau-Thierry, Amiens, Marne and Oise – show skulls and bones and the dead in trenches in various states of decay, sometimes making it difficult to distinguish between the rotting, twisted corpses and the churned-up landscape. Some of these pictures seem to have been

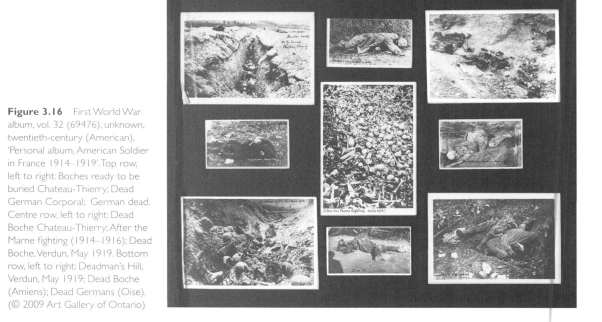

Figure 3.16 First World War album, vol. 32 (69476), unknown, twentieth-century (American), 'Personal album, American Soldier in France 1914–1919'. Top row, left to right: Boches ready to be buried Chateau-Thierry; Dead German Corporal; German dead. Centre row, left to right: Dead Boche Chateau-Thierry; After the Marne fighting (1914–1916); Dead Boche, Verdun, May 1919. Bottom row, left to right: Deadman's Hill, Verdun, May 1919; Dead Boche (Amiens); Dead Germans (Oise). (© 2009 Art Gallery of Ontario)

popular and feature in a number of other American soldiers' albums, sometimes with different captions. The top left-hand image captioned 'Boches ready to be buried Chateau-Thierry' features in another album captioned 'results of heavy French shell scutteling [*sic*] German trench'.[11] The bottom left-hand image captioned: 'Deadman's hill, Verdun 1916', features in an album that belonged to Lieutenant E.G. Nordstrom of the American Expeditionary Forces, captioned: 'German cemetery blown up by shell'.[12] In another album it appears twice, once with the caption: 'German dead dead man's hill' and on another page with no caption.[13]

In another American soldier's album the 'khaki portrait' of a young, handsome soldier presides over the rest of the pages that are almost exclusively made up of pictures of the rotting corpses either of soldiers or horses. One photograph shows the remains of a dead horse, its burnt flesh dangling from the branches of a tree with the caption: 'Horse blown into tree by exploding German shell'.[14] This photograph is included in another American soldier's photo album with the caption: 'A horse found in a tree in the Argonne. High explosives'.[15] Images of mangled dead horses on the battlefields of the Western Front were a popular subject for soldiers' cameras, perhaps more bearable than the mangled flesh of humans. In 2008 I came across a story on the Internet, written by the grandson of a First World War American soldier who described the photographs in his grandfather's photo album, which included 'a dead horse that was blown up into a tree'. The grandson did not include pictures with his story, but it could well have been the same image.[16]

The macabre scenes found in these American soldiers' albums do not portray epic scenes of war; they are not well composed pictures of suffering, the kind of

photographs that would be taken by a photojournalist less interested in the rotting corpses of the dead than the misery of the living. They have a different, but equally powerful message, that of stillness, emptiness, and a silence.

Historian Bernd Hüppauf has written of the gruesome soldiers' pictures taken during the First World War that they were the result, not of the 'affectionate eye of a participant observer', but 'of an emptied gaze of absolute disengagement'. Photo albums, he wrote, 'captured the emptiness and lack of orientation, in terms of both spatial and mental orientation, in a space which was emptied of all traditional characteristics of a landscape, and to which human senses no longer related.'[17]

Perhaps taking pictures made a scene more tolerable. Professional photographers sometimes say that looking through a camera creates a barrier between themselves and that being photographed, making it more possible to look at a horrific scene. When photojournalist Margaret Bourke-White took pictures at the liberation of the Nazi concentration camp at Buchenwald, she described a similar experience. 'Using a camera was almost a relief,' she wrote. 'It interposed a slight barrier between myself and the horror in front of me.' It was only when Bourke-White had developed the films and looked at the pictures that she fully realised the horror they depicted.[18] Perhaps the realisation described by Bourke-White is a factor in why soldiers often hide their albums away. The terror that they grow accustomed to and that becomes normalised at war looks abnormal in civilian life.

In search of meaning

The desire to create a personalised visual memory of wartime experiences was prevalent among soldiers who did not have cameras. Some compiled photo albums made up entirely of picture postcards personalised with the soldiers' handwritten captions.

One album of this type was compiled by Hubert Baum, a German soldier who served on the Western Front. Its worn and torn cover has a faded colour crayon drawing of a pink daffodil laid on a delicate lace mat – a reminder of the faint pastel drawing on the cover of the American soldier's album mentioned earlier in this chapter (Figure 3.17). Inside the album are colour scenic views of Cologne and Bonn, but most of the cards are bleak, black and white images of trench landscapes littered with decaying corpses.

One page has four images (Figure 3.18). One, which shows a trench landscape of twisted barren tree stumps, is almost identical to a photograph taken by William Fisk, but is identified as 'View from Priesterwald'. Another image shows a pile of human skulls that seem to have been artfully arranged around a ruined archway. Handwritten on the back of the card is the caption: 'Ossuary in the church of Leintrey'. One of the other two postcards shows two men posed in a clean trench devoid of weapons or death – probably an official image – and the second shows a destroyed bombed-out church. Corporal Louis Henry Matthews (see Figure 2.10), also made a photo album entirely of postcards. Many show similar trench landscapes to those in Hubert Baum's album, as well as reconnaissance aerial pictures in which the trenches look like cracks in the scarred, barren and scorched earth. Hundreds of thousands of reconnaissance pictures were taken and some printed on the Western Front in mobile darkrooms.[19] In Matthews's album one of these pictures shows barely distinguishable soldiers who

Figure 3.17 The cover of the photo album of Hubert Baum. (Courtesy Liddle Collection, Leeds University Library)

appear like a thin pencil line in one of the trenches. On the back of this card Matthews has written: 'This is a view of the German and French trenches. In the photo you will see troops moving about in the trench. This shows how near the enemy's trenches were to one another, in places. In this case there is actually a trench dug from one to the other. All the holes in the ground are made by shells.'

In the 1990s Corporal Matthews's daughter, Gladys Matthews, donated her father's photo album to a collection at Leeds University for safekeeping. She included a letter: 'When dad was in Bonn he bought postcards and put them into this album. At times he took some out to show to his pals. After his death I collected them and put them in a box. Later, I restored them to the album ... I do not wish to part with it, but it is not something I wish to look at often, it is too tragic. We see things like this on TV everyday, but somehow it is worse when they "frozen" in an album [sic].' But, she writes, 'It is the story behind the pictures that matters.'[20]

Whether Gladys knew the story behind her father's collection of images is doubt-ful. In her jottings there are hints at her endeavours to fill in the gaps. She recorded an

Figure 3.18 Page from the photo album of Hubert Baum. The handwritten captions read: top, left to right: Church in Vadessan (Aisne); Ossuary in the church of Leintrey. Bottom, left to right: View from Priesterwald; a trench in the 1st Line. (Courtesy Liddle Collection, Leeds University Library)

occasion when she had asked her father if he had ever killed a German. He told her never to ask that question again and then fell silent. In an attempt to try to make sense of her father's war, she had made her own photo album that included some of her father's photographs and her own thoughts and poetry about war. There is an urgency to her jottings and the perplexing array of images: pictures of her father and his colleagues as uniformed soldiers, roughly cut-out pictures from magazines of bunches of flowers and sunsets, a 'khaki portrait' of Jack Fisher ('Dad's boyhood friend'), and a picture postcard of an artist's impression of 'The Holy Land' sent to her father by Jack Fisher, who, she writes, survived the war but died later from cancer of the throat, as though there was an irony in that. News of Jack's death, she wrote, was one of the few times she saw her father weep. These chaotically arranged images express a similar sense of fragmentation to that conveyed in the American soldiers' albums.

Second Lieutenant William Fisk's wife Peggy also compiled an album of her husband's memories. In 1998 when Peggy died, Robert Fisk discovered, along with the pictures taken by William Fisk, a photo album with a green imitation leather cover

compiled by his mother of a family holiday in northern France in 1956 that traced William Fisk's war. The album includes colour picture postcards of war memorials and French towns and cities. On one page are three photographs with Peggy's handwritten caption: 'Through Montreuil, Hesdin, St Pol, Arras, to Louvencourt'. One shows a wide road flanked by trees, another shows buildings on the right-hand side of a road. This was the house on the Somme where William Fisk had spent the night of 11 November 1918, the last day of the war. The third snapshot taken from the roadside shows the lonely silhouette of William Fisk standing at the top of a flight of steps with his back to the camera. He is looking at a large stone war memorial. Peggy's caption reads: 'Memories for Bill for 1914–1918'.

In the 1990s Robert Fisk went to France on his own journey in search of his father's war, armed with William Fisk's wartime collection of picture postcards, including of Douai. Fisk wrote: 'I'm not sure what I hoped to find in Douai … I had the vague idea that it might be possible to use Bill's pictures to discover the city, to graft his image of Douai – albeit badly damaged by the time he sent his postcards home – onto the present, to walk in Bill's footsteps.'[21] Even to a seasoned war reporter, his father's war still seemed out of reach.

The desire to understand a loved one's war is discussed by Martha Langford in her book about photo albums entitled: *Suspended Conversations: The Afterlife of Memory in Photographic Albums*. She writes about Deborah Kurschner Clarke, the daughter of a Holocaust survivor who had grown up aware of a picture in a family album that showed her father as a gaunt young man dressed in a what she described as 'baggy stripped pyjamas' in front of wooden barracks 'draped with large pieces of material showing the star of David'. It had been taken at the liberation of Buchenwald, although Clarke did not know this at the time. The family silence that surrounded the picture meant that as a child she absorbed the fact that it was in some way poignant, but she did not understand why, only that it looked incongruous among family photographs that showed members of her family doing 'regular things'. Rather, the picture came to represent, as Langford wrote 'a strange, dumbing silence, a barrier between her and her father'. It was only much later when the family watched a television documentary together about the camps that the meaning of the image was explained to her, and Clarke was able to articulate in words her childhood feelings about it. But as Langford points out, Clarke's memory of not understanding the image remained as meaningful to her as the facts she learned about it. 'Memories of the unspeakable are powerful indeed', wrote Langford.[22]

The silence endured by Deborah Kurschner Clarke, and Gladys Matthews and Robert Fisk's search for details of their fathers' war is perhaps a consequence of society's silence regarding war's true effects. W. G. Sebald wrote, in his book *On the Natural History of Destruction*, about German society's complex silence that followed the terrifying destruction caused by the allied bombing of German cities during the Second World War. He said, 'There was a tacit agreement, equally binding on everyone, that the true state of material and moral ruin in which the country found itself was not to be described.' The darkest aspects of that destruction, he wrote, 'remained under a kind of taboo like a shameful family secret, a secret that perhaps could not even be privately acknowledged'.[23]

Those were the days

During the Second World War the most prolific soldier-photographers were the Nazis and German soldiers. Many compiled albums that contain all the regular themes: picture postcard views, drinks parties, social occasions, destroyed towns and villages and indigenous peoples, but there are other types of pictures that explicitly show crimes being committed against civilian populations. Other soldiers had committed crimes against civilians and taken photographs of them, but none as systematically as Nazis and German soldiers. Pictures of the humiliation of Slavs and Jews, Jewish ghettos, public executions and hangings, deportations to concentration camps and concentration camps themselves, were all themes for the soldier's camera.[24] Soldiers often featured in the pictures as if willing participants in the crimes being committed. This was a hotly contested element when German soldiers' pictures featured in an exhibition in Germany in 1995, as will be discussed in Chapter Five.

But in spite of the macabre themes, these albums do not convey the kind of confusion prevalent, for example, in the albums of First World War American soldiers. Instead they seem to express a sense of purpose and the confidence of their makers, giving the impression that this activity was not just personal, but part of a wider collective responsibility, tantamount to a duty, expressing a commitment to National Socialism.

As the Second World War ended, and Allied armies swept through previously occupied towns and villages, a glut of photographs, films and photo albums were found in the hurriedly abandoned private homes and offices of SS men and German soldiers as well as in publishing houses, photo shops and archives, and in concentration camps in Germany and Poland. During the 1940s and 1950s some were used as evidence in Nazi war crimes trials before being deposited in national, local or specialised archives or private collections. Rarely were records kept that disclosed their provenance. There was little public interest in pictures made by Nazis and German soldiers until the 1980s, when these images became eagerly sought after as evidence of the Holocaust and as collectors' items that fetched high prices. Even in the twenty-first century, previously unknown images are still surfacing.

In December 2006, at the time I was studying the album collection in the AGO in Toronto, a photo album compiled by a leading Nazi was posted to the United States Holocaust Memorial Museum (USHMM) in Washington DC by a retired US Army Lieutenant Colonel and former member of the Counter Intelligence Corps (CIC). In the package he included a letter in which he wrote: 'I would like to offer the Holocaust Museum a chance to review some World War II era photographs in my possession.' The American officer had apparently found the album in Frankfurt in 1946 in an abandoned bombed-out apartment and kept it. The donor asked that USHMM did not disclose his name. He died in the summer of 2007.[25]

It transpired that the album had belonged to SS-Obersturmführer (First Lieutenant) Karl Höcker, adjutant to Auschwitz-Birkenau concentration camp commandant Richard Baer, who served at the camp between May 1944 and January 1945. He was one of the successors of SS-Obersturmbannführer (Lieutenant Colonel) Rudolf Höss, who served as the camp's commandant for three years (1940–3) and returned to the camp in 1944 to oversee the gassing of thousands of Jews.

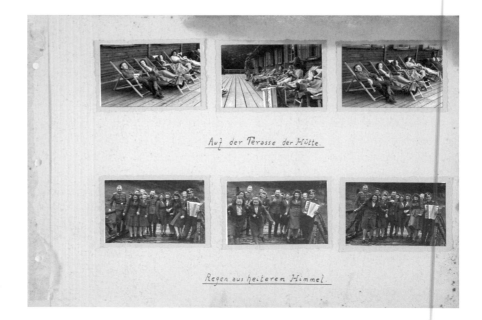

Figure 3.19 Page from an album created by Karl Höcker, adjutant to the Richard Baer commandant of Auschwitz-Birkenau. The text reads: 'On the terrace of the lodge' and 'Rain coming from a bright sky' (figuratively 'something unexpected'). (Courtesy of USHMM photo archives)

The inscription at the beginning of Höcker's album reads 'Auschwitz 21.6.1944'. The majority of its 116 pictures had been taken between May and September 1944 when the extermination programme at Birkenau was at its peak and tens of thousands of Jews from all over Europe were being murdered in the gas chambers. During August and September, around 67,000 remaining Jews were deported from the Łódź Ghetto alone, the majority of them immediately gassed.

In stark contrast to the horrific events taking place at Auschwitz-Birkenau, the pictures show Höcker greeting miners on a visit to a local coal mine; Höcker lighting candles on a Christmas tree; Höcker handing out bowls of blueberries to six young women sitting on a wall. On another page is a photograph of a funeral ceremony for SS comrades who had died following an accidental bombing of Auschwitz in December 1944 by Allied war planes – or as the caption states, 'from a terrorist attack'. Other pictures show high-ranking SS men and young female auxiliary staff enjoying themselves at the holiday retreat in Solahütte, a mountain holiday resort for the camp's hierarchy and their cohorts, around 30 kilometres south of the Polish town of Oświęcim – renamed Auschwitz in German. The holiday retreat still exists as a hotel.

On one page young women are seen lounging in deck chairs or in groups lurching around in fits of laughter; alongside them is a jolly accordionist (Figure 3.19).

An accordionist also features in another picture that includes some of the most notorious figures in Nazi demonology: Rudolf Höss, Dr Josef Mengele, infamous for his medical experiments on prisoners, and Otto Moll, supervisor of the gas chambers. They are part of a large gathering of around seventy uniformed SS men, assembled like a male-voice choir for a singsong (Figure 3.20). It seems that even perpetrators of genocide took an occasional weekend away.

Figure 3.20 Photograph from an album created by Karl Höcker, adjutant to the Richard Baer commandant of Auschwitz-Birkenau. The image shows leading SS men at Solahüette, including Rudolf Höss, commandant of Auschwitz-Birkenau 1940–4. (Courtesy of USHMM photo archives)

The Höcker album is one of only two surviving photo albums to include pictures taken at Auschwitz-Birkenau during the war. The other, sometimes referred to as the Lili Jacob album or Auschwitz album, includes more than 200 pictures taken at Birkenau in 1944 – the same period as those in Höcker's album. It shows the hundreds of thousands of European Jews, men, women and children arriving at the railway ramp with their baggage before being selected. Through their unremitting use in books, films and exhibitions and Holocaust museums worldwide, including at Birkenau, the photographs have become icons to the extermination of the 6 million Jews.

There is evidence to suggest that the Lili Jacob album was not a personal album but had been officially commissioned. The photographs are believed to have been taken by SS Hauptscharführer (Sergeant) Bernhard Walter who was in charge of the Erkennungsdienst – the camp's photographic department. In fact, inserted into the back of the Lili Jacob album is a page of another album that is thought to have belonged to Bernhard Walter. It features seven photographs of each of the auxiliary camps that formed part of the Auschwitz complex where more than 33,000 slave labourers were put to work. Another picture shows a view of Solahütte. This is the only other known surviving photograph of the mountain retreat at this time.

When, in 2000, I showed a copy of the Lili Jacob album to Wilhelm Brasse, a former Polish political prisoner who was put to work in the department as a photographer 1940–5, he told me that he recognised the handwritten captions as the work of Polish political prisoner Tadeusz Myszkowski, a graphic designer also put to work in the Erkennungsdienst and who was known to have decorated and captioned the personal albums of SS men and Nazi officials. After the war ended, Myszkowski and a small group of former prisoners established a museum at Auschwitz as a

memorial to those who had lost their lives there. In the early 1950s Myszkowski left the museum and emigrated to Israel.[26]

Although there is no known connection between the Lili Jacob album and the album compiled by Höcker, there are coincidences. In January 1945 as the Red Army drew near, Karl Höcker was transferred from Auschwitz-Birkenau to Dora-Mittlebau concentration camp. After the war Lili Jacob, who had survived deportation to Auschwitz-Birkenau in 1944, found the album in a drawer in a former SS barracks at the same camp. When she opened the album she recognised herself and members of her family, none of whom had survived. In 1963 Lili Jacob testified and presented the album as evidence at the Auschwitz trials in Frankfurt-am-main. Those on trial were former SS men who had worked at the camp, including Karl Höcker (Bernhard Walter had been tried in Kraków, Poland, in 1947 and sentenced to three years' imprisonment). Höcker was sentenced to seven years' imprisonment. In 1970 he was released and returned to his job as a chief cashier in a regional bank in Lübeck. Lili Jacob kept the album as a personal memento until in 1980 she donated it to Yad Vashem Martyrs' and Heroes' Remembrance Authority in Israel.

That Karl Höcker's album had been found by an American officer after the war had ended was not unusual. But why he did not hand it over to the authorities is not known. Presumably, since there was nothing criminal in what the pictures showed, he considered it of no evidential value. It did not have the implicit meaning it has now. Judy Cohen, director of the USHMM Photographic Reference Section, said of Höcker's album: 'The fact that they're engaged in common activities makes what they were doing all the more horrific.' But there is nothing horrific about what the photographs show. They do not depict gruesome war scenes or Jews being executed, as did those taken by SS Lieutenant Max Täubner. Nor do they show civilians being humiliated or hanged, as do pictures in albums made by other Nazis or German soldiers. What makes them shocking is what we now know about the Nazi officials and the crimes being committed at the time the pictures were taken. But this has little to do with the pictures themselves. In 2007, in an article about the discovery of the album, *New York Times* columnist Roger Cohen wrote:

> In thinking about the Holocaust, we have grown accustomed to images of the Nazis' victims: shadowy naked figures on the edge of ditches ...; huddled wide eyed children; skeletal human simulacra; piles of bones. Getting the perpetrators in focus is harder ... the German murderers in all their dumb humanity, flirting and joking and lighting Christmas trees ...[27]

In response to the article some readers said that the pictures in the Höcker album brought to mind those taken by American soldiers at Abu Ghraib. One anonymous person wrote: 'And what of the stories of Lynndie England and Sabrina Harman?'[28] That the Höcker album should prompt such a connection with pictures taken by American soldiers sixty years later was perhaps further evidence of the universality of the practice of assembling seemingly disconnected images of war in military albums that serve as a reflection of the barbarity and absurdity of war.

FOUR
Photographs as Resistance

The apparatus of M. Daguerre will become an object
of continual and indispensable use ... As soon as a
knowledge of it (photography) be acquired, everybody
may apply it to their own purpose. With it, the most
unskilful may make drawings, with the same dexterity as
the most clever artist. The process will, therefore, either
become the property of everybody, or forever remain a
secret. *Bill presented to the Chamber of Deputies,* France,
15 June 1839.[1]

The value of pictures

Somewhere near the small town of Ivangorod in Ukraine, a German soldier points
his weapon at a woman with a child in her arms. She has turned away from the
soldier and wrapped herself around the child. Her foot is lifted from the ground
as though she might be moving away from the soldier or perhaps the shutter has
caught the moment the bullet has hit her. On the left of the frame are the tips of
what look like two other guns pointing in her direction and on the right there
appear to be three or four people crouching beside an indistinguishable object. The
body of another person lies at the feet of the soldier. On the back of the photograph
handwritten in German is 'Ukraine 1942, Jewish Action, Ivangorod' (Figure 4.1).

This photograph, thought to be a snapshot taken by a German soldier, has become
a symbol of the barbarity of the Nazi regime and the murder of the 6 million European
Jews. It is used to represent the Holocaust in museums, exhibitions and books, although
in almost all these contexts the image is cropped to show only the soldier with the gun
and the woman and child. The less emotive and more confusing parts of the picture are
omitted. The photograph has also been the subject of controversy and its authentic-
ity disputed for various political and ideological reasons. So widely circulated is this
image that it would seem improbable to meet someone who claims to be its custodian.
The small original photographic print, however, is in the personal archive of a former
member of the Polish wartime underground, Jerzy Tomaszewski. To him the picture
is not only evidence of the Holocaust, but of the resistance shown to the Nazis by
the Polish Home Army, AK (Armia Krajowa, the nationalist wartime underground
movement) and the crucial role that photography played in that struggle.

When the German Army invaded Poland on 1 September 1939, the Poles mounted
the most formidable and complex resistance movement that the Nazis had to face

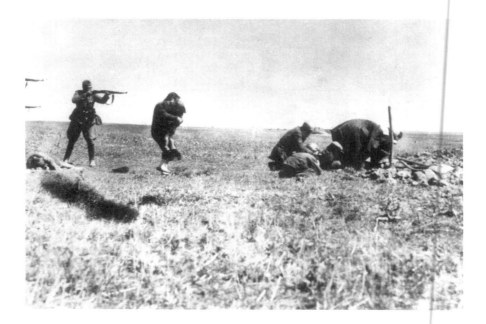

Figure 4.1 Ivangorod, Ukraine. (Courtesy of USHMM photo archives/ Jerzy Tomaszewski)

anywhere in occupied Europe. The Polish Home Army existed as an elaborate network of institutions known in occupied Poland as an underground state. Its commander was General Władysław Sikorski, head of the Polish government-in-exile, which was based in London from June 1940. To those who resisted the Nazi regime photography was of the utmost importance. In the first days of the war, as German bombs started raining over Warsaw, the city's mayor, Stefan Starzyński, made regular broadcasts to the besieged population to take photographs and collect documentary evidence.

Gradually the Home Army permeated all aspects of the occupied civil society. In 1942, an underground cell was established in Warsaw's main post office, where workers intercepted the personal letters of German soldiers sent from the Eastern Front destined for friends and loved ones at home. Sometimes they contained valuable information including the location of German troops, an indication of the soldiers' morale, the activities they were involved in or images of executions. According to Tomaszewski, the picture taken at Ivangorod was found in this way.

When valuable information was found, it was taken by a Home Army messenger to a secret laboratory in the city where Tomaszewski and his colleague Mieczysław Kucharski, a reconnaissance photographer, would copy it onto photographic film in preparation for its dispatch to London. Photographs and documents were sent to this laboratory from all over Poland. By 1942 Kucharski had developed a chemical process that transformed photographic film into small strips of microfilm. This made it easier for the network of hundreds of Polish couriers to smuggle information in innovative ways – in compartments built into pens, in cigarette lighters, the handles of razors or the heels of shoes. On one occasion Jan Karski, the most celebrated Polish underground courier, known for smuggling the first eyewitness account of the Warsaw Ghetto to Britain, used a hollow house key to transport the information. In 1944 Karski wrote an account of his missions in his book *Story of a Secret State*.

The microfilmed photographs and documents that survived the intrepid journey to the government-in-exile via Trieste or Belgrade or by some other secret routes were distributed as widely as possible – to the British Ministry of Information and other government offices, to Polish and Jewish organisations or to the press. The Polish Ministry also published its own leaflets in an attempt to alert the world to the crimes being committed in Nazi-occupied Poland.

A dangerous occupation

In occupied Poland itself Poles and Jews were not allowed to own cameras, buy film or take photographs. Photography quickly became an underground activity. Roman Niemczyński, a professor of photography, recognised the important role that images could play in the resistance movement and began to organise secret courses to train underground workers. Jerzy Tomaszewski, then sixteen years old, attended one of these courses on the advice of his older brother Stanisław, who under the pseudonym of 'Miedza' became the Home Army's artistic director and its most prolific artist. Stanisław Tomaszewski did not take photographs, but portrayed Nazi brutality in his drawings, sketches and paintings. Some showed scenes from the notorious Pawiak prison, where he was imprisoned for a time. They depicted prisoners being cruelly beaten and subjected to interrogation. In one drawing a prisoner is being attacked by dogs watched over by members of the Gestapo – an image reminiscent of the photographs taken by American soldiers with digital cameras at Abu Ghraib.[2]

In Warsaw, as in other Polish towns and cities, many pre-war photo studios and photo suppliers continued to function under the direction of the German occupying forces. They were largely staffed by Poles who had worked in the film and photographic industries before the war began. Niemczyński encouraged these workers to use their positions for the benefit of the resistance. In 1942 writer, broadcaster and documentary filmmaker Antoni Bohdziewicz established a photo studio called Foto Tres with colleagues Mieczysław Chojnowski and Andrzej Ancuta in one of Warsaw's most fashionable city centre streets. Besides functioning as a commercial portrait studio, it acted as a front for clandestine work – producing false identity cards for the beleaguered population, microfilming manuscripts of unpublished books by outlawed Polish writers including the acclaimed poet Czesław Miłosz, and preparing documents for dispatch to London. Bohdziewicz was also chief of the film department in the Home Army's *Biuro Informacji i Propagandy Komendy Głównej ZWZ-AK* (Main Command Office for Information and Propaganda) and used the studio, as well as his apartment, to run secretly held courses on the basic techniques of filmmaking, including scriptwriting, directing and editing.[3]

One of the largest photo shops in central Warsaw was called Fotoris, where in 1940 the young Jerzy Tomaszewski found employment as a darkroom worker alongside fellow conspirators Mieczysław Kucharski, Włodzimierz Baran and Andrzej Honowski. The shop manager was Ludwik Herbert. Fotoris was frequented by all ranks of the German Armed Forces. Besides official photographs, they brought in their private pictures that featured girlfriends, social occasions – and at times images of Jewish ghettos, deportations, executions and atrocities. 'The Germans loved photography', said Tomaszewski.[4]

The Polish workers were encouraged to talk with their German customers to find out as much information about the pictures brought in by them as was possible – where they had been taken, by whom, and exactly what they showed. 'We had to be careful because it was highly dangerous work', Tomaszewski said, 'but we were young and we didn't always understand the danger, or the importance, of the work we were doing.'[5]

On occasions Tomaszewski and his colleagues processed film that they suspected showed Poles who were being sought after by the Nazis, or underground hiding places. Then they would damage the film by scratching it or ruining it with chemicals. Tomaszewski recalled that on one occasion he spoiled a film brought in by a German officer that showed portraits of Poles whom he thought were wanted. When the officer returned to Fotoris to collect his photographs he was furious that the film had been ruined and threatened to send Tomaszewski to a concentration camp. Kucharski intervened and argued that it was an accident, that he was only a boy, though competent, and had developed hundreds of films. The young darkroom worker was spared.

As the war dragged on, the photographs brought in to Fotoris became increasingly macabre. As the marauding German Army swept through Poland, thousands of members of the Polish armed forces as well as Polish and Jewish civilians were arrested, deported to concentration camps or publicly hanged or executed. Many of these crimes were photographed. An image taken at Palmiry, near Warsaw, shows some of the hundreds of civilians who were taken to a forest and shot; during four years of occupation more than 2,000 people would be murdered at Palmiry. In Bochnia, on 18 December 1939, fifty-one civilians, including two Jews were taken to a nearby forest, made to dig their own graves and then shot and buried. Two other civilians were publicly hanged from one of the town's lampposts. They were murdered as reprisal for an attack on a German police station. After the war an official photo album was found in the home of a former SS man in Bavaria entitled: 'Retaliation in Bochnia'. It contained a detailed police report about the operation and pictures of the execution. During the war some of these pictures found their way into the hands of underground workers, including Tomaszewski and his colleagues. Tomaszewski does not remember when he first saw them, but he was horrified. 'It was a shock for everyone,' he said. It is possible they were distributed by a photo laboratory worker in Bochnia called Stanisław Broszkiewicz, who was known to have smuggled photographs from his workplace. Evidence suggests that many Polish workers in photo shops throughout Poland were involved with duplicating or distributing incriminating pictures taken by Nazis or German soldiers.[6]

At Fotoris photographs and negatives that were thought to contain valuable information were copied and smuggled out of the shop by the workers themselves, or they were placed in waste paper bins so that underground workers disguised as cleaners could pick them up. In early 1941 some of these pictures – including those from Bochnia – had begun to reach the government-in-exile in London.[7]

By 1942 a large number of photographs and documents had accumulated in Britain and the USA. Some were published on leaflets, or in the press while others were used by the British government and printed on propaganda leaflets to drop over Germany, including one image that showed civilians being escorted through

the forest by German soldiers at Palmiry, and another of a man holding the naked body of an emaciated young child in the Warsaw Ghetto. The information credited to them was not always correct. But that was not considered important; what was important was what they showed, or seemed to show.[8] In London the Polish Ministry of Information published a 600-page book entitled *The German New Order in Poland* that included eyewitness accounts, reports on massacres, executions, the persecution of the Jews and photographs as evidence. In 1943 in the USA more than 300 pages of photographs and documents were published in *The Black Book of Polish Jewry: An Account of the Martyrdom of Polish Jewry under Nazi Occupation*, a book produced by the American Federation of Polish Jews. It also included reports on deportations, gassings at the extermination camps of Chelmno, (Kulmhof) and Treblinka and Jan Karski's account of his clandestine visit to the Warsaw Ghetto. Although publicly neither of these books made an impression on British or American governments, among the respective communities they had enormous impact. In the USA, in cities with large Polish populations, *The German New Order in Poland* was 'in huge demand' including in Cleveland, Ohio where in October 1942 it was in the 'best seller' category. In Pittsburgh and Chicago the local press ran articles and pictures, and the *Detroit Evening Times* printed extracts.[9]

Throughout the war the Polish underground continued with their covert operation. But in January 1943 underground operations at Fotoris were uncovered. It is thought that the Nazi intelligence service, which was monitoring material published in the Allied countries, had managed to trace the origins of some of the German soldiers' pictures back to Fotoris. The shop was raided. Tomaszewski and Kucharski were tipped off and got away, but Andrzej Honowski was not so lucky. He was killed during a struggle with German police. It transpired that he had been denounced to the authorities by Ludwik Herbert. As a consequence, Herbert was sentenced to death by the Polish underground's Special Tribunal: the sentence was carried out on 16 January 1943 in front of his family in his apartment in Walecznych Street, Warsaw.[10]

After Herbert's execution Tomaszewski and Kucharski went into hiding until they received orders to organise a secret laboratory in Warsaw. It was in this laboratory in Chmielna Street in early 1943 that Tomaszewski first saw the photograph taken in Ivangorod. Although the laboratory workers were instructed to destroy material after it had been microfilmed, Tomaszewski often kept and hid pictures and documents in locations in and around the city, sometimes with help from his mother. She was known to stash photographs behind the altar of a church near the family home or to take them to the homes of relatives in the suburbs. In this way some of these images survived the war.

Jerzy Tomaszewski and Mieczysław Kucharski continued their illicit work until the beginning of 1944, when they received news that a Polish courier who had visited their laboratory had been arrested by the Nazis. The underground authorities were worried that he would be tortured and reveal its location. As a consequence it was closed down. The two underground workers were not deterred. They opened a new laboratory in an empty apartment in a district of the city where German officials and soldiers were housed. They continued to work there until 1 August 1944 when the Warsaw Uprising began.[11]

Armed with cameras

In preparation for the Warsaw Uprising, the Photo and Film Department of the Main Command Office for Information and Propaganda had assigned more than two dozen photographers to document the battle for the city; among them was Jerzy Tomaszewski. In addition a team of around fifty filmmakers was organised under the instruction of Antoni Bohdziewicz. Armed with their cameras, they took to the streets to record the struggle and daily life of resistance soldiers and civilians in the besieged city.

On the first day a large quantity of film was seized from a German laboratory called Falanga. Photo laboratories were also commandeered including Foto Greger where a female photographer named 'Wacława', who had attended a secret training school in photography, developed film and printed photographs for the uprising photographers. The prints were dispatched daily to some of the thirty newspapers and bulletins that were published during the uprising. After five years of brutal occupation, there was jubilation that the fight had begun. 'For the first three days', said Tomaszewski, 'it was a wonderful atmosphere.' The cultural life of this 'secret underground state' flourished. Polish radio took to the airwaves and concerts were organised. On 13 August the first of a series of uprising newsreel films, *Chronicle Number 1 – Warsaw Is Fighting*, was screened in the Palladium Cinema and all its 1,000 seats were filled. The film was accompanied by gramophone music and Antoni Bohdziewicz, seated on the balcony with a microphone, gave a live commentary. From then on there were nightly film screenings when the bombing ceased. Soldiers were issued with free tickets only hours before the films began as the locations of the screening were kept secret. Three *Chronicles* were completed.[12]

But after the first week of fighting the Germans had begun to mobilise special forces and a terrifying array of artillery and military might. There were round-ups, deportations to concentration camps and executions. In the city an estimated 35,000 men, women and children were massacred. The insurgents could not compete militarily, but their ingenuity and the support of the civilian population helped them maintain the insurrection.

The cost was enormous. 'As the daily bombardments increased, the death toll soared and as food and water supplies ran low the population became ever more desperate', says Tomaszewski. 'My duty was to photograph not only the fighting but also the civilians in order to find out how they were coping as they were confined to cellars without food nor medicine, weapons nor ammunition. It was difficult, they were suffering and I was taking photographs and writing about it.' But he never doubted the importance of his photographic evidence. 'Whenever I was in trouble or covered in rubble I worried only about the camera and film.' Jerzy Tomaszewski remembers the main principles of his job: always be on the front line; process the film as soon as possible and protect the negatives at all costs. But it soon became a matter of photographing whatever was possible, often with his Dolina 35 mm camera hidden beneath his coat. 'We had no military training and the work was increasingly dangerous. On one occasion I was told to photograph a German unit which was bombarding the city from the top of a building. I managed to get to the highest point of the building opposite. To test the situation I put my hat on a stick. It was immediately blown to pieces.'

When Tomaszewski heard that the city's central power station was under attack, he went to take photographs. 'By then the Germans were in the centre of town with tanks', he says. 'They were burning and destroying everything all around me. ... I was very frightened. There was tragedy everywhere ... people carrying injured children ... people being buried alive in the cellars ... I was scared all the time ... comrades were shouting at me not to risk my life taking photographs. ... No one knew which street would be next.'[13]

With the Old Town collapsing around him Tomaszewski ran across a street between tanks shelling the surrounding buildings. He was injured by shrapnel and falling rubble. His comrades dragged him to the ruins of his nearby family home where he collapsed. 'I was desperate to take more photographs', he says. There, lying on his side he took his last frame. It shows bodies strewn around a courtyard. More than six decades later, when he showed me the picture in his apartment in Warsaw, he fell silent.

After he had taken his last picture his comrades dragged the injured Tomaszewski to the hospital, which was already overflowing with the dead or wounded so he was left outside. They took away his camera as well as his underground identification papers in case of capture – effectively saving his life. 'There were so many other injured people worse than me ... many without arms or legs that I asked to be left ... so that I could be treated later', he says. 'This was the worst moment of the uprising for me. As I lay on the ground the hospital was shelled. ... Everything was in flames and people were jumping from the windows. I was crawling towards them but I couldn't help ... they were burning alive and I couldn't do anything to help them.'[14]

During that desperate fight, no one was helping the Poles. Despite endless pleas for assistance they were caught between the conflicting interests of the Western Allies and the Soviet Union and neither considered it in their interest to assist. In July 1944 the Red Army had crossed into Poland and liberated the city of Lublin and Majdanek concentration camp, where more than 350,000 people had perished. By August Soviet troops were silently waiting on the eastern bank of the Wisła river for the Nazis to obliterate what the Soviets saw as Polish reactionary forces under orders from nationalists in London.

British Prime Minister Winston Churchill pledged support for the uprising, but this was limited to a few airdrops. When Joseph Stalin refused Allied planes permission to land on Soviet-controlled airbases, making further airdrops impossible, neither Churchill nor President Franklin D. Roosevelt exerted pressure. In mid-September, when a German victory was imminent, the Russians airlifted a small amount of supplies, but it was too late. By allowing the Home Army to be annihilated Stalin in effect had the Nazis do his dirty work for him. On 2 October the Home Army capitulated. The Germans expelled the surviving population and razed the city to the ground. It was still another three months before the Soviet tanks rolled into the eerie landscape of deserted ruins.[15]

In the final days of the uprising, the injured Jerzy Tomaszewski was captured and deported to Pruszków transit camp outside of Warsaw from where, during August and September 1944, more than 10,000 of the city's inhabitants were deported to Auschwitz-Birkenau. Antoni Bohdziewicz, whose photo studio was destroyed in the

fighting, was also captured and deported to Pruszków, the same transit camp; he managed to escape, as did Tomaszewski, although separately. They were not known to each other. Their situation was further complicated by the fact that in the winter of 1944, members of the Home Army and its sympathisers were not only avoiding arrest by the German Army, but by followers of the Lublin-based communist-led Polish Committee of National Liberation (PKWN) as well. To the new provisional government, the Home Army was regarded as an illegal organisation and its members as enemies of the new Poland. Photography was once again outlawed. Following the Red Army's arrival in Kraków on 15 January 1945, the Polish Catholic Press Agency newssheet *Weekly Review* reported that 'the Lublin Freedom' had been installed in Kraków and that 'all cameras have been confiscated'.[16]

By 1945 around 60,000 former members of the Home Army and Poles associated with its work had been arrested by the NKVD, the Soviet secret police. Some were imprisoned in the former Nazi concentration camp at Majdanek, which had been liberated in July 1944. Thousands more were deported to the gulag in the Soviet Union. These Poles who had spent the war fighting the Nazi occupation – including many who had been interned in concentration camps – once again found themselves on the wrong side. In March 1945, sixteen leading members of the Polish underground, including General Leopold Okulicki, former commander-in-chief of the Home Army, were arrested in Warsaw and flown to Moscow, where between 18 and 21 June they were put on trial for anti-Soviet activity. They were all found guilty.

After the war had ended Jerzy Tomaszewski was unable to take pictures. The trauma of the uprising had left a permanent scar. In February 1945, he had returned to Warsaw to bury his mother and a brother. Their bodies had been found beneath the rubble of their home. As far as he knew all his uprising photographs had been lost. The images stashed in the church by Tomaszewski's mother were also lost when the church was destroyed. But some of those deposited in the homes of relatives in the suburbs did survive. Tomaszewski began to gather together the pictures, but he kept quiet about their origins and the fact he had been involved in supplying photographs and documents to the West. In a climate of fear and uncertainty, photographs and even family albums were hidden away for fear they told the wrong story.

Antoni Bohdziewicz survived the war. In May 1945 he began to establish a film school in Kraków but it was transferred to Łódź by the authorities; it would become one of Europe's most celebrated film schools, where Andrzej Wajda and Roman Polanski studied, and where Bohdziewicz worked until his death in 1970. In 1949 the authorities had prevented him from making films after he made a speech at the Polish Filmmakers Congress in which he demanded artistic freedom from an increasingly controlling state. The ban was not lifted until the political thaw of 1956.[17]

By that time the thousands of reports, document and photographs that had been smuggled from Poland had begun to gather dust in archives in the West. In London those that had accumulated in the offices of the Polish government-in-exile were divided between the Polish Underground Movement (1939–1945) Study Trust where documents and photographs related to the Home Army were deposited, and the Polish Institute and Sikorski Museum that kept official documents related to the government-in-exile. There seems to have been no logic to how the photographs were divided as copies of some of the same images can be found in both.

In the archive of the Study Trust there are a few strips of original microfilm sent from Poland that have survived. They could have been made in the laboratory in Chmielna Street, although this is impossible to verify. But there is evidence that some photographs sent by Jerzy Tomaszewski did reach their destination. In an old filing cabinet in the basement of the Polish Institute and Sikorski Museum I found two brown envelopes that seemed to have been undisturbed for many years. In them were photographic prints and a list of typed photo captions. According to records in the institute, the pictures were received some time in 1941–1942. In one envelope are pictures taken in the Warsaw Ghetto that show emaciated children, including the picture of the man holding the young child's naked emaciated body that was used on British propaganda leaflets. Other pictures show piles of corpses in mass graves in the Warsaw Ghetto cemetery. In the second envelope are prints which, according to the captions, show the emaciated naked corpses of Soviet POWs.[18] These prisoners of war, whose status was not recognised by the Nazis, were routinely rounded up and enclosed in 'camps', which were little more than enclosures surrounded by barbed-wire fencing. It is estimated that approximately 3.5 million Soviet POWs died at the hands of the Nazis of disease, starvation or execution. One of these pictures shows a uniformed German soldier with a gun over his shoulder posed for the camera alongside rows of naked corpses strewn in a field. In 1943 this picture was used by the British Foreign Office on propaganda leaflets dropped over Germany, though the victims were said to be Polish peasants.[19]

The pictures in the old brown envelopes are of poor quality and lacking in tone and detail, indicating that they had been copied many times. I sent copies of them to Jerzy Tomaszewski in Warsaw. It was the first confirmation he had in more than sixty years that some of those he had helped smuggle had arrived at their destination.

A picture at war

In 1959, more than a decade after the war had ended, Jerzy Tomaszewski was one of three editors commissioned by the Polish Foreign Office to compile a book entitled *1939–1945: We Have Not Forgotten*. Officially its publication commemorated the twentieth anniversary of the invasion of Poland by the German Army in September 1939, but there was a more pressing reason: as a response to what the communist-led government saw as the rearmament of West Germany and the rise of neo-Nazism in Western Europe. The introduction stated:

> 15 years after the liberation of Oświęcim (Auschwitz) ... when the memorials to the victims of fascism are being violated, when a wave of anti-Semitism is spreading in various directions and when young people in schools are presented with a false picture of the past that is insulting to the memory of the victims of fascism. In order to warn the young generation against the recurrence of genocide, to protect young minds from racial hatred and a desire for revenge, we shall continue to disseminate the truth about the Third Reich and its policy of national extermination which led to such horrible results.

The book, printed in five languages and with two further editions in 1960 and 1961, included almost 300 pages of pictures that showed deportations, Jewish

ghettos, mass executions and public hangings. The majority had been taken from *Głowna Komisja Badania Zbrodni Niemieckich w Polsce* (Main Commission for Research into German Crimes in Poland), the national archive formed in 1946 for the purpose of collecting evidence of Nazi crimes. But the cover featured the photograph from Tomaszewski's archive that showed the German soldier pointing a gun at a woman and child at Ivangorod. It was severely cropped so that only the soldier and the woman and child were visible, but it was the first time it had been published.

Jerzy Tomaszewski was well aware of the book's propaganda value. 'It wasn't the history I would have chosen to write', he told me, but he saw it as an opportunity to publish some of the photographs from his archive, including a few taken during the Warsaw Uprising – although the picture captions were adapted to play up the communist role. But it was the image taken in Ivangorod that became the centre of a political storm. On 26 January 1962, the West German newspaper, *Deutsche Soldaten Zeitung* (*DSZ*, The German Soldiers' Daily) founded in 1951, known for its right-wing views and its willingness to defend Germany's Nazi past, published an attack on the picture taken at Ivangorod. The newspaper, which reportedly received funding from 'US agencies' and the West German government, printed the photograph on its front page with the headline 'Achtung Falschung!' ('Beware Falsification!')[20]. The allegation was that the soldier pointing the gun at the woman and child was not a German soldier at all; he was neither wearing the uniform of a German soldier nor using a German weapon. The accompanying article, written by German Professor Otto Croy, a writer on photographic technique, accused the Polish authorities of fabricating photographic evidence in order to make false accusations against West Germany.

As a response to the article in *DSZ* on 25 February 1962, Jerzy Tomaszewski and fellow editor Tadeusz Mazur published an article in the Polish illustrated colour weekly magazine, *Świat*. It said that the readership of *DSZ* were 'old believers in the Third Reich' and accused them of 'a priceless "revisionist" campaign'. To support their claim they published five photographs as evidence of the atrocities that had been committed in Poland and in the Soviet Union by German soldiers, including the one taken at Ivangorod. Printed directly underneath this controversial picture there was a second image. It showed five armed men – four in uniform and one dressed as a civilian – standing looking towards the camera behind a number of bodies on the ground. We assume them to be dead. The flat barren landscape is identical to that featured in the first photograph. One of the uniformed men, with a weapon slung around his neck, looks remarkably like the man pointing the gun at the woman and the child. On the back of the photograph, in the same handwriting as the first, is written: 'Ukraine 1942'. As far as I am aware this is the only occasion that this image has been printed alongside the image of the soldier pointing his weapon. The image of the dead does not have the same dramatic impact as the image of the woman with the child, whom we imagine is about to be shot.

But the controversy over the picture taken at Ivangorod did not die down. The accusations continued for more than two years in what Tomaszewski called 'a press

war'. The Polish authorities grew concerned that if the allegations made by Croy were true, Poland could have a diplomatic incident on its hands. On one occasion officials from the Polish Interior Ministry of Security visited a concerned Jerzy Tomaszewski at his home in Warsaw. But when Tomaszewski showed them the original photograph they left his apartment seemingly convinced.

In 1965 the dispute appeared to have been resolved when *Der Spiegel* published a letter from a former German soldier called Kurt Vieweg. Vieweg verified that the uniform of the soldier in the photograph was indeed that worn by members of the German Police Battalions (the Einsatz), groups involved in 'actions' in Poland and in the Soviet Union. He knew this because he had been a member of a battalion but had been 'lucky enough,' he said, to be stationed in Norway and not on the Eastern Front.[21] After the publication of Vieweg's letter the matter was dropped. For almost forty years little more was written about the photograph and it received no special attention. But stories concerning Tomaszewski's wartime photo archive did not end there.

Recovering the memories

On 13 June 1975 Tomaszewski's daughter drew his attention to a notice in Warsaw's daily newspaper *Życie Warszawy* placed by someone called Wacława Zacharska, who was looking for him. He did not immediately realise it, but the woman was 'Wacława', the photographer who had processed his films during the Warsaw Uprising. In 1944 she was known to him only by her first name, and he had not seen or heard from her since, even though in the 1950s she had opened a portrait studio called Foto Zacharska less than a kilometre from his city apartment. But in the post-war climate of fear and recrimination the past was better left alone. However, one day in 1975, following the published notice, as he passed the Foto Zacharska shop front it suddenly occurred to him who the owner might be. He went inside. That first meeting revealed that in 1944, as Warsaw was razed to the ground, Wacława had rescued and hidden more than 600 of his negatives. She wanted to give them back.

In March 2008, I stood in front of the faded facade of Wacława Zacharska's photo studio with Anna Bohdziewicz, the photographer and daughter of Antoni Bohdziewicz, the Warsaw Uprising filmmaker. The Foto Zacharska shop-sign, a relic from the 1950s, was still in place, but the shop window that had previously been filled with small outdated framed portraits was empty. The door was ajar and the elderly and frail studio portrait photographer was busy taking down the last of the large framed portraits. They had been in place so long that the shapes of the frames were clearly etched onto the white walls, which had yellowed with time. The heads of the sitters were also eerily impressed on the wall, in a way that left a series of ghostly silhouettes. After fifty years in business, and due to rising costs, Wacława Zacharska was retiring and the photo shop was closing down. As she stood among the silhouettes of past customers, she revealed how in October 1944 as Warsaw collapsed around her, she had placed Tomaszewski's negatives in a container and then buried them at her father's grave. She also recalled their reunion when, more than thirty years later, Tomaszewski had walked into her photo studio.

Within two years of their meeting, in May 1977, Tomaszewski's photographs were on display at the International Press and Book Club in Warsaw in the first exhibition

of images of the Warsaw Uprising. The exhibition received extensive media coverage. It was the first time that the people of Warsaw felt able to talk openly about the uprising without fear of recrimination. There was an outpouring of gratitude from visitors who had come to remember the events but who also hoped to catch a glimpse in the pictures of friends, relatives or loved ones who had not survived.

In response some sent Tomaszewski letters with their own tragic stories and begged him to publish all his photographic evidence. One letter was sent by a woman who had seen her three children being shot through the head during a massacre by the Germans in the city. She was also shot along with her youngest son although they both survived. She visited the exhibition with that son, to bear witness. Another person wrote: 'The reality of the past has come back to us, you can lie using words…but a picture will never lie, it is simply reality.' In 1979 Jerzy Tomaszewski's book *Episodes in the Warsaw Uprising* was finally published. It was the first book to describe the events as the people of Warsaw remembered them.[22]

By the early 1990s, as communism crumbled and the world order began to change, so did the meaning of the photographs in Tomaszewski's archive. The Jewish tragedy became central to the memory of the Second World War, and the picture from Ivangorod, no longer of interest to Polish officials and Cold War propagandists, became important evidence of the murder of the 6 million murdered Jews in what by then had become known as the Holocaust.

Jerzy Tomaszewski, who had risked his life by placing his trust in the value of pictures by smuggling them, taking them and collecting them, had never questioned their importance. In this sense his archive stands as a testament to all those who had risked their lives to compile pictures as evidence although this is not always taken into account. When a Holocaust museum curator visited his archive in Warsaw and filed through the pictures, Tomaszewski had asked: 'Who do you think took these photographs and why?' The reply came: 'I have never thought about it.'

Tomaszewski's carefully ordered picture collection – which he calls his 'family archive' – is kept at his home in the Old Town of Warsaw, a stone's throw from where Fotoris was once located and from where he took pictures during the uprising. He showed me the photographs from his archive with a sense of urgency, as though they were his only link to remembering the past. It reminded me of the way in which my Uncle Cec had shown me his personal photo albums; every photograph prompted a story, which frequently led him to recall another. These fragments of Tomaszewski's war also reminded me of the pictures in the album that belonged to the First World War American soldier whose disparate collection of images had so poignantly conveyed the confusion of his wartime experience. Pictures will always prompt memories, even though they cannot in themselves explain the past.

It is possible that some of the pictures in Tomaszewski's 'family archive' might also be among the personal picture collections of German soldiers or their families. After the war had ended, many members of the Wehrmacht kept their wartime pictures as souvenirs. In 1995 some of these and hundreds more German soldiers' snapshots of war, found in archives in the former Soviet Union, would once again be used as evidence, this time by German historians in an exhibition that would destabilise the collective memory of a nation.

How Pictures Can Haunt a Nation

We had no knowledge nor had we thought about what
a photograph is, how dangerous it is, how ambiguous it
is and how it can be used in different ways. For histori-
ans a photograph is simply evidence. *Hannes Heer.*[1]

Pictures from the archives

On 5 March 1995, fifty years after the end of the Second World War, an exhibi-
tion called 'Vernichtungskrieg: Verbrechen der Wehrmacht 1941 bis 1944' ('War
of Extermination: Crimes of the Wehrmacht 1941–4') opened at the Hamburg
Institute for Social Research. The exhibition, which included documentation
and original photographs, had been devised by historians Bernd Boll, Walter
Manoschek, Hans Safrian and the director of the exhibition, Hannes Heer. Initially
it had been intended as a specialised study of three campaigns: the war against the
Partisans in Serbia, the German occupation of Byelorussia (1941–4) and the Sixth
Army on the road to Stalingrad (1941–2). But it drew bigger audiences than had
been anticipated; by the end of the century almost a million people in thirty-three
towns and cities in Germany and Austria had seen the exhibition, and it had caused
a political storm.

At the centre of the controversy was a display of more than a thousand
small black and white snapshots thought to have been taken by members of the
Wehrmacht (German Armed Forces). More than 300 of them formed the centre-
piece of the exhibition and were organised symbolically into the shape of an Iron
Cross – a German military medal for bravery since 1813. The pictures showed
scenes of general destruction, burnt villages, civilians being beaten, executed or
piled into mass graves, and starved, emaciated Soviet POWs.

They also showed soldiers humiliating their victims – jeering for the camera,
for instance, while cutting the sidelocks or beards of Jews. Dozens more showed
civilians being publicly hanged. In some of the pictures German soldiers had
placed themselves alongside the dangling corpses, touching an arm or a leg while
smiling for the camera (Figure 5.1). The pictures seemed evidence enough that
far from fighting an 'honourable' war, as the majority in Germany had previously
believed, these soldiers, as opposed to those in the SS, Gestapo or other ideological
Nazi units, had been willing participants in crimes committed by the Nazis, and in

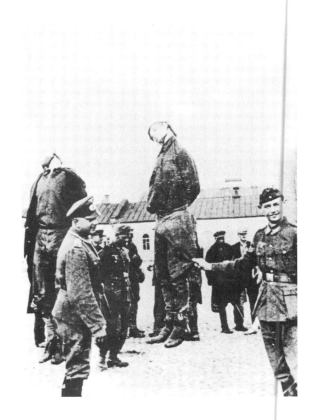

Figure 5.1 A German soldier smiles for the camera while touching the trouser leg of a hanged civilian during the Second World War. (Courtesy of the Society for the Cooperation of Soviet Studies)

some cases seemed to be enjoying themselves. It was the first time in Germany's post-war history that such evidence had been publicly displayed, and it called into question not only the individual recollections of former soldiers but according to Hannes Heer the collective memory of an entire generation.[2]

When Hannes Heer and his colleagues came across the snapshots in the archives of the former Soviet Union in Russia, Ukraine, Byelorussia and Serbia it became clear that the exhibition would be bigger than had been previously anticipated. Some of the pictures were found with handwritten captions in German, but others were in Russian – a location, a name, or a description written by the person who had found the photographs, or by the authorities. Some had no captions. Hannes Heer did not consider this particularly important at the time. There seemed to be little doubt as to what they showed. 'The theme of the photographs seemed very clear', said Heer, 'the shootings, hangings and the burning were all there.'[3]

Precise information about how these pictures had come to be deposited in the archives is impossible to obtain. But some of them had been previously used in a number of different contexts, including as evidence in the war crimes trials held in the Soviet Union, which began in 1943 in Ukraine at Krasnodar and Kharkov.

One picture included in the exhibition had featured in a photo album compiled after the war by the Soviet authorities as evidence for the Provincial Commission on the History of the Great Patriotic War entitled 'Photo Album of Atrocities and

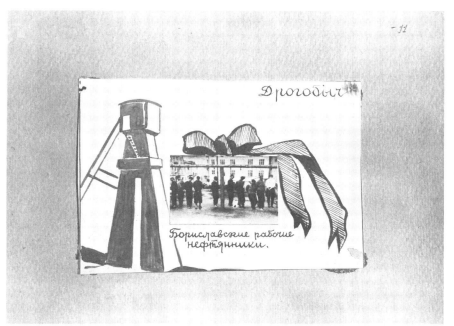

Figure 5.2 A page from a photo album compiled by the Provincial Commission on the History of the Great Patriotic War entitled 'Photo Album of Atrocities and Crimes Committed by Nazi German Aggressors in Drohobych Province during the Period of 1941–44'. The text reads: 'Droghobych: Oil Workers in Borislav'. (Courtesy L'viv Regional State Archive)

Crimes Committed by Nazi German Aggressors in Drohobych Province during the Period of 1941–44' (Figure 5.2). In the album the photograph that shows ten civilians hanging from a public gallows is captioned, 'Drohobych: oil workers in Borislav'. It is decorated with a drawing of a ribbon and bow – a gift from the Nazi regime. On the left-hand side of the page is a sketch of a concentration camp tower.

Other pictures in the exhibition had been published in Britain during the war. Throughout 1942 there were reports in the English-language Soviet newspaper *Soviet War News Weekly*, launched in January that year, concerning pictures that were being found among the possessions of captured or dead German soldiers on the Eastern Front. On 19 February 1942 six pictures showing the various stages of the hanging of five civilians, thought to have been taken near Smolensk, were published in the newspaper with the headline 'Six photographs' and an article by the eminent Russian war reporter Ilya Ehrenburg (Figure 5.3). In the article Ehrenburg speculates about the motives of the photographer, whom he imagined to be a 'glassy-eyed German officer with a cold, dull face' and who 'carefully recorded the stages of the execution of five Soviet citizens' as a gift for his 'sweetheart'.

In 1942 these and other German soldiers' pictures featured in two books published in Britain by the Soviet authorities entitled *We Shall Not Forgive: The Horrors of the German Invasion in Documents and Photographs* and *Soviet Documents on Nazi Atrocities*. In February 1942, the *Daily Sketch* had published three of the photographs of the hanging near Smolensk under the headline 'War pictures we have to print'. In February 1943 they were displayed in Doncaster, in the north of

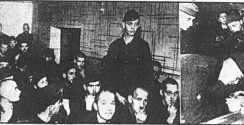

Figure 5.3 A page from the *Soviet War News Weekly*, 19 February 1942 entitled 'Six Photographs' by Ilya Ehrenburg.

England, at an exhibition entitled 'This Evil We Fight', although in this context the authorship of the pictures was of little consequence.[4]

For decades after the war had ended these German soldiers' pictures were of little interest to the press or historians, but in the 1980s some of them were exhibited

in Holocaust museums and exhibitions, gaining some notoriety although, in this context, their value as evidence was more important than their provenance and authorship – a point which lay at the root of the controversy caused by the 'War of Extermination' exhibition.

The myth of the past

When 'War of Extermination' opened in 1995 opposition was voiced by right-wing politicians and some military historians, but few seemed prepared to challenge the photographic evidence. Newspaper headlines reflected the trust placed in the pictures. The *Leipziger Volkszeitung* stated, 'An exhibition destroys the historic lie of the untainted soldier.' The *Frankfurter Rundschau* declared: 'The myth is reduced to a lie', while an article in the weekly *Die Zeit* stated: 'Instead of the Myth we can now hear the terrible truth which has never been able to penetrate the German public's protective wall of silence.' It had been 'the most important historical exhibition for a long time'. Hannes Heer said: 'It has been a secret that has taken fifty years to come out, because it is only now, with the end of the Cold War and the unification of Germany that we can deal with the enormity of these crimes.'[5]

The notion that German soldiers were innocent of Nazi war crimes had the official support of the Western Allied forces occupying Germany after the war. In May 1945, the British and American authorities began what they referred to as the process of the 'denazification' of Germany – to rid German society of National Socialism. By the time the Nuremberg International Military Tribunals (1945–9) had ended and leading Nazis were found guilty and either imprisoned or executed, it was generally accepted that National Socialism had been stamped out and those guilty of Nazi crimes – the political elite, the NSDAP (Nazi Party) functionaries and members of the SS, the SD, SA, Gestapo and RSHA (Reich Security Main Office) – had been punished.[6] From then on a clear distinction was made between crimes committed by the Nazis and the millions of soldiers who had fought an 'honourable' war. Historian Omar Bartov wrote: 'If the initial purpose (of the tribunals) had been to punish and purge, the ultimate result was to acquit and cover up.'[7]

As a part of this process, in 1947 the American authorities collected thousands of documents in Germany relating to National Socialism and shipped them wholesale to the USA. The US Library of Congress organised a mission to Europe to collect vast amounts of 'Nazi material', including 'several thousand films', sound recordings including radio broadcasts and public addresses by Nazi party officials, the private photographic collection of Heinrich Hoffmann, forty-seven personal photo albums of Hermann Göring and seventy photo albums belonging to other Nazis.[8] In Germany during the late 1950s the school curriculum rarely dealt with events after 1918 and hardly ever gave accounts of Germany's Nazi past. According to journalist Juergen Neven-Du Mont many primary school children had no knowledge at all of Hitler and National Socialism, or if they did they were seen in a favourable light.[9] In April 1951, in a speech to the German Parliament, Chancellor Konrad Adenauer said that 'those who committed crimes during the war were so insignificantly small that they do not tarnish the honour of the former German Armed Forces.'[10] By 1955 an exhibition of 'atrocity' photographs at the former

Dachau concentration camp was closed down by the Americans on the basis that it was 'damaging to international relations'.[11] Hannes Heer wrote that the traces of the Nazi period and its crimes 'were so thoroughly erased that those involved were capable of giving the impression that there had never been any Nazis or National Socialism in Germany'.[12]

As the Cold War got under way, it was not in the interest of Western powers to draw attention to this aspect of Germany's past. It would have been more difficult for the West to rebuild Germany as a democratic buffer against the supposed Soviet threat, if the ordinary German had been implicated in Nazi crimes and the Holocaust. National Socialism and its followers had to be seen to have been eradicated, in spite of the fact that some former Nazi officials took their places in German society as administrators, politicians and local dignitaries.[13]

Omar Bartov argues that the eradication of the memory of Nazi crimes was also made possible by the way the Holocaust was remembered, as something that happened separately from the war and outside German borders – a point still reflected in the fact that pictures of the Holocaust are often regarded as separate from the genre of war photographs. Bartov writes: 'The Holocaust has commonly been presented as separate from the war (even if genocide on this scale could only have been practiced within its context), and its perpetrators were seen as separate from the soldiers. ... Precisely because in Germany the Holocaust was seen as the epitome of evil, it had to be ascribed to perpetrators kept rigidly apart from the rest of the population.'[14]

Similarly Jan Philipp Reemtsma, the director of the Hamburg Institute, pointed out that the camps were only part of the story of the Holocaust. In his opinion the war in the Eastern campaigns was integral to the Holocaust. For example in Byelorussia one in four of the population was murdered, in the USSR more than 10 million people were killed including more than 5 million civilians, 3.5 million Soviet POWs – 2 million had been murdered by February 1942 – and an estimated 1.5 million Jews, as many as died at Auschwitz-Birkenau and the other Nazi death camps in Poland. He described what he called the 'misuse of Auschwitz' as a way of erasing 'the memory of the Jews exterminated in the War of Annihilation – as rendering invisible by highlighting the extremes'.[15]

In the 1960s, the trial of Adolf Eichmann in Jerusalem, and a vigilant West German student movement that demanded information about the country's Nazi past, meant that the silence that surrounded Nazi crimes and the murder of 6 million European Jews could no longer be maintained, although not every one complied. Increasing numbers of neo-Nazi groups attempted to intimidate those who spoke out.[16] But in West Germany a number of war crimes trials began, including the Auschwitz trial at Frankfurt that tried former Nazi officials, members of the police, the SS and special squads. Former SS man Karl Höcker, an adjutant or second in command at Auschwitz-Birkenau, whose photo album is discussed in Chapter Three, was also prosecuted during this period. But, as in previous trials, the focus remained firmly on officials who were alleged to have committed their crimes at the camps outside the borders of the Reich – at Majdanek, and at the extermination camps of Treblinka, Sobibór and Bełżec. The ordinary Wehrmacht soldier still remained absolved from involvement in the Nazis' crimes.

Scars of a generation

When Hannes Heer began his research for 'War of Extermination' he had regarded pictures not as unequivocal evidence, but, like his fellow historians, as 'supplementary source material', and as illustrations to support historical documents. But as the exhibition toured Germany and Austria, it became clear that its power lay with the pictures. Any antagonism was directed, Heer said, 'against its shocking and powerful medium; the images and the stories they told'. This was reflected in newspaper headlines: 'Pictures that you do not forget', 'The photographs jump out at you', 'The abominable truth of pictures' and 'War photos tear open the scars of a generation'. 'It was as though', wrote Heer, 'the photographs seemed to acquire a special authenticity by virtue of the fact that, to a large extent, they originated from nameless soldiers, effectively acting as unsuspecting witnesses.'[17]

But whether a grinning soldier standing alongside a corpse was a perpetrator or witness was a question posed by German historian Rolf-Dieter Müller of the Military History Research Institute in Potsdam. He wrote: 'A handful of letters home or pictures of grinning soldiers in front of people hanged are not sufficient for me as proof of a barbarian attitude. ... I am convinced that onlookers at a heavy accident on the highway look similar and that the photos of them can be interpreted in a similar manner. ... We simply do not know if the soldiers in the photos are perpetrators or ordered spectators, whether they are sensation hungry onlookers or murderous fellows.'[18] Veterans themselves who had seen the exhibition had different points of view about the complicity of the Wehrmacht in Nazi atrocities. Some denied any involvement, while others acknowledged that soldiers had indeed committed crimes. 'It was possible', said the coordinator of the exhibition, Petra Bopp, 'to divide the responses from veterans into three categories: those who said that the exhibition was simply a lie, those who admitted that the scenes depicted in the photographs had indeed happened, and those who said that the reality was much worse than what was shown in the pictures.'[19]

One veteran who visited the exhibition in Munich was quoted as saying: 'It is a walk through the past. All that is presented here in picture form, be it the photos on the walls or the films, bring across everything, to those that were there. Apart from the noises and the smells everything is here.'[20] For some veterans the photographs seemed to stir otherwise buried or forgotten recollections. Some were too much to bear. In the former East German city of Dresden, an elderly man stood alone staring at the pictures for a long time before he quietly began to cry. As he rushed out of the exhibition he shouted, 'It's me ... It's me.'[21] His identity is not known.

Some visitors saw their fathers, uncles, brothers or other family members in the pictures. A female visitor said, 'I am here to search for traces of my father. I believe it happened. The memories of what he said are welling up inside me ... we should not win the war, too many atrocities were committed.'[22] In Dresden, a woman wrote in the visitors' book that she was 'extremely distressed' to have discovered her father in one of the photographs. Another visitor wrote: 'These photographs are very familiar to me. I have seen similar in my grandfather's album.'[23] A woman, a schoolgirl during the war, remembered that one day her classmate had come to school with pictures: 'During the recess she took out these pictures. ... What I saw

in those pictures was so terrible I could never forget it. Well, there was a post or something and on top was a crossbar or post or something and hanging from it were not just three, four, there were ten, twelve, fifteen prisoners hanging there all lined up in a row.'[24] In order to address the distress of some visitors, whether caused by personal memories, or by seeing family members in pictures, or from looking at disquieting pictures, the Hamburg Institute organised psychologists to be on hand at all the venues. In addition, Petra Bopp received dozens of phone calls in the exhibition office, either from veterans or their families who simply wanted to talk about wartime experiences. 'For a few,' said Heer, 'it is the last chance to free themselves from these images.'[25]

Other people reacted to the exhibition by sending in their own personal pictures. One former Wehrmacht soldier, Sammlung Hennetmair, sent a series of four images he had taken in Ukraine in June 1941. They showed the different stages of an elderly Jew having his beard cut surrounded by four young jeering German soldiers. Hennetmair was able to identify all of them.[26]

Another soldier loaned his photo album to the Hamburg Institute. Kurt Wafner, an anarcho-syndicalist who had been unable to avoid conscription, travelled east with the Landesschützen-Bataillon 332 through East Prussia and Lithuania to Minsk, where his job was to guard Soviet POWs. Due to his weak eyesight he was assigned indoor duties and worked in the camp canteen. Wafner did not take pictures himself but bought them from colleagues or exchanged them 'usually for a little tobacco'. They showed the ruins of Minsk, the Minsk Ghetto, hanged partisans, social occasions in the barracks, and the mass graves of Soviet POWs.[27]

Gerhard Gronefeld, a former official photographer for the Propaganda Kompanien (PK), also came forward with pictures that showed an execution of civilians at Pančevo, near Belgrade on 22 April 1941. In 1997 one of these pictures was published on the cover of *Der Spiegel* and became an icon of the exhibition. It showed hostages being executed next to a cemetery wall and an officer aiming his pistol at a dying victim. In an interview Gronefeld recalled the situation in which this photograph had been taken. It was just before Easter in 1941 and orders had been given to shoot ten Serbian hostages, who had been dragged from their homes. 'A group of soldiers were preparing to shoot a long row of men lined up against a cemetery wall. ... My hands were sweating and my knees shaking. The town commander yelled out the order to fire and they all fell like cards. ... It was the worst [photograph] I have ever taken in my life,' he said.[28]

Following its publication in 1997, Gronefeld received a letter from a pensioner in Stuttgart accusing him of faking the Pančevo picture because, he wrote, 'It didn't look very convincing.' After considering a reply, eighty-five-year-old Gronefeld wrote back, 'Why would I want to fake such a macabre execution?'[29] There was no reply.

There were other responses to Gronefeld's photograph. It transpired that many other soldiers had taken photographs of the execution at Pančevo and kept them as souvenirs. Some relatives of veterans had recognised the scene from pictures in family collections or photo albums and sent them to the institute. These pictures depicted the same execution scene, but taken from different vantage points,

and some had handwritten captions on the back. Through careful analysis of the pictures, Heer and his colleagues were able to piece together previously unknown details about the events at Pančevo.[30] These souvenir snapshots had become vital historical evidence. This was not the only case of soldiers' snapshots serving as evidence to historical fact. An execution in September 1939 of 300 Polish POWs at Ciepielów, in eastern Poland, was verified only in 1950 when the German soldier who had taken photographs at the scene anonymously sent five of them to the Polish Consulate in Munich with a covering letter describing the incident.[31]

The popularity of photography

Photography had been immensely popular in Germany before the war began. In a country in which around 10 per cent of the population – 7 million people – owned a camera. Soldiers were encouraged to take their cameras to war to provide that vital link between home and front – the same intended purpose as the Snapshots from Home scheme in Britain during the First World War. So widespread did photography become among German soldiers that some scenes of massacres, executions and public hangings resembled contemporary paparazzi events. In pictures taken at Zhytomyr in Ukraine, that show two men being publicly hanged, soldiers with cameras are also visible. One who described the scene said, 'The soldiers who were watching shouted "slowly, slowly," so they could take better photographs.'[32] Whether as perpetrators or as bystanders, it seemed soldiers wanted reliable evidence that they had been witness to these macabre scenes.

These snap-happy soldiers caused Nazi commanders to repeatedly issue orders that banned private photography. With specific reference to picture-taking at the mass executions of Jews, Field Marshal von Reichenau, Commander of the Sixth Army, banned photographs in the fear that the troops' morale might deteriorate as a result of the circulation of these photographs.[33] At his court martial in 1943, SS man Max Täubner, who took pictures at the execution of Jews in Ukraine during 1941, was reminded that picture-taking at executions was prohibited, although he claimed not to have known about the orders.

That same year Reinhard Wiener, who served with the naval command in Latvia, filmed the shooting of truckloads of Jews by SS men on the beach at Leipāja with his Kinekodak 8 mm film camera, even though he was advised by a fellow soldier not to visit the scene. 'While I was filming, my whole body was trembling,' he said. He sent the exposed film to be processed at Agfa in Wolfen, Germany, where he said there was no censorship. When he showed the film to a few chosen colleagues they were 'shocked' and told him: 'This is dangerous. Don't get caught.' Reinhard Wiener had kept his film until the 1990s when he decided to make it public.[34]

That so many veterans had kept their wartime images came as a surprise to Hannes Heer and his colleagues. There had been a number of notable periods after the war when it had been thought wise to get rid of what could have been seen as incriminating evidence. Many people destroyed their personal pictures in the late 1940s when Germany was occupied by the Allied forces and at the time of the International Military Tribunals at Nuremberg, and again in the 1960s and 1970s

during the trials of former Nazi officials. Heer told me that as a boy during the 1950s he had known that his uncles, who had served on the Eastern Front, had kept photo albums, although he had never seen them. He later discovered that the albums had been thrown away. Heer does not know when, by whom or why. Historian Walter Manoschek knew that his father had kept a photo album of his service in the Sixth Army during the march toward Stalingrad. He asked his father about the album in the 1990s while working on the 'War of Extermination' exhibition, but he was told that he had destroyed it, only a few days before.[35]

Many former soldiers kept their private wartime photographs hidden not only from their families but also, it seems, from themselves. German soldiers Hans-Joachim Gerke, Heinrich Jöst, Willy Georg and Joe J. Heydecker kept their now well-known pictures of the Warsaw Ghetto tucked away for the greater part of their lives.

Dr Hans-Joachim Gerke, who before the war had graduated from Liepzig University with a PhD in journalism, was a keen amateur photographer. While stationed in Warsaw as a member of the Luftwaffe transport unit he visited the ghetto driven by what he called 'the journalist's curiosity'. After the war had ended he returned to Germany and kept his 500 negatives hidden in the bottom drawer of a desk for the best part of forty years. When, in 1992, he decided to make them public he said, 'I was also moved to record the horrors of war and the misery of the people – its victims.'[36]

Heinrich Jöst had treated himself to a photo excursion to the ghetto with his Rolliflex camera on his forty-third birthday. He took his film to be processed in a photo shop in Warsaw. 'I was given the day off,' he said 'and decided to see what went on inside those walls.' After the war he kept silent about his ghetto pictures. 'I could not talk about these experiences,' said Jöst, 'I didn't want to make my wife and relatives feel uncomfortable. But one thinks automatically: "My God, what kind of world is this?"' In 1982 he gave his pictures to journalist Günther Schwarberg for publication in *Stern* magazine, but the editor turned them down. In 1988 they were exhibited at Yad Vashem, Israel's memorial to the Holocaust, with some unforeseen consequences. When Ahron Potschnik, who emigrated to Palestine in 1933, visited the exhibition he recognised his mother, whom he had not seen since before the war began. Jöst had taken her picture sitting at a food stall in a ghetto street. She is looking directly into the lens of his camera. When Potschnik had first seen the picture he cried out 'My mother, my mother!' For months afterwards he had nightmares, but then he said, 'I am grateful to that German soldier, because he gave me one last sign of life from my mother.' These personal snapshots, later used as evidence of the brutality of the Nazi regime, were also poignant evidence for those whose family members were murdered.[37]

Willy Georg, radio operator and former professional photographer, had been asked to go to the ghetto by his commanding officer, who was curious about what lay behind the walls. He processed the films in a photo laboratory in Warsaw before sending them home to his wife in Münster. It was more than forty years before Georg looked at those pictures. He wrote: 'I felt shocked to the core when I saw these photographs anew and recalled those times.'[38]

Photographer, writer and journalist, Joe J. Heydecker, who reported on the International Military Tribunals at Nuremberg, said that the pictures were 'still testimony to the fear I had when I took them long ago: that people might not believe that all this ever happened'. He had taken pictures, he said, so 'that this disgrace should not be forgotten, to keep alive the screams I wanted the world to hear'. But he did not choose to publish them until the 1980s. He said he was not sure why. By then he could no longer remember many of the details of his photo trips to the Warsaw Ghetto, but he said: 'The photographs speak for themselves.' He called them an 'aid to memory' – the exact words written by Michael Kimmelman in the *New York Times* about pictures of atrocities taken by perpetrators, including those taken by American soldiers at Abu Ghraib.

Heydecker wrote that he could not remember taking some of the pictures, including one that showed a balloon seller in the ghetto, who he said he had no memory of at all. If someone had asked him if he had seen balloon sellers in the Warsaw Ghetto, he would have said categorically, no. 'The idea would have struck me as absurd and I could have sworn on oath that that I hadn't. ... How careful one has to be with one's memories!' he said.[39] That photographs can be more reliable than memory was a point vehemently contested by some veterans and historians as the 'War of Extermination' toured Germany and Austria.

An aid to memory

During the late 1990s, as the 'War of Extermination' exhibition moved between towns and cities that a few years earlier had been separated by the borders between East and West Germany, it became clear that there were marked differences in how the past was being remembered. In Petra Bopp's opinion the exhibition was harder to confront for those who had lived in the East, because after Germany was divided in the 1960s, the German Democratic Republic (GDR) had entirely disassociated itself from National Socialism. Instead the wartime memory in the GDR had focused on the resistance and the communist fight against fascism. In this framework the crimes committed by the Nazis were seen as a consequence of imperialist and capitalist ideologies which were associated with West Germany. As historian Edith Raim writes:

> The Cold War and its aftermath had hindered the formation of an objective view, since each Germany had sought to make the other responsible for the horrors of Nazism. While East Germany saw capitalism as the root of fascism, and West Germany saw the former's socialism as equivalent to Nazism, both were prevented from coming to terms with their common history.[40]

In both West and East Germany photographs of Nazi crimes were used to support these different ideologies, although the type of pictures used by each side varied. In West Germany Nazi crimes were generally represented by images taken by American and British Army photographers and photojournalists at the liberation of the Nazi concentration camps in West Germany, or by images taken by PK photographers. In East Germany photographs taken by Soviet Army photographers at

the liberation of the Majdanek and Auschwitz-Birkenau, or those taken by German soldiers, of the kind found in the archives by Hannes Heer and his colleagues were used to place blame for Nazi crimes squarely on the West.

This polarisation of attitudes and use of pictures was fixed in the late 1950s following West Germany's inclusion in NATO, a period also marked by the spread of neo-Nazism in Western Europe. As a response a proliferation of Nazi atrocity pictures were hurled at the West by the Soviet Union and the Eastern Bloc countries in films, books, and reminiscences. In the Soviet Union the previously ignored recollections of those former Red Army soldiers and POWs who had been incarcerated in Nazi concentration camps were published.[41] In East Germany a series of documentary films was made by leading filmmakers Andrew and Annelie Thorndike on the theme of former Nazis who held positions of power in West Germany. One film, entitled *Urlaub auf Sylt* (*Holiday on Sylt*, 1957), concerned Heinz Reinefarth, who had played a leading role in the crushing of the Warsaw Uprising in August 1944 but who later became a Christian Democrat Mayor on the island of Sylt. Another film, *Operation Teutonic Sword* (1958), concerned General Speidel, who was a commander of NATO's Central European Land Forces from April 1957 to September 1963 and who, it was alleged, had been involved in Nazi war crimes.[42] The Polish authorities also protested at the publication of *1939–1945: We Have Not Forgotten* edited by Jerzy Tomaszewski, discussed in Chapter Four. Curiously, the picture taken in Ivangorod (Figure 4.1) was not included in 'War of Extermination'. Hannes Heer considered there was not sufficient information about the circumstances in which it was taken.

During this period, as a further consequence of the polarised ideologies in Western Europe, images of Nazi atrocities and the Holocaust became commonly associated with communist propaganda and were frequently dismissed. In the early 1960s the British Board of Film Censors (BBFC) refused to give certification to amateur film footage of the Warsaw Ghetto that in the 1980s became central to the representation of the Holocaust.[43] In the same period Willy Georg had offered his Warsaw Ghetto pictures to the Jewish community in the West German town of Münster, but they turned them down, possibly because they were regarded as propaganda from the East.

In the 1990s the type of criticism levelled at 'War of Extermination' made it clear that these Cold War attitudes to pictures were still prevalent in both the East and West. Critics in former East Germany dismissed the exhibition as an attempt to discredit communism and the country's anti-fascist stance.[44] In former West Germany, critics asserted that, since many of the pictures had been found in the archives of the former communist countries, they were probably communist propaganda. There were also personal attacks on Heer for his previous political involvement and activities. A former television journalist, Rüdiger Proske, called him a former communist and late-68er.[45] Jan Philipp Reemtsma also became the object of criticism. He was accused of funding the exhibition because he was ashamed of his family history. The Reemtsma family had had a monopoly on cigarette production in Nazi Germany and made a fortune. Reemtsma's father had been a business colleague of Göring, and his uncle Alwin was a member

of the SS.[46] In 1996, Reemtsma, who had inherited some of that fortune and used it to fund the Hamburg Institute, was kidnapped from outside his home in Hamburg and held hostage for thirty-three days until a ransom of 30 million dollars had been paid. In 2000 he wrote and published a book entitled *In the Cellar* in which he described his captivity. He also briefly considered whether his abduction had anything to do with the exhibition which, he said, had unleashed 'politically motivated controversy'. He concluded there was no evidence that it had.[47]

In Austria the public response to 'War of Extermination' was no less controversial. In 1938 Austria had been annexed to the German Reich and its army had been merged into the Wehrmacht. But the way Austrian veterans chose to remember their role varied. In 1995 filmmaker Ruth Beckermann made a film about the exhibition, based on interviews with members of the public and veterans, at its venue in Vienna. *East of War* includes angry and emotive exchanges between veterans and visitors who disagree about the role played by Austrian soldiers. But while Beckermann conducts interviews with veterans alongside the mounted photographs, she does not ask any of them whether they took pictures themselves. It is not clear why.[48]

In one scene, a veteran acknowledges that the photographs displayed on the walls around him tell the truth, but asserts that the crimes depicted were committed by Nazis. He points to an image that shows a row of civilians hanged from a balcony of a building in Kharkov. He said that he had personally seen scenes like this, but that the crimes had been committed by the Special Units and the SS and not by ordinary soldiers, and particularly not by Austrian soldiers. 'I and especially Austrian units never did anything like that. ... We are all shocked at all this dirt being poured over us after fifty years,' he said. As he spoke a man interjected and said that while he was stationed in the former German town of Breslau (now Wrocław, in Poland) he saw men and women being beaten and tortured. 'How can anyone justify themselves today?' he asked. 'The extermination was only possible because of the Wehrmacht ... willingly beating these people to death. ... The murderers are still among us we are all guilty because we just stood by and closed our eyes.'

Another veteran admitted that the soldiers of the Wehrmacht had committed atrocities but added that so had other armies. He also rejected the idea of personal guilt and said that as a Sudeten German he had also suffered. 'I find it one-sided and strange that German historians should show their own army in such a negative light and not the atrocities of other armies that were just as horrible.' An elderly man denied knowing anything about atrocities. He said: 'I was in Russia at the front and behind the lines but I never heard anything about atrocities,' while another man said, 'I find the exhibition deeply shocking ... it is strange to hear people who don't seem to remember.'

In another scene, Ruth Beckermann approached a veteran and asked him why he came to the exhibition. He answered, 'To see what I experienced at first hand again. ... It is a hundred per cent accurate.' Another quietly spoken man, who had been in the Sixth Army right up to Stalingrad, said that he had witnessed the hangings in Kharkov. 'It is the truth that is being shown here,' he said, '... the photos

here are true ... there are lots of photos of Kharkov. People were hanged from balconies of houses, from gas street lamps. It was minus four degrees and they'd frozen solid like blocks of wood. If one walked through the streets at night when the wind was blowing it made a terrible noise, the corpses banging against each other. It was gruesome.'[49]

Beckermann also asked a woman, who appeared visibly agitated and angry, for her reaction to the exhibition. She responded by saying that it makes all members of the Wehrmacht out to be murderers. 'I can't believe that,' she said. 'I don't believe my uncles are murderers. I don't believe my grandfather is a murderer. I can't believe that, otherwise I would have to hang myself.'

Interpreting the evidence

As the popularity of the exhibition gathered pace so did its critics. In February 1997 an angry crowd of more than 5,000 veterans and right-wing organisations gathered in the centre of the Bavarian capital of Munich to protest about the opening of the exhibition in the town hall. During a television report on the events, a journalist asked the question that was at the centre of the dispute: 'The Wehrmacht was a criminal organisation but does that mean that all its members were criminals?'[50]

Peter Gauweiler, the leader of the Munich branch of the Christian Social Union (CSU), sister party to the Christian Democrat Party (CDU), was one person who thought not. He boycotted the opening ceremony and instead placed a wreath on the tomb of the Unknown Soldier. 'The aim,' he said, 'was to defend the honour of the Wehrmacht.' He called the exhibition 'historically incorrect and manipulated' and cast doubt on the authenticity of many of the photographs.[51] In other cities Mayors from the CSU followed suit and refused to attend the official openings. Hans Zehetmair, the Bavarian Culture Minister, advised teachers not to take their pupils to see it.[52]

In Bonn, Volker Rühe, the German Minister for Defence, banned branches of the Bundeswehr (German Federal Armed Forces) from 'events taking place within the framework of the exhibition' which included discussions and debates, or any official contact with those responsible for it. War veterans including CDU politician Alfred Dregger, a former chairman of the Free Democratic Party (FPD), and former Wehrmacht officer Erich Mende, appeared on television alongside Helmut Schmidt (SPD) to defend the 'besmirched honour of the Wehrmacht'.[53]

The culmination of the events that led up to the demonstration in Munich and the protest itself led to the isolation of the right-wing opposition. The government could no longer remain silent. On 13 March 1997, the exhibition became the subject of an emotive debate in the Bundestag (the German Parliament) that seemed to act as an official sanctioning of the exhibition. Members from all parties attempted, sometimes in a very personal and emotional way, sometimes in tears, to come to terms with this previously unacknowledged aspect of German history.[54] From then on critics were subdued and increasing numbers of public institutions including museums, archives, adult education centres and universities, expressed interest in hosting the exhibition. Public discussions and forums became an integral part of the

exhibition in each of its venues. The list of public figures prepared to be associated with it increased. By the end of 1997 an English-language version of the exhibition was in preparation which was due to open in New York in December 1999.

Then, unexpectedly, another wave of criticism blew up, this time not from veterans or right-wing groups, but from fellow historians, who accused the Hamburg Institute of fabricating photographic evidence. At the centre of the allegations was a photograph included in the exhibition that showed a crowd of men, some naked, others partially clothed, and others in the process of taking off their clothes, apparently on a riverbank. The text read: 'Jews preparing for execution'.

Franz Seidler, Professor of Modern History at the University of the Bundeswehr, a defender of the Wehrmacht and fierce opponent of the exhibition, wrote that the photograph actually showed 'a column of Jews bathing'. Seidler based his assertion on the fact that the same picture had been reproduced in a book called *Deutsches Vorfeld im Osten* (German Area in the East) published in Nazi-occupied Kraków in 1941 by the publisher Helmut Gauweiler, the uncle of the CSU leader, Peter Gauweiler. Franz Seidler said: 'Nobody who treats sources and photographs in this manner has any right to be taken seriously. When dealing with such a complex topic... historical honesty... is an absolute necessity.' Seidler's accusations provoked more newspaper headlines, but this time they reflected a more cautious attitude towards the idea that photographs tell the truth. One headline stated, 'The dubious power of pictures', and another 'A false picture of war'.[55]

Hannes Heer had first come across the image of the 'Jews bathing' in a photo album at the *Zentrale Stelle der Landesjustizverwaltungen zur Aufklärung nationalsozialistischer Gewaltverbrechen* (Central Office of the State Justice Administration for the Investigation of National Socialist Crimes) in Ludwigsburg, an institute established in 1958 for the purpose of compiling and collating documentary evidence to present during the West German trials of SS men and Nazi officials that took place during the 1960s and 1970s. It transpired that the album had been assembled some time in the late 1950s shortly after the institute had been established. On the same page as the photograph of the 'Jews bathing' were three other pictures, two of them showing a group of elderly partially clothed Jews digging, taken from different perspectives. The other photograph shows three naked men standing on the edge of a death pit. Another man and a boy, also naked, are walking towards the pit. Behind them are seven perpetrators, some armed. The page was captioned: 'The Jews are forced to dig a mass grave and undress and are then driven into the pit.' Hannes Heer had no reason to believe that the caption was wrong.[56]

Following Seidler's accusations, Heer began to search in other archives for copies of this photograph in the hope that he might find more information. At the United States Holocaust Memorial Museum (USHMM) in Washington DC he found four copies of the 'death pit' picture, each from a different archive. I have seen copies in other archives in Britain, Poland and Israel, each time with a different caption and information regarding the location and the date it was taken – including in Poland, Lithuania, Latvia in 1939, 1941, 1943 or 1944. I also found a copy in the Polish Institute and Sikorski Museum in London. This was the first copy I had seen that included a man in the right-hand frame of the picture seemingly directing

proceedings. The text on this version of the picture reads: 'Śniatyń – tormenting Jew before their execution II.V.1943'. Whether this text is correct cannot be verified. Śniatyń is now in Ukraine.[57]

With the interpretation of that picture unresolved, two years later more accusations followed. Krisztián Ungváry, a Hungarian historian, questioned the caption of another photograph. It purported to show an execution of Serbian youths – five victims are visible in the pictures – by the Wehrmacht in the Yugoslavian town of Stari Bečej. He argued that the town had never been occupied by the German Army, but by the Hungarian Army, and that the execution had been carried out by Hungarian soldiers. Ungváry knew this, he said, because although the executioners were wearing German helmets they were First World War helmets and the uniforms were Hungarian, not German. These were details that the Hamburg Institute historians had overlooked. On this basis Ungváry publicly claimed that if the interpretation of this photograph was wrong, then the interpretation of 90 per cent of the other pictures was probably also wrong.

In 1999, following on the heels of this criticism, a Polish historian called Bogdan Musial, then working at the German Historical Institute in Warsaw, launched an attack on other pictures in the exhibition. These allegations proved to be much more serious and far reaching. The ten pictures in question had been taken in Złoczów, a small town in Galicia, formerly in eastern Poland, now in Ukraine. They show rows of the dead lined up in the streets. In some of them German soldiers can be seen standing alongside the corpses. Hannes Heer had come across these pictures in the State Archives of the Russian Federation in Moscow (GARF). The majority of pictures did not have captions, and there was no information, except that they had been found among the possessions of a German soldier called Richard Worbs. To Hannes Heer it seemed clear what the pictures showed; the German soldiers in the photographs were responsible for these murders or at least involved as witnesses. But to Bogdan Musial the photographs had an entirely different meaning. The dead in the photographs had not been killed by German soldiers, but by the NKVD – Stalin's secret police – *before* the German Army had arrived. It transpired both interpretations could have been correct.

In September 1939 Złoczów and other towns in the eastern regions of Poland were occupied by the Soviet Union under the terms of the Nazi-Soviet pact of August 1939. In June 1941, as the German Army advanced into this Soviet-occupied territory, the NKVD did kill many thousands of Polish, Ukrainian and Jewish prisoners before they withdrew. In Lvov (Lvov in Russian, Lwów in Polish, Lemberg in German and now L'viv in Ukrainian) an estimated 4,000 people who had been imprisoned in the city's prison were murdered by the NKVD. After the Soviet withdrawal, and before the Germans arrived, the city's residents began to exhume the bodies to identify missing relatives. When the Nazis arrived on 30 June 1941 and discovered the unearthed victims of the NKVD they seized the opportunity and publicly blamed the Jews for the killings, claiming that the Jewish-Bolshevik enemy was still a threat to the German nation. The Nazis took pictures of the bodies and used them to incite a pogrom against the Jews. According to Gerald

Reitlinger, in his book *The Final Solution*, in Lemberg some of these photographs were posted in shop windows as evidence of the so-called 'Jewish killings'.[58]

These pictures were widely distributed by the Nazi propaganda machine not only in Lemberg, but in Germany and in Britain as anti-Soviet propaganda. In July 1941, two images that showed weeping relatives alongside exhumed bodies were published in the *Daily Mirror*, with an accompanying article by Sir Stafford Cripps, the then British Ambassador in Russia. Cripps attached his own meaning to the pictures. He did not believe the Nazi version of events and wrote that when the Russians evacuated Lvov the 150 prisoners were 'in good health'. They had been murdered by the 'Huns,' he wrote, 'just to make propaganda pictures'.[59]

During the pogrom in Lemberg thousands of Jews were killed. Photographs thought to have been taken at the pogrom have survived. They show half-naked and terrified looking women with torn clothes running through cobbled streets pursued by civilian men armed with sticks. German soldiers are visible in some of the photographs. One image shows three German soldiers filming from the back of a truck.[60]

In 2001, twenty-four of these pictures were sent anonymously from Hamburg to the Wiener Library in London with an accompanying letter. It stated that the pictures had been stored for safekeeping in a psychotherapy practice for thirty years. It noted that the soldiers visible in the pictures were members of the Wehrmacht and not the SS. It is likely that the person who had sent them was prompted to do so by the debates and controversy surrounding the 'War of Extermination' exhibition.[61]

In the summer of 1941, the same pattern of events in Lemberg also took place in Tarnopol and Złoczów, including pogroms. In Tarnopol a soldier wrote a letter to his parents in Germany, dated 7 June 1941, in which he described the pogrom. 'So far we have sent about 1,000 Jews into the hereafter, but that is far too few for what they have done. The Ukrainians have said that the Jews had all the leadership positions and, together with the Soviets, had a regular public festival while executing the Germans and Ukrainians. I ask you, dear parents, to make this known, also father, in the local branch (of the NSDAP). If there should be doubts, we will bring photos with us. Then there will be no doubts.'[62]

The German Army had arrived in Złoczów, where around half of the town's 20,000 inhabitants were Jews, on 1 July 1941. Several hundred of them were made to exhume the bodies of the NKVD's victims. A pogrom was incited and more than 2,000 Jews were rounded up and taken to the citadel and killed over a five-day period. The pogrom was known to have been photographed by a large number of soldiers, including at least one who had a film camera. One Jewish survivor who recognised some of those in the pictures wrote: 'Many German officers watched the pogrom with calm cynicism, clicking their cameras all the time. A few months later I happened to come across some of these photographs in an illustrated German weekly. One of them depicted the scene at the citadel, with women weeping over a pile of corpses. Among these I definitely recognised Lusia Freiman, the daughter of Shyjo and Dziunka Kitaj. The photo bore the caption: "Ukrainian women mourning their husbands, who were murdered by Jews." '[63]

In order to confirm some of these events, in March 1999 an elderly man, originally from Złoczów, called Shlomo Wolkowicz, then living in Haifa, Israel, was invited to the Hamburg Institute to tell his story. He brought with him a photograph taken on 3 July 1941 that, he said, showed rows of the bodies of Jews massacred by the German Army. Wolkowicz knew this because he was among those lined up on the edge of a mass grave ready to be shot. But the bullets had missed him and although he fell into the grave he was not physically harmed. Left for dead by the German soldiers, he described how he survived by lying still under a pile of corpses waiting for the Germans to leave.

Shlomo Wolkowicz had seen the picture in a biography of General Otto Korfes, one of the commanders responsible for the massacre. He recognised the scene of the crime as being that from which he had escaped.[64] But his assertions about the picture had no bearing on the consequences of the controversy.

Dangerous memories

In November 1999, the 'War of Extermination' exhibition was on display in Osnabrück with a hundred more venues waiting to host it – including the Cooper Union in New York City. An English-language catalogue entitled *The German Army and Genocide: Crimes Against War Prisoners, Jews and Other Civilians, 1939–1944* was already on sale in the USA. But even so, with controversy over the pictures intensifying, and public and political pressure increasing, Jan Philipp Reemtsma decided to withdraw the exhibition from the public domain. In his opinion the exhibition and the Institute had lost credibility.[65]

Jan Philipp Reemtsma declared a moratorium and ordered a thorough investigation into the photographs and the documents. He invited a panel of eminent historians, including Omar Bartov, to form an independent commission to investigate the authenticity of the pictures, and if necessary revisit the relevant archives. That process took almost a year. On 15 November 2000, after extensive debates and rigorous research, the commission presented its final report. While Heer and his fellow historians were criticised for a 'remarkably casual use of photographic sources' the report acknowledged that the picture research methods were no different to those employed by curators of other exhibitions and that some mistakes had been made due to the fact that some archives filed their pictures without captions or context.

But the report also praised the team and stated that 'no historical exhibition involving photographs has ever been so thoroughly researched.' It went on to say that although mistakes had been made, out of the 1,433 photographs on display in the exhibition, fewer than twenty should be withdrawn due to questionable or inaccurate captions. Importantly, it concluded that in just two of the twenty photographs that showed either German or NKVD crimes in Galicia, victims of the NKVD had been falsely referred to as victims of the Wehrmacht.[66]

To Hannes Heer and his colleagues the report vindicated their work and demonstrated that a great deal of criticism thrown at the exhibition had been unfounded. Heer assumed that the report would mark the end of the matter and the exhibition programme would be resumed. But his assumption proved to be wrong. On

4 November 2000, Jan Philipp Reemtsma pre-empted the final conclusion of the independent commission and took a decision to permanently withdraw the exhibition. He also sacked Hannes Heer.

Reemtsma then employed a new group of historians and designers to create a second exhibition. On 27 November 2001 'Verbrechen der Wehrmacht: Dimensionen des Vernichtungskrieges 1941–1944' ('Crimes of the Wehrmacht: Dimensions of the War of Annihilation 1941–1944') opened in Berlin. The Defence Minister, Rudolf Scharping, who had prevented soldiers from contact with the previous exhibition, attended the opening. The press reaction was positive and the general consensus was that this exhibition had a more objective tone, a view reflected in the headlines 'Sophistication replaces provocation', 'strictly factual', 'less provocation, more objectivity' and 'more context, less emotion'.[67] The overall message of the exhibition seemed little changed, but one central question had been removed: how could these crimes have occurred? The Holocaust, which was the common axis of the original exhibition, was only one of six sections on Nazi war crimes, and the role of the Wehrmacht was substantially reduced.

The design of the exhibition, and the 750-page catalogue, were cool and clinical, and consisted predominantly of text, diagrams and documents. Hannes Heer likened the new exhibition to 'reading an academic book'. He said that it had been 'not made out of consideration for the aesthetics, but rather on the basis of a radical assessment of the value of photographs as source material'. The number of photographs was reduced by half, and most of these were mounted on desks reserved for additional documentation. The soldiers' pictures which had been given a status of historical evidence in the first exhibition, albeit unintentionally, had been reduced to supplementary source material – as illustrations to the texts, that is if they were used at all. They had fallen into the same uneasy space between private mementoes and historical evidence – as did the pictures taken at Abu Ghraib, and other snapshots taken by troops of their own brutality. An article in *Frankfurter Allgemeine Zeitung* stated that it was as though 'those responsible for the exhibition had almost completely lost confidence in the pictures.'[68] In place of the hundreds of soldiers' snapshots, 'Crimes of the Wehrmacht' included around seventy uniformed studio portraits of generals and those in command who presided over each section of text, documents, maps and other photographs, a layout that reinstated the myth that it had been generals, officials and SS men who had been responsible for the war crimes committed, and that the Wehrmacht were merely carrying out orders.[69] As an article in *Der Spiegel* stated, it was 'no longer the ordinary soldiers, but Hitler's generals in the dock'.[70]

On display were also the professional photographs of PK photographers whose job had been to produce propaganda pictures for use in the Nazi press, though this was not mentioned in the exhibition. Instead these pictures relied on the perceived authority and 'objectivity' of professional pictures. In a section that dealt with the execution in Pančevo, only those pictures taken by PK photographer Gerhard Gronefeld were used, and none of those taken by soldiers. The professionalism of Gronefeld's photographs, and those of other PK photographers, was further legitimised by the fact that they had been filed and catalogued in official German

archives, rather than in the perceived chaos of largely unknown state archives of the former Soviet Union, or, worse still, hidden among the personal possessions of former Wehrmacht soldiers.

Once again, it was not necessarily the crimes that were in question but the snapshots that showed the proof. It was one thing for soldiers to take pictures for themselves and their comrades, but it was quite another for them to be foisted on the civilian population.

The personal reflection that the amateur pictures in 'War of Extermination' had demanded of its audience was not required by the professional pictures in the second, and a lid was placed firmly on difficult and awkward memories. The German soldiers – 10 million at the Eastern Front – in their role as amateur photographers had become 'questionable eyewitnesses' and their pictures were withdrawn. Hannes Heer wrote: 'It was the private pictures that had vanished. The grinning faces captured in front of the frozen dangling corpses, the pistols in the back of the victims necks, the toecaps of soldiers' boots at the edge of the excavated pits filled with bodies: none of this counted any more as a meaningful source supposedly because one could no longer determine who the photographer was, where and when the picture was taken, which studio developed it, who owned it, or how and when it found its way into the archive.' To Hannes Heer the lack of soldiers' pictures was a catastrophe. 'It was the pictures and the people's emotions that were the most important thing...it involved each German and he [Reemtsma] hated these emotions because they were too dangerous.'[71]

The justification for the changes had been made on scientific grounds. Jan Philipp Reemtsma said that pictures would only be used when the content and provenance was not in dispute and where 'it is always clear what they are saying.' But this impossible task being asked of pictures would in Heer's view deem all images as 'too dangerous' and limit their use as historical evidence. It would be the equivalent to 'rendering the photograph inadmissible as evidence in a court of law,' said Heer.

In 2005 in a military court at Osnabrück, the last town to display the 'War of Extermination' exhibition before it was withdrawn, a number of soldiers' pictures were in fact presented as evidence; however, the pictures were not taken by Germans, but by British soldiers in Iraq.

SIX
Inadmissible Evidence

As a witness of war, photography's status is assured,
but the role and veracity of the witness is always open
to question. *Val Williams*.[1]

'Britain's Abu Ghraib'

In January 2005 at a military garrison in Osnabrück, Germany, which had once served as a base for Hitler's Wehrmacht, a British Court Martial was asked to attempt to answer a question that has preoccupied scholars and historians for more than a century – whether or not a photograph can tell the truth.

At the trial, described as 'Britain's Abu Ghraib', the Judge Advocate Michael Hunter instructed the jury – a board of seven military officers – to pronounce on the meaning of a number of photographs that involved three British soldiers: Corporal (Cpl) Daniel Kenyon, Lance Corporal (LCpl) Darrel Paul Larkin and Lance Corporal (LCpl) Mark Paul Cooley from the 1st Battalion The Royal Regiment of Fusiliers, at a British army base near Basra in southern Iraq. The charges against them ranged from 'Prejudice to Good Order' to 'Military Discipline'. Only one soldier, LCpl Larkin, pleaded guilty.[2]

The pictures were taken during the course of one day in May 2003, two months after the American-led invasion of Iraq, two weeks after former US President George W. Bush declared an end to major combat operations and five months before the infamous Abu Ghraib pictures were taken by American soldiers. Some were innocuous snapshots of smiling soldiers and Iraqi children but others showed male Iraqi civilians being subjected to abuse, cruelty and humiliation. Three photographs showed two Iraqi men engaged in simulated anal and oral sex.

That photographs were being used as evidence in a court of law was not in itself unusual. Since the mid-nineteenth century, photographs had been admissible as legal documents in courts of law. In the 1960s S. G. Ehrlich, a specialist on the subject of 'legal' photographs, wrote a seminal work on the topic. He said that a photograph could be worth hours of testimony and argument and serve as an effective means of informing and persuading judge and jury. But Ehrlich also acknowledged – and these were among the concerns addressed at Osnabrück – that there are differences between what the camera records and what a human witness sees at the time the exposure is made. Counsel must bear in mind, he wrote, that 'the eye

does not see in the same way that the camera sees, nor does a photograph reproduce, except approximately, what was seen by a human observer in the camera's position at the time the exposure was made. ... In different situations, one may be better than the other, but they never perceive and record alike.' He also asserted that legal photographs should 'strive for accuracy' rather than 'dramatic effect', which he said was achieved by unusual camera angles or manipulative darkroom techniques. Legal photographs, he wrote, 'should be rich in information but not expensive in appearance'. Any attempt to 'dramatise' a picture would, he wrote, lead jurors to conclude that the image could not be trusted.[3]

This was the conclusion drawn at the War Crimes Tribunals held at Leipzig in 1921, where twelve German soldiers were accused of crimes mostly related to ill-treatment of prisoners of war and unlawful submarine warfare.[4] The decision was based on the fact that during the First World War a glut of 'atrocity' images had been widely circulated as propaganda by all sides, and some were discovered to have been faked. It was considered that the use of pictures as evidence could call into question the 'truth' of the images and therefore might undermine the legitimacy and integrity of the courts.

By the end of the Second World War at the trial of twenty-two leading Nazis at the International Military Tribunals at Nuremberg (1945–9), that was not a consideration. This time a large and diverse collection of images of atrocities was presented as undisputable evidence. Some had been taken by British, American and Soviet military photographers at the liberation of the concentration camps in Germany and Poland. Others had been taken officially by Nazis or as souvenirs by German soldiers, as discussed in Chapter Five. But at Nuremberg who had taken the pictures and why was not necessarily considered important. What was important was what they showed or appeared to show.

Whereas at the Nuremberg tribunals images were used as additional material to support documentary evidence, at Osnabrück the photographs were the crux of the case. So the truth of the images – their precise meaning, and who had taken them and why – was fundamental, though their interpretation was a matter for dispute. While the prosecution argued that the photographs should be taken at face value, the defence argued that the true meaning of the pictures could more accurately be determined by establishing what was happening outside the frame of the photograph at the time the shutter was released.

One image, referred to by the court as Photograph 19, shows LCpl Larkin wearing black boxer shorts and sandals. In his left hand he is holding a 'cam pole' – a pole used to support camouflage netting (Figure 6.1). He is standing with both feet on top of a partially clothed blindfolded Iraqi man who is lying in a foetal position, on the ground. The man is wearing orange boxer shorts and a white vest; his head and torso are covered by blue cargo netting. There is a pool of liquid at his feet. Three people are taking photographs at the scene. One soldier, who can be seen behind Larkin holding a camera to his eye, is identified as Cpl Kenyon, a veteran of Operation Desert Storm (1991). The other soldier on the right-hand side of the frame also appears to be taking a picture, although his identity is not known. It was not established who had taken Photograph 19, although the film was taken from the camera of Fusilier O'Toole.

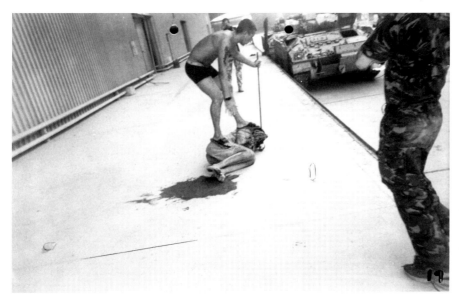

Figure 6.1 A photograph taken by a British soldier in Iraq in May 2003 and presented as evidence at the court martial of three British soldiers in Osnabrück; referred to by the court as Photograph 19.

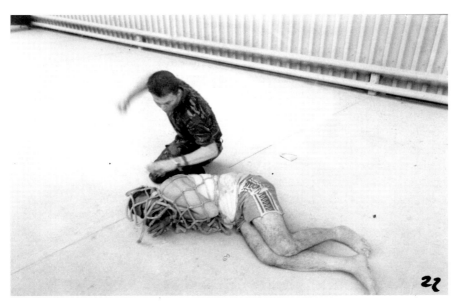

Figure 6.2 A photograph taken by a British soldier in Iraq in May 2003 and presented as evidence at the court martial of three British soldiers in Osnabrück; referred to by the court as Photograph 22.

The Iraqi man in Photograph 19 (Figure 6.1) also features in another picture referred to in the court as Photograph 22 (Figure 6.2). In this image, LCpl Cooley is kneeling next to the man, who can be seen to be blindfolded. Cooley's arm is raised as if about to punch the man.

LCpl Cooley also appears in another photograph, referred to by the court as Photograph 9 (Figure 6.3). He is seen sitting at the wheel of a forklift truck and appears to be smiling as he looks up at another Iraqi man who is suspended on

Figure 6.3 A photograph taken by a British soldier in Iraq in May 2003 and presented as evidence at the court martial of three British soldiers in Osnabrück; referred to by the court as Photograph 9.

the raised forks. The man has cargo netting over the upper part of his body and a grimacing expression on his face. In the background are two military vehicles, one flying an English Saint George's flag, the other a British Union Jack.

These pictures were taken on 15 May 2003 at Camp Bread Basket, near Basra, presumably named because it was being used as a storage and distribution depot for humanitarian aid. At the time it was being looted with regularity by local Iraqis. In order to catch the culprits, the camp's commanding officer, Captain Daniel Taylor, launched an operation pointedly code-named Operation Ali Baba – a presumed reference to the Hollywood film *Ali Baba and the Forty Thieves* (directed by Arthur Lubin, 1944). On the morning of the operation Captain Taylor had given orders for the soldiers to go 'Ali Baba hunting', capture the looters, bring them back to the camp and 'work them hard', even though such an order is contrary to international law and was in contravention of Article Four of the Geneva Conventions on Human Rights, which forbids the use of prisoners as forced labour.[5] The army authorities had decided that Captain Taylor had indeed broken the law but that he had acted with 'well-meaning and sincere but misguided zeal'. Rather than facing prosecution, Captain Taylor, who had thrown away his service notebooks only two weeks before he gave evidence because he was 'downsizing' his house, was promoted to the rank of major. According to witness Fusilier Thorne Sergeant Major Jackson, had also given the following order to soldiers. He said: 'If you catch any Choggies, give them a beating, if you're not man enough, bring them down to us and we'll do it for you.'[6]

On the day of Operation Ali Baba, around twenty-eight captured Iraqi men were marched around the camp with the looted boxes containing dried milk, on their heads. At one point they were gathered together at the cookhouse where LCpl Cooley testified that they 'looked like they had been beaten, dragged

around ... basically, they looked battered'. Captain Taylor had addressed the prisoners through an interpreter and told them that photographs would be taken and given as evidence to the local police. After his announcement 'several cameras appeared'.[7]

Despite Captain Taylor's declaration none of those in command seemed sure whether taking pictures of the prisoners was lawful. A British senior legal adviser in Iraq, Lieutenant Colonel Nicholas Mercer, responsible for informing soldiers about the correct procedures for the treatment of prisoners, said there were no orders that people were not to be photographed and that it might be appropriate to photograph prisoners. He considered that if the Iraqis were told that their pictures would be shown to the Iraqi police then that might act as a deterrent to further looting. He conceded that as long as they were not 'paraded or made the subjects of photographs that would offend dignity' then taking pictures was acceptable.[8]

But the Judge said that the photograph taken outside the cookhouse of the group of twenty-eight Iraqis – referred to by the tribunal as Photograph 7 – seemed to have been taken 'for the key reason of producing trophy photographs'. The definition of a trophy picture was explained to the court martial by Mr Joseph Giret, Defence Counsel for Cpl Kenyon, who said:

> ... Soldiers have taken trophy photos since cameras have been permitted to be taken into the field. We know that. We know through all sorts of theatres because we have seen the results of not just the Don Macullens [transcript error] of the world, and the war photographers who have produced epic and extraordinary scenes from wars. ... But we also know that soldiers often find them a way of releasing, becoming comfortable with the scenes that they were witnessing at first hand. It is an extraordinary subject in fact, as you will no doubt know far better than I, that soldiers in the field have taken trophy photographs from campaigns in the Far East, Africa, Crimea, and of course the Second World War and the First World War. They are taken for good reason, and nobody has ever criticised them, although people have plainly said that the contents are sometimes difficult to digest. But it is a fact and it is not surprising is it, that soldiers will one day wish to reflect on precisely what they had been involved in. So there it is.[9]

The incriminating pictures

The soldiers' pictures had come to the attention of the authorities less than two weeks after they were taken. On 28 May 2003 eighteen-year-old Fusilier Gary Bartlam, from Dordon, Warwickshire, took two rolls of film to Max Spielmann's photo processing shop in Tamworth in Staffordshire. The films included the picture of LCpl Cooley driving the forklift truck (Figure 6.3) and three pictures of two naked Iraqi men involved in simulated sex. When shop assistant Kelly Tilford saw the photographs she was horrified. 'I felt sick when I looked at the pictures,' she said. 'They were grim. I just felt awful ... I immediately realised something terribly wrong had happened and something had to be done about it, I started shaking and was panicking.'[10] She decided to inform the police.

When Gary Bartlam returned to the photo shop to pick up his pictures the civilian police were waiting for him. When they asked him whether or not the photographs were his, he replied: 'Yes, they are. I know I should have destroyed the evidence.'[11] Bartlam was arrested and handed over to the army's Special Investigation Branch (SIB) and taken into military custody at Colchester. The *Sun* newspaper was quick to pick up the story and ran a front-page headline that read: 'Squaddie held over "torture" snaps of Iraqi POWs', but without the pictures the story made little impact. The images were not released to the public until the first day of the soldiers' court martial in Osnabrück, some twenty months later in 2005.

Among friends and colleagues, Gary Bartlam was known as a keen amateur photographer.[12] He compiled albums of photographs that depicted his life as a soldier, including a visit to Auschwitz-Birkenau. Following his arrest he was sent on a tour of duty in Kosovo and accepted onto a military photography course, which in hindsight an army spokesman said was 'unfortunate' but added that, 'photographing people was a core skill'. In response to the discovery of Bartlam's pictures, his mother was reported as saying: 'If [his photos] were so wrong, why did they send him on a course?'[13]

On 10 January 2005 Gary Bartlam, who was originally due to stand trial with three colleagues, faced his own court martial at the Military Court Centre (MCC) at Höhne in Germany a week before the Osnabrück hearing began. He pleaded guilty to all charges related to disgraceful and indecent conduct. Lieutenant Colonel Nick Clapham for the Army Prosecution Authority (APA) said that what was important to the case was not only the act of photographing but 'the effect of that photography and the context in which that photography took place'. While the court accepted that Bartlam was not responsible for instigating the scenes depicted in his pictures, it concluded that taking photographs amounted to 'wilful encouragement'. On 11 January 2005 he was given a custodial sentence of eighteen months in 'an appropriate institution', reduced from two years on account of his guilty plea and the assistance he had given the authorities during their investigations. He later gave evidence at Osnabrück. He was dismissed from the army with disgrace. Following an appeal Bartlam was released in June 2005. Mr Justice Wakerley said that the case was unfortunate because among the 'gross and disgusting' pictures that Bartlam had taken were some that showed 'himself and his fellow troops ordinarily enjoying themselves, and sympathetic photographs of Iraqi children and Iraqi civilians around the camp'.[14]

After Bartlam's arrest the military authorities had begun an investigation that led them to other members of the Royal Regiment of Fusiliers, including Cpl Kenyon. When police turned up at Kenyon's home he said that he knew that it was about 'what was in the news' and had been expecting them. He pointed to a cupboard and said: 'All the photographs I have are in that drawer.' The police confiscated three packets of negatives and colour prints and Kenyon was arrested 'on matters of ill treatment and torture' although his photographs were later considered to contain no incriminating evidence.[15]

On 18 January 2005 when the court martial at Osnabrück began, these and other pictures were presented as evidence by Lieutenant Colonel Clapham on

behalf of the APA. One set of pictures compiled as a 'Compilation Album' consisted of around ninety soldiers' pictures described by the Lieutenant Colonel as 'innocent photographs' which, he said, would be referred to during the course of the hearing as 'happy snaps' and which the Judge said were 'of no evidential value'. They included pictures of soldiers posing and smiling for the camera, smiling Iraqi children, a dog in a street and Iraqi landscapes – similar to the tourist photographs found on the CDs that belonged to the American soldiers at Abu Ghraib.

Another folder of twenty-two pictures, including Photographs 9, 19 and 22, (Figures 6.1, 6.2 and 6.3) had been taken from the cameras of five different soldiers including one from the camera of LCpl Cooley and fourteen from the camera of Gary Bartlam. In order that these pictures could be put in context, official 'scene of the crime' photographs and a video taken by the SIB were also presented to the court. They included a satellite image, and more than thirty detailed pictures of the locations and warehouses where the alleged incidents had taken place.[16]

When Lieutenant Colonel Clapham presented the trophy pictures to the court he gave a warning in what he called this 'unusual case' against making an immediate judgement on what the photographs appeared to show. He said:

> ... It cannot be said that those photographs depict images that are anything other than shocking and appalling. But, notwithstanding the nature of the photographic evidence, gentlemen, I have to, I believe, caution you against allowing that shock, perhaps a feeling of being appalled on seeing these for the very first time, to caution you against that being allowed to influence your objectivity in the case when you come to decide not if these incidents happened, because already it is apparent that these incidents happened. What I have to prove, and what you have to decide, is what role, if any, these defendants played in these incidents. And that is a different question. So I ask you not to allow yourself, your prejudice, and I am sure it will not be, but of the shock and the appalling nature of those photographs to unduly influence you. In effect, I invite you to approach this case with an attitude of clinical objectivity as it were ...[17]

On the first day of the five-week trial, the Judge made a decision to release the twenty-two incriminating pictures to the media, though he appealed to members of the press to 'exercise responsibility' when publishing them. In order to protect the Iraqis from further humiliation he requested their identity should not be revealed and asked a member of the press, trained in digital imaging, to 'pixellate' the faces of the victims. He was also concerned that if Photographs 19 and 22 were reproduced in black and white the pool of liquid visible in both pictures might be interpreted as blood and not water, which he said it no doubt was. The Judge's assumption seemed to have been based on the fact that there is a bottle of water visible in one of the other photographs – though he confessed that when he had first seen the pictures 'photocopied in monochrome', he had himself assumed that the Iraqi was lying in a pool of his own blood.[18]

Within hours of their release, the pictures were circulating online. On 19 January 2005, Photographs 9, 19 and 22 (Figures 6.1, 6.2 and 6.3) were splashed

across the front pages of British national daily newspapers. The headlines predictably drew parallels between these pictures and those taken by American soldiers at Abu Ghraib which had made headline news only nine months before. The *Guardian* ran a headline: 'Shocking images revealed at Britain's "Abu Ghraib trial"', while the London *Evening Standard* asked: 'Is this Britain's Abu Ghraib?' The *Sun* ran with the headline: 'Brute camp, Brit soldier and an abused Iraqi' and reminded its readers that the Osnabrück trial had begun just a week after Charles Graner had been jailed for ten years for his role in the Abu Ghraib picture scandal. The newspaper also carried a comment from author and former SAS veteran Andy McNab, who had been interned and tortured in Abu Ghraib prison during Operation Desert Storm. He wrote: 'These shocking photographs will soon be on the streets of Iraq – and I fear that they will act as a recruitment for Al-Qaeda'.[19] Some Arab press chose not to publish the pictures. Abdel Bari Atwan, editor of the London Arab daily *Al-Quds al-Arabi* said: 'People would say it's tasteless and accuse us of encouraging pornography.'[20]

Despite the dramatic headlines, the image of a soldier raising his fist at a trussed-up Iraq man did not seem to invite the same degree of speculation and fantasy as the pictures taken at Abu Ghraib. Yes, they were shocking, and some were of an explicitly sexual nature – the naked Iraqis involved in simulated sex – but the absence of mocking soldiers in the frame seemed to diffuse their lasting impact.

However, politicians were quick to respond. During Prime Minister's Question Time at the House of Commons, Prime Minister Tony Blair said, 'First let me say that everyone finds these photographs shocking and appalling. There are simply no other words to describe them.' During a BBC radio interview, British Foreign Secretary Jack Straw called them disgusting and degrading. 'I am absolutely clear,' he said, 'that activity of this kind, illustrated by these photographs, was confined to a tiny handful of British soldiers. But yes, it is damaging, they are appalling photographs.'[21] These comments might have placated the public, but they were not what the Judge wanted to hear. He conceded that the responses were perhaps a 'natural reaction', and that Tony Blair and Jack Straw were probably 'echoing the view of all right thinking people', but he pointed out that the comments had been made without any knowledge of any evidence as to how these photographs came to be taken, or what they in fact depict.[22] The court had not yet established whether the pictures were 'disgusting', 'degrading' or 'appalling'. That was its purpose. For this reason the Judge said that the comments could be 'inherently prejudicial' and undermine the integrity of the court with the potential to jeopardise a fair trial. He asked that the board disregard the comments and listen to the evidence.

The defence agreed and argued that pictures could be deceptive. In summing-up the Judge referred to Photograph 9 (Figure 6.3) and LCpl Cooley's claim that he had placed the man on the forklift truck to move him from the heat of the sun into the shade and that far from being an act of cruelty it was 'an act of kindness and humanity'. The fact that the Iraqi man had fallen off the forklift truck after the picture had been taken, had been, he said, an accident.[23]

When LCpl Cooley was asked about Photograph 22, he said that he had wanted the picture 'as a sort of souvenir'. He told the court that the photograph

had been taken with a 24-frame Kodak disposable camera which he had bought at Shatt al Arab Hotel in Iraq, where the regiment was based. He said that when he had seen the man lying on the ground covered by netting, he had rushed to get his camera so that he could 'get a photograph with this guy'. When he returned he had handed the camera to Fusilier Wells and asked him, 'Just take a picture of us'. Cooley wanted a picture because, he said: 'I knew I was going home in less than a week, I did not have any photographs of any prisoners or nothing like that. I had seen everyone down the cookhouse taking photographs, I thought it must be all right. It was my last chance, because by then I had already terminated from the Army, I knew I was not going to be involved in any more wars, so this was my last chance.'[24]

After giving Fusilier Wells his camera Cooley had knelt down and put his head next to the head of the Iraqi man lying on the floor. He then made a 'cheesy grin'. But Fusilier Wells had suggested that, rather than a grin, he should 'do something hard, look hard'. In response he lifted his arm and simulated a punch. Cooley accepted that the picture was a trophy photograph and said: 'I thought it was generally OK to take trophy photographs.'[25]

LCpl Cooley, who had served in Northern Ireland, Kuwait and Kosovo, had no experience or training in dealing with POWs, looters or civilians. He had thought that he was going to Camp Bread Basket to 'do vehicle maintenance'. Before being sent to Iraq he had been briefly stationed in Kuwait where, he said, 'we were going to do prisoner of war training', but there was a sandstorm and the training was cancelled. The only 'training' he said he had with respect to POWs was to 'bag them, tag them, send them to the platoon sergeant...'. He described how in Iraq he had been involved in a house search as the 'main break-in' person, but that it had not gone very well. The biggest of the 'lads,' he said, had run at the door with a sledge hammer but it was a steel plated frame so he bounced straight off it. Instead the soldiers rang the doorbell, and it was duly answered. Around the time the pictures were taken, the court heard, Cooley was not well and was vomiting every day, a fact he put down to taking a combination of the controversial nerve agent pre-treatment (Naps) tablets – administered to soldiers during Operation Desert Storm – and malaria tablets. When he left Iraq he continued to be ill and was diagnosed with PTSD: 'I was having to drink a lot to get us through the days, to get us to sleep. I was very tearful, tearful, anger, instant. When I was back home, I was just not me, I was somebody else,' he said.[26]

Towards the end of May Cooley had returned to the regiment's base in Celle, Germany. He took the disposable camera to a photo shop for processing in the same way as Gary Bartlam had done, and SS man Max Täubner before him. When he picked up the pictures and saw the snapshot known as Photograph 22, he said that he threw it away (although he forgot to throw away the negative). 'I was quickly looking through the photographs to see what I looked like,' he said, '...it was not what I expected. ... It did not look what it was meant to be, so I decided just to get rid of the photograph...it was not something I wanted to keep. ... It just shows a stupid second of time. It depicts something that never happened.' The picture of

course could not show something that had not happened but implied what might have happened next.

Major R. H. Clifton for the APA asked why, if the punch was simulated, did his arm appear to be blurred in the picture? In a previous statement Cooley had said that he had done that consciously '... to show that it's real ... it's for realism, isn't it? ...' Major Clifton wondered whether there was any point in recording something that is fake? He suggested that, generally speaking, there are two reasons for taking a photograph: 'either to take a record of it for your own memory, so that you can look back and think, that is what I did, I remember that now, and it jogs your memory'; or, he said, to show to people as if to say, '... this is what I did, this is how I behaved, look at me in this photograph'. Major Clifton also suggested that by throwing away the picture Cooley had 'destroyed the evidence'. But Cooley said, 'I did not realise it was possibly going to be evidence at that time.'[27] Defending LCpl Cooley, Mr Simon Vullo remarked to the court:

> I know that you do not like the image of the posed simulated punch, ... I am not going to try to convince you that it is an artistic or good photograph, something that anyone would want to keep. Lance Corporal Cooley did not like it either, that is why he threw it away, he did not show it to anybody. But you do not hold his actions to be criminal because you do not like them, that is the whole point But it is your duty not to convict him because you do not like the photograph ...
>
> You have to put the photograph and what happened in that posed situation into some perspective. There are lots of images in respect of what happened, for example, in Iraq. Some are terrible images, some are official photographs that go out from even our allies, and some, of course are terrible images from the other side. So there are lots of images, his is not at least the only one that will be remembered.[28]

Similarly, in defence of Kenyon, Mr Joseph Giret had argued that there were far worse pictures from Iraq. When referring to Photograph 19 he said that it could not be compared to images of 'the butchering of a journalist on Al Jazeera television by Al-Qaeda', a comment that presumably referred to the videoed beheading of American journalist Daniel Pearl in June 2002. He suggested that the Iraqi was not hurt but humiliated and that the image showed 'Larkin being a clown ... and Kenyon encouraging him'.[29]

In his summing-up statement the Judge said that when Cpl Kenyon had first been confronted with Photograph 19, he had apparently denied that he was in the picture until a 'photographic specialist' identified him as the person in the background with a camera to his eye. Even then Kenyon said that he had no memory of holding the camera or taking the photograph. He also said that he would never have permitted Larkin to stand on the Iraqi, and therefore he would definitely not have taken a picture of it. 'So this photograph,' said Kenyon, 'would have been taken like a second or even less than a second before I would have told him to get off.' He said that a photograph could only depict a split second of time, so it was

impossible for the court to know what had happened before and after the picture had been taken. If, he said, the image had been a video it would have been possible to see what had happened after that. Kenyon had said that no photograph taken from where he was supposed to have been standing had been found. This, he said, 'proved' that he did not take a picture of the incident as seen in Photograph 19.[30]

Although Photograph 19 was discussed at great length, no one asked Kenyon or any other defendant why Larkin might have been standing on top of the Iraqi in such a way in the first place. I asked Andy McNab what *he* thought the picture showed. He was in no doubt. 'It is called surfing,' he told me. 'It has nothing to do with Iraqis. Soldiers often do this to each other.' According to McNab, the practice is a ritual, soldiers' play, a way of showing that one soldier has authority over another. He recalled his own experience. 'We used to do bed ending,' he said. 'After an argument [with a fellow soldier] you would follow the guy into the washroom with a steel bed end, sort him out then surf him. It is all about dominance.'[31] I wondered if the board of officers knew this, which is why they did not ask.

In summing up for the prosecution Lieutenant Colonel Clapham argued that 'all the photographs speak for themselves.' He asked the court to leave aside the verbal evidence and just look at the pictures. Photograph 19, he said, 'is what it is'. He agreed that the pictures 'cry out for an explanation' but asked whether or not the explanation is 'good enough'. With regard to Photograph 22, he asked the board to 'bear in mind exactly how you felt when you first saw that photograph'. To Mr Joseph Giret, Lieutenant Colonel Clapham's comments were 'dangerously misleading'. To illustrate his point, he drew attention to the pictures of the well-known French documentary photographer and founder of Magnum photo agency, Henri Cartier Bresson and said, 'all of those wonderful scenes, of course they were not natural at all, they were staged. We know that images play tricks. Pictures only capture a fragment of an event and imagination supplies the rest. ... Pictures do not carry the atmosphere or the context.' He said that the idea 'every picture tells a story is useful,' but asked, 'it [the story] is in the eye of the viewer of the photograph is it not?'[32]

On 24 February 2005 the three soldiers were found guilty on charges related to 'disgraceful conduct'. While the Judge acknowledged that they had all served their country well until what he called 'this moment of madness', all three were 'dismissed with disgrace' from the military. Cpl Kenyon, said to be an accomplice in the assault on an Iraqi because he was pointing a camera at the scene and was 'part of the whole scheme to produce trophy photographs' was sentenced to eighteen months' imprisonment. LCpl Cooley, who the Judge said had put the prisoner on the forklift truck for amusement 'and to enable trophy photographs to be taken', was sentenced to two years' imprisonment, and LCpl Larkin was given credit for his guilty plea but sentenced to five months' imprisonment.[33] Although the soldiers had been reprimanded and found guilty for the treatment they had meted out to the Iraqis, the court martial seemed more a lesson in semantics and the ephemeral nature of photography than a serious awakening to soldiers' brutality.

The high-profile nature of this case might have given the impression that the violence and cruelty inflicted on the Iraqi civilians by Bartlam, Kenyon, Larkin

and Cooley had been isolated incidents. But at the time that these soldiers were sentenced, SIB had already investigated 160 allegations of abuse by British soldiers and more cases were in the pipeline.[34] In addition *The Times* reported that the APA were considering charges against members of the Queen's Lancashire Regiment (QLR) that ranged from the ill-treatment of eleven Iraqi prisoners to the death of twenty-six-year-old Iraqi hotel worker Baha Mousa, who died in September 2003 while in the custody of QLR soldiers. In May 2004 the *Daily Mirror* published reports about the violent behaviour of members of the QLR along with what was thought to be photographic proof. But, unlike the pictures presented at Osnabrück, these soldiers' pictures were deemed inadmissible as evidence.

The *Mirror*'s great scoop

On 1 May 2004, just two days after the release of the first pictures that showed American soldiers abusing Iraqis at Abu Ghraib, the *Daily Mirror* claimed to have a 'world exclusive' of more than twenty black and white photographs that allegedly showed British soldiers abusing Iraqis. The *Mirror*'s full-page front cover photograph appeared to show a British soldier from the QLR urinating on a hooded and bound Iraqi prisoner. The headline read: 'VILE ... But this time it's a BRITISH soldier degrading an Iraqi'. On the inside pages, four other pictures showed the same hooded man wearing a torn Iraqi flag T-shirt and boxer shorts being butted in the groin with a weapon, kicked in the face, stamped on the neck and with a weapon to his head. The pictures had apparently been handed to the *Mirror* by two soldiers, who were described in the newspaper as 'one of the attackers and a colleague'. In order to protect their identities the newspaper referred to the soldiers as Soldier A and Soldier B. The *Mirror* had reportedly paid the soldiers £10,000 for the pictures, although it later denied this. A leading media commentator, former editor of the *Mirror* Roy Greenslade, wrote that cash had exchanged hands but it appeared that money was not the central motivation.[35]

Soldiers A and B told *Mirror* journalists how QLR soldiers had regularly subjected Iraqi detainees to a catalogue of horrific abuse, torture and beatings. They claimed that just weeks after the pictures were taken a prisoner was beaten to death in custody. Soldier B said that after the 'September beating' when an inquiry was launched into a death in military custody, they were told to 'destroy incriminating evidence. ... We got a warning, saying that the military police had found a video of people throwing prisoners off a bridge. It wasn't: "Don't do it" or "Stop it," it was, "Get rid of it".'[36] One of the soldiers who claimed that computer discs were destroyed and digital camera cards wiped clean said, 'I ripped pages out of my own diary. I had written things down I shouldn't have, I destroyed it.'[37]

The soldiers claimed that the army knew that there were 'pictures of other incidents' and that soldiers regularly swapped photographs of degrading treatment of Iraqi prisoners. One of the soldiers said that he had seen hundreds of pictures: 'Everyone out there is carrying a digital camera. In some cases they are even Ministry of Defence issues. ... I know one lad who was walking around with a video camera.' Soldier A stated: 'Every time we went out on an arrest we carried cameras. We were told to photograph everything in a house when we went in. The army

were issuing Sony cameras which were very good. ... But the Iraqis were selling digital cameras for about £70. Everyone was buying them.' Soldier B said, 'If the world thinks they were shocked by these pictures they haven't seen anything.'[38]

Within hours of the publication of the images, picture desks from around the world were contacting Mirrorpix, the *Daily Mirror*'s syndication service, for copies and the rights to reproduce them. The newspaper was alleged to have made an estimated £100,000. The *Mail on Sunday* were said to have paid around £10,000 and the *Sunday Telegraph* paid a reported £2,000 for the pictures.[39]

The photographs caused a storm and were widely distributed in print and online. But from the outset there was a rumbling of doubt from broadcasters, journalists and the public about whether the pictures had been faked. As voices of the critics grew louder, the *Mirror* was forced to respond. On 3 May the front-page headline read: 'We told the truth: pictures of torture are real, say squaddies.' This time the newspaper printed pictures of Soldier A and Soldier B, although their faces were blacked out. One of the soldiers was reported as saying: 'This happened. The pictures are real. We stand by every word of our story'. On the inside pages the headline reaffirmed their position: 'This is not a hoax. I saw it I was there ... and the army knows a lot more has happened.'[40]

On 7 May the *Mirror* published another front-page headline: 'I saw POW beatings'. The article stated that the newspaper had received more information, this time from a third soldier, dubbed Soldier C, who told the newspaper that brutal treatment had been meted out to Iraqis and that he believed that the pictures published in the *Mirror* to be 'genuine'. He added: 'I probably know who took the pictures.' He told the *Mirror*: 'I witnessed beatings when people were punched and kicked. One corporal went up to a suspect who had a sandbag over his face and poked his fingers into the guy's eyeballs until he was screaming in pain ... I've seen the state of their faces when they took the sandbags off. Their noses were bent – they looked like haggises. But it was mainly the rib area.' He added: 'I am not surprised that someone died. But if it wasn't for that death in custody nothing would have been done about it.' The *Mirror* reported that Soldier C was prepared to speak to SIB and if necessary testify at a court martial.[41] In the same issue the *Mirror* also published the picture of Lynndie England holding the Iraqi man on a leash at Abu Ghraib.

On the following day, 8 May, the *Mirror* claimed another 'world exclusive'. A fourth soldier, dubbed Soldier D, had come forward to give more information and support the claim that the pictures published on 1 May were 'genuine'. 'I think the pictures are real. I totally believe them,' he said. As proof that abuse did happen, the soldier gave the newspaper a colour photograph which it published on the front page with the headline: 'Snapped: picture that proves Queen's Lancashire Regiment did take trophy photographs of beaten Iraqi POWs'. The picture shows three soldiers (with pixellated faces) sitting in the back of a vehicle. The soldier on the far right of the frame appears to be taking a picture of an Iraqi man who is wearing a torn T-shirt and who has his hands tied, his eyes closed and bloodied teeth. Soldier D said, 'There were no rules out there. I saw the man dragged into the vehicle, beaten up, kicked and punched. It lasted about a minute. I took the picture as I opened the doors of the vehicle and could see dirt on his shirt and blood on his teeth.' (see Figure 6.4).

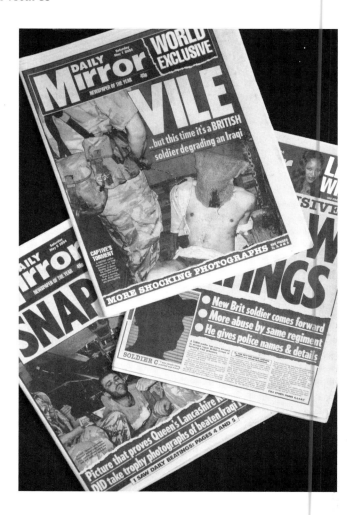

Figure 6.4 A compilation of *Daily Mirror* headlines during May 2004.

Soldier D also claimed that soldiers took photographs and video footage to look tough and to prove to friends what had happened. 'You'd come back from Iraq and people wouldn't know what you've been through,' he said, 'If you had pictures you could show them.' Soldier D said that they had been told to 'get rid of all of them. But if they'd done a proper search,' he said, 'they'd have found CDs and all sorts of things. ... There was a CD going round our room with about 500 shots on it. Some were "before and after" pictures of beatings.'[42]

But these powerful stories of the alleged abuse and the glut of soldiers' pictures in Iraq were overshadowed by the issue of whether or not the pictures published in the *Mirror* had been faked. As accusations began to increase, there were claims of abnormalities in the details of the soldiers' uniforms and weapons. Eamonn McCabe, former picture editor of the *Guardian*, said that both the soldiers and the prisoners looked remarkably clean and the photographs simply looked too staged; the soldiers' boots were not laced up correctly and the floppy hats were not those worn by soldiers in war zones. The rifle, he said, looked too clean and was not

standard issue in Iraq and 'the stream of urine does not look authentic'. Karen Davies, a deputy picture editor of the *Sunday Telegraph*, agreed and said that the urine looked as though was being 'squeezed out of a water bottle'.[43]

There were details about the pictures themselves that also did not make sense and indications that they could have been taken by a professional photographer. The photographs were well composed and sharply focused. A correct shutter speed was chosen to freeze the supposed stream of urine, an effect which a small amateur camera could not necessarily have achieved. In addition, when the *Sunday Telegraph* received copies of the pictures from the *Mirror*, Karen Davies was surprised not only by the 'huge' digital file size of each picture, which in itself indicated that the images had been taken with a professional digital camera, but that each image was black and white and not colour – all digital cameras produce colour photographs, although they can be converted to black and white. One suggestion was that the person who had taken the pictures could have used a film camera, but Davies was not convinced. As an experienced picture editor, she said she could tell that the photographs had been taken with a digital camera and, as she pointed out, 'It would be highly unlikely for a squaddie to be taking black and white film in Iraq'. Davies concluded that they could have been distributed in black and white to disguise the skin tones if, rather than an Iraqi, the man being abused had been a white European.

Other theories emerged. An article in the *Guardian* suggested that the incident shown in the picture was real enough but the participants were posed. 'It is possible that those supposedly mistreating the captive were posing while taking part in a real incident.' But a report in the *Independent on Sunday* stated that the pictures could have been 'stunted up' and taken with equipment issued to the unit's intelligence branch. A former regimental commander was quoted as saying: 'The photographic and weapons intelligence sections which form the battalion intelligence unit both shoot with...black and white film because the definition is better for that kind of work than colour film. ... There have been several cases of military photographers stunting up pictures and spoofing scenes for the private amusement of their colleagues.'[44]

But even if the pictures were 'stunted up', they did seem to portray the actions being described in words. Roy Greenslade wrote that they were 'a genuine portrayal of a torture episode in Iraq ... it is plausible to argue that the pictures may be a set-up of some sort, a staged reconstruction of what really did happen. In other words, if not strictly genuine, they nevertheless reveal the truth.'[45] If Greenslade's assertion was correct and the pictures did portray events that had taken place, did it matter if they were mocked up?

To find out what members of the public thought, BBC News Online conducted a survey. Although some doubted their authenticity, there was an overwhelming willingness to believe that the pictures told the truth. One person wrote, 'Yes, these revolting photos should have been shown, because seeing is believing.' Another wrote, 'In the US Americans are consumed with reality TV, perhaps it's time we see the reality of war and the world as it really is.' One person asked, 'Why would anyone take a photo of a wrongdoing?' While another said, 'Whether these pictures

turn out to be true or not it seems to me that the harm is done as they have now been distributed all over the Arab world.'[46] This was an important point. Photographic historian John Taylor writes 'that no matter how unstable photographic evidence may be in general, in specific cases its evidence is devastating.'[47]

The *Daily Mirror* continued to defend its integrity for two weeks until 13 May when the images were declared to have been faked. (Coincidentally this was one day after the apparently faked rape picture had been published in the *Boston Globe* – see Chapter One.) The *Mirror*, not new to controversy over pictures – in 1911 it became the first British national paper to publish war atrocity pictures and during the First World War it defied the censors to publish unauthorised war pictures (see Chapter Two) – was in trouble again. The *Mirror* admitted that it had fallen victim to 'a calculated and malicious hoax'. But according to the *Guardian*, editor Piers Morgan, echoing Greenslade's point, insisted that even if the pictures were not genuine, they illustrated a story that was true. As far as senior management at *Trinity Mirror* was concerned, Morgan's position was untenable. They issued a statement that said that it would be 'inappropriate for Piers Morgan to continue in his role as editor'. On 14 May Morgan was sacked and escorted from the *Mirror*'s office. The following day the newspaper issued an apology with the headline 'Sorry we were hoaxed' but added that it was 'categorically not sorry for telling the truth that acts of cruelty were committed by a tiny number of British troops'. In response to the revelations that the pictures were faked, Colonel David Black, a former QLR officer, reportedly said: 'Doubtless I am right in saying that the regiment won't feel triumphant. They will feel vindicated and relieved. We can get on with life.' But contrary to Colonel Black's comment, Cpl Donald Payne of QLR had already been arrested on charges related to the death of Baha Mousa, the Iraqi hotel worker who had died while in the custody of the regiment in September 2003.[48]

While the newspaper apologised to its readers, other journalists speculated why the *Mirror* had been hoaxed. Some thought that its high profile anti-war stance, which had been criticised by its own management and shareholders, had led the newspaper into a trap. The National Union of Journalists magazine, *Journalist*, speculated that the pictures may have been set up with the connivance of the Ministry of Defence to discredit the *Daily Mirror's* anti-war campaign. In 2002 the *Mirror* had presented a 'No to war' petition to the then Prime Minister, Tony Blair, with more than 200,000 signatures. Subsequently Piers Morgan was ordered by management at *Trinity Mirror* to 'tone down' the anti-war coverage.[49] But Karen Davies at the *Sunday Telegraph* suggested that in the wake of the Abu Ghraib scandal 'the *Mirror* was desperate to have a story to show that British soldiers were part of the abuse as well.' While the *Independent on Sunday* suggested that 'the timing and the content seemed, from the newspaper's point of view, too good to be true.' But it appears that the *Mirror* could have received the pictures on 28 April, the day that *Mirror* journalist Paul Byrne interviewed Soldier A and Soldier B and the day that CBS broadcast the Abu Ghraib photographs for the first time. According to a *Mirror* journalist, Piers Morgan had kept the pictures 'locked in his safe for three days' before deciding to publish them.[50]

In May, as speculation about the *Mirror* picture affair rumbled on, twenty-eight-year-old Stuart Mackenzie, a former member of the Lancastrian and Cumbrian

Volunteers Territorial Army (TA), a part-time unit that had been attached to the QLR, had been arrested, accused of 'playing a role' in faking the photographs. The pictures, according to an investigation by SIB, had not been taken in Iraq, but had been staged in a truck found at the TA's Kimberley barracks in Preston.[51]

For more than a year an investigation was under way but in December 2005, just before the case was brought to court, the potential offence considered by the Crown Prosecution Service (CPS) against Mackenzie of 'obtaining property by deception' was dropped on the basis that there was 'insufficient evidence for a realistic prospect of a conviction'.[52] Mackenzie was initially subject to a court martial for misconduct which was stayed in April 2005. It transpired that members of the TA are outside of military jurisdiction when not on duty. In addition to that his alleged role could not be proven. But the army continued to believe that Mackenzie was responsible. On 22 August 2006, Commander of the 42nd Northwest Brigade, Brigadier Powe, OBE, officially terminated Mackenzie's service from the TA for, he wrote, 'gross misconduct in that you on the balance of probabilities participated in the making and supply of fake photographs purporting to depict the abuse of an Iraqi detainee by British Military personnel ...'[53]

The story did not end there. In September 2006 seven QLR soldiers, including a high-ranking officer, faced charges over the death of Baha Mousa in Britain's first ever war crimes trial, which lasted five months and cost British taxpayers an estimated £20 million. During the trial elements that had been portrayed in the faked pictures were repeatedly referred to: hooded prisoners being transported in Bedford trucks, prisoners being urinated on by soldiers and cruel and violent behaviour meted out to Iraqis. Among the witnesses for the prosecution was Stuart Mackenzie.

Crimes of war

On 1 November 2006, I sat on the press bench at the Military Court Centre (MCC) at Bulford army camp in Wiltshire where the soldiers from the QLR – renamed the Duke of Lancaster Regiment after the *Mirror* picture scandal – were on trial. It was the first time that British servicemen had been prosecuted for war crimes under the International Criminal Court Act 2001. Those accused – Corporal (Cpl) Donald Payne, Lance Corporal (LCpl) Wayne Ashley Crowcroft, Private Darren Trevor Fallon, Sergeant Kelvin Lee Stacey, Major Michael Edwin Peebles, WO II Mark Lester Davies and Colonel Jorge Mendonca, MBE, former commander of the regiment and the most senior officer to be brought before a court martial in recent decades – faced charges that ranged from the ill-treatment of eleven Iraqi prisoners to the death of Baha Mousa, who died, it was revealed, as a result of ninety-three brutal injuries to his body, including broken ribs and a broken nose, and restraint asphyxia. The trial focused on the events of 14 and 15 September 2004 that led to the death of the Iraqi. Only one defendant, thirty-five-year-old Cpl Donald Payne, pleaded guilty to inhumane treatment.

The court martial had begun with a showing of approximately sixty seconds of chilling video footage taken by a British soldier, although it has not been established with any certainty who that soldier was. It had been found on a CD handed to the authorities by a British soldier. The prosecution said that soldiers in Iraq

took photographs and videos as 'keepsakes' as the disc also contained pictures of people and places 'which are quite innocent' – the familiar combination.[54]

The video clip, taken on a shaky hand-held camera or perhaps on a mobile phone, shows a room in which six hooded and handcuffed Iraqi prisoners are standing against the walls in the 'stress position', defined as 'retaining a position with their backs to the walls, knees bent and arms outstretched'. The prosecution pointed out that the use of the 'stress position', hooding and sleep deprivation had been 'expressly forbidden as a technique' since 1972 following a government investigation over interrogation techniques in Northern Ireland.[55] In 2009, a public inquiry into the death of Baha Mousa was told by former British military personnel that soldiers themselves were commonly subjected to stress positions during training or as a form of punishment or discipline.[56]

In the disturbing video clip a soldier identified as Cpl Payne is dressed in fatigues and a black T-shirt with the slogan 'Helles Coy' printed on it – probably referring to the company of Lancashire Fusiliers who landed at Cape Helles, in Turkey, during the First World War. He can be seen violently pushing and pulling at the prisoners who are being made to crouch with their knees bent and arms outstretched in front. He can be heard shouting: 'Fucking get down … Fucking get up.' One man is forced into a knees bent position before being dragged back up before he collapses. Distressing whimpering and moaning sounds can be heard coming from the prisoners. It was pointed out to the court that even though Payne must have been aware of the camera, he continued with the abuse. The court ruled that the video should not be released into the public domain. Consequently, when the court martial began there were no front-page images to accompany press reports as there had been at the onset of the court martial at Osnabrück. Instead, some newspapers provided an artist's impression of scenes from the video. This was permitted. Perhaps Judge Advocate Mr Justice McKinnon feared the kind of public outcry that followed the release of the soldiers' pictures presented at Osnabrück and that Cpl Payne would be judged on what the video clip showed rather than the verbal evidence.

In his opening address, the chief of the prosecution team, Julian Bevan QC, said that Payne had systematically assaulted the detainees in a practice he called 'the choir' which involved hitting and punching each prisoner in turn to make each of them shriek out in pain. Mr Bevan referred to other images that had apparently been taken. One prisoner had spoken of being photographed with a soldier standing next to him with clenched fists – a reminder of the picture taken of LCpl Cooley. It transpired that after the picture had been taken the soldier had punched him. In the Crown's case were other accounts of the violent behaviour of soldiers towards detainees and details of a conversation that had taken place between a member of SIB and defendant LCpl Crowcroft in a bar in Cyprus in November 2005. Crowcroft, who the SIB member said 'clearly had been drinking' touched upon his concern at the impending court martial and said, in an apparently 'bravado' way, 'We all kicked him to death.'[57]

As I watched the young uniformed soldiers appear one by one in the witness box, dwarfed by the authority of the military court room – the board of seven highly

decorated uniformed officers, a high court judge, an unprecedented assembly of QCs, lawyers and solicitors – I remembered what Andy McNab had told me about the twelve-week training programme of young British soldiers. 'You are telling them [the recruits] that they are the most aggressive and hardest things on the planet ... and you are teaching them how to kill ... you turn it into a competition ... by week 12 you get them all sparked up and they are getting into bayonet drills and by then they are not actually recognising what they are doing because you don't want them to know what they are doing, you just want them to go and do the drills It is all about aggression, aggression If you don't grip the guys they will beat each other up and beat up other people ... but bizarrely that is the sort of character you want'[58]

On 1 November Stuart Mackenzie, then a civil servant, was sworn in as a witness for the prosecution. He was neatly dressed in a dark suit and a matching blue shirt and tie. His round face seemed permanently flushed with an etched frown. According to Mr Bevan, he was a reluctant witness. On 10 October 2003, barely a month after the death of Baha Mousa, and six months before the *Mirror* picture scandal broke, Mackenzie had made a witness statement to SIB which included a detailed description of how Cpl Payne had beaten and kicked a prisoner. Mackenzie had even drawn a detailed 'sketch plan' of where the incident took place. But on 15 August 2006, just a month before the court martial at MCC Bulford began, Mackenzie decided to amend that statement. He now said that he did not see Cpl Payne beating an Iraqi and that it was a rumour he had heard at the time. Extracts from Mackenzie's original witness statement were read to the court:

I saw Corporal Payne punch the prisoner in the stomach with his right clenched fist very hard causing the man to fall back against the wall. ... The man looked frightened and apprehensive. Corporal Payne then moved forward and grabbed him with both hands, one on the top of his head and one placed at the scruff of his neck and pulled him forward and down to the floor. The man hit the floor face first and although he had his hands in front of him he hit it with some force moaning as he did so. ... Corporal Payne then stood over him with his arms pressed against either wall stabilising himself. He began to kick the man very hard indeed. He used his right foot and kicked out six or seven times striking the man about the head and shoulders. ... I cannot describe these any better as he was going berserk, just frantically kicking. ... Although there were people in front of me. ... I had a clear and unobstructed view at the time. ... I was only two to three metres away. Corporal Payne had on his desert boots. ... the man did not cry out when kicked. He only moaned.

In the witness box, Mackenzie described some of the events that led up to that statement being made. On 14 September 2003 he had taken part in Operation Salerno, which involved a search of Hotel Salerno in Basra where weapons were found and a number of Iraqis arrested. He and three other soldiers, Privates Bentham, Kenny and Allibone, had travelled with the prisoners in the back of a Bedford truck to Battle Group Main camp outside Basra. While at the camp

Mackenzie had been witness to Cpl Payne's 'choir' and said that like other soldiers he had been initially amused. He remembered a few things: the room with six prisoners, his orders while on 'stag' duty to keep the prisoners in a 'stress position' and not allow them to sleep, the torn prisoners' clothing, how one man was only dressed in boxer shorts and the 'hot, sweaty' environment that smelt of urine. But, like the majority of other witnesses, he was no longer able to remember very much at all.

When Defence Counsel for Cpl Payne, Mr Julian Knowles, stood before Mackenzie and asked 'Do you buy a daily newspaper ... Did you buy a copy of the *Daily Mirror* on the 1 May 2004?' there was an expectant silence in the court. After a pause Mackenzie replied: 'I think I know what you are referring to, so I think so, yes.' Mr Knowles then waved a copy of the *Mirror's* front page that read 'VILE ... But this time it's a BRITISH soldier degrading an Iraqi'. He put it to Mackenzie he had approached the *Daily Mirror* in order to 'expose violence by QLR soldiers' in Iraq and that he wanted £5,000. Knowles said that Mackenzie was the soldier urinating in the front-page picture, and that the person being urinated on was probably Private Bentham.

Mr Knowles also put it to Mackenzie that he in fact had been Soldier A; he had been found out because in the original photograph a mole was visible on the urinating soldier's arm, one that fitted with the mole on Mackenzie's arm. And that despite having his faced blacked out in the picture published by the *Mirror* on 3 May 2004, members of the QLR immediately recognised him because of the way he stood, the way his shirt hung over his belt, the shape of his face and ears and the way he wore his beret. When these questions were put to Mackenzie he looked to the Judge for guidance. The Judge told him that he did not have to answer the questions if he felt they might incriminate him. From then on, in reply to almost all other questions regarding the *Mirror* photographs, Mackenzie told the court: 'I do not wish to answer that question.'[59] My question was if Mackenzie had been the soldier urinating in the photograph, he could not have taken the picture. I wondered who had? No one asked.

The court did not establish with any certainty who Mackenzie's accomplice was; that was not its purpose. However, on 30 November 2006, Ali Aktash, a former member of the TA, also gave evidence and admitted that he had been the *Daily Mirror's* Soldier C. (Aktash had also been the unidentified soldier interviewed by Trevor McDonald on ITV's *Tonight* programme, *The Soldier's Story* on 14 May 2004.) Aktash told the court martial that after he had seen the abuse pictures published in the *Mirror* he told a friend that he knew that 'this stuff did actually go on.'[60] His friend had then contacted the newspaper on his behalf.

However, in a statement to a public inquiry into the death of Baha Mousa three years later in 2009, Aktash claimed that he had been reluctant to speak to *Mirror* journalists and that some details in the article published in the newspaper following his interview had been 'an exaggeration'. He denied the published claim that he had known who had taken the pictures. Aktash said that although he had told journalists that the pictures did look genuine, he had also voiced reservations and said there were 'certain things (that) made me think that the pictures could be faked',

although in his statement to the inquiry he said he could no longer recall what those things were.[61]

During Mackenzie's cross-examination at MCC Bulford there had been further revelations. It transpired that between 24 July and October 2003, Mackenzie had written a diary in Iraq that described the activities of his multiple which had been nicknamed the Grim Reapers, seemingly because they 'got the first kill in Iraq'. Mr Knowles read out a number of entries:

11 September, Found three Ali Babas … beat them up with sticks and filmed it. Good day so far; 13 September, House raid for hours, nothing found. Caught three Ali Babas. Beat fuck out of them on back of Saxon. One had a punctured lung and broken ribs and fingers. One had a dislocated shoulder and broken fingers; 15 September, … Finally got back to camp at 13.30. … The fat bastard who kept taking his hood off and escaping from his plasticuff's got put in another room. He resisted (five or six words scratched out) he stopped breathing then we couldn't revive him (seven or eight words scratched out) What a shame …; 16 September, … It is going massive, it's now a SIB investigation. Murder?

There were murmurings around the court about how Mackenzie could have known that one prisoner had a punctured lung and broken ribs and fingers – conditions that could only have been diagnosed by a doctor. Had he faked his diary as well as the pictures? Stuart Mackenzie's diary ended on 9 October 2003, the day before he made his first statement to SIB, although the diary was not discovered until his home was searched during the investigation into the *Mirror* pictures in May 2004. Mackenzie claimed not to remember writing the majority of entries, including the filming of the 'Ali Babas'. When he was asked at the court martial if he had embellished events to make them more dramatic, he replied, 'Possibly'.[62]

When Mackenzie had finished giving evidence he was promptly ushered away from the camp in a police vehicle. A policeman told me that he was afraid of his fellow soldiers from the QLR. He had broken ranks with the regiment and discredited their name. As I too left the camp I wondered about Mackenzie's motives and involvement in the *Mirror* pictures affair. Who had taken the pictures? Were they taken purely for financial gain? Was it to draw attention to the abuse perpetrated against the Iraqi prisoners? Or was it really a complicated plot to discredit the *Mirror* and its anti-war campaign? If the incidents portrayed by the pictures published in the *Mirror* had actually happened, did it matter if they had been mocked up? The pictures may not have told the truth, but had they really lied?

In both the *Mirror* picture affair and the court martial at Osnabrück it had seemed at times that photographic truth was on trial rather than those who had perpetrated the abuse. In effect, rather than draw attention to soldiers' brutality in Iraq, the images had inadvertently helped to cover it up. At Osnabrück the very nature of photographs – the framed fraction of a second – had allowed the abuse to be defined as moments of folly in the more serious business of war. As if to support this point the Judge, in passing sentence on the soldiers, had described the incidents

as 'this moment of madness' seemingly referring to the clicking of the camera shutters, rather than the prolonged suffering the Iraqis had no doubt endured. Similarly in the *Mirror* affair it was the dubious provenance of the images that became the story, rather than the soldiers' powerful and detailed testimonies of the brutality of the QLR.

Instead of Mackenzie being discredited for his alleged role in creating the pictures, perhaps he should have been praised for bringing the abuse to public attention. However, in another twist to the story, on 10 November 2009, as a witness in the public inquiry into the death of Baha Mousa, Mackenzie took the inquiry by surprise when he unexpectedly denied he had been the *Mirror's* Soldier A. 'I could have proved I wasn't but I didn't get that far,' he said, presumably referring to the discontinued court case in 2005. But Sir William Gage, chairman of the inquiry, revealed that comments made by Soldier A in the transcript of the taped interview with Soldier A and Soldier B conducted by *Mirror* journalist Paul Byrne on 28 April 2004, were remarkably similar to those recorded in Mackenzie's diary, including a reference to a diary itself.

That interview was not made public, but the inquiry was shown four colour snapshots that had been found during a search at Mackenzie's home. Some details in the pictures were similar to those depicted in the faked *Mirror* pictures although these were undoubtedly amateur snapshots without the professional qualities of those published in the newspaper. One shows the naked torso of a seated hooded man wearing white underwear. His arms appear to be behind his back. Next to him is a soldier identified as Private Kenny. Another shows two Iraqi civilians in the back of a Saxon. Mr Gerard Elias QC, lead Counsel to the inquiry, suggested that one Iraqi looks 'quite distressed' while the other appears to have torn clothes and blood on his arm and wrists. Mackenzie agreed. Another picture shows a hooded man in a white shirt lying on the floor. A soldier who is partially visible in the right-hand side of the frame has placed his foot on the man's arm. The soldier is holding a small camera as though he is preparing to take a picture. When Mr Elias asked Mackenzie why this picture would have been taken, he simply replied: 'Bravado'. Mackenzie said he couldn't remember who had taken this or the other three pictures but added: 'a lot of pictures were swapped around within the multiple ... we all had lots of photographs.'[63]

In October 2010 the last session of the public inquiry concluded. The chairman's report is forthcoming. At MCC Bulford Cpl Payne was the only soldier to be found guilty and was sentenced to one year's imprisonment and dismissed from the army. He remains the only British soldier ever convicted of a war crime. No one has yet been convicted of the murder of Baha Mousa.

SEVEN
Breaking the Silence

War forms its own culture. It distorts memory, corrupts
language, and infects everything around it. ... War exposes
the capacity for evil that lurks not far below the surface
within all of us. Even as war gives meaning to sterile lives,
it also promotes killers and racists. *Chris Hedges.*[1]

Telling the truth

A few weeks after the publication of the pictures from Abu Ghraib in July 2004,
the *London Review of Books* (*LRB*) carried an article by the Israeli author Yitzhak
Laor about an exhibition of around ninety pictures taken by former Israeli Defence
Force (IDF) soldiers while on active duty in the Occupied Palestinian Territories.[2]
The exhibition, called 'Bringing Hebron to Tel Aviv', had not been compiled by
historians, but by Breaking the Silence (BTS – Shovrim Shtika), an organisation
conceived in 2003 by former IDF soldiers. Its purpose was simple: to attempt to
break the silence of what its founder, twenty-three-year-old Yehuda Shaul, called
'the corruption of the occupation' and to 'tell the truth'. Shaul said that he was
aware that a large proportion of the Israeli public would not want to know the truth
but his response, he said, was this: 'We are the average Israelis, not anarchists ... and
we want you to take responsibility for what you send us to do.'[3]

The *LRB* published a photograph that showed a group of six Palestinian chil-
dren playing in an urban wasteland under the watchful eye of an Israeli soldier
(Figure 7.1). Four of the children are standing with their hands against the wall
while the other two are holding sticks and searching the others. The juxtaposition
of the armed soldier in combat gear and the young children playing is disturb-
ing. There is nothing overtly violent about the image, but some time later Yehuda
Shaul gave me his interpretation. 'It takes a moment to grasp what is going on,' he
said, 'but it's insane. It shows Palestinian children playing at being soldiers, body
searching each other. That's the way they live.'[4]

Yitzhak Laor had written that the soldiers who curated the exhibition had been
undertaking what he called 'journalistic research', as though 'collecting evidence
for some sort of imaginary trial'. But unlike the American or British soldiers who
had been brought before a court martial for taking pictures of the humiliation and
abuse of Iraqi prisoners, the Israeli soldiers were effectively placing *themselves* in

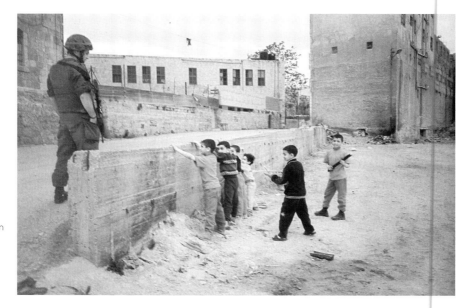

Figure 7.1 A snapshot taken by an Israeli IDF soldier that shows Palestinian children being watched over by an IDF soldier in the Occupied Palestinian Territories. (Courtesy of Breaking the Silence)

the dock by revealing what soldiers of other armies preferred to conceal, their private pictures. They were confronting Israeli society with the photographic evidence of what they called the 'terrible moral price' of occupation and asking it to judge for itself. 'The first silence to break is the personal silence,' says Yehuda Shaul, 'the second is the silence of a society.'[5]

The idea for BTS had begun while Yehuda Shaul was serving as an IDF platoon sergeant in the elite Nahal brigade. He started to think about what he might do when he finished his three-year national service. Shaul, who described himself as an orthodox and right-wing youth, had assumed that he would do what most other young former IDF soldiers do after their national service – 'travel around the world and forget'. With a Canadian father and an American mother, he had intended to go to live in Canada. But there were elements of the occupation that deeply troubled him.

For example, there were contradictions between IDF statements made in the media and what Shaul knew to be happening on the ground. The IDF claimed that the car keys of Palestinian drivers were never confiscated at checkpoints, but Shaul knew this was blatantly untrue. He had found more than 100 sets of car keys in a barracks where he and his platoon were based. Shaul also knew this practice was a part of a soldier's daily routine, a punishment for not obeying a curfew, or simply carried out on the personal whim of a soldier.

Disturbed by these cruel and illegal practices and the way in which Israeli society was being misled, he decided to travel the country to search for other like-minded soldiers. It was during these meetings that he became aware of the importance and significance of pictures. Those who spoke with him often began their stories by showing him their private pictures or opening their photo albums – something that initially surprised him. They were not showing them to shock him or to boast about their exploits, or as a critique of their actions, but simply as a way

of remembering and telling their stories. 'These pictures had not been taken from a critical perspective. The soldiers were simply documenting their banal daily lives,' said Shaul. 'You don't think of it as an occupation. You document your life as you would in any other situation.' This is what interested Shaul. He found that many of their pictures were remarkably similar. But he realised that as commonplace as these scenes were to them as soldiers, they told stories that no one else knew. 'It is only later,' said Shaul, 'that they (the soldiers) realise that the pictures have a story within them; that the pictures tell a story at different levels ... And that in our photos is a story that no one except us knows.'[6]

Yehuda Shaul showed the pictures to Miki Glatzmann, a photographer on the Israeli newspaper *Ha'aretz*. Glatzmann was impressed and encouraged Shaul to hold an exhibition. Shaul knew that if that were to happen, the focus would have to be on Hebron, a city where he had served for more than fourteen months and which for him represented 'the essence of the occupation'. Hebron, a once thriving Arab commercial and cultural centre of around 150,000 Palestinians, has a presence of around 500 Jewish settlers guarded twenty-four hours a day by approximately 450 Israeli soldiers. Even though their right to live in the city is not recognised by international law, the settlers' presence has meant that Palestinian communities have been expelled from the city centre area and hundreds of shops and warehouses have closed down. Jan Kristiansen of Temporary International Presence described the removal of Palestinians from the city as 'ethnic cleansing'.[7]

In 2003, when Yehuda Shaul finished his military service, he and other like-minded colleagues pooled their IDF discharge bonuses and began to prepare an exhibition that would bring, as Shaul said, 'the garbage, coils of barbed wire, standard issue combat gear, metal and broken doors from Hebron to Tel Aviv'.

They collected photographs and made video-recordings of soldiers – whose identities were not revealed – willing to testify to the litany of abuses and humiliations inflicted on Palestinian civilians. The soldiers spoke of occupying homes in an arbitrary way, civilians including children being beaten for no apparent reason, and how they used them as 'human shields'. They described throwing stun grenades at kids and making men stand for hours in the sun 'just for fun'. There were also stories about Jewish settlers in Hebron whom the soldiers were there to protect, although most said that they had to protect the Palestinians from the violent actions of the settlers. One soldier said: 'I'd come home, then go back to Hebron and it feels as though I had gone abroad, really. ... Whatever I used to call democracy here, would simple vanish in Hebron. Jews did as they pleased there, there were no laws. No traffic laws nothing. Whatever they do there is done in the name of religion, and anything goes – breaking into shops, that's allowed ...'[8]

The exhibition 'Bringing Hebron to Tel Aviv' opened at a small venue at the Academy for Geographic Photography in Tel Aviv College in June 2004. At the entrance a notice read, 'We decided to speak out. Hebron isn't in outer space. It's one hour from Jerusalem.' Inside were the videoed testimonies of the soldiers, an exhibit of the confiscated car keys of Palestinian drivers and a display of pictures. There were no 'trophy' images. BTS had made a conscious decision not to show them – although they had collected many. They believed that little could be

achieved in that way. 'The aim is not to bring Israelis to puke so they will just want to leave, it is to try to bring them to a level where we could break their denial and walls and reach them and try to touch them on a personal level,' Yehuda Shaul told me. 'Neither did we want to show extreme cases of violence,' said former IDF soldier Avichay Sharon, but rather 'to tell the story about the daily routine of an occupation soldier. What makes the occupation so corrupt is the daily routine. It is not about the extreme cases ... that happens in every war. The story is about the nineteen-year-old soldier who controls people at checkpoints, who invades someone's home, confiscates car keys ... these are the real stories.'[9]

Former IDF soldier Dotan Greenvald said that 'the exhibition shows the personal stories of how we became occupiers; how we became numb ... I'm telling stories about what I have been through – stories that sound crazy, but were normal back then. And I want to show people how it became normal.' Another former IDF soldier, Yonatan Baumfeld, said: 'Some pictures I took because I knew I couldn't handle what I was seeing at the time and I wanted to think about it later, and some I took just as "souvenirs".'[10]

One photograph shows a fifteen-year-old Palestinian boy blindfolded and handcuffed to a chair while in the background IDF soldiers lounge around playing backgammon and smoking. Another shows a group of IDF soldiers watching television in a Palestinian home. The house was raided and the family put into one room, not for strategic reasons but because the soldiers wanted to watch a football match on the family's television.[11] A Palestinian boy standing on a rooftop feeding his pigeons is photographed through the crosshairs of an IDF sniper's weapon scope. 'The first time I had a kid in my sights I was shocked,' said Yehuda Shaul 'but then you get bored on eight-hour duty, you aim at God, at the kid, at your friends and that's your daily routine. It doesn't bother you much any more.'[12]

Yehuda Shaul knew the exhibition would draw a mixed response from the public but he was not prepared for such volatile reactions. On the first day crowds poured into the venue. Shaul said: 'We watched people coming into the exhibition and they were shocked and some crying and others yelling at us. There was a lot of emotional reaction.' Shaul asked himself: 'What are they shocked about? These are not bad pictures, just the daily life of the occupation in Hebron. These images are the images that I feel at home with ... these images are my life! The visitors saw a reality that they do not know, that they did not recognise.' It was only then that he and his colleagues realised the enormous gulf that divided their reality as soldiers, from the reality of the Israeli public.[13] Former IDF soldier Micha Kurtz said about the exhibition, 'This is not political opinion. We are not left or right. These photographs are facts.'[14] But the facts were open to interpretation.

Some parents of soldiers found bearing witness to these facts disturbing. A mother of a serving IDF soldier said: 'I feel sick, I feel physically sick ... I know a little bit about what he was doing these last three years, but he's never told me everything ... and just now to see my son and to actually physically see his photo and his friends and what they have to put up with. ... As bad as I felt about the occupation before as an Israeli citizen, now seeing it as a mother, it's just awful.'[15] Another mother, whose son was about to enlist, said she thought that her son would act in a humane way but added: 'It

is possible that what these soldiers who organised the show say is true. Perhaps when you get there you slowly lose it.'[16] An eighteen-year-old woman whose mandatory service was imminent looked at the photos and said: 'It's pretty shocking. You know it's a different universe. That is why I am here, to get prepared.'[17]

Within a month of its opening the exhibition was raided by IDF Military Police. They confiscated a folder containing press cuttings and the video-taped testimonies of seventy soldiers. Yehuda Shaul, Micha Kurtz and Yonatan Baumfeld were arrested and interrogated for seven hours. The police said they needed to know the identities of the soldiers who had given testimonies so that if crimes had been committed against Palestinians, then an investigation could be carried out and the perpetrators punished. The soldiers knew this was highly unlikely and did not comply. Instead, Shaul and his colleagues claimed the status of journalists and refused to reveal their sources. The ploy worked. After a battle in the courts BTS won the right to protect the names of the soldiers. 'The idea was to frighten us,' said Shaul, 'to declare us an extreme case of "rotten apples".' Micha Kurtz said: 'They're not going to shut us up, because we have a lot to say, and they're not going to scare us off.'[18]

That members of BTS had claimed the status of journalists shows how they saw their task. Shaul said that the majority of Israeli journalists were not prepared to tell the story of the 'corrupt reality of society', therefore it had been left to willing soldiers. 'Breaking the Silence comes through a mindset of a soldier becoming a journalist and reporting on himself,' Shaul told me. 'The reality of the Occupied Territories does not cross the checkpoints. That is a fact. Everyone knows what is going on but no one is talking about it. That is the much deeper level of silence.'[19]

Some military colleagues supported the right of BTS to speak out. Shay Nevo, a former IDF commander who had served with Yehuda Shaul and at times was critical of what he called his liberal attitudes, wrote an open letter to the military police investigators about the exhibition. He wrote that it is 'shocking, hurting, overwhelming, beautiful, interesting. But most of all for me the exhibition is truthful. It simply reflects a reality. They simply tell their story.'[20]

More than 8,000 Israelis visited 'Bringing Hebron to Tel Aviv'. BTS organised gallery tours as well as discussions in schools, colleges and universities and more former IDF soldiers came forward with their stories. Within months stories about soldiers' pictures were being published in the Israeli press and some were deplorable. Israel's highest circulation daily newspaper, *Yedioth Ahronoth*, ran a story about how pictures of the bodies of 'terrorists' had become 'a vital part of Israeli soldiers' photo albums'. The article stated that the body of a Palestinian suicide bomber killed by the elite Nahal unit was later abused for the purpose of taking trophy pictures. Some were sold for two shekels. In another incident the body of an unarmed Palestinian who had been machine gunned to death by Israeli soldiers was tied to a military jeep and taken to the unit's base. He was nicknamed 'Haffi' (which means innocent) and pictures were taken. 'Haffi' became a battalion mascot. The report also stated that soldiers had 'played with' the bodies of dead Palestinian men and taken pictures that were circulated among soldiers in the unit. 'They were simply part of the album,' said one anonymous soldier. 'We used to take photos

with each other at the end of the training period, for memory. Now we're taking pictures with dead bodies too.'[21]

As a response to the article in *Yedioth Ahronoth* a spokesman for the IDF said that soldiers were living in a 'complex reality'. But an editorial in *Ha'aretz* stated that this complex reality was in fact quite simple. 'For decades the IDF and the settlers have acted as they pleased in the territories, while the Palestinians' image as human beings with rights and with a face has gradually diminished. The process of dehumanisation has reached a peak during the last four years, and certainly where there is no respect for human life, there can be no respect for the dead.'[22]

This point was exemplified when BTS representative former Lieutenant Noam Chayut took part in a radio discussion with Lieutenant General Moshe Ya'alon about the story published in *Yedioth Ahronoth*. Chayut said he was shocked that Lieutenant Ya'alon kept the debate centred firmly on the trophy pictures.[23] The fact that an innocent person had been killed was not addressed at all. Again it was as if the fault lay with the pictures rather than the crimes they depicted – the same point that has been implied on other occasions when soldiers' cruel pictures have come into the public domain.

The story published in *Yedioth Ahronoth* prompted other former IDF soldiers to come forward with their stories and pictures. Alon Kastiel, an Economics student at Tel Aviv University, said he had kept his pictures hidden in a drawer for more than five years but decided to make them public to show that the behaviour described in the newspaper article was widespread among IDF soldiers.

Kastiel had served in the elite Duvdevan unit, made up of the sons of affluent professionals' families, 'the finest of the country's youth'. 'If picture-taking happens in our unit then all soldiers take these kinds of photographs,' he said. Kastiel described what happened after his unit had killed Iyad Batat, a leading member of Hamas, and other 'militants' and when the bodies were taken to the base.

> One of the soldiers started taking pictures with a small pocket camera. Very quickly there was a big demand for pictures. Then we took out our gear – there were a lot of cameras in the unit – and there was a hysterical demand to have our pictures taken. We were all around the bodies. ... We sat next to the bodies, we exchanged experiences, we looked, we played games with the bodies. I think they touched the bodies a little. The camera made that happen. We had a few rounds of pictures taken. It went on for maybe two hours. ... When we see a camera, everyone runs to stand behind the bodies, to be in the frame. A souvenir of one of the most dramatic nights of our lives. I, who was totally revolted by it, even then, didn't have my picture taken, but nevertheless a film made its way to me as a souvenir of a turbulent night. I am standing 20 centimetres from the frame. I am there. I didn't say a word, I didn't think about morality ... and your commander is having his picture taken with them and you never make a critical comment to a commander. ...
>
> Iyad Batat is lying on a stretcher, his face is covered with a mixture of plaster and blood. His eyes are wide open. The soldiers around are all smiling,

some of them broadly, as when the photographer commands 'Say Cheese!' They arrange themselves in a photographic pose, like hunters with their prey. Three of them place a hand on the stretcher on which the dead man is lying. No one, but no one, looks at him: they are all looking at the camera. ...

Then we went to the unit and we occupied ourselves with the topic of how we would develop the photos. ... There is a procedure where the pictures are developed at headquarters, but we couldn't give them things like that. It wouldn't have gone through. They were private photos. ... One of the guys volunteered to take the film home. Then we imagined some woman in a photo shop seeing the pictures while they were being developed. What would she think? What would she say? It was a store in Kfar Sava. About a dozen copies of each photo for all the guys. We took up a collection and paid. You look at the pictures and then you put them in the most remote corner of the house, making sure you don't chance on them in the years ahead. They disgusted me. I don't know what disgusted me more, the bodies or my behaviour. Once a year I saw the bag from a distance and didn't open it. Burial at the back of a drawer.[24]

The story told by Kastiel was familiar. Had the camera encouraged the prank to happen? The Israeli soldiers had taken their pictures to a photo shop in the way that SS man Max Täubner and British soldier Gary Bartlam had taken theirs. Then like other soldiers, including the German soldiers who took pictures in the Warsaw Ghetto, Kastiel had kept them even though their existence seemed to haunt him. Why keep unwanted memories? Maybe as proof that the experience really happened? Avichay Sharon said, 'When you leave the military you give everything back, you sign a few forms and no questions are asked. There is no place for you to put your memories, your experiences, your behaviour, your apathy and your numbness.'[25] But why take a disturbing picture in the first place if you know the situation to be wrong? I put the question to Yehuda Shaul.

'You don't know. You really don't,' he said. 'During your service you just photograph. Why not? You don't think of it as an occupation. If you are used to documenting your life, you document your life ... if you are interested in photography so you photograph wherever you go – so today you were in Hebron, tomorrow you go to travel with your girlfriend to the Golan Heights and take pictures, and then you return to Nablus and you take pictures there. ... If your dream was to climb Everest and you got to the top would you take a picture? If you are a combat soldier and the highest thing you can do is to kill your enemy ... why not take a photograph of it? Why not be proud? If your reality is that if you kill an armed Palestinian you ... are more honoured among the combat community? Why does it surprise you? You remember the images from Vietnam with the American soldier walking with strings of ears? Why was that? In 1994 Israeli soldiers did the same, they cut the ears from Hezbollah that they killed. Why not? This is an achievement as a combat soldier. Why not take a picture?[26]

Until 2006 little was known outside Israel about Breaking the Silence. Following the publication of Yitzhak Laor's article, I had tried to make contact with BTS but the message came back that they did not want to discuss the exhibition with journalists outside Israel. Yehuda Shaul explained to me that at that time 'we did not want to wash our dirty laundry in public'. But they eventually changed their minds. I asked Yehuda Shaul why. He told me that there were two reasons: that BTS wanted to show Europeans and Americans the reality of the occupation, and to ask that they take some responsibility for the situation in Israel. 'When I was in the Occupied Territories you could have said that I was an American soldier,' said Shaul. 'I owned an M-16... I shot grenades that were not produced with Israeli money, but with American money. Everyone, especially Americans, has a responsibility to know what's going on in the world.' The other reason, said Shaul, 'is about maturing and growing up and realising that information must be free to all... Everyone can do what they want with the information but we must provide it to anyone who wants to hear. People who are anti-Semite don't need us to be anti-Semite but people who are blinded need us to open their eyes.'[27]

But in Israel there was opposition to BTS taking the exhibition abroad. An 'open letter' addressed to BTS on a website entitled 'Stand With Us' from fellow IDF soldiers, stated that they were 'deeply pained and outraged' and accused BTS of 'spreading misinformation and hate'. The angry soldiers used photographs to protest. But these pictures are quite different. One shows members of the IDF laughing and playing with neatly dressed Palestinian children. The caption reads: 'Israel soldiers playing with Palestinian children in Hebron, 1995'. The second shows a smiling soldier 'playing with Palestinian toddler at Nablus checkpoint'. Smiling parents look on. The other two show two Israeli soldiers mourning the loss of their comrade, and a third who has lost a leg, according to the caption: 'survivor of a terrorist attack'.[28]

Spreading the word

In October 2006 I stood among a large crowd in an art gallery in Amsterdam to listen to Avichay Sharon and Noam Chayut talk about the display of photographs surrounding us. It was BTS's first exhibition outside Israel and included some of the pictures of Hebron that were exhibited in Tel Aviv, and others taken in the Occupied Palestinian Territories and in Gaza. One photograph showed a large comradely group portrait of young men in uniform. The assembled group, playful and smiling, resembled the snapshot given to me by Robert Fisk of the King's Liverpool Regiment that featured his father, Second Lieutenant William Fisk (see Figure 2.1).

Avichay Sharon began by explaining to the mostly Dutch audience that although the pictures were in an art gallery, they were not taken by professional artists or photographers but by soldiers who had never intended to make them public. 'When you open a magazine or newspaper you don't usually ask yourself who took the pictures, you just look, but with these photographs it is important. They were all taken by soldiers. None thought that they would ever be publicly shown,' said Sharon, 'they took pictures of their life and put them in

Figure 7.2 A photograph of Hebron taken by an Israeli IDF soldier. (Courtesy of Breaking the Silence)

their photo albums and later found that there is a story there to be told. This is the point of view of a soldier … we wanted to tell the story of the reality of the occupation through the eyes of soldiers.' Sharon explained that these pictures had different meanings in different contexts. 'The pictures were not taken from a critical view point, but in a public context, they can be used to support a critical viewpoint.'

We gathered in front of a photograph, a cityscape of Hebron, taken from a high vantage point, looking out over the rooftops of the city (Figure 7.2). It seemed to show a peaceful, benign scene. But Noam Chayut told us that 'the picture is horrifying.' He began to describe what the picture itself could not show. It had been taken from the rooftop of a former Palestinian school. The children had been driven out and the school closed down by the IDF because it provided a good vantage point over the city. It was here that Israeli soldiers responded to Palestinians shooting assault rifles – which apparently had little chance of reaching their target – with grenades launched from machine guns.

Yehuda Shaul had explained that a grenade is not a bullet and the weapon is not accurate. 'It hits something and explodes and kills everyone on a radius of eight meters and injures everyone in a radius of 16 meters,' he said. Shaul had had first-hand experience. When he first received orders to shoot from a rooftop he was horrified and asked himself, 'I'm supposed to shoot grenades into a city where people live?' He prayed that no one would be hurt. 'But after a week,' he said, 'it is a game. It becomes the exciting moment of the day. You're bored. You're stuck in this house. You don't go out. You play it like a video game with your joy-stick on top of the city – boom, boom, boom.'[29]

We continued on our gallery tour and walked past bunches of car keys mounted on a wooden board (Figure 7.3). These were the keys that had been confiscated from

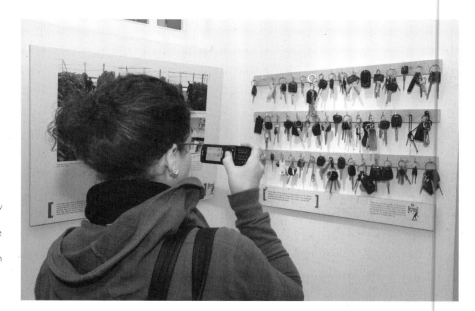

Figure 7.3 A visitor at an exhibition of Israeli IDF soldiers' pictures in a gallery in Amsterdam, November 2007, taking a digital picture of an exhibit of car keys confiscated from Palestinian drivers in the Occupied Palestinian Territories. (© Janina Struk)

Palestinian drivers. Another picture showed a Jewish settler carrying an assault rifle with a decal on the magazine clip that read: 'Kill 'em all, Let God sort 'em out'.

Another photograph showed two Israeli soldiers and a group of three Palestinian women and five children standing at a checkpoint (Figure 7.4). They are all aware of the camera and some are smiling. Both soldiers are looking at the camera and one has a broad grin. This picture seems to show an amicable scene: soldiers sharing a joke with Palestinian families? But Avichay Sharon described it as 'horrifying. The calm nature of the picture is an illusion,' he said, 'I know that to the photographer it is just another scene, like dead bodies. ... You have to understand the power that these soldiers have, they can send them back home, tell them what to do, where to go, how to carry their bags, whatever they want. They [the Palestinians] are smiling for the soldiers maybe because they are trying get across the checkpoint faster, trying to prove their loyalty to the soldiers ... trying to be quiet occupied people.'

In the exhibition, the soldier with the broad grin features in six other pictures taken in different locations. In all of them he is casually standing alongside his captives – young Palestinian men blindfolded with their hands cuffed behind their backs – looking at the camera, with a broad grin. It is as though the victims serve as a backdrop for the grinning soldier. Do the Palestinians know they are being photographed? The soldier has written a text to accompany his pictures. It says:

I have a hobby to take pictures and all my life is documented with a camera. I don't know what I was thinking taking these pictures. In the army I used to have a camera in my hand all the time and I remember how I waited to take more pictures to add to my 'collection'. I always smiled while I was photographed and never paid any attention to who was beside me. I had too much adrenalin, looking for action and I was very proud of myself, and yet

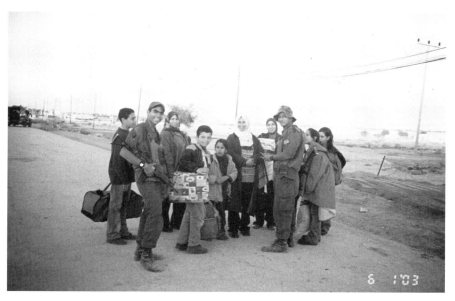

Figure 7.4 A photograph taken by an Israeli IDF soldier of a group of Palestinians with IDF soldiers at a checkpoint in the Occupied Palestinian Territories. (Courtesy of Breaking the Silence)

somewhere I was ashamed of it. I don't know what happened to me and the truth is that I still don't know.

We stood in front of another picture that showed an IDF soldier with a blackened face standing in full combat gear holding a weapon in a Palestinian home. At his feet is a blindfolded Palestinian man, his body covered by a red blanket. We assume he is dead. Under the photograph the soldier has written:

My commander, when he saw me carrying a camera in my vest, asked me, 'Why?', so I told him, 'For social reasons, and also, if I come across something interesting I take a photo.' So he said nothing. He knew that I was taking photos of severed hands and blown up heads and all that. Every once in a while he would ask if the photos have been developed. He wanted to see them. Of course, it's not just photos of bodies; they're also part of everyday life, passed around by everybody. And I still have it. A black album I try to bury, so that I won't find it by mistake.

The exhibition also included six trophy pictures taken in Gaza. They were mounted together on a board. In each of the photographs a different IDF soldier stands alongside the same body of a 'Palestinian militant' shot dead by the IDF in a 'Gaza Strip hot house'. The shirt of the dead victim is open to reveal his bare chest. His trousers have been unzipped and pulled below his twisted legs to show his underwear. A row of grenades are neatly arranged at his feet. In one of the pictures an officer is kneeling next to the corpse. He is smiling for the camera. But this officer, said Sharon, was not present at this scene. His image has been pasted into the picture using computer technology, so that he too could have a 'personal victory photo'.

Avichay Sharon pointed at these images and said: 'I know that many people look at this and feel sick, but for soldiers these are victory pictures. Soldiers are trained to kill ... when you kill the enemy you reach the peak of your profession and especially where your daily routine is always so frustrating because the enemy is always kids, old people and families it is never someone you can fight with. Who is the enemy?' he asked, as he looked around at us, his audience, 'I never saw the enemy. I saw a society. I was three years fighting a society in Palestinian cities. Finally we have some real fighter to fight with and we kill them so we take pictures and we add ourselves later on so that we all have a piece of the memory.'

We stood and stared at these photographs in an uneasy silence. I felt sure that most of us had seen trophy pictures before, not least those taken at Abu Ghraib, but these were not splashed on the front page of a newspaper, neither was anyone telling us that these images were the pranks of 'a few bad apples' nor a regrettable mistake. I had listened to photojournalists talking about their war pictures and the dangerous escapades that were sometimes involved, but this was different. Here was an insider's view. Avichay Sharon was making us confront these disturbing pictures and far from telling us they were exceptional, said that they were commonplace. He explained that for a soldier they represented triumphant cherished moments. How were we to respond? No one seemed sure.

Surveying the exhibition as a whole, I wondered which was more shocking and powerful, the stories told by the two former soldiers, or the pictures themselves. I asked some of the Dutch visitors. Opinions were diverse. One person said 'definitely the stories'. Other visitors thought that the 'proof' lay with the pictures rather than the words: 'It is much more important to have visual proof rather than spoken proof,' said one man. Another person said: 'If the collective memory [in Israel] forces people to keep their mouths shut then may be the image is a better way to speak up.' Another man thought that in comparison to images taken by photojournalists, the soldiers' amateur pictures were more effective and 'honest'. One person who was shocked to discover that these soldiers had taken pictures said that they reminded him of the pictures taken at Abu Ghraib. 'The soldier who takes pictures for curiosity ... is the same as taking pictures as the American did at Abu Ghraib,' he said. Another man thought that the stories were more shocking, but that the combination of images and words gave a filmic quality. He said: 'No I am not shocked by the pictures, I am shocked by the stories that go with them. When you hear a guy who was three years in service, who tells us about the process, the torture ... when you see the pictures you just see the snapshots, but when you get the whole story it becomes like a movie and it becomes real and that impresses me.'[30]

When I first entered the gallery in Amsterdam I was surprised by the seeming banality of the images. The majority had looked harmless. Only when Avichay Sharon and Noam Chayut began to tell the stories that the pictures could not reveal did they have the power to disturb. A picture can tell a story but only if we know what that story is. In the exhibition even an image of graffiti daubed on a wall in Hebron that read in English: 'Arabs to the gas chambers' needed an explanation (Figure 7.5).

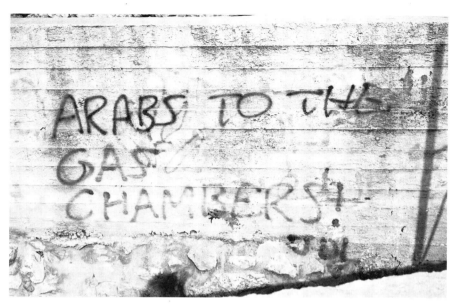

Figure 7.5 Graffiti that reads: Arabs to the Gas Chambers, on a wall in Hebron signed by the Jewish Defense League (JDL). (Courtesy of Breaking the Silence)

Yehuda Shaul had heard about this graffiti from a fellow soldier. He was shocked and decided to go and take a picture as evidence. When Yitzhak Laor had emailed me a copy in 2004, I had wondered why graffiti in Hebron would have been written in English. I asked Shaul. 'This graffiti was probably written by one of those extremist fascist Jews who came to visit Hebron from the States,' he said. He was referring to members of the Jewish Defense League (JDL), an organisation founded in Brooklyn, New York by Rabbi Meir Kahane, whom he described as a 'Jewish Nazi'. He pointed out the initials 'JDL' visible in the bottom right-hand corner of the picture.[31] In the exhibition this picture was accompanied by a text written by BTS:

> They themselves didn't go through the Holocaust but I'm sure that some of them come from families who survived the Holocaust. If they are capable of writing on the Arabs doors 'Arabs Out' or 'Death to the Arabs' and drawing a Star of David, which to me looks like a swastika when they draw it like that, then somehow the term Jew has changed a little for me with regard to who is a Jew.

In his article in the *LRB*, Yitzhak Laor had described this settler graffiti and had written: 'What the Israeli Army (like the Israeli state) needs to reproduce in its soldiers is either sheer racism – that is, faith in "the murderous nature of the Arabs" – or a brand of religious messianism, neo-Nazi ideology wrapped in Judaism. ... This kind of discourse has its weaknesses: it needs soldiers to fight for it. There are a lot who won't.'[32] There were other images of hateful graffiti in the exhibition, some in English, some in Hebrew, including: 'Kill Arabs', 'Watch

out Fatima we will rape all Arab women', 'Exterminate the Muslim' and 'Gas the Arabs'. The Holocaust, it seemed, was not far away.

'Our own Abu Ghraib'

In 2004 journalist Jonathan Freedland wrote in the British newspaper the *Jewish Chronicle* about video footage, taken by a Jewish woman peace activist, that had surfaced in Israel. It showed a Palestinian musician forced by Israeli soldiers to play his violin at a military checkpoint. An Israeli soldier had reportedly suggested that the Palestinian, Wissam Tayem, who was on his way to a music lesson in Nablus, 'play something sad'. Once he obliged they jeered and laughed at him.[33] The similarity between the behaviour meted out by Israeli soldiers and that perpetrated by Nazis and German soldiers, who had commonly made Jewish musicians play at the checkpoint entrances to Jewish ghettos or concentration camps, could hardly be clearer.

But for Yoram Kaniuk, author of a book about a Jewish violinist forced to play for a camp commandant, the main consideration seemed to be that the image 'belonged' to Jewish suffering. According to an article by Chris McGreal in the *Guardian*, Kaniuk wrote in *Yedioth Ahronoth* that the soldiers responsible should be put on trial 'not for abusing the Arabs, but for disgracing the Holocaust ... this story is one which negates the very possibility of the existence of Israel as a Jewish state. ... If we allow Jewish soldiers to put an Arab violinist at a road block and laugh at him, we have succeeded in arriving at the lowest moral point possible. Our entire existence in this Arab region was justified, and still is justified, by our suffering; by Jewish violinists in the camps.'[34]

Yitzhak Laor has written that Israel needs Holocaust images to sustain its image as victim. The 'atrocities are always perpetrated against us,' he writes, 'and the more brutal Israel becomes, the more it depends on our image as the eternal victim. ... The Holocaust is part of the victim imagery, hence the madness of state-subsidised school trips to Auschwitz. This has less to do with understanding the past than with reproducing an environment in which we exist in the present tense as victims. Together with that comes the imagery of the healthy, beautiful sensitive soldiers.'[35]

In Yad Vashem, Israel's memorial to the Holocaust, there are hundreds of images of Jewish suffering on display – some taken by Nazis and German soldiers. I asked Yehuda Shaul if he saw parallels between these pictures and those taken by IDF soldiers. He said that although what happened during the Holocaust was not comparable, the experience of the soldiers was in some ways similar.

> You cannot compare the occupation with what happened in the Holocaust ... but soldiers or criminals who did these kind of things went through the same process. ... It is the same moral and emotional numbness, it is the same blocking your eyes from seeing ... it is the same silence in a way. ... It is not the same evil but it is the same banality. The fact that it's impossible to compare the Holocaust to anything else doesn't mean that it's impossible to take something from it. As someone once wrote,' he said, 'racists stand for the siren on Holocaust remembrance day too.'[36]

Although Shaul does not make direct parallels with pictures taken by IDF soldiers and images taken during the Holocaust, he does see parallels between those taken by Israeli soldiers and the American soldiers at Abu Ghraib.

> The footage from Abu Ghraib is exactly the same that is for sure. ... You see the pictures of Palestinian bodies ... this is exactly the same. It is not the same story but it is exactly the same numbness and the same personal silence that we are talking about. It does not get close to documenting Auschwitz, a factory of murder and genocide, but it is like documenting Abu Ghraib. Between documenting Abu Ghraib and documenting the (Israeli) occupation it is only a quantity difference, not a quality difference.

Shaul mused on why shocking pictures taken by soldiers in any war or occupation fail to ignite protest.

> The Abu Ghraib pictures were worse than what we show in our exhibition but they did not break the silence of the American society, not at all. The question is not *why* do the population remain silent, but why not? I really believe that the nature of human beings is to be silent. To resist, to open your eyes, to criticise, is against human nature. ... How many British soldiers come back from Iraq and open their mouths? How many in Iraq? Power corrupts. Eighteen-year-old people with uniforms and guns and with ability to control people ... it is like a maths equation ... occupation ends like this.[37]

Since 'Bringing Hebron to Tel Aviv' opened in 2004 stories about pictures that show abuse inflicted on Palestinians by IDF soldiers continue to seep into the Israeli press. In 2008 an editorial in *Ha'aretz* described the activities of the Kfir Brigade as 'Our own Abu Ghraib affair'. The Israeli television programme *Fact* had reported that soldiers had 'exposed their backsides and sexual organs to Palestinians, pressed an electric heater to the face of a young boy, beat young boys senseless, recorded everything on their mobile phones and sent the images to their friends.' The editorial stated that perfectly ordinary people – like those found guilty at Abu Ghraib – 'are capable of behaving like monsters when they receive a message from the top that it is permissible to abuse, beat, choke, burn, make people miserable and generally do anything that man's evil genius is capable of inventing to others who are under their control.'[38]

If this was Israel's 'Abu Ghraib affair', then why did the pictures fail to make worldwide headlines? Was the abuse less abusive than that perpetrated on the Iraqis, or the humiliation less humiliating, or did the images not capture viewers' imaginations? Or is it a question of context? Yitzhak Laor has said that the image of Israel as an 'eternal victim' – an image generally supported by Western politics and media – is required to justify the continued occupation of Palestine. Israel cannot be both victim and oppressor at the same time. In 2002, a picture of an IDF soldier taking a photograph of two other Israeli soldiers casually posed behind the body of a dead Palestinian who lay at their feet, was published in Britain in the *Journalist* magazine and *Palestine News*. It made no impact at all.[39]

Likewise, the image of the grafffiti 'Arabs to the gas chambers' has not, as far as I know, made headline news or been published. It is worth considering the outrage that would be expressed if instead of 'Arabs' the word 'Jews' had been scrawled on that wall in Hebron. Like a protective shield, Israel is powerfully cloaked in Holocaust imagery, that absorbs and renders the images of abuse perpetrated on Palestinians as virtually invisible. In order for the Israeli soldiers' pictures to become accepted as evidence of injustices and atrocities, they will have to wait, as those taken during the Holocaust by Nazis and German soldiers had to wait for nearly half a century, until a broader understanding and acknowledgement of that event gave them context and meaning.

EIGHT
The Inside View of War

War is not for photography. If, heaven forbid, I had to
photograph war again, I would do it quite differently. I
agonise now at the thought of all the things I did not
photograph. *Dimitri Baltermanc.*[1]

A particular kind of truth

The pictures taken at Abu Ghraib provoked outrage, disgust – and also a prurient
curiosity. The idea that on the front lines of war, in Iraq and Afghanistan, soldiers
were equipped with digital cameras, laptops and mobile phones with the ability
to instantly transmit images to friends or family thousands of miles away, or post
them on websites, was intriguing to some journalists and academics, particularly
in the USA.

The attention given to these amateur soldiers' pictures was similar to that paid to
professional photographs in previous wars, but during the war in Iraq, despite the
twenty-four-hour news coverage, there seemed to be no memorable professional
images. One factor was that Iraq very quickly became a dangerous working environ-
ment. The only secure option was for journalists to be 'embedded' with American or
British troops, which made independent working practices all but impossible. There
were also problems of censorship. The media were tightly controlled, particularly
in the USA, and few outlets existed for innovative photography. But there was also
a pervading sense that traditional photojournalism was inadequate and outdated in
this first war of the Internet age. Now it was imagined by some that, instead, soldiers'
pictures could give an eagerly sought-after, authentic and unedited inside view of
war. The growth and popularity of 'reality' television, which enthralled audiences
with its dramatisation of the mundane realities of everyday life, had made the idea of
seeing a soldier's war from the inside appealing, and a marketable proposition. The
enthusiasm that welcomed this possibility, offered by developments in technology
and changes in popular taste, was similar to the eagerness that greeted the invention
of the camera in the nineteenth century, discussed in Chapter Two, when commen-
tators mused with some excitement on the prospects of how war might 'really' look.
It appeared that, after more than a century, this desire was still unfulfilled.

But there was also apprehension among some commentators about what the
consequences of these amateur pictures might be for the genre of war photography.

Some lamented over what was seen to be this lost tradition and referred repeatedly to what were considered as the 'great' iconic war photographs. The same three Pulitzer prize-winning pictures were drawn upon time and again: the photograph taken at the end of the Second World War by Joe Rosenthal of the US marines raising the American flag at Iwo Jima, which was actually staged after the battle, in the final months of the war and was really propaganda; the picture taken during the war in Vietnam by Eddie Adams of the public shooting of a Viet Cong fighter by a senior South Vietnamese police officer, about which it is said that the presence of the photographer encouraged the execution; and Nguyen Kong (Nick) Ut's photograph of burning Vietnamese children fleeing in terror following a napalm attack – a stroke of incredible luck.[2]

The Vietnam War is commonly regarded as a war that produced some of the most powerful and memorable war pictures. Images of innocent victims filled the pages of a press with an appetite for photojournalism. It was also the first time that American soldiers were portrayed as the casualties of war in any significant way. While soldiers became victims, Western photojournalists – including Don McCullin, Tim Page, Philipp Jones Griffiths and Larry Burrows – became heroes and their pictures were etched into the public memory as images that were 'objective', told the 'truth' and had the power to move opinion.

But it was a very particular truth. Documentary photography, like other genres, is bound by cultural, social and aesthetic conventions, which Western audiences, for whom it is generally produced, have learned to take for granted. The skilled photographer makes war seem tragic and dramatic but inevitable, rational and palatable. War photographs must have drama as well as pathos, meet high technical standards and have eye-catching and aesthetically pleasing compositions. A photograph is the subjective view of the photographer, who makes a series of choices each time the camera shutter is released: which part of the scene to photograph, how best to compose it, then technically how to achieve the required results – the use of lenses, the angle, distance, the type of lighting and focus. The carefully composed moment should shock and fascinate while giving the impression of the event being controlled. That moment must also 'tell a story'; the saying is that a picture is 'worth a thousand words'.

Suffering and death should be poignant, dignified and beautiful, never ugly, messy or repulsive. They must not portray atrocity or the horrors of war – the severed body parts, spilling guts and the agony of dying – because such pictures are not marketable and do not sell newspapers or magazines. When, for example, during the war in Iraq editors at the *Sunday Telegraph* published a front-page image of a Western contractor who had been beaten and shot to death in Iraq, hundreds of letters of complaint were sent in by readers.[3] The difference between an atrocity image and a conventional war picture is the difference between excessive and acceptable violence. When Robert Fisk referred to the carnage he had witnessed in Iraq, and the lack of any meaningful press coverage of atrocities, he said that an image of such atrocity would only be marketable 'if an Iraqi soldier is obliging enough to die by the side of a road in a romantic pose, and you can get him against a skyline without any boiled flesh'.[4]

The aesthetic and artistic demands made on professional photography are a consequence of the idea that photography is an art form, a notion that has been doggedly attached to the medium since its invention. These demands are sometimes at odds with the subject matter and seldom more so than when the subject is war. In 1869 photographer Felice Beato, who took photographs of a massacre in Tietsin during the Chinese Opium Wars, was reportedly in a state of 'great excitement' over a pile of the dead which he thought would make a wonderful composition. He characterised the corpses as 'beautiful' and begged that the heap not be interfered with until he had taken his pictures.[5]

Similarly, when celebrated Western photographers, such as Margaret Bourke-White and George Rodgers, took pictures of the horrifying scenes at the liberated Nazi concentration camps in Germany in the spring of 1945, they bestowed on these scenes of unimaginable horror aesthetic values, incongruous to the subject and potentially offensive to those they photographed. But images taken in the camps set a precedent for bearing witness to atrocity in photographs and changed the relationship between words and image.[6] When Bourke-White made a dramatic flash-lit composition of a row of emaciated prisoners standing against a barbed wire fence at Buchenwald it looked like a still photograph from a fiction film. And when she photographed a pile of twisted, emaciated corpses, they were framed with an aesthetically considered composition and lit with powerful lighting that added drama to a scene that hardly needed dramatic effect. George Rodgers, who took photographs at Bergen-Belsen, said that he found himself framing the bodies 'into artistic compositions in his viewfinder'. He was so appalled by his own insensitivity that he vowed never to take another war picture. There is no evidence to the contrary. In 1947 Rodgers became a co-founder of the celebrated Magnum photo agency whose socially concerned photographers travelled to poor and war-torn regions of the world in search of pathos and tragedy. He turned his attention to Africa and made photographic studies of the Nuba tribe in South Africa. The modern-day photojournalist seemed much like the nineteenth-century traveller, but with a liberal conscience.[7]

Almost every conflict has had its visual cliché. During the 1960s the Biafran War was largely represented by the bloated bellies of wide-eyed naked African children, while in the 1990s, when wars were being fought in Islamic countries for the first time in more than a century, including in Kosovo, Chechnya and Palestine, images of grief-stricken wailing Muslim women became a standard in the representation of these conflicts. As a photojournalist, during a photo assignment to Kashmir in northern India, where at the time thousands of civilians were being seized by the Indian Army, many vanishing without trace, I photographed a group of women gathered together to publicly grieve the discovery of the tortured body of one of their sons, found in the gutter.

I was aware at the time of the problem of framing these distressed women into an aesthetically pleasing, colourful composition. As they had invited me to take photographs of their mourning, they too seemed aware of the possible impact of such a photograph that might draw Western attention to the suffering of their community and help their cause in the war. In the Western media at that time, images

of colourfully clad wailing Muslim women swept the board in professional photographic award ceremonies. I had also taken pictures in Kashmir of the horrific wounds of Kashmiri victims of torture as they lay dying in their hospital beds. I knew at the time that these pictures, rich in information but weak in aesthetics, would not interest the Western press.

Although the images of the women I took in Kashmir might have conformed to a widely held view of what professional images of suffering are supposed to look like, they revealed nothing at all about the conflict. Neither were they of any local value. In photographs of universal suffering, victims are generally portrayed as innocent and passive. Looking at the pain of these Kashmiri women evokes a complex cocktail of emotions including sympathy but also inertia – there is nothing we can do to ease their pain. Images such as these do not compel us to action, nor do they inform. As early as the 1930s, Bertolt Brecht had described a photograph as 'a terrible weapon against the truth' in that its success lies in giving an immediate and emotional connection to what suffering or atrocity or war might look like, and in doing so preventing rational thought.[8]

But in Kashmir at the time there were some very different photographs being published, which did have a local public use. Every day on the front pages of the local press, columns of small black and white amateur photographs of the disfigured faces or tortured, mutilated corpses of those found dumped were printed. There was no drama or pathos in these pictures. They did not beautify their subjects as Felice Beato, George Rodgers or Margaret Bourke-White had done. They were records, taken as the passing eye records them, by the authorities or amateur photographers who found the bodies. They were published partly for their propaganda value but mainly so that relatives or friends might identify the corpses.

Similarly, in Iraq, independent American citizen journalist Dahr Jamail collected pictures taken by an Iraqi in Fallujah who had been allowed into the city to bury the dead following the American military assault in 2004. He had taken snapshots of the victims before they were buried so that survivors could identify their dead. Jamail posted the grisly pictures on his website. When he was asked why the public should be subjected to such stark images of the dead, he said, 'Because this is what Iraqis are seeing all the time, this is what US soldiers are seeing all the time. And this is what people back here never see.'[9]

These, like all amateur pictures and those snapshots taken by soldiers, need not strive to attain the aesthetic or commercial production values of a professional photograph. They are not concerned with drama, pathos or marketability. They just say: 'Look! this is what I saw. I was there', as the pictures on the pages in the American soldiers' First World War albums cited in Chapter Three seemed to do. Amateur pictures are more like the continuous and more random choices of the onlooker whose gaze records in passing rather than the single constitutive choice of a professional photographer. They are not expected to *tell* stories on their own or 'speak for themselves'. They *prompt* stories, as I discovered when my Uncle Cec showed me his wartime photo albums and when Jerzy Tomaszewski showed me pictures from his archive. John Berger has written that a professional photograph 'is torn from its context, and becomes a dead object which, exactly because

it is dead, lends its self to arbitrary use,' whereas by contrast an amateur picture 'remains surrounded by the meaning from which it was severed. ... The photograph is a memento from a life being lived.'[10]

This was the attraction when British newspapers appealed to soldiers for their pictures from the front during the First World War. It was thought that amateur pictures were more authentic and less contrived than those taken by professionals. Such photographs also had a novelty value, as did the pictures taken by soldiers of the Christmas Truce, one of the most significant events in the history of warfare, discussed in Chapter Two, although the pictures are rarely used in the context of war photography. They would not meet professional standards.

Amateur soldiers' pictures were also sought after when the Nazi concentration camps were liberated by the Allied forces in 1945. Then American soldiers were encouraged by their superiors to take their own snapshots of the horrific scenes, not for publication, but to show friends and family back home. It was thought that they might be more believable than the well-composed and technically proficient professional photographs. Susan Sontag has written: 'People want the weight of witnessing without the taint of artistry, which is equated with insincerity or mere contrivance. Pictures of hellish events seem more authentic when they don't have the look of being "properly" lighted and composed, because the photographer either is an amateur – or just as serviceable – has adopted one of several familiar anti-art styles.'[11]

The belief in the authenticity of amateur pictures was exemplified in an exhibition in Kraków, Poland, in 2004, when pictures taken by German soldier Helmut Riemann, who had served during the Second World War, were displayed alongside those taken by Polish soldier Czesław Elektorowicz. The purpose of the exhibition entitled 'Przełamywać Bariery, Budować Mosty' ('Cross the Barriers, Build the Bridges') was not to show the complicity of members of the Wehrmacht in Nazi crimes, as had been the case in the 'War of Extermination' exhibition in Hamburg in 1995 (discussed in Chapter Five), but rather, as an act of reconciliation between the two countries. Underpinning the exhibition was an unyielding belief that their amateur pictures simply depicted reality. The catalogue stated: 'Being the work of amateurs who have captured on film the world around them, these photographs are much the same as the reality they depict. They bear no sign of accomplished selection of motifs, no aesthetic frame by frame approach, no manipulation. ... These types of photographic collections appear to be authentic documents, a record of the surroundings and reflecting time passing, as well as tragic moments.' But in spite of the conviction that amateur pictures told the truth, they were flanked by the professional photographs of Polish Second World War photographer Tadeusz Szumański, as if to give them an authority they might be seen to lack.[12]

This dichotomy between the seeming ability of amateur photographs to reflect the real and their lack of authority is also reflected in a book by acclaimed Dutch photojournalist Geert van Kesteren, whose work has been described as the Second Gulf War's equivalent to that of Philipp Jones Griffiths in Vietnam and as representing a 'new departure in photojournalism'.[13] Van Kesteren's book, entitled

Baghdad Calling, is a visual record of the plight of some of the 2 million Iraqi refugees exiled by war in Jordan, Turkey and Syria. The majority of pictures in the book were taken by Iraqis on mobile phones as a way of keeping in touch with friends and loved ones inside and outside the war zone. They were collected by van Kesteren and his team via personal contacts, blogs and websites. The team were also sent pictures that showed 'American soldiers firing guns while seated on a donkey' and 'insurgents with rocket-propelled grenade launchers and AK-47s' but these were considered inappropriate to the book's 'journalistic narrative' and rejected.[14]

The idea of using amateur snapshots had developed because as a photographer, van Kesteren said he found it difficult to capture the drama of the plight of the refugees. 'This suffering is not as photogenic as, for instance, the plight of the refugees from Kosovo, who trekked through the snow-decked mountains, wounded and destitute,' he wrote. In *Baghdad Calling* drama was replaced by amateurism, and this became the appeal. But van Kesteren chose to distinguish between the amateur images – printed on rough newsprint paper, and his own pictures – printed on glossy paper – in much the same way that curators of the exhibition at the International Center of Photography (ICP) in New York and at the major exhibition of war photography in Brighton had chosen to distinguish between the pictures taken at Abu Ghraib and professional war pictures. Academic Brigitte Lardinois wrote about the amateur pictures in van Kesteren's book: 'Though the photographs are not always particularly well taken, somehow the fact that the images have not come through the filters of professional photographers, who are often outsiders, increases their narrative power.'[15]

But the blurred, technically inept snapshots of destroyed streets and buildings in Iraq, a group of anonymous people in their home, or at a wedding party, or a graduation ceremony, or a Ramadan Eve, or the indecipherable out-of-focus image of a mortuary, cannot increase their narrative power. In the modish context of citizen journalism, the power of these amateur snapshots, if it exists at all, is not in what they show, but in their perceived authenticity.

The elusive image

In 2004, while some photographers and academics were praising the authenticity of amateur pictures, the US authorities were trying to counter such claims with the merits of traditional professional photographs. Besides the amateur pictures taken at Abu Ghraib, there had been others that had some impact. Tami Silico, an airline worker, took snapshots of the coffins that contained the remains of American military personnel. The controversy her pictures incited helped force the US government to release official photographs of the coffins after Russ Kick of Memory Hole, a website committed to combating US government secrecy, won a Freedom of Information request for the release of 360 similar images of the coffins of the war dead.[16] Following the widespread publication of these pictures, the US authorities badly needed a compensating image. There were a few contenders.

During the assault on Fallujah, in November 2004, professional photographer Luis Sinco, embedded with American troops, took a close-up portrait of a

rugged-looking American marine called Blake Miller. The marine's face is smeared with dirt and partly obscured by a curl of smoke from a Marlboro cigarette dangling from the corner of his mouth. It was widely broadcast and published in the USA, where Miller was dubbed by the media as a wartime 'Marlboro Man'. CBS News anchorman Dan Rather called it, incongruously, 'the best war photograph in recent years'. He asked viewers to 'see it, study it, absorb it, think about it. Then take a deep breath of pride. ... This is a warrior with his eyes far on the horizon, scanning for danger.'[17]

But the image of Miller looked outdated. The handsome young marine with a rugged mean look and a cigarette dangling from his lips referred back to the cigarette advertising of the mid-twentieth century that associated smoking with masculinity, adventure and cowboys. This image might have been meaningful during the Vietnam war, but during the war in Iraq, in the age of digital technology, Marlboro man was way outside the public imagination. When Miller returned to the USA and confessed to suffering from PTSD on the CBS television programme *The Early Show*, media interest in the warrior quickly waned and the image was largely forgotten. In 2008 the photograph was exhibited with a few other professional images from Iraq alongside well-known images from Vietnam in the exhibition of war photography in Brighton entitled 'Memory of Fire: The War of Images and Images of War', but rather than celebrating contemporary photojournalism it seemed to be fulfilling an obligation to the moribund genre of war photography.[18]

There had been attempts to stage-manage other pictures. The 'shock and awe' images of the rain of bombs dropped on Baghdad following the invasion of March 2003 were intended to demonstrate the supremacy of the USA and scare the Iraqis into submission but were widely regarded as an attack on civilians; photos of the cheering crowds that witnessed the toppling of the statue of Saddam Hussein in a Baghdad square opposite the Palestine Hotel, where the world's media were conveniently on hand, were discredited by the revelation that they had been cropped to make a small gathering look like a large crowd. In May 2003 there were images of President George W. Bush standing on board USS *Abraham Lincoln* in a fighter pilot uniform announcing to television cameras that 'major combat operations in Iraq have ended', at a time when the war had hardly begun. Even the most hardy warmongers in the White House preferred to forget this one, especially when it was revealed that the warship was anchored off the coast of California.[19] In an unfortunate attempt to reaffirm the potency of this image, President Bush referred in his speech on board the ship to the 'falling statues' and to 'Iwo Jima' – presumably, in the latter case, drawing attention to Joe Rosenthal's famous image rather than the battle itself, in which more than 6,000 American soldiers were killed and 20,000 injured, in what has been described as the worst battle in the history of the Marine Corps.[20]

The US authorities also released gruesome pictures of Saddam Hussein's sons, Uday and Qusay, as they lay dead in a mortuary. At a US military press conference, an enormous photograph of the head of the dead Abu Musab al-Zarqawi, said to be a leader of Al-Qaeda in Iraq, was put on display. These pictures, used as evidence

of the capture of the people concerned, may have shared the amateurism and ghoulishness of soldiers' trophy pictures but they hardly gave the impression of successful military operations. There were also pictures of Saddam Hussein after his capture, in a white-tiled room having his mouth probed by rubber-gloved hands. These also had an amateurish quality – perhaps an attempt to adopt the same 'reality' style as soldiers' pictures and those taken at Abu Ghraib? But their contrivance was more perplexing than convincing.

In a further attempt to generate favourable imagery, exploiting the growing popularity of digital technology among soldiers as online photo album entitled *Through the Lens of a Soldier* was posted on pbase.com. The pictures were purported to have been taken by 'Debbie' who served in the 101st Airborne Division, then based in Mosul even though she featured in many of them. They showed 'Debbie' sleeping, standing alongside smiling Iraqi children and Iraqi medical staff. They also had a remarkable professional quality. 'Debbie' apparently managed to take pictures of official military functions and American soldiers through a sight range silhouetted against a glorious sunset. But the image of 'Debbie' as a dutiful and attractive smiling soldier stood in stark contrast, no doubt deliberately, to the slight and androgynous figure of Lynndie England in Abu Ghraib.

Alongside the pictures of Debbie's serene and picturesque war, she wrote: 'Look this album was put together so that my friends and family could see what I was doing in Iraq What we [soldiers] are doing for the people of this country is so amazing and I am so proud to have done my part. This is an experience that I will never forget and will hold dear to my heart forever all the smiles and the hugs and the laughter I have seen, felt and heard.' Then, in an abrupt change of mood, she continues: 'Please respect what I have done and what my fellow soldiers have done for these people – keep your shitty comments to yourself. You haven't been here so you don't know how it is. Enjoy the pics and thank you to all those who have supported us in our endeavors. Please refrain from posting negative comments about the USA or US armed forces. Many military families that visit this site may be harmed by your comments. I review the comments occasionally and delete the negative ones, so why bother posting them?'

One visitor to the site, a former member of the 101st, responded: '... my good friend is headed back to Iraq for a second tour This time he will be taking a digital camera and half a dozen memory sticks that I'm giving him. The plan is to set up a web page documenting his year in Iraq. The sights and views from a soldier's eyes. Similar to what you have done here. Hopefully if things work out like we plan he will fill a memory stick up and mail it to me where I will then set up a photojournal so that his family and the families of his unit can see them and what they are doing. ...'[21] In a war in which digital cameras were practically 'standard issue gear', thousands more soldiers would have the same idea.

In search of the 'real'

In 2004, editors in the New York office of *GQ*, a glossy monthly men's magazine, began an appeal to soldiers for their pictures of war with the intention

of producing a book to mark the second anniversary of the invasion of Iraq. In much the same way as the British press in 1915, *GQ* offered large sums of money – between $200 and $1,000 – for each picture published. The idea was instigated by *GQ* journalist Devin Friedman, who during a month's assignment in Iraq had been amazed to discover that most American soldiers had digital cameras, memory sticks and laptops. One soldier told him about the day a roadside bomb had exploded in a Baghdad neighbourhood where he was stationed and how he had received an email from his sister in the USA who was worried about his safety. The soldier took a picture of himself and emailed it to her as evidence that he was still alive. That this was technically possible was 'remarkable' to Friedman. The same soldier showed him pictures that he kept on his memory stick on a lanyard around his neck. Among them were photographs from his unit and pictures of 'every man his unit had killed'. One frame described by Friedman showed 'a body slumped in the front seat of a sedan with a grapefruit-sized hole where his face should be'.

Devin Friedman found this trove of soldiers' pictures inspiring. He wrote: 'While media outlets around the world were spending millions of dollars to ship scruffy men in safari vests to Iraq with thousand-dollar cameras, more than 140,000 American servicemen were compiling the most extensive documentation of a war that's ever existed.'[22]

On his return to the USA Friedman and other *GQ* editors set about collecting soldiers' pictures of war. Advertisements were placed in the US military press, including *Stars and Stripes*, which some months later began its own appeal for soldiers' pictures. They were published in a column called 'Your View', which advised: 'Candid (not posed) shots are the best' – a reminder of the press advertisements for soldiers' pictures in 1915 (discussed in Chapter Two).[23] *GQ* also contacted soldiers directly by email and through a network of milbloggers' websites, although some distrusted the motives of the magazine. An advertisement placed on blackfive.net, established by army veteran Matthew Burden, prompted one visitor to the site to warn soldiers against sending pictures on the grounds they might be used as propaganda in what he called 'a hate-bush elitist fest ... an utterly contemptible rag'.[24]

The *GQ* advertisement read 'We want pictures of you, your buddies, battles, what you do to entertain yourself when you're bored, even pictures your families have sent you from home. ... What may not seem interesting to you could be important for the essay. This project will reflect the war the way it really is and we are not averse to blood, dirt or anything else as long as it really happened.'

Soldiers' pictures also interested Kim Newton, a former Reuters news agency picture editor and photojournalist (and the son of film actor Robert Newton). He established an online project 'Digital Warriors: Iraq Through Soldiers' Eyes' (thedigitalwarriors.com) and appealed to soldiers to send in their pictures although not in return for payment. He took the view that digital technology offered exciting new image opportunities. 'I realised that this was the first major war where digital technology had become mainstream for the masses and that soldiers, who had always taken cameras to war, not only

had cameras in their cell phones, but were also taking point-and-shoot digital cameras with the potential to produce publication quality images.' Newton was looking for what he called 'an unfiltered point of view' that filled the gap left by the lack of professional pictures in what he called an atmosphere of 'blatant and obvious' censorship by the US administration: 'I wasn't looking for just sensational images as we saw from Abu Ghraib,' he said, 'but certainly pictures from situations that we weren't seeing. ... The attack on Fallujah would be a good example.'[25]

The US military attack on Fallujah had been accompanied by a rigid media censorship. When in April 2004 American troops began their first assault on the city there was a complete media blackout. Journalists from Al Jazeera television were discovered to have broadcast from a hospital that had been closed down by US forces and were banned from the city, and an *Al Arabiya* reporter who had filmed in Fallujah was arrested and released only after he had handed over his tapes.[26] But, curiously, no restrictions seemed to have been imposed on soldiers with cameras. Chad Petersen, a marine who took part in the assault, said that he had 'a pouch on [his] gear where I could just pull [a digital camera] out real quick and keep my weapon there and be ready to fight'.[27] When Duncan Anderson, Head of War Studies at Sandhurst Royal Military Academy, visited Fallujah following the assault, he said that about 20,000 Americans were involved in the 'battle' and most had digital cameras or cell phone cameras. 'In the battle for Fallujah alone,' he wrote, 'I wouldn't be surprised if there were as many images of the fighting ... as were taken by the entire US armed forces in the Second World War.'[28]

Despite the sheer numbers of soldiers taking pictures, Kim Newton had a disappointing response. After a year he had received only a handful of photographs from British soldiers and around fifty from American soldiers. It had been difficult, he said, to convince people he was legitimate and not out to exploit or make a profit from their willingness to contribute. He decided to put the idea on hold, and complete his thesis, 'Does Documentary Photography Matter?' He concluded that the project was simply ahead of its time. 'Soldiers from World War II and Vietnam still have problems talking about and showing their images,' he said, 'time will filter these images out.'[29]

In contrast to Newton's lack of success, *GQ* magazine reported that it had received more than 10,000 pictures. By March 2005, 256 pictures taken by sixty-eight soldiers had been published in a glossy hardback book entitled *This Is Our War: Servicemen's Photographs of Life in Iraq*. The book's editor, Devin Friedman, told me that the editorial team had chosen pictures that they felt reflected the full spectrum of the experience for an enlisted person in Iraq. 'The basis test was,' he said, 'is this interesting to look at?'[30]

The disparate collection of pictures were given an authority and context by the foreword written by General Wesley Clark, rather in the same way that a soldier's personal photo album is given authority by a portrait of its maker. The photographs show soldiers having haircuts, shaving, sleeping, patrolling, reading letters from home. Three of them were taken by CJ, the milblogger who

had objected to Donald Rumsfeld's attempted ban on cameras, mentioned in Chapter One.[31] Other pictures show soldiers as tourists: posing in front of poster images of Saddam Hussein or beside the ancient sites of Babylon, Oayyarah or Nimrud. A few gruesome images were published in the book; one series shows the rescue of a badly injured American soldier who had asked a photographer to take pictures in the event that he was injured. Another picture shows the burnt twisted bodies of soldiers blown up in an explosion, but they were Iraqi National Guardsmen, not Americans. Not all pictures were digital. One contributor called Alvin Benjamin said that he took pictures on film to send to his wife. 'I took tons of pictures – I don't know how many rolls – and I would send them back to my wife. It was like "Here's something for you". And she would go rush to Walmart and develop them. It was a way for me to let her in on my life,' he said – a reminder of the woman who had asked her husband to send her pictures of 'a good view of a nice battle' from Crimea, mentioned in Chapter Two.[32]

Devin Friedman described the soldiers' pictures as 'a collective memory of the war in Iraq' that was 'beautiful, honest, intimate, hilarious, harrowing'. Their intention, he wrote, was 'to record what they'd experienced, to make it seem real to themselves', as though taking pictures had validated their experiences. This 'collective memory' also included a well-known photograph taken at Abu Ghraib by Jeremy Sivits with Charles Graner's camera. Under the heading 'A soldier's story: one infamous photograph' is a full-page picture of Graner with one arm around the head of a hooded Iraqi prisoner and the other arm raised as if about to strike at him. The caption quotes Sivits: 'Almost every soldier that goes to Iraq has a camera with him – so that you can remember things and show people where you were.'[33] Graner's pose reminded me of Corporal Cooley's snapshot of a 'simulated punch' taken in Basra in 2003 and the pose struck by the white man with a raised whip over the back of a black man in the picture taken during the Boer War (see Figures 6.2 and 3.10). After Sivits had taken the picture Graner had apparently punched the prisoner. Then no one took pictures.[34]

In *This Is Our War* Friedman wrote that the pictures surpassed those taken by professional photographers and were probably 'far superior' to those on the photo servers at the *New York Times* or *Newsweek*. But some pictures had all the hallmarks of being taken by professionals. I made an Internet name search of the contributors and discovered that some were award-winning military photographers, including Stacy Pearsall, Brien Aho and Aaron Ansarov. Ansarov told me he submitted hundreds of photographs.[35] According to Kim Newton, a member of the military at Camp Pendleton in California had told him that *GQ* magazine had allegedly been given 'thousands' of military photographs by the US authorities even though official US military pictures are considered in the public domain and available on official websites for anyone to use.

But I was curious why a book marketed as a book of soldiers' pictures seemed to include a large proportion taken by professional military photographers. Kim Newton had considered military photographers in the same category as

photojournalists and therefore outside his remit, but Devin Friedman did not agree. When I contacted Friedman he told me: 'People who've been given some training (I still wouldn't call them professional) tend to use their cameras better … .They know a little better how to compose a shot … but they (the army photographers) are enlisted men first and foremost.' He conceded that pictures taken by amateurs 'tend to feel more intimate. Possibly for feeling rougher … . The idea that they were out there to document their lives makes their photographs interesting. You are seeing the war almost literally through their eyes. You don't get a lot of combat pictures that way, but you get a sense of what it was like to be there, to imagine yourself as them.'[36] The criteria for a good war picture, it seemed, had changed little. Friedman was articulating the same sentiment as expressed in the paper circulated by Ivor Nicholson in the British Press Bureau, the government's First World War media office, in 1917. That paper had stated that a successful war picture would be one that made the viewer think, 'What should I feel like if I were there?' It had also suggested that photographers should take 'intimate pictures' and that 'the closer the camera can bring the war to the neutral or the civilian, the more successful will be its work' (see Chapter Two).

In spite of the fact that many of the pictures in *This Is Our War* seem to have been taken by military photographers, Devin Friedman was keen to tell me that the two men who submitted the most technically adept and artistically composed photographs were amateurs, though one of them did become a professional photojournalist after he left the military. That soldier, I discovered, was Edouard Gluck.

When I tracked down Gluck in May 2008, he was in London busy making his film debut as a weapons inspector in Iraq, alongside Hollywood star Matt Damon, in a Paul Greengrass film entitled *Green Zone* (2010). Gluck was having a 'good war', even though he had not supported the US-led invasion. 'It really was the American military safari adventure … an extension of the ideas of the Bush administration playing on the post 9/11 wounded psyche of America,' he told me. But he reflected on the opportunities that had come his way since the publication of *This Is Our War*, which he was keen to point out was not only inspired by his work but was primarily a book of his pictures, although it had not been marketed as such. In fact his favourite picture, 'pin-ups', had been used to promote both the book and a supporting exhibition, *Life during Wartime: A Soldiers' Portfolio*, which opened in March 2005 in New York.[37] The picture shows a uniformed soldier asleep on a camp bed in a makeshift army barracks in Ramadi. The wall behind the soldier is filled with pin-ups cut out from the pages of magazines. The camera angle gives an impression of the images towering over him. There is something vulnerable and innocent about the sleeping soldier, in contrast to the harshness of war, but this innocence is counteracted by the pin-up pictures that leave his masculinity intact. If the sleeping soldier had been a sleeping civilian, the image might have been looked upon quite differently. The picture, says Gluck, is now considered a 'museum piece' and first edition prints sell at $7,500.[38]

Even though Gluck had built his reputation on being a war photographer he was damning of the profession's macho appeal. War photographers, he said, 'are the epitome of the alpha male … . Being known as a war photographer is like being known as a convicted felon. There is a dirtiness to it … most of it is driven by the sex appeal of getting a picture in *Newsweek* – it is not about trying to tell a story.' The retired British war photographer Don McCullin has also been critical of war photographers, albeit for a different reason: 'I'm not seeing, not smelling the truth somehow,' said McCullin, 'I hate the idea of being a war photographer … . You might as well call me a hangman.'[39]

In March 2003 Gluck had left for Iraq with Florida-based 1st Battalion 124th US Infantry. As an army reservist he had spent weekends in training and, as a keen amateur photographer, taking pictures of his battalion's activities. So admired were his pictures by fellow soldiers and his commanding officers that when the unit was deployed to Iraq, the officer in charge decided that Gluck would be the battalion's 'unofficial' photographer. Gluck thought this decision had not only been based partly on his photographic skills, but also on the vanity of his commanding officer, who liked the idea of having a personal photographer at hand to document his proud moments at war. For Gluck this was an opportunity not to be missed. 'I went to Iraq with the intention that I would take pictures that would speak to the world so I could become a working photographer,' he said.[40]

But Gluck did not have digital cameras; instead he took with him two Nikon film cameras and around 125 rolls of film. The cost of digital cameras was prohibitive, but there was another more important reason. Gluck is not a fan of digital technology. In his opinion digital cameras have made photography easy, de-skilled the process and, he said, 'lowered the standard'. With a digital camera it is possible to take hundreds of pictures on the same reusable memory card, deleting or saving the pictures as desired, whereas with a film camera, the film has to be processed and prints made at additional cost. For Gluck, having a limited amount of film imposed a self-discipline that he welcomed. It required him to carefully consider the picture – the subject matter and the framing – before he pressed the shutter, the reverse of what he says happens with what he calls a digital point-and-shoot camera. 'Using film,' said Gluck, 'forces me to think, to compose, to see, whereas digital photography is like sex with a prostitute, they show up and you do it. Photography used to be an in-depth romantic process and now it isn't.'[41] Gluck was affronted by the amateurism of point-and-shoot cameras, in a similar way to the early twentieth-century photography enthusiasts who had been offended by the perceived crudeness of amateur snapshot photography.

After a year in Iraq, Gluck returned to the USA with around 9,000 negatives. A friend told him about the *GQ* project so he sent in a CD of around eighty digitally scanned pictures. When *GQ* editors received them they immediately got in touch. He was the soldier-photographer the editors had been looking for. His dislike of digital photography, incongruous to a project which championed the digital age, was seemingly overlooked. According to Gluck, at the time prospects for a book of soldiers' pictures were not looking good. *GQ* was receiving the

wrong kind of pictures. 'After Abu Ghraib detainees with bagged heads were not so popular,' he said.[42] Friedman confirmed that *GQ* had received 'thousands' of images but many were 'trophy' pictures while others were considered 'too gruesome to publish'. The editorial team had lengthy discussions about whether or not to publish these grisly pictures, but ultimately had decided against it. 'We didn't want to sugar-coat the war,' said Friedman, but 'we ultimately decided that we weren't covering that stuff.'[43] They showed a soldier's inside view of war, but not the one *GQ* wanted.

At the time, the *GQ* team had been surprised that soldiers had willingly submitted gruesome pictures for publication. Devin Friedman concluded: 'I think that there is a sense among younger people in America that it's OK to put it all out there. It's a far more exhibitionistic generation. Their concern was mostly that their photographs and their stories get out there, that they had a sense that people were acknowledging what was a very significant event.'[44] I asked Gluck why soldiers take grisly images: 'It is a coping mechanism,' he said, 'you lump them into the category of bizarre travel photos from Iraq they get thrown into a folder, then they put them away and see them later and say that they can't believe that they took these.' But why do soldiers keep pictures once they are back in normal life? Why not throw them away? It was the same question as I had asked Yehuda Shaul about the Israeli soldiers' pictures, quoted in Chapter Seven. 'I think it is *because* they have gone back to normal life ... because you are never normal after something like that ... the level of carnage in war is so massive that you almost can't fight off the urge I think you photograph the dead in combat in the same way as you slow down in a traffic accident ... the finality of death ... Your mind shuts down ... I was more frightened of Iraq when I got home than I was at any time in Iraq.'

As someone who understood what he called the 'brand identity' and 'expectations' attached to professional war photographs, Gluck knew that no one would publish gruesome pictures so he decided not to take them. 'I deliberately made a conscious effort that I was not going to do that stuff,' he said. 'The beauty, if you can find one in the entire situation, is that the truth is out there there are plenty of places you can see it, such as on liveleak.com (a commercial website) – it is unfiltered and it is raw ... it is just that we choose not to see it.'[45] But if these 'raw' and 'unfiltered' pictures tell the truth, how are images taken by Gluck and other professional photojournalists to be defined?

Hardcore warnography

Throughout 2004 hundreds if not thousands of American soldiers' snapshots – the 'stuff' that Friedman had decided not to publish and that Gluck had not taken, had begun to appear on personal and commercial websites, including undermars.com, thenausea.com and ogrish.com (which in July 2006 became liveleak.com). When I first came across these sites, I was horrified by the array of grotesque colour pictures displayed on my computer screen that showed bloodied Iraqi corpses, severed heads and limbs, gaping wounds and barely recognisable charred body parts strewn in the streets like pieces of raw meat, the result of explosions from suicide bombings,

an Improvised Explosive Device (IED) or coalition attacks. I had seen thousands of images of war, but never like these. I wondered if the sickening images of rotting bodies in the trenches that featured in the First World War soldiers' photo albums, mentioned in Chapter Three, would have looked something like this in garish colour.

Some soldiers, like their First World War counterparts, created 'photo albums' of their personal war pictures which conveyed the same fragmented and frenetic sense. One online album posted under the 'Travel' section of webshots.com by 'Jafo11110' included twenty-four pictures of charred and bloodied body parts strewn in the streets. The trench landscapes had been replaced by desert landscapes or the streets of Baghdad. But looking at albums online is different from rifling through albums in an archive. Their individuality is replaced by the uniformity of the formatted webpage. But the sense of voyeurism and the frustration in trying to make sense of the stories they try to tell is much the same.

I was aware that anyone with Internet access could look at these photo albums. Unlike soldiers in other conflicts, who had kept their pictures private, it seemed that these soldiers were making them available to any one who cared to look. Or was it that the Internet offers the anonymity or pseudonymity that allows soldiers to display the images without being identified with them – a present-day equivalent of hiding unsavoury war pictures in the back of a desk drawer.

Though each website that displayed soldiers' pictures had individual aims, they had one common commitment – to counter mainstream limitations and give what all sites called a 'raw' and 'unfiltered' view of war. Dan Klinker of ogrish. com said that the site is 'about freedom of speech ... to give everyone the opportunity to see things as they are, so that they can come to their own conclusions rather than settling for biased versions of world events as handed out by the mainstream media.'[46] Thenausea.com, a professed anti-war site, also posted pages of the shocking war images from the book *Krieg dem Kriege!* (War against War!) published in 1924 by political activist Ernst Friedrich who believed in the evidential value of photographs, and used them to promote pacifism and build an anti-war movement. *Krieg dem Kriege!*, popular at the time, contained around 200 photographs taken from military and medical archives as well as some seemingly taken by soldiers. The pictures show trenches, corpses and scattered body parts – the kind included in the photo albums of soldiers who served on the Western Front. More than two dozen portraits show the horrifically disfigured faces of severely injured soldiers. In the 1920s Friedrich established an anti-war museum in Berlin where he displayed the pictures, but on 17 February 1933, a month after the National Socialists took power and on the night that the Reichstag was burnt down, Nazi storm troopers broke into Friedrich's museum, destroyed the images and closed it down.[47]

More than seventy years later the collection of pictures from Friedrich's book and the gruesome soldiers' digital pictures from Iraq displayed on all the mentioned sites, came to epitomise a popular resistance to media censorship. It seemed

whatever imagery that soldiers wished to upload and hurl into the public domain was accepted – among those who sought an alternative to government spin and mainstream media – as an incontrovertible truth about war. Within a few months of going online undermars.com received 'tens of thousands' of hits a day and within a year had received around 2,000 soldiers' pictures. So well used did the site become that rumours circulated online about attempts to close it down, although nothing transpired. Shannon Larrett of undermars.com told me: 'People got angry on all sides because they couldn't figure out whether it was pro or anti-war, but it was neither – just an attempt to give an accurate snapshot I don't think that censoring soldiers' voices is a good thing. If the public doesn't know the truth of the experience of war, they can't make honest decisions on whether they want to be involved or not.'[48]

These sites also attracted postings from Islamic and other resistance groups and some encouraged them. By July 2006 ogrish/liveleak.com, that claimed up to 800,000 hits a day, reportedly had access to sophisticated Internet technology that allowed it to monitor Islamic websites and pick up new images within hours of them being posted. When the beheading of kidnapped Ken Bigley was videoed and posted by an 'insurgent' group, ogrish.com claimed to be the first Western-produced site to show it in its entirety. When the site posted the video of the beheading of American contractor Nick Berg it was reportedly downloaded 15 million times.[49] Hayden Hewitt, co-founder of liveleak.com defended its right to post 'raw' war imagery: 'It is all about freedom and it is all about choice. You should have the ability to watch pretty much whatever you choose within legal bounds and we give you the opportunity to do that. You will see things that upset you, you will see things that offend you, but that is not necessarily a bad thing because it is all really happening. It is just an ability to see things that you can't see elsewhere.'[50]

Hewitt's ringing assertions on the principals of free speech were not appreciated by the US military. It issued a number of warnings to American military personnel, including one on military.net which read: 'Don't post links to or display pictures from sites like thenausea.com or ogrish.com, for any reason. They serve purely as conduits for terrorist propaganda and aren't allowed here. Don't post terrorist propaganda videos. These can be identified by usually having terrorist organisation logos, featuring terrorist themed music, and reading of manifestos or shouting of religious decrees while sniping, bombing, or beheading a victim.' But this and other warnings did not seem to have much effect.

In the summer of 2004 American soldiers' pictures from Iraq and Afghanistan began to appear on an amateur pornography site. Nowthatsfuckedup.com (NTFU) was created as a site where men could swap their amateur pictures of 'wives and girlfriends', and quickly became popular among military personnel in Iraq and Afghanistan. But when site owner Chris Wilson discovered soldiers were having difficulties getting credit card authorisation from war zones to pay the ten dollar registration fee, the former police officer from Florida was quick to act. He offered them free access in exchange for their snapshots of war. The

Figure 8.1 An American soldier's snapshot that according to the caption shows a 'charred Iraqi' posted on the amateur pornographic website, Nowthatsfuckedup.com (NTFU), 2004.

only conditions imposed by Wilson were that the images must have been taken by serving soldiers, not by professional photographers, and that they must not have been faked or stolen from elsewhere. Neither did Wilson want pictures that showed soldiers engaging in illegal behaviour, such as the type taken at Abu Ghraib. That is a line that he said he would not cross. But like those before him, including *GQ* journalists and Kim Newton, he wanted what he called 'real' pictures of war.[51]

Chris Wilson was surprised by the overwhelming response. Some of the pictures submitted were innocuous touristy snapshots, but others were grotesque, the kind featured on ogrish.com, undermars.com and thenausea.com. He confessed to being amazed by the sheer number of grisly pictures, but he also pledged not to edit them: 'I felt I was in no position to censor them ... I enjoy seeing the photos from the soldiers themselves, I see pictures taken by CNN and the mainstream media, and they all put their own slant on what they report and what they show. To me, this is from the soldier's slant. This is directly from them I think it's newsworthy.'

But so hideous were some pictures sent to NTFU that Wilson decided to divide the collection into two sections: 'Pictures from Iraq and Afghanistan – general' and 'Pictures from Iraq and Afghanistan – gory'. Those in the 'gory' category were frequently posted with glib captions, and equally glib comments were added by visitors as a response. Three pictures of grotesquely charred corpses lying in the street had the comment: 'Die Haji Die'. 'Haji', a term for a Muslim who has made the pilgrimage to Mecca, had become a derogatory term among American soldiers for referring to Iraqi civilians.

Another photograph that showed five American marines smiling and fooling around for the camera beside a charred corpse read: 'Cooked Iraqi' (Figure 8.1). A rotting corpse lying in the street had the comment: 'Bad day for this dude'. One

soldier posted eight photographs of body parts of a person whom he claimed was a suicide bomber. One user wrote: 'Wow. Nice set of pics. Amazing how the face just wrapped off.' A picture that showed a badly mutilated dead person at a vehicle steering wheel inspired a long list of comments including, 'Wow that musta hurt' and 'They get what they deserve. Wish I was manning the 50cal'.[52] Underneath the photograph of a dead man with entrails and brains spewing from his body, the caption read: 'What every Iraqi should look like Kill 'EM All and let ALLAH sort them out!' This was similar to the slogan attached to the Jewish settler's assault rifle that read: 'Kill 'em all, Let God sort 'em out' and was displayed in the exhibition of Israeli soldiers' pictures discussed in Chapter Seven.

This lurid combination of pornography, 'gory' war images and glib comments attracted a diverse group of people to NTFU. A contentious debate began between soldiers in combat, war veterans, anti-war campaigners and supporters of the war about the nature of war and war crimes though almost all agreed that the 'gory' pictures represented victory over the censors. Some visitors thanked the soldiers for sending them. One wrote: 'Thanks to the troops for breaking the media silence Send in the gore until we can't take it anymore and then send in some more. Democracy may well depend on it.'[53]

Any opposition to the gruesome picture posts was often greeted with a tirade of angry responses. In answer to one critic, a 'Gulf and Panama' veteran wrote: 'War is death, destruction, and it looks that by the few photos I have seen we seem to be doing ok. ... War is not about respect, war is about surviving and winning ... so if it bugs you that a soldier would kill an injured enemy, then you my friend have no concept of what war is. ... Years later when this war is over, the pics our guys have taken will turn from "trophys" to memories ... mine did.' The veteran ends with a message to all soldiers: 'I have been there, and you guys make me proud.' The same veteran responded to further criticism of the picture of the charred remains of an Iraqi (Figure 8.1). He wrote: 'As a nation at war, the USA is exactly what you described, we are nasty, brutal soldiers, and I am Very proud of that. Because to be that way takes a lot of discipline, maturity, confidence. And when I left the army I was definately [*sic*] a more well rounded and mature human.'[54]

Another soldier responded to a critic who put the 'gory' pictures in the same category as 'insurgent' videos of beheadings. He wrote: 'Get down out of your ivory tower moron how dare you equate these grave images of war with those we have seen from the other side on algizeera [*sic*]. I'm sick and tired of you lefties equating our troops to these terrorist and equating people like Lindy England [*sic*] who made a bunch of hadjis get down on their hands and knees in their underwear to the same bunch that cut the head off Nick Berg on video. Reality Check Lefty – It Ain't the Same Thing!'[55]

But some veterans had different points of view. One thought the 'gory' pictures should not be displayed: 'As a career soldier and Vietnam veteran I have a different perspective on these photos,' he wrote, 'I have no sympathy for the crazy suicide bombers but pictures like this demean us all and appeal to our lowest instinct. Imagine if we were to see similar photos of our own men and

women. I used to confiscate anything like this from my troops so they didn't fall into the wrong hands, eg the media. Having said that, I would gladly cut out the heart of Osama bin Laden and take a bite out of it. I just wouldn't take a picture of it.'[56]

Besides the war in Iraq, the images prompted comments and sometimes pictures concerning atrocities committed in other wars, including during the Second World War by the Japanese Army, about the blitz bombing of German cities by the British, the American dropping of the atomic bombs on Japan, and crimes committed by the Nazis. One American soldier juxtaposed a snapshot of a uniformed soldier (in Afghanistan or Iraq) with a broad grin standing in front of an enormous bulldozer with a well-known photograph taken by a British photographer during the liberation of Bergen-Belsen in 1945. It shows a British soldier driving a bulldozer pushing a pile of naked, twisted, tangled, skeletal corpses into a mass grave. The soldier had written a caption to both pictures that read: ' "My Big Toy!!!" It's amazing how much bulldozer technology has advanced in 60 years.'[57]

Comparisons were also made between the 'gory' pictures and those taken at My Lai in Vietnam in March 1968, where more than 400 civilians, the majority women and children, were massacred by American soldiers. The pictures at My Lai were taken by American Army Photographer Ron Haeberle but with his personal camera rather than his official camera. He kept the pictures private until November 1969 when he decided to allow their publication. CBS broadcast them and within days they had been circulated worldwide.[58] Like the Abu Ghraib pictures, those taken at My Lai had come to symbolise all that was wrong with the war in Vietnam – though they never became iconic images.

By 2005 NTFU had more than 150,000 registered users, including around 45,000 military personnel and 180,000 daily visitors accessing amateur pornography and more than 5,000 (mainly American) soldiers' pictures. The site began to attract the attention of the world's press and in response to a flood of media enquiries, Chris Wilson posted a statement on his site:

> Some have questioned why we publish explicit, even gruesome images of war time violence. One only need look back to World War II, when images of dead soldiers were censored by the government, and no cameras were allowed on the battlefields. ... As *Time* magazine said when it published the first war time casualty photos of three dead soldiers on a beach in New Guinea being washed up in the tide: 'Dead men have indeed died in vain if live men refuse to look at them.'[59]

Although many journalists baulked at the vulgarity of NTFU – one wrote that the site had reduced the horrors of war to a 'spectator sport' – most marvelled at the fact that digital technology had made it possible to witness what one journalist referred to as the 'obscenity' of war. Ken Tran, a columnist on the *Daily Texan*, wrote that in a society 'more desensitized to violence' Wilson's site is 'both excessive and necessary', while in the *Nation*, George Zornick coined

a telling word for this lurid combination of photography and pornography, 'warnography'.[60]

Some journalists signed up to NTFU to file questions to soldiers posting gory pictures. One soldier who responded said that he thought the current generation of soldiers were 'desensitised'. In a telephone interview he told American journalist Mark Glaser: 'When I was in Iraq, I had plenty of photos like that. You don't know why. In Iraq, everyone's pulling out digital camera; it's like a Kodak moment. Over there, you're taking pictures of it and not really thinking that much of it. Then you come back and it sinks in. When you come back to normal life, you think, "Whoa, I can't believe I did that".'[61]

But the majority of those who responded to journalists' questions reiterated what others had already said; that the public needed to know 'the true face of war', a statement that had begun to seem like justification for any level of violence. Other soldiers seemed irritated at the idea that their pictures might be criticised at a time when 'insurgents' were posting beheadings of American citizens on the Internet. 'Yes, I have posted kill photos on other forums sites,' another soldier emailed to Glaser. 'It was obvious that photos of dead insurgents would surface as time went on and it is not a new occurrence. There have been pics from all wars of the fighters standing over the bodies of the enemy. The insurgents are more than willing to showcase our dead and wounded so if people have issues with what's shown on this site then they need to stay away and quit bitching about things they know nothing about. ... We will always shoot first and ask no questions, period. The military brass will always try to sanitize the effects of war, no matter when or where, and yes if it was possible they would censor all media coming out of this country, pics and stories.'[62]

The resentment and defiance these soldiers showed towards the sanitisation and censorship of their experiences of war – by governments, the media and the military brass – indicated that posting pictures was a kind of resistance. They were refusing to keep silent about what they were being made to do and to witness in the name of war. Perhaps the 'reality' culture had encouraged them to make public what previous generations of soldiers had felt the need to hide. As one soldier told Mark Glaser: 'There were plenty of guys in Vietnam who took gory photos like that, a lot of them have them now – but I don't think a lot of them would expose them.'[63]

By 2005, the US military authorities had begun to take an active interest in Chris Wilson. It wasn't the first time. In March 2003 he had been investigated by Orange County Sheriff's Office, in Florida, following a complaint that he was selling pornography via websites including core39.com, named after Wilson's Police Academy class at Polk Community College in Florida. But the matter was dropped when Wilson pledged not to promote or distribute pornography in Polk county.[64]

A year later the Pentagon began investigations into allegations that images of nude female US service personnel in Iraq and Afghanistan were being displayed on NTFU. But the matter was dropped and no action was taken.[65] Then in February 2005 a message was posted on NTFU, allegedly written by the army chief of staff.

It read: 'Inform your personnel that we could unwittingly magnify enemy capabilities simply by exchanging photos with friends, relatives, or by publishing them on the Internet or other media ... we must protect information that may have a negative impact on foreign relations with coalition allies or world opinion.'

There was some debate on the site as to the authenticity of this message, but by early September the US military authorities had begun to investigate whether the 'gory' images contravened US military or international laws, or violated the Geneva Conventions. But they seemed unable to decide. Matt McLaughlin, of US Central Command (Centcom) said that the Geneva Conventions 'prohibit photographing detainees or mutilating and/or degrading dead bodies', but he added: 'Centcom has no specific policy on taking pictures of the deceased as long as those pictures do not violate the aforementioned prohibitions.' Captain Chris Karns, also of Centcom, said he was 'not sure about the regulation concerning photos of dead bodies' but that the graphic photos of the bodies of Uday and Qusay Hussein, officially released by the Bush administration, had confused the issue.[66] A Pentagon army spokesman, Colonel Joe Curtin, seemed more concerned that a soldier's First Amendment right to free expression under the US constitution should not be violated. He added: 'Soldiers encounter the horrors of war, and they are able to record it. You mix it with the porn site, now you muddy the waters.' By the end of September the US Army Criminal Investigation Command (CIC) concluded that there was no proof that American soldiers were responsible for the pictures on NTFU or that the pictures showed 'actual war dead'.[67] But the matter did not end there.

On 7 October 2005, as media interest in NTFU escalated, Wilson was arrested by the Polk County Sheriff's Office and charged with the 'wholesale distribution of obscene material and 300 misdemeanor counts'. Twenty video clips and eighty 'graphic images' were seized from his home, though curiously no soldiers' pictures were among them. Orange County Sheriff Grady Judd issued a damning statement that read: 'In my 33 years of law enforcement experience this is one of the most horrific examples of filthy, obscene materials we have ever seized.'[68] In response Wilson's lawyer Lawrence Walters, a First Amendment specialist, said: 'I have no idea what they are talking about, unless they are referring to the Iraqi war photos, which in my opinion is political news. ... The rest of it is merely sexually-orientated entertainment, which has become virtually mainstream in current society ... Of all the hundreds of thousands of webmasters in the county, and even in central Florida, why would Chris Wilson be arrested a week after he hits national spotlight news on the Iraqi war photos? ... I think any reasonable person would be suspicious of that.'[69]

Following Wilson's arrest support flooded in and a 'Free Chris' campaign was launched. In January 2006 Wilson pleaded 'no contest' to five counts of possession of obscene material. In the plea bargain, the felony charges were dropped and the website closed down. After April 2006 anyone trying to access NTFU was automatically redirected to the website of the Polk County Sheriff's Office. It seemed that NTFU had fallen victim to political censorship. But when

I contacted Wilson he said, 'Let me tell you something, the real story is not me, it's them.'[70]

In the controversy surrounding Wilson, the issue of the soldiers' pictures had faded from public view. I wondered what had happened to the images since the site had been closed down? Unlike a traditional photographic archive where pictures are carefully stored, the world wide web is an ephemeral space, where material has no guaranteed permanence. I contacted Wilson to find out. He told me that many pictures had been lost during the transfer of servers, but some had survived, and that a selection of the 'gory' images were displayed on his new website theliberalblogger.com. Since I first accessed this site it has undergone redesign and updating. The soldiers' grisly pictures no longer feature prominently. They are submerged beneath his expanding collection of shocking images of murders, freak occurrences and other wars, among which are the pictures of the disfigured faces of former First World War soldiers published in Friedrich's book *Krieg dem Kriege!*

But that was not the end of Wilson's 'gory' picture collection. In 2008 I recognised some of them in an artwork displayed on the walls of a gallery in Brighton. The exhibit was part of the larger exhibition entitled 'Memory of Fire: The War of Images and Images of War' and included grisly pictures from NTFU as well as from undermars.com and thenausea.com. They had been roughly printed on white bed sheets and hung as a huge banner 4 metres high and 18 metres long. At the top, the text in large black capital letters read 'The Incommensurable'.

The artist Thomas Hirschhorn said the banner was about 'truth', although he did not say whose 'truth' that was. None of the pictures were credited to soldiers, and NTFU was not mentioned. In the context of an art gallery the 'gory' pictures had in effect been transformed into an artwork, abstract horror, with no other apparent purpose than to shock. To make that message clear, the exhibit was screened off behind a large frosted glass panel, and at the entrance eager attendants were on hand to warn visitors of the explicit nature of the images.

In an audio interview that formed part of the exhibit, neither artist nor interviewer thought it necessary to ask who had taken the pictures. At least on the website visitors were aware of who had taken them and sometimes why. Furthermore, at a crowded public seminar held at the venue to discuss the work, the debate was remarkably similar to that which had taken place on NTFU. Opinions were polarised between those who thought that the pictures were too shocking to display publicly and those who thought they should be displayed because they represent the 'reality' of war – although no one asked whose 'reality' that might be.

Films that star them

The closure of NTFU had little effect on the production or proliferation of soldiers' images, which were simply posted elsewhere. As digital cameras and website technology advanced, soldiers in Iraq and Afghanistan began to post not only snapshots but also videos on myriad websites including YouTube.com, liveleak.com, filecabi.net and googlevideo.com. Some were two-minute unedited clips, probably filmed with a mobile phone, while others were skillfully edited with music

and still images and sometimes staged occurrences. Jan Bender, a Marine Combat Correspondent who filmed in Fallujah, said that his idea of war was influenced by Hollywood movies: 'I probably had the same ideas about it as most any American has when you watch movies [like] Saving Private Ryan.'[71] Making movies was not only an individual activity but a collective one. One soldier said: 'We started making videos to send home that showed what our life here was like. Then we started making little two minute movies.'[72] Former soldier and milblogger Colby Buzzell described the collective process of making films in his book *My War: Killing Time in Iraq*. He writes:

> One person in each squad, usually the person most computer literate, would go around and gather up all the photos and digital footage that he could find from everybody in the squad and from the platoon, and then he'd download all of it onto his computer, and from there he'd digitally edit them all together with all sorts of cool editing techniques and special effects, and dub cool soundtrack music over it, and create a war movie. ... Almost every single soldier in my platoon was going home with a video that stars them.[73]

In a reflection of the growth of celebrity culture and intent on capturing the reality of their war, American soldiers became inventive in their filmmaking techniques. Some wore cameras strapped to their helmets – known as helmetcams – and filmed themselves shooting or killing, live, as the action unfolded. As marine Scott Lyon said of one of his colleagues who wore a helmetcam: 'It helped him catch more intense footage because you don't have to stop and put the camera down.' Soldier Adam Lingo, who took 'candid camera' shots and 'taped his cameras to the top of tanks to capture unfiltered firefights' said that he made video films as an attempt to explain his experience to friends and family. 'Once you come back you kind of want to share your experience with somebody. In a way I guess [it's] therapeutic. Everyone always thinks that you're going to go to Iraq and come back and you are just going to get on with your life and everything will be normal, and it just doesn't work out that way. ... Making some of these videos and stuff has been one of the ways I can somehow show them If a picture is worth a thousand words ... how much is a video worth, you know?' he said.[74]

The dozens of films I watched on liveleak.com, filecabi.net and YouTube.com displayed the same shocking and violent themes: American soldiers in 'urban combat' wearing full combat gear and shades, clutching weapons, running through deserted, crumbling, bombed-out buildings, shouting, cursing and firing rounds of ammunition seemingly randomly and out of control. All this was accompanied by heavy pounding rock or rap music, giving the impression of war as a colossal video game. Much of this footage was claimed to have been taken in Fallujah. US marine Jason Shaw said that after the assault on the city many soldiers compiled movies on their laptops. These videos, he said, provided an 'indisputable historical document. You look at World War II and Vietnam and the Holocaust. It's hard to imagine that those events actually took place Even now when I look back on some of the things we experienced, I'm like "Man, did that really happen?" '[75]

A film entitled *The Enemy* includes images of an Iraqi man being shot in the street, an aerial view of more than two dozen people being blown up, images of blindfolded men with their hands tied, people with their heads blown off, destroyed buildings and scenes of gruesome body parts. *Awesome helmet-cam footage from some soldier in Iraq* (two minutes twenty-four seconds) features a close-up of a severed head lying in a street, then footage shot from a moving vehicle as soldiers fire rounds of ammunition on a deserted, bombed-out street as they drive by. The titles at the end read: 'This has been a Whats up Slut productions, Mosul, Iraq 2004–2005'.

There are numerous video clips taken from moving vehicles. One, explicitly entitled *Troops Throw Flashbang Grenade at Iraq Farmer and His Sheep* (approximately one minute) shows precisely what its title suggests. A grenade is thrown from a moving vehicle at an elderly shepherd tending his flock of sheep grazing by the side of the road. It hits the target and explodes. There is laughter and the film ends. Another film, entitled *Humvee Traffic Driving in Iraq* (two minutes thirty-eight seconds) is filmed from the Humvee driver's point of view – perhaps with a helmet-cam. It shows the Humvee approaching other vehicles at great speed – including a local bus – and pushing them off the road. Another film, called *Owning the Road – Iraq: We OWN the Road This Is What Happens when You Cut Us Off or Stay in the Way too Long (You Get a Glass Mountain Dew Bottle through Your Window)* (fifty-five seconds) shows what the title suggests: a bottle is thrown through the window of a moving Iraqi car and then a bang. A voice says: 'I think I got them.'

Another film, made up of four separate clips, shows someone with an automatic weapon randomly shooting from the back of a fast moving vehicle at approaching civilian cars. This film was thought to have been made by British contractors. In one clip a Scottish or Irish accent can be heard above the sound track 'Mystery Train', by Elvis Presley. One vehicle which is shot at crashes into a civilian taxi and grinds to a halt. Another car is sprayed with bullets, then stops. This film was also available to watch on NTFU. Most users who posted comments on the site thought that the cars were probably being driven by suicide bombers. One visitor wrote: 'I say blast the fuck outta those moron's that come up on the tail end of that marked vehicle!'[76]

Despite the violence shown in these films, the US military authorities, publicly at least, concluded that none 'violated policy'. In 2006 when Mark Glaser asked Centcom to comment on the proliferation of soldiers' films on the Internet, Major Matt McLaughlin replied that although photographing or filming detainees or human casualties was prohibited, the films did not appear to violate policy. He conceded that they did fall into the category of what some would consider bad taste but added: 'Bad taste is however a subjective standard.'[77]

But in 2007 the US authorities were attempting to stop soldiers posting imagery and closed down access to thirteen networking and photo sharing sites from military computers, including YouTube.com and MySpace.com. Milblogger Matthew Burden wrote: 'The army has been flooded with young soldiers who have laptops, iPods, digital cameras, and recorders, and that has put the fear of god into some generals.' The British Ministry of Defence also issued a gag order that forbade

blogging, speaking to the press or sending images from war zones without permission from the authorities.[78] As if by way of compensation the then Prime Minister, Tony Blair, launched his own YouTube blog to present 'unmediated' information. But the US authorities went one step further. They created their own YouTube channel and posted films of what Armando Hernandez, US media outreach embed chief in Iraq, called an 'unfiltered view' of war. The films, with their grainy, shaky amateur effects, looked a lot like those made by soldiers – although without the gore.[79]

These amateur-looking films, however, were not compensation for *Military Families Speak Out*, which protested about the withdrawal of Internet access from soldiers. The link between home and front that in previous wars had been encouraged by governments and official channels was now being initiated by families themselves. Corey Robinson, who had served in Iraq, said that the Internet was a lifeline between soldiers at war and families at home and made a huge difference to morale. She said the sites were like 'a modern-day form of writing letters, the same sort of letters that soldiers in the trench holes in World War II wrote'.[80]

A serious blow to morale came when Islamic insurgents' groups began to post online film footage of American soldiers being shot in the streets of Baghdad. The chilling footage taken through the sights of a sniper's weapon shows soldiers being tracked as they patrol in a street, or as they look out from the top of an armoured vehicle. Then as the crack of a weapon rings out we see the soldier slump to the ground injured and sometimes killed. The sniper then vanishes without trace. That an image could be taken through the sites of a gun of a person being shot was similar to the fantasy expressed in E. W. Horning's novel *The Camera Fiend* mentioned in Chapter Two.

The notorious sniper who allegedly injured or killed dozen of American soldiers became known among American troops as 'Juba, the Baghdad Sniper'. Officially the US military denied his existence, and attributed the casualties to a group of snipers, but one American sniper, Travis Buress said: 'He's good … He's a serious threat to us.'[81]

Juba became a romantic legendary hero among the Iraqi resistance and a number of 'Juba' films were made. The film footage of American soldiers being shot was edited together with an animated Juba depicted as a handsome rugged idol who wears a flowing keffiyeh, his weapon always close to hand. In one film this figure is riding a white horse across a desert landscape into the setting sun like some modern-day Lawrence of Arabia. In the films, slick graphics and other imagery is also used including the infamous soldiers' pictures from Abu Ghraib. In a film entitled *Iraqi Resistance's Sniper Attack on U.S. Army*, the image of Lynndie England holding the Iraqi man on a leash is flashed on the screen. In another frame political leaders are depicted with red target marks on their foreheads (Figure 8.2).[82]

There were diverse reactions to the Juba films. Some American soldiers responded with online video replies that according to journalist Adrienne Arsenault showed an 'image of helmets with bullet holes in them, a retaliatory "you didn't get me, I'm still here" taunt'. This, she wrote, is the 'modern equivalent of First World

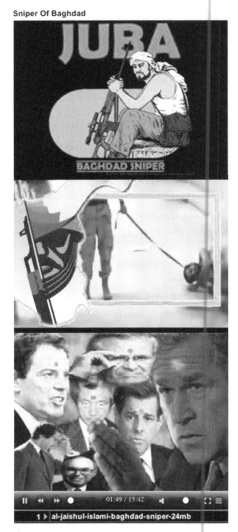

Figure 8.2 Three still images from a Juba film that show, from top to bottom: an animated image of Juba the Baghdad Sniper, Lynndie England holding an Iraqi prisoner on a leash at Abu Ghraib and political leaders including George W. Bush, Tony Blair and Donald Rumsfeld each with a red target mark on their foreheads. 2006 (?)

War soldiers barking threats at each other across the trenches.' Major General Cordingly commented: 'It's extraordinary. It's like pawns on a chessboard playing each other.'[83] One amazed soldier even saw a fellow American soldier in a Juba film being shot through the scope of a rifle. The soldier had survived the shooting and was able to watch the footage of himself online.[84]

By 2007 Juba films became harder to find on popular websites. There had been complaints from members of the public who objected to seeing American soldiers being injured or killed live online. One visitor to googlevideo.com said about the film *Juba Sniper: (Baghdad Sniper)* 'I came across this accidentally and personally [*sic*] I think that google needs to rethink its posting guidelines or at the very least be sued by every family whose loved ones appears in these videos'[85] But as live footage of Juba the sniper seemed to disappear, a number of digitised animated

Juba video games began to appear on some of the same websites, making it some-times difficult to distinguish these from the location footage.

But by then Juba was reportedly no longer prowling the streets of Baghdad and there was speculation as to why. An article in the US military newspaper *Stars and Stripes* mused on whether Juba had been killed, or whether he had been, as the article stated, 'the product of hype and fear on the part of US soldiers, as well as enemy propagandists who hope to sap the troops' morale'. CNN correspondent Michael Ware considered he had been an 'Internet legend' while an anonymous visitor to googlevideo.com suggested US propaganda. No one seemed sure. Captain Brendan Hobbs said, 'Juba the Sniper? He's a product of the US military. We've built up this myth ourselves,' as though he was not real at all.[86]

But in 2008 Juba was back. A report in the British Sunday tabloid newspaper the *News of the World* stated that 'graphic' sniper footage had been sent to unsuspecting British soldiers via a link on YouTube.com through the Forces Reunited website. The horrified soldiers complained to YouTube.com, and the site removed the offending footage.[87] The same year an Internet search revealed that a Juba tribute site entitled baghdadsniper.net had been established under the auspices of *The Islamic Army in Iraq Jihad and Reform Front*.

Reinventing the real

Despite the media attention accorded to the Juba films and the soldiers' videos, none achieved the public notoriety of the photographs taken at Abu Ghraib. In an article in *Rolling Stone* magazine, David Sax had written that the soldiers' videos, what he called 'a virtual scrapbook of the war', may become to Iraq 'what footage on the evening news was to Vietnam: a powerful way of bringing the war home'.[88] But there was no evidence that the videos were known sufficiently to achieve this aim. Instead those films that were reported in the press caused revulsion, but it was short-lived and the moving images did not seem to capture the public's imagination.

In 2006 the *News of the World* reported on an amateur video clip that showed British soldiers beating defenceless Iraqi teenagers in Amarah. The newspaper's front-page headline read: 'World exclusive: army video outrage'. It claimed its report would 'shock the world and ignite a huge military scandal' but neither claim proved to be true and no soldiers have yet been prosecuted.[89]

When soldiers' films were reported on, journalists and commentators seemed to focus on the films' curiosity value rather that on the violence they portrayed. When the BBC television *Newsnight* programme produced a feature on American soldiers' videos posted on liveleak.com the journalist seemed more interested in their lack of context than the offensive material. In describing the videos as ranging from 'the banal to the chilling via the utterly childish' the reporter said: 'With no context we don't know whether to be appalled or amused by what they show and yet the lack of context is part of the attraction'.[90]

Journalist Ana Marie Cox, who said that soldiers' videos had turned the war in Iraq into 'The YouTube War', was also concerned about their lack of context. Cox wrote: 'While they offer the credibility of an unvarnished image, they lack any

meaningful context of what came before and after the clip, or what's happening outside the frame.'[91] But no image can ever tell us that. Mark Glaser also seemed perplexed. He wrote: 'I don't have the context of who was filming, why they are filming and what's going on inside their head. Where are they? What's the situation? Did they succeed or fail?'[92] Similar questions had of course been raised about the amateur pictures taken at Abu Ghraib, or those taken by German soldiers exhibited in Hamburg in 1995 or the countless others whose lack of context so perplexes the viewer. That these questions were asked at all reflects just how accustomed we have become to the slick seamless narrative structures of commercial film – often seen as being more 'real' than reality itself – or the perceived ability of a professionally taken photograph to contain the story within the frame. These elements, which can be defined as professionalism, forestall enquiry and avert uncomfortable questions being raised about context.

But with regard to soldiers' films from Iraq, there has been at least one attempt to make a professional documentary film with soldiers' footage shot for the purpose. In 2008 filmmaker Deborah Scranton produced an award-winning film entitled *Bad Voodoo's War* (ninety-seven minutes). It had been edited from 500 hours of film shot mainly, but not entirely, by American soldiers from a platoon called 'Bad Voodoo'. Scranton had decided that rather than go to Iraq as a filmmaker embedded with the military she would give willing soldiers digital video cameras so that they could film their own version of war. This had happened during the Boer War (1899–1902), when two officers were given cameras by a London-based commercial film company in order to capture exciting scenes, as mentioned in Chapter Two. Deborah Scranton was just the latest to strive to achieve what others had sought for more than a century: to capture the 'reality' of war. 'I wanted to crawl inside the experience to see it, to hear it and smell it,' Scranton said.[93]

With the cooperation of the military authorities, Scranton supplied soldiers of the 'Bad Voodoo' platoon with fifteen Sony digital video cameras. As the platoon were assigned to convoy security, which involved driving through Iraq for days or weeks at a time, constantly under threat of IED attacks, it was decided to place some cameras inside vehicles: one on the dashboard, referred to as a 'dash-cam', one in the gun turret, and another just lower than the dashboard. Scranton's role did not end there. Digital camera and computer technology allowed her to keep a twenty-four hour online link with the soldiers from her office in New Hampshire, from where she could direct the filmmaking process. The link made it possible for her to talk to them about their thoughts, feelings and experiences and discuss how best to interpret and capture them on film. 'We spent a lot of time trying to work out how to translate their experiences and in a visual way,' she said. 'They want people to know what they are experiencing and what they are going through and to reach out and to bridge that disconnect.'[94] Sergeant First Class (SFC) Toby Nunn, who features prominently in the film said: 'This project is very therapeutic, you have the opportunity to speak, give testimonial confessions. ...' The soldiers were able to tell Scranton about events sometimes as they unfolded. When the platoon got hit by an IED, within twenty-four hours Nunn was able to go online and talk to Scranton about it.

Scranton described this way of working as 'virtual embedding' which she called 'a new frontier in storytelling, the intersection where Web 2.0 meets technology meets documentary. Without instant messaging,' said Scranton, 'the soldiers could never have become filmmakers – without email and cheap video, the soldiers could never have told their stories as they happened.'[95]

Bad Voodoo's War, said Scranton, was 'the first movie filmed by soldiers themselves on the front line.' It was not in fact the first film to be made by soldiers – as those posted online make evident – but it did put their footage into a firm professional context. Just as editors at *GQ* magazine in pursuit of the 'real' had rejected the 'stuff' soldiers had supplied for *This Is Our War*, and just as curators of the second Wehrmacht exhibition in Hamburg removed the troublesome soldiers' images that had featured so prominently in the original exhibition (discussed in Chapter Five), so Scranton had edited the raw footage from Iraq into an acceptable and engaging narrative and given soldiers' imagery an authority it was seen to lack. As a result, this soldiers' view looked very much like the conventional outside view consistent with the conventions established by professionals, in accordance with what is perceived to be public taste.

The murderous, brutal, generally boring and sometimes horribly frightening aspects of war are rarely published in commercial media, though there is no formal system of censorship preventing it. But professional photographers, filmmakers and editors can rarely challenge the consensus that compels these restrictions. Heroics, discipline and drama can be shown, and so can tragedy and loss among civilians, but brutality by the troops on 'our' side, bloodied corpses, dismembered body parts and the agony or death throes of the wounded cannot. Robert Fisk said about scenes he saw in Iraq in 1991 following bombing by the British and American military: 'There were women and children and in bits, and all these dogs came out of the desert and started eating them. If you saw what I saw you would never even think of supporting another war of any kind against anyone again.'[96]

The standard representation of war has become perceived as neutral – just as the imperialistic attitudes reflected in images of the empire were also regarded as neutral at the time. But paradoxically, rather than reveal the true nature of war in the way that commentators imagined photography would do when it was invented more than 150 years ago, photographs have had the effect of concealing it. By serving commercial and aesthetic demands above the political, war photography does little to counter the ideological view that war is just and inevitable – in fact it could be argued that it goes some way to sustaining it.

Perhaps this is precisely the point: that the nineteenth-century idealists, and all those in the business of representing war ever since, were not really searching for true depictions of war but rather drama, heroism and humanity as perceived by those of us who have never been there. As a consequence what they were seeking was not images of war, but 'war photography', a genre that would suitably reflect these elements. Perhaps that is why the snapshots taken by soldiers that capture fragments (and that is all a picture can do) of the brutal, mundane, frightening and shameful world of war, that ignore the conventions of war photography, are deemed problematical, confusing or unacceptable.

I asked a Vietnam veteran what he thought of the well-known photographs taken by photojournalists during that war. He told me that they had never been of any concern to him. In Vietnam he had taken his own snapshots, but when he got home he found that no one was interested in looking at them or listening to his stories. So he kept them to himself. Decades later, he now posts his innocuous pictures of military hardware and the 'khaki portraits' of comrades on a veterans' website; he sees this as a way of alleviating the pain he suffered, not so much as a consequence of the war, but of the long unacknowledged silence that followed.

Notes

Preface

1. Philip Gourevitch, speaking at 'Photography and Atrocity' conference in New York, 2007. Webcast at: www.photographyandatrocity.leeds.ac.uk (accessed September 2008).
2. E. Klee, W. Dressen and V. Riess (eds), '*The Good Old Days': The Holocaust as Seen by Its Perpetrators and Bystanders* (New York, 1988), pp. 196–207.
3. Jess Smee, 'Germany shocked by photos of soldiers posing with skull', www.guardian.co.uk, 25 October 2006; the *Independent*, 'Does this picture show British soldiers broke Geneva Conventions?', 24 November 2009.
4. Author's vox pop interviews with visitors at the Rijksmuseum, Amsterdam. Names withheld, November 2007.
5. Susan Sontag, *On Photography* (London, 1979), pp. 18–19.
6. Rachel Shabi, 'Anger over ex-Israeli soldier's Facebook photos of Palestinian prisoners', www.guardian.co.uk, 16 August 2010; 'Israeli ex-soldier says Facebook prisoner pictures were souvenirs', 17 August 2010, www.guardian.co.uk.
7. Raphael Samuel, *Theatres of Memory* (London, 1994), pp. 337–49.

One: Outrage at Abu Ghraib

1. Quoted at the Diane Arbus retrospective, Haywood Gallery, London, 2003.
2. Gary Younge, 'Abu Ghraib woman soldier brokers plea deal', the *Guardian*, 2 May 2004.
3. The *Independent*, 8 May 2004, p. 34.
4. The *Independent*, 7 May, pp. 1–3, and 8 May 2004, p. 8.
5. The *Guardian*, 13 May 2004 and 2 May 2005.
6. Philip Gourevitch and Errol Morris, *Standard Operating Procedure: A War Story* (London, 2008), p. 139.
7. John Berger, *About Looking* (London, 1980), p. 117.
8. Eric Deggans, 'Prison photos a devastating hit in the war of images', *St Petersburg Times* online, www.sptimes.ru, 9 May 2004.
9. The *Guardian*, 22 May 2004, p. 5.
10. See Joanna Burke, the *Guardian*, G2, 7 May 2004; Deggans, 'Prison photos a devastating hit in the war of images'; Jon Swain, the *Sunday Times*, 23 January 2005, p. 15.
11. Philip Gourevitch and Errol Morris, 'Exposure: the woman behind the camera at Abu Ghraib', *New Yorker*, 24 March 2008, www.newyorker.com; Rory Kennedy (director), *The Ghosts of Abu Ghraib*, 2007.
12. Seymour Hersh, Democracynow.org, 10 May 2004.
13. Susan Sontag 'Regarding the torture of others', *New York Times Magazine*, 23 May 2004, www.nytimes.com.
14. Author's interview with Karen Davies, a deputy picture editor of the *Sunday Telegraph*, London, February 2005.

15. *Sunday Times*, 23 January 2005, p. 15.
16. Deggans, 'Prison photos a devastating hit in the war of images'; David Simpson, 'Two Jima v. Abu Ghraib', *London Review of Books*, 29 November 2007, pp. 25–7.
17. Press Release, 'Inconvenient evidence: Iraq prison photographs from Abu Ghraib', September 2004; Brian Wallis, speaking at 'Photography and Atrocity' conference in New York, 2007. Webcast at www.photographyandatrocity.leeds.ac.uk/pa_07/pa_07_2.htm (accessed March 2008).
18. Michael Kimmelman, 'Abu Ghraib Photos return, this time as art', *New York Times*, 10 October 2004, p. 29; see also Nic Dunlop, *The Lost Executioner: A Story of the Khmer Rouge* (London, 2005); James Allen, Hilton Als, Congressman John Lewis and Leon F. Litwack, *Without Sanctuary: Lynching Photography in America* (New York, 2005).
19. Kimmelman, 'Abu Ghraib photos return, this time as art'.
20. Joanna Burke, 'A taste for torture?', the *Guardian*, G2, 13 September 2006, pp. 14–15.
21. The *Independent*, 5 February 1995; Janina Struk, *Photographing the Holocaust: Interpretations of the Evidence* (London, 2004), p. 206.
22. Gourevitch and Morris, *Standard Operating Procedure*, p. 86.
23. The *Guardian*, 20 May 2004, p. 4; *Stars and Stripes*, 20 May 2004; Gourevitch and Morris, 'Exposure: the woman behind the camera at Abu Ghraib'.
24. Kennedy, *Ghosts of Abu Ghraib*; Gourevitch and Morris, 'Exposure: the woman behind the camera at Abu Ghraib'.
25. Tara Mckelvey, 'Robo-Tripping at Abu Ghraib', www.prospect.org (accessed 19 September 2007).
26. Gourevitch and Morris, *Standard Operating Procedure*, pp. 113–14.
27. Susan Sontag, *On Photography* (London, 1979), pp. 161, 106.
28. *Stars and Stripes*, 28 May 2004; Gourevitch and Morris, *Standard Operating Procedure*, p. 94.
29. Gourevitch and Morris, *Standard Operating Procedure*, pp. 137, 142.
30. Gourevitch and Morris, *Standard Operating Procedure*, pp. 136–9.
31. Gourevitch and Morris, *Standard Operating Procedure*, p. 134.
32. Gourevitch and Morris, *Standard Operating Procedure*, pp. 127–8, 199.
33. Gourevitch and Morris, *Standard Operating Procedure*, pp. 106–7.
34. Gourevitch and Morris, *Standard Operating Procedure*, pp. 110–11.
35. Gourevitch and Morris, *Standard Operating Procedure*, pp. 99–100.
36. Gourevitch and Morris, 'Exposure: the woman behind the camera at Abu Ghraib'; Gourevitch and Morris, *Standard Operating Procedure*, pp. 181–3.
37. Gourevitch and Morris, *Standard Operating Procedure*, pp. 75–7; Gourevitch and Morris, 'Exposure: the woman behind the camera at Abu Ghraib'.
38. Kennedy, *Ghosts of Abu Ghraib*.
39. Gourevitch and Morris, *Standard Operating Procedure*, p. 179.
40. Geoffrey Macnab, 'Return to Abu Ghraib', the *Guardian*, 19 February 2008.
41. Gourevitch and Morris, *Standard Operating Procedure*, p. 270.
42. Gourevitch and Morris, *Standard Operating Procedure*, p. 236.
43. Author's interview with Karen Davies; *Sunday Telegraph*, 9 May 2004.
44. Christian Davenport, 'New Prison Images Emerge', *Washington Post*, 6 May 2004, p. AO1.
45. Kennedy, *Ghosts of Abu Ghraib*.
46. Wil S. Hylton, 'Prisoner of conscience', *GQ*, September 2005.
47. Gourevitch and Morris, *Standard Operating Procedure*, pp. 233, 244.
48. Hylton, 'Prisoner of Conscience'.

49. Gourevitch and Morris, *Standard Operating Procedure*, pp. 251–2.
50. *Time*, 17 March 2004, pp. 30–6.
51. Gourevitch and Morris, *Standard Operating Procedure*, pp. 247–8.
52. Kennedy, *Ghosts of Abu Ghraib*; Gourevitch and Morris, *Standard Operating Procedure*, pp. 248–9.
53. Gourevitch and Morris, *Standard Operating Procedure*, p. 179.
54. ACLU press release, 18 February 2005.
55. Gourevitch and Morris, *Standard Operating Procedure*, p. 265.
56. Gourevitch and Morris, *Standard Operating Procedure*, p. 267.
57. Seymour Hersh, 'Torture at Abu Ghraib', *New Yorker*, 10 May 2004; Seymour Hersh, 'The General's report', *New Yorker*, www.newyorker.com, 25 June 2007; see www.salon.com (accessed 14 March 2006).
58. Amy Goodman interview with Seymour Hersh, Democracynow.org, 11 May 2005.
59. ACLU press release: 'U.S. Soldier instructed Iraqi detainee to dig own grave', 19 May 2005.
60. Struk, *Photographing the Holocaust*, see ch. 1; Janina Struk, 'The death pit', the *Guardian*, G2, 27 January 2004, pp. 12–13.
61. Report of the ICRC on the treatment by the Coalition Forces of Prisoners of War and other protected persons by the Geneva Conventions in Iraq during arrest, internments and interrogation, February 2004, pp. 11–12.
62. Deggans, 'Prison photos a devastating hit in the war of images'.
63. Kennedy, *Ghosts of Abu Ghraib*.
64. Christopher Brandon Arendt, former guard at Guantanamo Bay detention camp, speaking at a press conference in Westminster, London, 9 January 2009.
65. John Sheed 'Guantanamo abuse videotaped', the *Australian*, 21 March 2005.
66. Susan Sontag, 'What have we done (in Abu Ghraib)?', the *Guardian*, 24 May 2004, pp. 2–4.
67. Kennedy, *Ghosts of Abu Ghraib*.
68. Seymour Hersh, ACLU Keynote speech, 15 July 2004.
69. *Time*, 17 May 2004, pp. 30–6.
70. Suzanne Goldenberg, 'Abu Ghraib leaked report reveals full extent of abuse', the *Guardian*, 17 February 2006; 'The Abu Ghraib files', www.salon.com (accessed 14 March 2006).
71. *Boston Globe Online*, 12 May 2004.
72. See www.wnd.com: Sherrie Gossett, 'Bogus GI rape photos used as Arab propaganda', 4 May 2004; 'Porn site depicting 'GI rapes' shut down', 5 May 2004; 'Fake rape photos infuriate Arab world', 9 May 2004; 'Boston Globe publishes bogus GI rape pictures', 12 May 2004, www.greaterboston.tv, 'Beat the press: Globe runs Bogus Iraq rape photos', originally broadcast on Greater Boston TV, 14 May 2004.
73. ACLU, 'Defense department invokes Geneva Convention to withhold torture photos', 29 April 2005; ACLU press release, 29 April 2005; ACLU court order document, 'ACLU against Department of Defense', filed 1 June 2005.
74. Chris McGreal, 'Obama moves to postpone release of images showing alleged detainee abuse', the *Guardian*, 13 May 2009; 'Obama U-turn on abuse photographs', BBC News, www.bbc.co.uk/news, 13 May 2009; Jennifer Loven, 'Obama seeks to block release of abuse photos', www.sfgate.com, 13 May 2009. 'Account tells of one-sided battle in bin Laden raid' Mark Landler and Mark Mazzetti, *The New York Times*, 4 May 2011; 'Bin Laden body photos will not be published says Obama', Channel 4 News, 4 May 2011; Tom Geoghegan, BBC News US & Canada 'Should photos of Bin Laden's corpse be released?', 4 May 2011.

75. Vicki Allen, 'New abuse images shock Congress', *Daily Mirror*, 13 May 2004; see ACLU press releases 2005; Ari Berman, 'More images of Abu Ghraib', CBS News, 22 August 2005.

76. David Jones, 'Why the hell should I feel sorry, says girl soldier who abused Iraqi prisoners at Abu Ghraib', www.dailymail.co.uk, 13 June 2009.

77. Deggans, 'Prison photos a devastating hit in the war of images'.

78. Gourevitch and Morris, *Standard Operating Procedure*, pp. 155, 179.

79. Paul Wood, 'Arab anger at prison scandal', BBC News, www.bbc.co.uk/news, 6 May 2004.

80. BBC News, 'Media fury at abuse of Iraqis', www.bbc.co.uk/news, 1 May 2004; Wood 'Arab anger at prison scandal'.

81. Gossett, 'Fake rape photos infuriate Arab world'.

82. International Center of Photography, *Inconvenient Evidence: Iraq Prison Photographs from Abu Ghraib* (exhibition pamphet, New York, 2004).

83. CBS News Mailbag: court martial in Iraq, 29 April 2004 (names withheld).

84. *Stars and Stripes*, 17 and 19 May 2004.

85. CBS News Mailbag: court martial in Iraq.

86. Sontag, 'What have we done (in Abu Ghraib)?'.

87. Toni Locy, ' "Trophy photos" led to soldiers' demotions', *USA Today*, 17 February 2005.

88. Author's interview with Andy McNab, London, September 2005.

89. See *Camera Iraq*, www.camerairaq.com, 4 June 2004.

90. Author's email correspondence with CJ, 2007.

91. Roeder Jr., George H., 'Missing on the home front: wartime censorship and post-war ignorance', www.awitness.org/news/november_2001/wartime_censorship_pictures.html (accessed March 2007); dc.indymedia.org/front.php3?article_id=15441&group=webcast

92. Commander of the Wehrmacht, East territory/White Ruthenia, Special Order no 55, 12/13/1941, quoted in Thomas Eller (ed.), *Shadows of War: A German Soldier's Lost Photographs of World War II* (New York, 2004) p. 20.

93. Author's interview with Andy McNab.

94. Author's interview with Andy McNab.

95. Author's telephone interview with veteran of Operation Desert Storm (1991) (name withheld).

96. 'Sight Range', press release, 19 November 2004.

97. www.regardingwar.org (accessed January 2006); see also 'Photographer John Movius discusses war and perception in his project "Sight Range"', interview by Sarah Andiman, 15 December 2005, available at www.teachingphoto.com/movius.html (accessed January 2006).

98. Jon Swain, 'The telling shots of war', *Sunday Times*, 23 January 2005, p. 15; David, B Rivkin Jr and Lee A. Casey 'Abuses are Abuses', www.nationalreview, 12 May 2004 (accessed June 2006); see 'Photos reveal Belgian paratroopers' abuse in Somalia, CNN, 17 April 1997; see CBS Archives, 2 April 1993.

Two: Learning to Photograph War

1. John Berger, *Another Way of Telling* (London, 1989), p. 97.

2. Erich Stenger, *The March of Photography* (London, New York, 1958), p. 161.

3. Vicki Goldberg, *Photography in Print: Writings from 1816 to the Present* (Albuquerque, 1981), p. 64.

4. Bill Jay, 'Passing shots: the pistol/rifle camera in photographic history 1858–1938', www.billjay.com (accessed October 2008); Colin Ford (ed.), *The Story of Popular Photography* (London, 1989), p. 63.

5. Liz Wells (ed.), *Photography: A Critical Introduction* (London and New York, 2000), pp. 70, 128.

6. Alan Trachtenberg, 'Albums of war: on reading Civil War photographs', *Representations*, No. 9, Special Issue: 'American culture between the Civil War and World War 1' (Winter 1985), pp. 6, 8.

7. Susan Sontag makes this point in *Regarding the Pain of Others* (London, 2003).

8. Hubertus von Amelunxen, 'The century's memorial: photography and the recording of history', in Michel Frizot (ed.), *A New History of Photography* (Cologne, 1998), p. 133.

9. Roger Taylor, *Impressed by Light* (New York, 2007), pp. 123–4; Pat Hodgson, *Early War Photographs* (London, 1974) pp. 13–14; the images of John McCosh are kept at National Army Museum, London.

10. Hodgson, *Early War Photographs*, pp. 11–12, 22–3.

11. Sean Couglan, 'Why the charge of the Light Brigade still matters', BBC News Online magazine, 25 October 2004.

12. Helmut and Alison Gernsheim, *Roger Fenton, Photographer of the Crimean War: His Photographs and His Letters from the Crimea* (London, 1954), p. 11.

13. Hodgson, *Early War Photographs*, p. 11.

14. National Army Museum, photo album, 7510–87.

15. Jay 'Passing shots'.

16. Brian Coe and Paul Gates, *The Snapshot Photograph: The Rise of Popular Photography 1888–1939* (London, 1977), p. 62.

17. Ford, *The Story of Popular Photography*, pp. 67–8; David Kenyon, *Inside Amateur Photography* (London, 1992), pp. 18–20.

18. Coe and Gates, *The Snapshot Photograph*, pp. 22–9.

19. Carlo Rim, 'On the snapshot', *Photography in the Modern Era* (New York, 1989), p. 39.

20. National Army Museum, photo album 5201–33-51.

21. The National Archives (TNA), HO/139/19.

22. Coe and Gates, *The Snapshot Photograph*, pp. 30–5.

23. Coe and Gates, *The Snapshot Photograph*, pp. 31–3.

24. John Updike, 'Visual trophies: the art of snapshots', *New Yorker*, 24 December 2007; *British Journal of Photography (BJP)*, 1 October 1915, p. 641; Martha Langford, *The After Life of Memory in Photographic Albums* (Montreal, 2001), p. 4.

25. *The Amateur Photographer & Photographic News (AP)*, 1 February 1915, p. xiii.

26. *Daily Mail*, 5 and 8 January 1915, front page and p. 7; *Daily Sketch*, 5 January 1915, p. 12, 8 January 1915, pp. 4–5; *Daily Mirror*, 8 January 1915, back page.

27. Duncan Anderson, *War: A History in Photographs* (London, 2003), p. 86.

28. *Daily Mail*, 4 January 1915, 'Letters from the Trenches', p. 9.

29. *AP*, 8 November 1915, p. 370.

30. *AP*, 1 May 1916, pp. 350, 354.

31. Silvana Rivoir, 'The soldier photographer', in P. Holland, J. Spence and S. Watney. (eds), *Photography/Politics: Two* (London, 1986), pp. 82–6.

32. Paul Wombell, 'Face to face with themselves', in P. Holland, J. Spence and S. Watney (eds), *Photography/Politics: Two* (London, 1986), p. 76.

33. TNA, HO/139/19; HO/139/42, 5 December 1917.

34. Philip Knightley, *The First Casualty: The War Correspondent as Hero, Propagandist and Mythmaker from the Crimea to Vietnam* (London, 1975), p. 99.
35. *AP*, 22 February 1915, p. 142.
36. *Daily Mirror*, 29 January 1915, back page.
37. TNA, HO/139/31/122, memorandum 22/12/1916 and 5/12/17, p. 30.
38. John Taylor, *War Photography: Realism in the British Press* (London, 1991), p. 47.
39. Taylor, *War Photography*, p. 30.
40. *Daily Sketch*, 29 March 1915, 3 June 1915, 13 September 1915.
41. TNA, FO/371/2538; Wombell, 'Face to face with themselves', pp. 74–6.
42. TNA, HO/139/31; Taylor, *War Photography*, p. 43.
43. *Daily Mirror*, 2 and 25 February 1915.
44. *AP*, 29 March 1915, p. 254.
45. *Daily Mirror*, 4, 7, 11 November 1911.
46. TNA, HO 139/13.
47. *Daily Mail*, 26 February 1915, p. 5; *Daily Sketch*, 27 February 1915.
48. *AP*, 15 March (supplement); Photography at the front, *AP*, 22 March 1915, pp. 227–8.
49. *Daily Mirror*, 25 February 1915.
50. Ian Jeffrey, *Photography: A Concise History* (London, 1981), p. 48.
51. Gernsheim, *Roger Fenton, Photographer of the Crimean War*, p. 13.
52. Gernsheim, *Roger Fenton, Photographer of the Crimean War*, p. 13.
53. *Daily Sketch*, 9 March 1915, p. 4.
54. Sontag, *Regarding the Pain of Others* (London, 2003), p. 48.
55. Gen Doy, 'The Camera against the Paris Commune', in T. Dennett, J. Spence, D. Evans and S. Gohi (eds), *Photography Politics One*, (London, 1979), pp. 13–26; Hodgson, *Early War Photographs*, pp. 24–5; von Amelunxen, 'The century's memorial', p. 147.
56. Hodgson, *Early War Photographs*, p. 29; John Ellis, *Seeing Things* (London, 2002) p. 21; John Barnes, *Filming the Boer War* (London, 1992), pp. 19–21.
57. *Daily Sketch*, 3 March 1915, p. 4.
58. *Daily Mail*, 4 March, 14 June and 7 June 1915.
59. *Daily Mirror*, 2 August 1915.
60. *Daily Mirror*, 31 March 1915, 2 August 1915, p. 3.
61. *Daily Mirror*, 6 November 1915, p. 9.
62. *Daily Mirror*, 2 August 1915, p. 20; Jorge Lewinski, *The Camera at War* (London, 1978), p. 66; Anderson, *War: A History in Photographs*; *Daily Mirror*, 27 March 1915; Knightley, *The First Casualty*, p. 99.
63. *Daily Sketch*, 31 July 1915, p. 2; 29 May 1915.
64. TNA, HO/139/19.
65. TNA, HO/139/42.
66. Jane Carmichael, *First World War Photographers* (London, New York, 1989), p. 23.
67. *BJP*, 4 December 1914, pp. 885–7, see also 18 December 1914, pp. 918–19.
68. National Army Museum, photo album 5910/2/73.
69. Ernst Jünger, 'War and photography', *A New German Critique*, No. 59 (1993), pp. 24–6.
70. TNA, HO/139/31.
71. *AP*, 18 October 1915, p. 311.
72. *AP*, 6 September 1915, p. 186; 30 August 1915, p. 167; 8 February 1915, p. 105.
73. Carmichael, *First World War Photographers*, p. 34.
74. Leeds University, Liddle Collection, WO109: A letter to Mrs Y. M. Smythe, from William Dixon, 25 November 1916.

75. See Boris Mollo, *The British Army from Old Photographs* (London, 1975).

76. Gernsheim, *Roger Fenton, Photographer of the Crimean War*, p. 11.

77. Rivoir, 'The soldier photographer', p. 82.

78. *AP*, 1 February 1915, p. 92.

79. *Daily Mirror*, 3 April 1915, p. 4.

80. Liddle Collection, GS 1070, Box 5.

81. *AP*, 26 July 1915; 6 March 1916, pp. 68, 182; *BJP*, 31 December 1915, p. 846; *The British Empire YMCA Weekly* (*YM*), 19 November 1915, 14 January 1916.

82. *AP*, 13 September 1915, p. 208.

83. *YM*, 19 December 1915, p. 1185.

84. *AP*, 8 November 1915, p. 376; 24 January 1916, p. 68; 20 March 1916, p. 228.

85. *AP*, 13 September 1915, p. 208.

86. *YM*, 21 January 1916.

87. Imperial War Museum, Department of Documents, Misc. 159/2469.

88. Liddle Collection, DF 110, Robb.

89. The *Independent*, 'Hello mum, this is going to be hard for you to read', 21 July 2009.

90. Bernd Hüppauf, 'Experiences of modern warfare and the crisis of representation', *A New German Critique*, No. 59 (1993), p. 59.

91. Author's meeting with Robert Fisk, October 2006; see Robert Fisk, *The Great War for Civilization: The Conquest of the Middle East* (London, 2005), p. 362.

Three: Telling Tales

1. llan Ziv, quoted in Pat Holland, ' "Sweet it is to scan ...": personal photographs and popular photography', in Liz Wells (ed.), *Photography: A Critical Introduction* (London, 2000), p. 152.

2. John Berger, *About Looking* (London, 1980), p. 89.

3. Roland Barthes, *Camera Lucida* (London, 1982), p. 73; see also Martha Langford, *Suspended Conversations: The After Life of Memory in Photographic Albums* (Montreal, 2001), p. 18.

4. Sarah Graham-Brown, *Images of Women: The Portrayal of Women in Photography of the Middle East 1860–1950* (London, 1988), p. 44.

5. *Basra Times*, 12 October 1917, Vol. 3, No. 219.

6. Jane Carmichael, *First World War Photographers* (London and New York, 1989), pp. 86, 91.

7. Leeds University, Liddle Collection, MES 012/Box 1.

8. For more on pictures taken during the siege of Kut see Carmichael, *First World War Photographers*, p. 86.

9. Imperial War Museum, Department of Photographs, 2004–11-20; see also Stuart Hood, 'War photographs and masculinity', in P. Holland, J. Spence and S. Watney (eds), *Photography/Politics: Two* (London, 1986), pp. 91–2.

10. Quoted in W. G. Sebald, *On the Natural History of Destruction* (New York, 2003), pp. 183–4.

11. Art Gallery of Ontario (AGO) Toronto, album 69933.

12. AGO, album 69478.

13. AGO, album 69598.

14. AGO, album 69933.

15. AGO, album 69665.

16. See http: www.dtsonline.us/a-world-war-in-soldiers-photo-album-gas-guts-and-eternal-glory (accessed 28 January 2008).

17. Bernd Hüppauf, 'Emptying the gaze: framing violence through the viewfinder', in Hannes Heer and Klaus Naumann, *War of Extermination: The German Military in World War II 1941–1944* (London, 2002), pp. 364, 355.

18. Vicki Goldberg, *Margaret Bourke-White, a Biography* (London, 1987), p. 291.

19. *The Photographic Journal*, December 1916, pp. 263–73.

20. Leeds University, Liddle Collection, GS 1070.

21. Author's meeting with Robert Fisk, October 2006; Robert Fisk, *The Great War for Civilization: The Conquest of the Middle East* (London, 2005), p. 371.

22. Langford, *Suspended Conversations*, pp. 156–7.

23. Sebald, *On the Natural History of Destruction*, p. 10.

24. Janina Struk, *Photographing the Holocaust: Interpretations of the Evidence* (London, 2004), pp. 57–73.

25. For details of Karl Höcker's album see USHMM website: www.ushmm.org (accessed September 2008).

26. Struk, *Photographing the Holocaust*, pp. 118–19.

27. Roger Cohen, 'Down time from murder', *New York Times*, 24 September 2007.

28. See www.Spiegalonline.de/international (accessed September 2007).

Four: Photographs as Resistance

1. Vicki Goldberg, *Photography in Print: Writings from 1816 to the Present* (Albuquerque, 1981), p. 33.

2. Author's interview with Jerzy Tomaszewski, Warsaw, May/June 2005; see also Janina Struk, 'My duty was to take pictures', the *Guardian*, G2, 28 July 2005, pp. 8–10; Elżbieta Berus, Jerzy Tomaszewski, *Zachowy Obraz -Nieznana Kolekcja z Lat 1939–1945* (Warsaw, n.d.).

3. Author's conversations with Anna Bohdziewicz, Warsaw, April 2007.

4. Author's interview with Jerzy Tomaszewski.

5. Author's interview with Jerzy Tomaszewski.

6. Author's interview with Jerzy Tomaszewski; author's conversation with Janina Kęsek, Muzeum Im. Stanisława Fischera w Bochni, 1999; Janina Struk, *Photographing the Holocaust: Interpretations of the Evidence* (London, 2004) pp. 41–5; see also Tim Smith and Michelle Winslow, *Keeping the Faith: The Polish Community in Britain* (Bradford, 2000), p. 13.

7. Struk, *Photographing the Holocaust*, pp. 42–5.

8. Klaus Kirchner (ed.), *Flugblätt-Propaganda IM2: Weltkrieg Flugblätter aus England*, *G-1943-G-1944* (Erlangen, 1979), pp. 52, 149.

9. Polish Institute and Sikorski Museum, Document A10–4/12.

10. Author's interview with Jerzy Tomaszewski; see also Polish Institute and Sikorski Museum, Document A10–4/14.

11. Author's interview with Jerzy Tomaszewski.

12. The personal papers of Anna Bohdziewicz; for information about photographers and filmmakers during the Warsaw Uprising see: Wladysław Jensiewicki, *Powstanie Warszawskie 1944* (Warsaw, 1989).

13. Author's interview with Jerzy Tomaszewski; Struk, 'My duty was to take pictures'.

14. Author's interview with Jerzy Tomaszewski.

15. For general information on the Warsaw Uprising see Norman Davies, *Rising '44: The Battle for Warsaw* (London, 2003).

16. Polish Institute and Sikorski Museum, Document A10/5/45.

17. Author's interview with Jerzy Tomaszewski; the personal papers of Anna Bohdziewicz.

18. Polish Institute and Sikorski Museum, Document A48/4/A2.

19. The National Archives (TNA), FO 371/34549.

20. *The New Germany and the Old Nazis* (London, 1961), p. 116.

21. *Świat*, No. 6, 7 February 1965, p. 13.

22. Author's interview with Jerzy Tomaszewski; Jerzy Tomaszewski, *Epizody Powstania Warszawskiego* (Warsaw, 1979).

Five: How Pictures Can Haunt a Nation

1. Author's interview with Hannes Heer, Hamburg, November 2006.

2. Hannes Heer, 'The head of Medusa: the controversy surrounding the exhibition "War of Annihilation: Crimes of the Wehrmacht, 1941 to 1944"', in H. Heer, W. Manoschek, A. Pollack and R. Wodak (eds), *The Discursive Construction of History: Remembering the Wehrmacht's War of Annihilation* (London, 2008), p. 234; for an analysis of the exhibition see Hannes Heer, 'Die visuelle Provokation der ersten Wehrmachtsausstellung', in Gerhard Paul (ed.), *Das Jahrhundert der Bilder 1949 bis heute*, (Göttingen, 2008), pp. 638–45; Hannes Heer, *Vom Verschwinden der Täter. Der Vernichtungskrieg fand statt, aber keiner war dabei* (Berlin, 2004).

3. Author's interview with Hannes Heer.

4. *Doncaster Gazette*, editorial, 23 July 1942; Janina Struk, *Photographing the Holocaust: Interpretations of the Evidence* (London, 2004), p. 52.

5. Hannes Heer, 'The head of Medusa', p. 228; *Electronic Telegraph*, 23 March 1995.

6. Edith Raim, 'Coping with the Nazi past: Germany and the legacy of the Third Reich', *Contemporary European History*, Vol. 12, No. 4 (November 2003), p. 549.

7. Hamburg Institute for Social Research, (ed.), *German Army & Genocide: Crimes against War Prisoners, Jews, and Other Civilians, 1939–1944* (New York, 1999) p. 11.

8. Struk, *Photographing the Holocaust*, p. 158.

9. T. H. Tetens, *The New Germany and the Old Nazis* (London, 1961), see ch. 18.

10. Michael Verhoeven (dir.), *The Unknown Soldier* (Germany, 2006).

11. James E. Young, *The Texture of Memory: Holocaust Memorial and Meanings* (New Haven, CT and London, 1993), p. 63.

12. Heer, 'The head of Medusa', p. 233.

13. Tetens, *The New Germany and the Old Nazis*, p. 13 and see generally ch. 9, 'Old soldiers never die'.

14. Hamburg Institute for Social Research, *German Army and Genocide*, p. 14; O. Bartov, A. Grossman and M. Nolan (eds), *Crimes of War: Guilt and Denial in the Twentieth Century* (New York, 2002) p. xv.

15. Heer, 'The head of Medusa', pp. 11–12, 18.

16. Tetens, *The New Germany and the Old Nazis*, pp. 225–8.

17. Heer, 'The head of Medusa', pp. 245, 243.

18. 'Immune against criticism', *Spiegel*, no 23, 1999.

19. Author's interview with Petra Bopp, Hamburg, November 2006.

20. *SOS*, Paul Rowinski, 2 March 1997.

21. Author's interview with Petra Bopp.

22. Verhoeven, *The Unknown Soldier*.

23. Petra Bopp, 'Les images photographiques dans les expositions sur les crimes de la Wehrmacht ou comment l'histoire devient intime', in Sophie Wahnich *Fictions d'Europe: La guerre au musée* (Paris, 2003), pp. 194–6.

24. Hamburg Institute for Social Research, *German Army & Genocide*, p. 210.
25. Verhoeven, *The Unknown Soldier*.
26. Hamburg Institute for Social Research archive: see file on Sammlung Hennetmair; Author's interview with Petra Bopp.
27. Hannes Heer and Klaus Naumann (eds), *War of Extermination: The German Military in World War II 1941–1944* (London, 2006), p. 127.
28. The *Guardian*, 26 February 1997; *Sunday Times*, 12 September 1997.
29. The *Guardian*, 26 February 1997.
30. Author's interview with Petra Bopp.
31. Janusz Gumkowski, Kazimierz Leszczyński, *Poland under Naʒi Occupation* (Warsaw, 1961), pp. 47–56.
32. Hamburg Institute for Social Research, *German Army and Genocide*, p. 84; Petra Bopp, 'Viewing the photographs of Willi Rose', in Thomas Eller (ed.), *Shadows of War: A German Soldier's Lost Photographs of World War II* (New York, 2004).
33. Joe J. Heydecker, *The Warsaw Ghetto – A Photographic Record, 1941–1944* (London, 1990), p. 25; Hamburg Institute for Social Research, *German Army and Genocide*, p. 89.
34. Document V-23-A, Yad Vashem Film and Photo archives, Israel. For Max Täubner's case see E. Klee, W. Dressen and V. Reiss (eds), *'The Good Old Days': The Holocaust as Seen by Its Perpetrators and Bystanders* (New York, 1988), pp. 196–207.
35. Author's interview with Hannes Heer.
36. Eugeniusz C. Król, *I Never Played with Tin Soldiers, Warsʒawa 1940–1941 w Fotografii Dr Hansa-Joachima Gerke* (Warsaw, 1996).
37. Günther Schwarberg, *In the Ghetto of Warsaw: Heinrich Jöst's Photographs* (Göttingen, 2001); see also Judith Lavin and Daniel Uziel, 'Ordinary men, extraordinary photos', in *Yad Vashem Studies*, Vol. 26 (1998), p. 271.
38. Rafael Scharf (ed.), *In the Warsaw Ghetto, Summer 1941* (London, 1993).
39. Heydecker, *The Warsaw Ghetto*, pp. 20–2.
40. Raim, 'Coping with the Nazi past', p. 550.
41. Raya Kagan, 'Russians on German concentration camps', in *Yad Vashem Bulletin*, No. 4–5 (October 1959), pp. 22–3.
42. Bert Hogenkamp, *Film, Television and the Left, 1950–1970* (London, 2000), see ch. 4, 'After Hungary', p. 77.
43. Struk, *Photographing the Holocaust*, p. 168.
44. Raim, 'Coping with the Nazi past', p. 550.
45. Heer, 'The head of Medusa', p. 228.
46. *Daily Telegraph*, 16 April 1997; Heer, 'The head of Medusa', p. 229.
47. Jan Philipp Reemtsma, *In the Cellar* (London, 1999), p. 61.
48. Ruth Beckermann (dir.), *East of War* (Vienna, 1996).
49. There are many extant images of the hangings in Kharkov. See for example Ministry of Information files – Russ-Horror, Imperial War Museum, London.
50. *German News Online*, 9 March 1999; Verhoeven, *The Unknown Soldier*.
51. *Sunday Times*, 12 September 1997; *Electronic Telegraph*, 26 February 1997.
52. The *Independent*, 26 March 1997.
53. Wolfgang Weber, 'The debate in Germany over the crimes of Hitler's Wehrmacht', 19 September 2001, *World Socialist Website*, www.wsws.org
54. Heer, 'The head of Medusa', p. 229.
55. Heer, 'The head of Medusa', p. 230.
56. Author's interview with Hannes Heer.

57. Struk, *Photographing the Holocaust*, see ch. 1 for the story of this 'death pit' photograph. See also Janina Struk, 'The death pit', the *Guardian*, G2, 27 January 2004.

58. Gerald R. Reitlinger, *The Final Solution: The Attempts to Exterminate the Jews of Europe, 1939–1945* (London, 1953), p. 242.

59. *Daily Mirror*, 28 July 1941, p. 5.

60. Janina Struk, 'Images of women in Holocaust photography', *Feminist Review*, Vol. 88, War, 2008, pp. 111–21.

61. Struk, *Photographing the Holocaust*, p. 205.

62. Hamburg Institute, *German Army and Genocide*, p. 82.

63. Bernd Boll, 'Złoczów, July 1941: the Wehrmacht and the beginning of the Holocaust in Galicia: from a criticism of photographs to a revision of the past', in O. Bartov, A. Grossmann and M. Nolan (eds), *Crimes of War: Guilt and Denial in the Twentieth Century* (New York, 2002).

64. Shlomo Wolkowicz, *The Mouth of Hell* (Haverford, 2002), pp. 134–5.

65. 'The German army and genocide: bitterness stalks an exhibition', *New York Times*, 5 December 1999.

66. Heer, 'The head of Medusa', pp. 231–2.

67. Heer, 'The head of Medusa', p. 234.

68. Heer, 'The head of Medusa', p. 245.

69. Miriam Arani makes this point and is quoted in Heer, 'The head of Medusa', p. 246.

70. Heer, 'The head of Medusa', p. 240.

71. Heer, 'The head of Medusa', pp. 244, 246; author's interview with Hannes Heer.

Six: Inadmissible Evidence

1. Val Williams, *Warworks: Women, Photography and the Iconography of War* (London, 1994), p. 10.

2. Office of the Judge Advocate General, London, Transcript of Proceedings of a General Court Martial held at Osnabrück on 18th day of January 2005 to the 25th day of February 2005.

3. S. G. Ehrlich and Leland V. Jones, *Photographic Evidence: The Preparation & Use of Photographs in Civil and Criminal Cases* (London, 1967), pp. 11–12, 24–31, 46–7, 277–8.

4. Paul Betts, 'Some reflections on the "visual turn"', *FORUM: German History after the Visual Turn* on H-Net: Humanities and Social Sciences Online, http://www.h-net.org (accessed October 2009); *Department of the Army Review*, July 1960, Washington DC; see in general Arthur Ponsonby, *Falsehoods in Wartime* (London, 1928).

5. The *Guardian*, 24 February 2005, p. 7.

6. Transcript of Proceedings of a General Court Martial held at Osnabrück, p. 1376; evidence given by Fusilier Stuart William Thorne, p. 1155; the *Independent*, 24 February 2005, pp. 4–5; *The Times*, 24 February 2005.

7. Transcript of Proceedings of a General Court Martial held at Osnabrück, pp. 77–83, 85, 88, 1182–3.

8. Proceedings of a General Court Martial held at Osnabrück, p. 77.

9. Proceedings of a General Court Martial held at Osnabrück, pp. 152, 1357–8.

10. 'Photos indicate torture and sexual abuse by British troops in Iraq', *World Socialist website*, www.wsws.org (accessed 4 June 2003).

11. Office of the Judge Advocate General, London, Transcript of Proceeding of General Court Martial held at Military Court Centre Höhne on 10th and 11th days of January 2005, p. 14.

12. The *Independent*, 24 February 2005, p. 1.
13. The *Independent*, 24 February 2005, pp. 1, 4–5.
14. Transcript of Proceeding of General Court Martial held at Military Court Centre Höhne on 10th and 11th days of January 2005; see also the transcript: In the Courts-Martial Appeal Court before Lady Justice Smith, Mr Justice Wakerley, 28 June 2005.
15. Transcript of Proceedings of a General Court Martial held at Osnabrück, p. 97.
16. Transcript of Proceedings of a General Court Martial held at Osnabrück, pp. 10–12.
17. Transcript of Proceedings of a General Court Martial held at Osnabrück, p. 19.
18. Transcript of Proceedings of a General Court Martial held at Osnabrück, p. 20.
19. The *Sun*, 19 January 2005, pp. 2, 5.
20. The *Guardian*, 20 January 2005.
21. Transcript of Proceedings of a General Court Martial held at Osnabrück, pp. 48–9.
22. Transcript of Proceedings of a General Court Martial held at Osnabrück, p. 51.
23. Transcript of Proceedings of a General Court Martial held at Osnabrück, pp. 73–4.
24. Transcript of Proceedings of a General Court Martial held at Osnabrück, pp. 1218–20.
25. Transcript of Proceedings of a General Court Martial held at Osnabrück, p. 1222.
26. Transcript of Proceedings of a General Court Martial held at Osnabrück, pp. 1175, 1186, 1224.
27. Transcript of Proceedings of a General Court Martial held at Osnabrück, pp. 117–19, 1222–6, 1171–3, 1251.
28. Transcript of Proceedings of a General Court Martial held at Osnabrück pp. 137–8, 1379.
29. Transcript of Proceedings of a General Court Martial held at Osnabrück, p. 128.
30. Transcript of Proceedings of a General Court Martial held at Osnabrück, pp. 73–6, 1316, 1359.
31. Author's interview with Andy McNab, London, 2005.
32. Transcript of Proceedings of a General Court Martial held at Osnabrück pp. 1326–7, 1333, 1346, 1350–51, 1361.
33. Proceedings of a General Court Martial held at Osnabrück, pp. 147–54.
34. The *Independent*, 24 February, p. 5.
35. Kevin Maguire, the *Guardian*, 10 May 2004; www.guardian.co.uk, Roy Greenslade, 'Torture is the real issue, not these photographs', 4 May 2004.
36. *Daily Mirror*, 1 May 2004, p. 2.
37. *Daily Mirror*, 3 May 2004, pp. 6–7.
38. *Daily Mirror*, 3 May 2004, pp. 6–7.
39. Author's interview with Karen Davies, a deputy picture editor of the *Sunday Telegraph*, 2005.
40. *Daily Mirror*, 3 May 2004.
41. *Daily Mirror*, 7 May 2004.
42. *Daily Mirror*, 8 May 2004, pp. 4–5.
43. See www.guardian.co.uk, 5 May 2004; Author's interview with Karen Davies.
44. 'Experts may fail to unravel mystery of abuse photographs', the *Guardian*, 6 May, 2004; *Independent on Sunday*, 2 May 2004.
45. Roy Greenslade, www.guardian.co.uk, 4 May 2004.
46. BBC News Online, 'British troops photographs: your views', www.bbc.co.uk/news, 4 May 2004.

47. John Taylor, 'Iraqi torture photographs and realism in the press', in *Journalism Studies*, Vol. 6, 2005.
48. *Daily Mirror*, 15 May 2004, pp. 4–5, p. 15; the *Guardian*, 15 May 2004.
49. John Pilger, *New Statesman*, 31 May 2004.
50. Author's interview with Karen Davies; *Independent on Sunday*, 2 May 2004, p. 9; *Journalist*, June 2005, p. 29; the *Guardian*, 15 May 2004, p. 3.
51. Court martial at Military Court Centre, (MCC) Bulford, Transcript of Proceedings, Military Court Service; the *Independent*, 15 May 2004; the *Guardian*, 15 May 2004.
52. Crown Prosecution Service statement, 9 December 2005.
53. Court martial at MCC, Bulford, Transcript of Proceedings, Stuart Mackenzie, 2 November 2006.
54. Court martial at MCC, Bulford, Transcript of Proceedings, Opening of the Crown's case, p. 14.
55. Court martial at MCC, Bulford, Transcript of Proceedings, Opening of the Crown's case, p. 8.
56. See for example former Corporal Payne's statement, Baha Mousa public inquiry, Day 32.
57. Court martial at MCC, Bulford, Transcript of Proceedings, Opening of the Crown's case, p. 11, pp. 25–26.
58. Author's interview with Andy McNab.
59. Court martial at MCC, Bulford, Transcript of Proceedings, Stuart Mackenzie, 1 and 2 November 2006.
60. Court martial at MCC, Bulford, Transcript of Proceedings, 30 November 2006.
61. Baha Mousa public inquiry, London, Transcript, Day 16.
62. Court martial at MCC, Bulford, Transcript of Proceedings, testimony of Stuart Mackenzie.
63. Baha Mousa public inquiry, Transcript, Day 29.

Seven: Breaking the Silence

1. Chris Hedges, *New York Times* quoted in *Online Journal*, 4 February 2005.
2. Yitzhak Laor, *London Review of Books (LRB)*, Vol. 26, No. 14, 22 July 2004, pp. 32–3.
3. Author's interview with Yehuda Shaul, September 2006; Aviv Lavie, 'Hebron Diaries', www.haaretz.com, 7 July 2004 (accessed September 2006).
4. Author's interview with Yehuda Shaul; ABC Online, http://www.net.au/pm/comment/2004/s1128405.htm (accessed October 2006).
5. Author's interview with Yehuda Shaul.
6. Author's interview with Yehuda Shaul.
7. Donald MacIntyre, 'A rough guide to Hebron: the world's strangest guided tour highlights the abuse of Palestinians', www.independent.co.uk, 13 February 2008.
8. *Breaking the Silence: Soldiers Speak out about Their Service in Hebron* (Jerusalem, 2004), p. 4.
9. Author's interview with Yehuda Shaul; author's interview with Avichay Sharon, Amsterdam, November, 2006.
10. The *Jewish Advocate*, 3 June 2008; Donald MacIntyre, 'Breaking silence over the horrors of Hebron', the *Independent*, 23 June 2004.
11. Author's interview with Avichay Sharon.
12. *Israeli Soldiers Talk about Hebron* (Breaking the Silence, Israel, 2005).

13. Author's interview with Yehuda Shaul.
14. MacIntyre, 'Breaking silence over the horrors of Hebron'.
15. ABC Online, http://net.au/pm/content/2004/s128405.htm (accessed October 2006).
16. *Los Angeles Times*, 20 June 2004.
17. *Washington Post*, 24 June 2004.
18. *Washington Post*, 24 June 2004; Daniel Sturm, 'You don't see, you don't feel, and you don't look', *Information Clearing House*, 9 April 2006; author's interview with Yehuda Shaul.
19. Author's interview with Yehuda Shaul.
20. See www.breakingthesilence.org.il (accessed September 2006).
21. *Yedioth Ahronoth*, 21 November 2004; Author's interview with Noam Chayut, Amsterdam, 2006.
22. Quoted in Tom Regan, *Christian Science Monitor*, 22 November 2004.
23. Author's interview with Noam Chayut.
24. Gideon Levy, 'Twilight zone: pictures at an exhibition', *Ha'aretz*, 23 December 2004.
25. Author's interview with Avichay Sharon.
26. Author's interview with Yehuda Shaul.
27. Author's interview with Yehuda Shaul.
28. See www.standwithus.com
29. *The Toronto Star*, 17 December 2006; Sturm, 'You don't see, you don't feel, and you don't look'; author's interview with Yehuda Shaul.
30. Author's vox pop interviews at the exhibition, Amsterdam, names withheld.
31. Author's interview with Yehuda Shaul.
32. Laor, *LRB*.
33. Jonathan Freedland, 'Let's take off blinkers and see clearly', *Jewish Chronicle*, 3 December 2004, p. 31; Eric Silver, 'IDF "abuse" incidents shock Israeli public', *Jewish Chronicle*, 3 December 2004, p. 3.
34. Chris McGreal, 'Israel shocked by image of soldiers forcing violinist to play at road-block', the *Guardian*, 29 November 2004, www.guardian.co.uk.
35. Laor, *LRB*.
36. Author's interview with Yehuda Shaul; Lavie, 'Hebron Diaries'.
37. Author's interview with Yehuda Shaul.
38. *Ha'aretz*, editorial, 25 February 2008, http://www.shovrimohtika.org/press_item
39. *Palestine News*, June 2002, p. 3; *Journalist*, May 2002, p. 35.

Eight: The Inside View of War

Some websites mentioned in this chapter and located before September 2007 no longer exist. Others have changed their design and content considerably.

1. Quoted in David King, *Red Star over Russia* (London, 2009), p. 310.
2. For comments on photography see Eric Deggans, 'Prison photos a devastating hit in the war of images', *St Petersburg Times* online, www.sptimes.ru, 9 May 2004; Peter Howe, 'Amateur Hour', *The Digital Journalist*, June 2004; Steve Winn, 'What can photos teach us about war. Have a look', www.sfgate.com, 19 April 2005; Jonathon Curiel, 'War Images and digital technology', www.sfgate.com, 16 May 2004; Susan Sontag, *Regarding the Pain of Others* (London, 2003), p. 53.
3. Author's interview with Karen Davies, a deputy picture editor of the *Sunday Telegraph*, February 2005.

4. Dan Glazebrook, 'Talking to Fisk: truth as a causality of war', *Palestine Chronicle*, 19 April 2008, www.informationclearinghouse.info (accessed April 2008).

5. Hubertus von Amelunxen, 'The century's memorial: photography and the recording of history', in Michel Frizot (ed.), *A New History of Photography* (Cologne, 1998), p. 141.

6. Barbie Zelizer, *Remembering to Forget: Holocaust Memory through the Camera's Eye* (Chicago, 1998), pp. 10–15.

7. Jorge Lewinski, *The Camera at War* (London, 1978), p. 14; Carole Naggar, *George Rodgers: An Adventure in Photography 1908–1995* (Syracuse, 2003).

8. Susie Lingfield makes this point in 'The treacherous medium', *Boston Review*, October 2006.

9. Barry Bergman, 'A citizen journalist in Iraq', *Berkeleyan*, 21 April 2005; see also http://dahrjamailiraq.com (accessed September 2007).

10. John Berger, *About Looking* (London, 1978), pp. 56, 119.

11. Sontag, *Regarding the Pain of Others*, p. 24.

12. Stefan Czyzewski, *Pprzełamywać Bariery: Budować Mosty: wojna na fotografiach polskiego i niemieckiego żołnierza Muzeum Historii Fotografii w Krakowie*, June–September 2004 (exhibition catalogue, Kraków, 2004).

13. *On the Subject of War*, Barbican, London, 2008; Geert van Kesteren, *Baghdad Calling* (Netherlands, 2008), p. 13.

14. Van Kesteren, *Baghdad Calling*, pp. 11–14.

15. Van Kesteren, *Baghdad Calling*, p. 12.

16. For the story about the images see: the *Guardian*, 'Pentagon insistent over photo ban', 23 April, 2004; *New York Times*, 'Photos of soldiers' coffins spark a debate over access', 24 April 2004; Ann Scott Tyson, 'Hundreds of photos of caskets released', www.washingtonpost.com, 29 April 2005.

17. 'The war within', www.sfgate.com, 29 January 2006; *Znet Commentary*, 15 January 2006.

18. Norman Solomon, 'Media's war images delude instead of inform', *Znet Commentary*, 15 January 2006; Matthew B. Stannard, 'The war within', www.sfgate.com, 29 January 2006; 'Memory of fire: the war of images and images of war', Brighton, 2008.

19. David Holloway, *9/11 and the War on Terror* (Edinburgh, 2008), p. 71.

20. White House Press Release, 1 May 2008.

21. See www.pbase.com. Comment posted 22 November 2004. In 2009 Debbie's pictures were no longer on www.pbase.com

22. Devin Friedman and the editors of *GQ*, *This Is Our War: Servicemen's Photographs of Life in Iraq* (New York, 2005), pp. 14–18.

23. See generally issues of *Stars and Stripes* in 2006 and 10 April 2008.

24. See www.blackfive.com, 2007; Mike Spector, 'Cry bias, and let slip the blogs of war', *Wall Street Journal*, 26 July 2006.

25. Author's email interview with Kim Newton, October 2007; Sarah Colombo, *Online Journalism Review*, 11 February 2005.

26. 'Unseen pictures, untold stories: how the US press has sanitized the war in Iraq', 24 May 2005, www.democracynow.org

27. See www.mtv.com/articles.

28. Author's correspondence with Duncan Anderson, 23 November 2005.

29. Author's email interview with Kim Newton, 2007.

30. Author's email interview with Devin Friedman, March and April 2008.
31. Author's correspondence with CJ, October 2007; Friedman and the editors of *GQ*, *This Is Our War*, pp. 39, 51, 160.
32. Friedman and the editors of *GQ*, *This Is Our War*, p. 174.
33. Friedman and the editors of *GQ This Is Our War*, pp. 147–8.
34. Philip Gourevitch and Errol Morris, *Standard Operating Procedure: A War Story* (New York, 2008), p. 191.
35. Author's email correspondence with Aaron Ansarov, October 2008.
36. Author's email interview with Devin Friedman.
37. Author's interview with Edouard Gluck, London, May 2008.
38. Author's interview with Edouard Gluck.
39. Mark Peters 'Interview with Vietnam and Iraq war photographers', *Let Go Digital*, 6 May 2005.
40. Author's interview with Edouard Gluck.
41. Author's interview with Edouard Gluck.
42. Author's interview with Edouard Gluck.
43. Author's email interview with Devin Friedman.
44. Author's email interview with Devin Friedman.
45. Author's interview with Edouard Gluck.
46. James Harkin, 'Shock and gore', www.ft.com, 13 January 2006.
47. Ernst Friedrich, *War against War!* (London, 1987), pp. 13, 20–35.
48. Author's email correspondence with Shannon Larrett of www.undermars.com, 17 September 2007.
49. Harkin, 'Shock and gore'.
50. Hayden Hewitt interviewed on BBC2 *Newsnight*, 29 July 2006.
51. Casey N. Cep, 'Warnography visceral allure', *The Harvard Crimson*, online edition, 13 October 2005.
52. NTFU, 23 July 2005.
53. NTFU, 29 October 2004, NTFU, 8 October 2005.
54. NTFU, 24 and 25 October 2005.
55. NTFU, 25 October 2005.
56. NTFU, 21 February 2005.
57. NTFU, February 2005.
58. Vicki Goldberg, *The Power of Photography: How Photographs Changed Our Lives* (New York, 1991), pp. 230–7.
59. NTFU, 30 September 2005.
60. Ken Tran, 'Graphic photos have a purpose', *Daily Texan*, 13 October 2005; George Zornick, 'The porn of war', *Nation*, 22 September 2005.
61. Mark Glaser, 'Can a Florida sheriff police obscenity on the Internet?', *Online Journalism Review*, 18 October 2005.
62. Glaser, 'Porn site offers soldiers free access in exchange for photos of dead Iraqis'.
63. Glaser, 'Can a Florida sheriff police obscenity on the Internet?'
64. Glaser, 'Porn site offers soldiers free access in exchange for photos of dead Iraqis'; Wilson claimed that he got rid of core39 in 2002. Author's email interview with Chris Wilson, October 2007.
65. Author's email interview with Chris Wilson.
66. Reuters, 'US Army ends probe on porn site photos of Iraq corpses', 28 September 2005; *Boston Globe*, 7 April 2005, 29 September, 2005; Glaser, 'Porn Site offers soldiers free

access in exchange for photos of dead Iraqis'; Zornick, 'The porn of war'; Thompson, www.eastbayexpress.com.

67. Reuters, 'US Army ends probe on porn site photos of Iraq corpses'.

68. Polk Sheriff's Office New Release, 7 October 2007; author's correspondence with Chris Wilson.

69. Travis Reed, 'Webmaster for site with Iraqi corpse pics accused of obscenity', Associated Press, 10 August 2005.

70. *North Country Gazette*, 17 December 2005; author's email interview with Chris Wilson.

71. Gil Kaufmann, 'Iraq uploaded: the war network TV won't show you, shot by soldiers and posted online', www.mtv.com, 20 July 2006.

72. David Sax, 'Combat rock', *Rolling Stone*, 1 June 2006.

73. Colby Buzzell, *My War: Killing Time in Iraq* (New York, 2005), pp. 349–50.

74. Kaufmann, 'Iraq uploaded'.

75. Kaufmann, 'Iraq uploaded'.

76. NTFU, 30 December 2005.

77. Mark Glaser, 'Soldier videos don't violate policy', 30 January 2006, www.pbs.org; Mark Glaser, 'Your guide to soldier videos from Iraq', 1 August 2006, www.pbs.org

78. BBC News Online, 'US blocks soldiers from websites', www.bbc.co.uk/news, 15 May 2007; Dan Frosch, 'Pentagon blocks 13 websites from military computers', *New York Times*, 15 May 2007; Audrey Gillan, 'MoD issues gag order on armed forces', the *Guardian*, 9 April 2008; Gil Kaufman, 'Army restricts blogging: blocks access to YouTube, MySpace, MTV, More', 14 May 2007.

79. BBC News, 'Blair launches YouTube "channel"', www.bbc.co.uk/news, 7 April 2007; Tom Meagher, 'Army puts war videos on YouTube', HeraldNews, 30 May 2007; CBS News, 'The military embraces YouTube', 27 March 2007.

80. Frosch, 'Pentagon blocks 13 websites from military computers'.

81. Rory Carroll, 'Elusive sniper saps US morale in Baghdad', the *Guardian*, 5 August 2005.

82. Juba films include: *Sniper of Baghdad*, *Iraqi Resistance Sniper Attacks*, *Iraqi Resistance's Sniper Attack on U.S. Army*, *Juba The Sniper*, www. baghdadsniper.net.

83. Adrienne Arsenault, 'The Iraq war and the electronic trench: blogger, bullets and Baghdad', www.cbc.ca, 11 June, 2007.

84. See www.liveleak.com 'Survivor of famous sniper video tells his story' (accessed November 2008).

85. See www.googlevideo.com posted 29 September 2007 by 'The last rebel'.

86. See www.googlevideo.com, 14 August 2007, posted by 'anonymous'; *Stars and Stripes*, 'Juba the sniper legend haunting troops in Iraq', 22 April 2007.

87. *News of the World*, 9 March 2008, p. 3.

88. David Sax, 'Combat rock'.

89. *News of the World*, 12 February 2006.

90. BBC2 *Newsnight*, 21 June 2007.

91. Quoted in Glaser, 'Your guide to soldier videos from Iraq'.

92. Mark Glaser, 'War tapes' film lets soldiers tell their stories from Iraq', 15 August 2006, www.pbs.org.

93. Q & A with Deborah Scranton, at the Frontline Club, London, 7 October, 2008; see full film transcript at www.pbs.org; Richard Allen Greene, 'Film sees war through soldiers' eyes', BBC News, www.bbc.co.uk/news, 15 October 2008.

94. Q & A with Deborah Scranton, Frontline Club.
95. *CNET News*, Jonathon Skillings, ' "The war tapes": making movies the Web 2.0 way', 4 May 2006; 'The war tapes', 22 March 2007, transcript of an interview with Deborah Scranton, www.washingtonpost.com.
96. Glazebrook, 'Talking to Fisk'.

Bibliography

Printed sources

The Allied Museum, *Berlin 1945: A Private View* (Berlin, 2005).

Allen, J., Als, H., Lewis, J. and Litwack, Leon F., *Without Sanctuary: Lynching Photography in America* (New York, 2005).

Anderson, Duncan, *War: A History in Photographs* (London, 2003).

——, *Glass Warriors: The Camera at War* (London, 2005).

Apel, Dora and Smith, Shawn Michelle, *Lynching Photographs* (Berkeley, LA, 2007).

Apenszlak, Jacob (ed.), *The Black Book of Polish Jewry: An Account of the Martyrdom of Polish Jewry under Nazi Occupation* (New York, 1943).

Barnes, John, *Filming the Boer War* (London, 1992).

Barthes, Roland, *Camera Lucida: Reflections on Photography* (London, 1982).

Bartov, Omar, Grossman, Atina and Nolan, Mary (eds), *Crimes of War: Guilt and Denial in the Twentieth Century* (New York, 2002).

Benjamin, Walter, *Illuminations* (London, 1979).

Berger, John, *Ways of Seeing* (London, 1972).

——, *About Looking* (London, 1980).

——, *Another Way of Telling* (London, 1989).

Berus, Elżbieta and Tomaszewski, Jerzy, *Zachowany Obraz – Nieznana Kolekcja z Lat 1939–1945* (Warszawa, n.d.).

Boger, Jan, *To Live in the Fire … . The Photographic Journal of an Israeli Soldier* (New Jersey, 1977).

Boll, Bernd, 'Złoczów, July 1941: The Wehrmacht and the beginning of the Holocaust in Galicia', in O. Bartov, A. Grossmann and M. Nolan (eds), *Crimes of War: Guilt and Denial in the Twentieth Century* (New York, 2002).

Booth, Allyson, *Postcards from the Trenches: Negotiating the Space between Modernism and the First World War* (New York, Oxford, 1996).

Bopp, Petra, 'Les images photographiques dans les expositions sur les crimes de la Wehrmacht ou comment l'histoire devient intime', in Sophie Wahnich (ed.), *Fictions d'Europe: La guerre au musée* (Paris, 2003), pp. 189–209.

——, 'Viewing the photographs of Willi Rose', in Thomas Eller (ed.), *Shadows of War: A German Soldier's Lost Photographs of World War II* (New York, 2004), pp. 13–23.

——, *Fremde im Visier: Fotoalben aus dem Zweiten Weltkrieg* (Oldenburg, 2009).

Bourke, Joanna, *An Intimate History of Killing: Face-to-Face Killing in Twentieth-Century Warfare* (London, 1999).

——, 'A taste for torture?', the *Guardian*, G2, 13 September, 2006.

Brecht, Bertolt, *War Primer*, in John Willett (ed.) (London, 1998).

Brothers, Caroline, *War and Photography* (London, New York, 1997).

Bull, Rene, *Black and White War Albums: Snapshots by Rene Bull* (London, 1899).

Bullock, Marcus Paul, 'A German Voice over Paris: Ernst Jünger and Edgardo Cozarinsky's Film One Man's War', in *New German Critique*, No. 59 (1993), pp. 77–99.

Buzzell, Colby, *My War: Killing Time in Iraq* (New York, 2005).

Carmichael, Jane, *First World War Photographers* (London and New York, 1989).

Carter, Brian, *Saved by the Bomb* (Sussex, 2001).

Coe, Brian and Gates, Paul, *The Snapshot Photograph: The Rise of Popular Photography 1888–1939* (London, 1977).

Cook, Sir Edward, *The Press in War-Time* (London, 1920).

Danner, Mark, *Torture and Truth: Abu Ghraib and America in Iraq* (New York, 2004).

Davies, Norman, *Rising '44: 'The Battle for Warsaw'* (London, 2003).

Department of the Army Review (July 1960, Washington DC)

Doy, Gen, 'The camera against the Paris Commune', in T. Dennett, J. Spence, D. Evans and S. Gohi (eds), *Photography Politics One* (London, 1979).

Dunlop, Nic, *The Lost Executioner: A Story of the Khmer Rouge* (London, 2005).

Egan, Eleanor Franklin, *The War in the Cradle of the World: Mesopotamia* (New York and London, 1918).

Ehrlich, S. G. and Jones, Leland V., *Photographic Evidence: The Preparation & Use of Photographs in Civil and Criminal Cases* (London, 1967).

Eisenman, Stephen F., *The Abu Ghraib Effect* (London, 2007).

Eller, Thomas (ed.), *Shadows of War: A German Soldier's Lost Photographs of World War II* (New York, 2004).

Ellis, John, *Seeing Things: Television in the Age of Uncertainty* (London, 2002).

Ernst, Friedrich, *Krieg dem Kriege! War against War!* (Berlin, 1924).

———, *War against War!* (London, 1987).

Fabian, Rainer and Adam, Hans Christian, *Images of War: 130 Years of War Photography* (Hamburg, 1983).

Ferguson, Niall, *The Pity of War* (London, 1998).

Figes, Orlando, *A People's Tragedy: The Russian Revolution 1891–1924* (London, 1996).

Finkelstein, Norman G., *Image and Reality of the Israel-Palestine Conflict* (London and New York, 2001).

Fisk, Robert, 'The search for my father', *Independent on Sunday*, 21 February 1999.

———, *The Great War for Civilization: The Conquest of the Middle East* (London, 2005).

Ford, Colin, (ed.), *The Story of Popular Photography* (London, 1989).

Fralin, Frances and Livingston, Jane, *The Indelible Image* (Washington DC, 1985).

Frazer, John, 'Propaganda on the picture postcard', *The Oxford Art Journal* (1980).

Freund, Gisèle, *Photography and Society* (London, 1980).

Friedman, Devin and the editors of *GQ*, *This Is Our War: Servicemen's Photographs of Life in Iraq* (New York, 2006).

Frizot, Michel (ed.), *A New History of Photography* (Cologne, 1998).

Fussell, Paul, *The Great War and Modern Memory* (New York, Oxford, 1975).

Gardner, Alexander, *Photographic Sketch Book of the War* (Washington DC, 1865).

Garliński, Józef, *Poland in the Second World War* (London, 1985).

Gass, Izabela, 'Zbiór Fotografii Głownej Komisji Badania Zbrodni Hitlerowskich w Polsce – Instytut Pamięci Narodowej', *Fotografia*, Vols 3–4, Nos 49–50 (1988), pp. 54–7.

Gear, John H., 'The influence of photography in war', *The Photographic Journal*, December 1916.

Gernsheim, Alison and Helmut, *Roger Fenton, Photographer of the Crimean War: His Photographs and His Letters from the Crimea* (London, 1954).

Gernsheim, H., *The Rise of Photography, 1850–1880: The Age of Collodion* (London, 1988).

Goldberg, Vicki, *Photography in Print: Writings from 1816 to the Present* (Albuquerque, 1981).

——, *Margaret Bourke-White, a Biography* (London, 1987).

——, *The Power of Photography: How Photography Changed Our Lives* (New York and London, 1991).

Goldhagen, Daniel Jonah, *Hitler's Willing Executioners: Ordinary Germans and the Holocaust* (London, 1996).

Gourevitch, Philip and Morris, Errol, 'Exposure: the woman behind the camera at Abu Ghraib', *The New Yorker*, 24 March 2008.

—— and Morris, Errol, *Standard Operating Procedure: A War Story* (London, 2008).

Graham-Brown, Sarah, *Images of Women: The Portrayal of Women in Photography of the Middle East 1860–1950* (London, 1988).

Grant, Ian, *Cameramen at War* (Cambridge, 1980).

Grescoe, Audrey and Grescoe, Paul, *The Book of War Letters: 100 Years of Private Canadian Correspondence* (Toronto, 2003).

Gross, Jan T., *Fear: Anti-Semitism in Poland after Auschwitz* (New York, 2006).

Grupińska, Anka (ed.), *Warszawa 1943, Warszawa 1944: fotograf nieznany* (Warsaw, 2001).

Gumkowski, Janusz and Leszczyński, Kazimierz, *Poland under Nazi Occupation* (Warsaw, 1961).

Gutman, Roy and Rieff, David (eds), *Crimes of War: What the Public Should Know* (New York, 1999).

Haggith, Tony and Newman, Joanna (eds), *Holocaust and the Moving Image: Representations in Film and Television since 1933* (London, 2005).

Hamburg Institute for Social Research, (ed.), *The German Army and Genocide: Crimes against War Prisoners, Jews, and Other Civilians, 1939–1944* (New York, 1999).

Hamburger Institut für Sozialforschung (ed.), *Vernichtungskrieg: Verbrechen der Wehrmacht 1941–1944* (Hamburg, 1996).

Hamburger Institut für Sozialforschung (ed.), *Verbrechen Der Wehrmacht: Dimensionen Des Vernichtungskrieges 1941 bis 1944* (Hamburg, 2002).

Hariman, Robert and Lucaites, John Louis, *No Caption Needed: Iconic Photographs, Public Culture and Liberal Democracy* (Chicago, 2007).

Hannes Heer, *Vom Verschwinden der Täter. Der Vernichtungskrieg fand statt, aber keiner war dabei* (Berlin, 2004).

——, and Naumann, Klaus (eds), *War of Extermination: The German Military in World War II 1941–1944* (New York, 2006).

——, 'Die visuelle Provokation der ersten Wehrmachtsausstellung', in Gerhard Paul (ed.), *Das Jahrhundert der Bilder 1949 bis heute* (Göttingen, 2008).

——, Manoschek, Walter, Pollack, Alexander and Wodak, Ruth (eds), *The Discursive Construction of History: Remembering the Wehrmacht's War of Annihilation* (London, 2008).

Heilbrun, Françoise, 'Around the world: explorers, travelers, and tourists', in Michel Frizot (ed.), *A New History of Photography* (Cologne, 1998), pp. 149–68.

Hemment, John C., *Cannon and Camera: Sea and Land Battles of the Spanish-American War in Cuba, Camp Life and the Return of Soldiers* (New York, 1898).

Hersh, Seymour M., 'Torture at Abu Ghraib', *The New Yorker*, 5 May 2004.

——, *Chain of Command: The Road from 9/11 to Abu Ghraib* (New York, 2004).

——, 'The General's report', *New Yorker*, 25 June 2007.

Heydecker, Joe J., *Where Is Thy Brother Abel? Documentary Photographs of the Warsaw Ghetto* (São Paulo, 1981).

——, *The Warsaw Ghetto: A Photographic Record 1941–44* (London, 1990).

Hillerman, Tony, *Kilroy Was There: A GI's War in Photographs* (Kent, OH, 2004).

Hodgson, Pat, *Early War Photographs* (Reading, Berks, 1974).

Hogenkamp, Bert, *Film, Television and the Left 1950–1970* (London, 2000).

Holland, Pat, ' "Sweet it is to scan..." Personal photographs and popular photography', in Liz Wells (ed.), *Photography: A Critical Introduction* (London, 2000), pp. 119–61.

Holloway, David, *9/11 and the War on Terror (Representing American Events)* (Edinburgh, 2008).

Honnef, Klaus, Sachsse, Rolf and Thomas, Karin (eds), *German Photography 1870–1970: Power of a Medium* (Cologne, 1997).

Hood, Stuart, 'War photographs and masculinity', in P. Holland, J. Spence and S. Watney (eds), *Photography Politics/Two* (London, 1986), pp. 90–2.

Howe, Peter, *Shooting Under Fire* (New York, 2002).

Hunt, Robert and Hartman, Tom (eds), *Swastika at War: A Photographic Record of the War in Europe as Seen by the Camera Men of the German Magazine Signal* (London, 1975).

Hüppauf, Bernd, 'Experiences of modern warfare and the crisis of representation', *New German Critique*, No. 59 (1993), pp. 41–77.

——, 'Emptying the gaze: framing violence through the viewfinder', in Hannes Heer and Klaus Neumann (eds), *War of Extermination: The German Military in World War II 1941–1944*, (New York, 2006), pp. 345–77.

Iraq Army in Pictures (Baghdad, 1938).

Iraq in Wartime (Basra, n.d.).

Jay, Bill, 'Passing shots, the pistol/rifle camera in photographic history, 1858–1938', www.billjayonphotography.com

——, and Moore, Margaret, *Bernard Shaw on Photography* (London, 1989).

Jeffrey, Ian, *Photography: A Concise History* (London, 1981).

——, 'Wilhelm von Thoma: war at first-hand', in *Photo works* (Autumn–Winter, October–April 2008–9), pp. 78–81.

Jensiewicki, Władysław, *Powstanie Warszawskie 1944* (Warszawa, 1989).

Jünger, Ernst, 'War and photography', *New German Critique*, No. 59 (1993), pp. 25–6.

Kaes, Anton, 'The cold gaze: notes on mobilization and modernity', *New German Critique*, No. 59 (1993), pp. 105–18.

Karski, Jan, *Story of a Secret State* (London, 1944).

Kenyon, Dave, *Inside Amateur Photography* (London, 1972).

King, David, *Red Star over Russia* (London, 2009).

Kirchner, Klaus, *Flugblätt-Propaganda IM2: Weltkrieg Flugblätter aus England, G-1943-G-1944* (Erlangen, 1979).

Klee, Ernst, Dresden, Willi and Riess, Volker (eds), *'The Good Old Days': The Holocaust as Seen by Its Perpetrators and Bystanders* (New York, 1991).

Knightley, Phillip, *The First Casualty: The War Correspondent as Hero, Propagandist and Mythmaker from the Crimea to Vietnam* (London, 1975).

Kuhn, Annette 'Remembrance', in L. Heron and V. Williams (eds), *Illuminations: Women Writing on Photography from the 1850s to the Present* (London, 1996), pp. 471–8.

Kusnierz, Dr Bronisław, *Stalin and the Poles* (London, 1949).

Langford, Martha, *Suspended Conversations: The Afterlife of Memory in Photographic Albums* (Montreal, 2001).

Langton, Loup, *Photojournalism and Today's News* (West Sussex, 2009).

Lee, Anthony W. and Young, Elizabeth, *On Alexander Gardner's Photographic Sketch Book of the Civil War* (Berkeley, LA, 2007).

Lemagny, Jean-Claude and Rouille, André (eds), *A History of Photography: Social and Cultural Perspectives* (Cambridge, 1987).

Levin, Judith and Uziel, Daniel, 'Ordinary men, extraordinary photos', in *Yad Vashem Studies*, No. 26 (1998), pp. 265–93.

Lewinski, Jorge, *The Camera at War: A History of War Photography from 1848 to the Present Day* (London, 1978).

Livingston, Jane and Fralin, Francis (eds), *The Indelible Image: Photographs of War – 1846 to the Present* (Washington DC, 1985).

McNally, *Camera in My Kitbag* (Cape Town, 1988).

Meyer, Pedro, 'The icons of this war', in *Zerozero*, May 2004.

Moeller, Susan, D., *Shooting War: Photography and the American Experience of Combat* (New York, 1989).

Mollo, Boris, *The British Army from Old Photographs* (London, 1975).

Muzeum Historii Fotografii w Krakowie, *Pprzełamywać Bariery, Budować Mosty: Wojna na Fotografiach Polsjkiego i Niemieckiego Żołnierza* (Kraków, 2005).

Naggar, Carole, *George Rodgers: An Adventure in Photography 1908–1995* (Syracuse, 2003).

Nazi Crimes in Ukraine 1941–1944: Documents and Materials (Kiev, 1987).

Newhall, Beaumont, *Photography: Essays & Images* (London, 1981).

Newton, Julianne H., 'Burden of visual truth: the role of photojournalism in mediating reality', in *Visual Communications Quarterly*, Vol. 5, No. 4 (Autumn 1998), pp. 4–9.

Nicholls, Horace W. 'Face to face with themselves', in P. Holland, J. Spence and S. Watney (eds), *Photography/Politics: Two* (London, 1986).

Page, Tim, *Page after Page* (London, 1990).

Parkes, Frederick, *Nature and God: Cruelty, War Atrocities and Atrocity Myths* (London, 1926).

Paton, Harold, *Private Paton's Pictures: Behind the Lines with Kiwi Soldiers in North Africa* (New Zealand, 2003).

Phillips, Christopher (ed.), *Photography in the Modern: European Documents and Critical Writings 1913–1940* (New York, 1989).

Polish Ministry of Information, *The German New Order in Poland* (London, 1942).

Ponsonby, Arthur, *Falsehoods in Wartime* (London, 1928).

Rabinowitz, Paula, *They Must Be Represented: The Politics of Documentary* (London, 1994).

Raim, Edith, 'Coping with the Nazi past: Germany and the legacy of the Third Reich', *Contemporary European History*, Vol. 12, No. 4 (2003), pp. 547–59.

Reemtsma, Jan Philipp, *In the Cellar* (London, 1999).

Reitlinger, Gerald, *The Final Solution: The Attempts to Exterminate the Jews of Europe, 1939–1945* (London, 1953).

Rennie, D. F., *British Arms in North China and Japan* (Shanghai, 1863).

Rivoir, Silvana, 'The soldier photographer', in P. Holland, J. Spence and S. Watney (eds), *Photography/Politics: Two* (London, 1986), pp. 82–9.

Roeder, George H., Jr, *The Censored War: American Visual Experience during World War Two* (New Haven, CT and London, 1993).

Roosevelt, Kermit, *War in the Garden of Eden* (London, 1920).

Rossino, Alexander B., 'Destructive impulses: German soldiers and the conquest of Poland', *Holocaust and Genocide Studies*, Vol. 2, No. 3 (1997), pp. 351–65.

——, 'Eastern Europe through German eyes: soldiers' photographs 1939–42', *History of Photography*, Vol. 23, No. 4 (1999), pp. 313–21.

Samuel, Raphael, *Theatres of Memory* (London, 1994).

Sandweiss, M. A., Stewart, R. and Huseman, B. W., *Eyewitness to War: Prints and Daguerreotypes of the Mexican War, 1846–1848* (Washington DC, 1989).

Scharf Rafael, F., *In the Warsaw Ghetto: Summer 1941 (Photographs by Willy Georg)* (London, 1993).

Schwarberg, Günther, *In the Ghetto of Warsaw: Heinrich Jöst's Photographs* (Göttingen, 2001).

Sebald, W. G., *On the Natural History of Destruction* (New York, 1999).

Seidler, W. Franz, *Verbrechen an der Wehrmacht: Kriegsgreuel der Roten Armee 1941/1942* (Selent, 1997).

Sekula, Allan, *Photography against the Grain: Essays and Photoworks 1973–1983* (Nova Scotia, 1983).

Shah, Sidar Ikbal Ali, *Westward to Mecca: A Journey of Adventure through Afghanistan, Bolshevik Asia, Persia, Iraq & Hijaz to the Cradle of Islam* (London, 1928).

Simpson, David, 'Iwo Jima v. Abu Ghraib', *London Review of Books*, 29 November 2007.

Smith, Tim and Winslow, Michelle, *Keeping the Faith: The Polish Community in Britain* (Bradford, 2000).

Sontag, Susan, *On Photography* (London, 1979).

——, *Regarding the Pain of Others* (London, 2003).

——, 'Regarding the torture of others', *New York Times*, 23 May 2004.

——, 'What have we done?', the *Guardian*, G2, 24 May 2004.

Soviet Documents on Nazi Atrocities (London, 1942).

Stallabrass, Julian, 'The power and impotence of images', in *Memory of Fire: The War of Images and Images of War* (exhibition catalogue, 2008), pp. 04–09.

Stallings, Laurence (ed.), *The First World War: A Photographic History* (New York and London, 1933).

Stenger, Erich, *The March of Photography* (London, New York, 1958).

Stephens, Patrick, *Cameraman at War* (Cambridge, 1980).

Struk, Janina, *Photographing the Holocaust, Interpretations of the Evidence* (London, 2004).

——, 'My duty was to take pictures', the *Guardian*, G2, 28 July 2005.

——, 'Images of women in Holocaust photography', *Feminist Review*, 88 (2008), pp. 111–21.

Tagg, John, 'Part One: a means of surveillance: the photograph as evidence in law', *Screen Education*, Vol. 36 (1980), pp. 17–55.

——, 'Power and photography', Part Two: 'A legal reality: the photograph as property in law', in *Screen Education*, No. 37 (1980–1981), pp. 17–27.

——, *The Burden of Representation: Essays on Photographies and Histories* (London, 1988).

Taylor, John, *War Photography: Realism in the British Press* (London, 1991).

——, *Body Horror: Photojournalism, Catastrophe and War* (Manchester, 1998).

——, 'Iraqi torture photographs', *Journalism Studies*, Vol. 6 (2005), pp. 39–49.

Taylor, Roger *Impressed by Light, British Photographs from Paper Negatives 1840–1860* (New York, 2007).

Tetens, T. H., *The New Germany and the Old Nazis* (London, 1961).

Thomas, Allan, *The Expanding Eye: Photography and the Nineteenth-Century Mind* (Croom Helm, 1978).

Tomaszewski, Jerzy, *Epizody Powstania Warszawskiego* (Warsaw, 1979).

Trachtenberg, Alan, 'Albums of war: on reading Civil War photographs', *Representations*, No. 9, Special Issue: 'American culture between the Civil War and World War 1' (1985), pp. 1–32.

Tropp, Martin, *Images of Fear: How Horror Stories Helped Shape Modern Culture* (London, 1990).

Updike, John, 'Visual trophies: the art of snapshots', *The New Yorker*, 24 December 2007.

Van Kesteren, Geert, *Why, Mister Why?* (Amsterdam, 2004).

——, *Baghdad Calling* (Amsterdam, 2004).

Von Amelunxen, Hubertus, 'The century's memorial: photography and the recording of history', in Michel Frizot (ed.), *A New History of Photography* (Cologne, 1998), pp. 131–47.

Wagner, Jon (ed.), *Images of Information: Still Photography in the Social Sciences* (London, 1979).

Warszawa 1940–1941 w Fotografii Dr Hansa-Joachima Gerke (Warsaw, 1996).

We Shall Not Forgive: The Horrors of the German Invasion in Documents and Photographs (Moscow, 1942).

Wells, Liz (ed.), *Photography: A Critical Introduction* (London and New York, 2000).

Williams, Val, *Warworks: Women, Photography and the Iconography of War* (London, 1994).

Wilson, H. W. and Hammerton, J. A. (eds), *The Great War: The Standard History of the All-Europe Conflict* (London, 1915).

Wolkowicz, Shlomo, *The Mouth of Hell* (Haverford, 2002).

Wombell, Paul, 'Face to face with themselves: photography and the First World War', in P. Holland, J. Spence and S. Watney (eds), *Photography/Politics: Two* (London, 1986), pp. 74–81.

Young, James E., *The Texture of Memory: Holocaust Memorial and Meanings* (New Haven, CT and London, 1993).

Zelizer, Barbie, *Remembering to Forget: Holocaust Memory Through the Camera's Eye* (Chicago, 1998).

Films

Beckermann, Ruth (dir.), *East of War (Jenseit des Krieges)* (Austria, 1996).

Breaking the Silence (dir.), *Israeli Soldiers Talk about Hebron* (Israel, 2005).

Kennedy, Rory (dir.), *Ghosts of Abu Ghraib* (USA, 2007).

Morris, Errol (dir.), *Inconvenient Evidence* (USA, 2008).

Scranton, Deborah (dir.), *Bad Voodoo's War* (USA, 2007).

Verhoeven, Michael (dir.), *The Unknown Soldier* (Germany, 2006).

Index